ULTIMATE WILDLIFE DESTINATIONS

ULTIMATE
DESTIN

The World's Most Incredible Places to See Wild Animals

Samantha Wilson

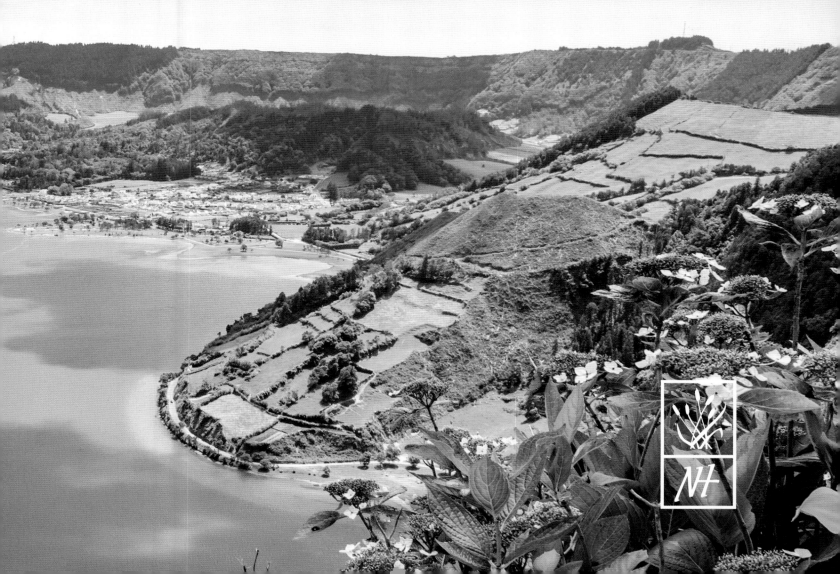

WILDLIFE
ATIONS

CONTENTS

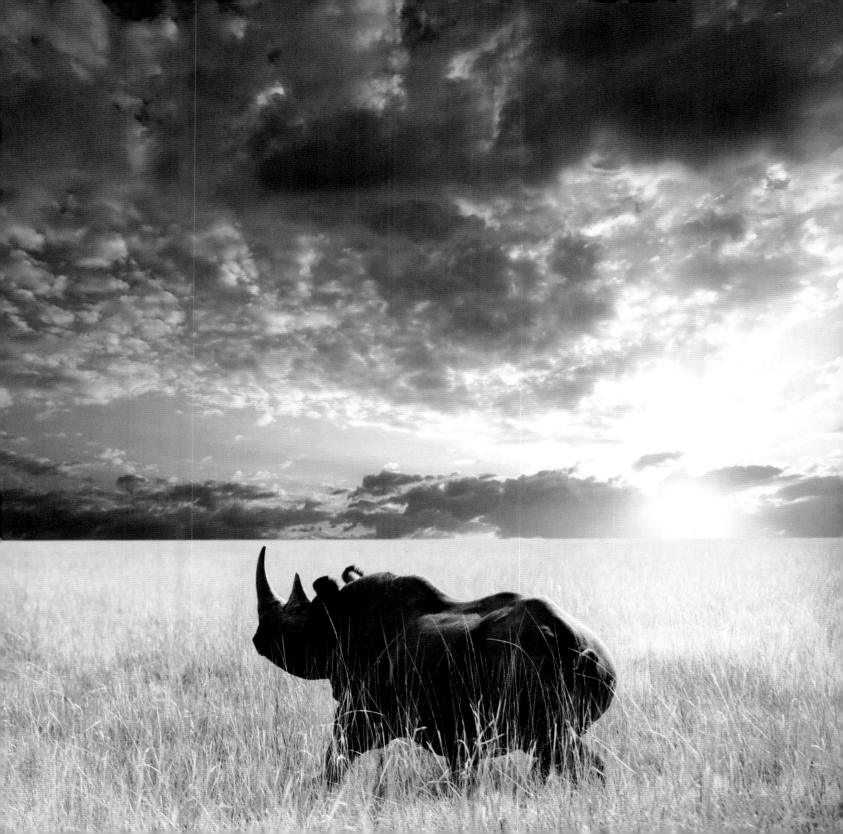

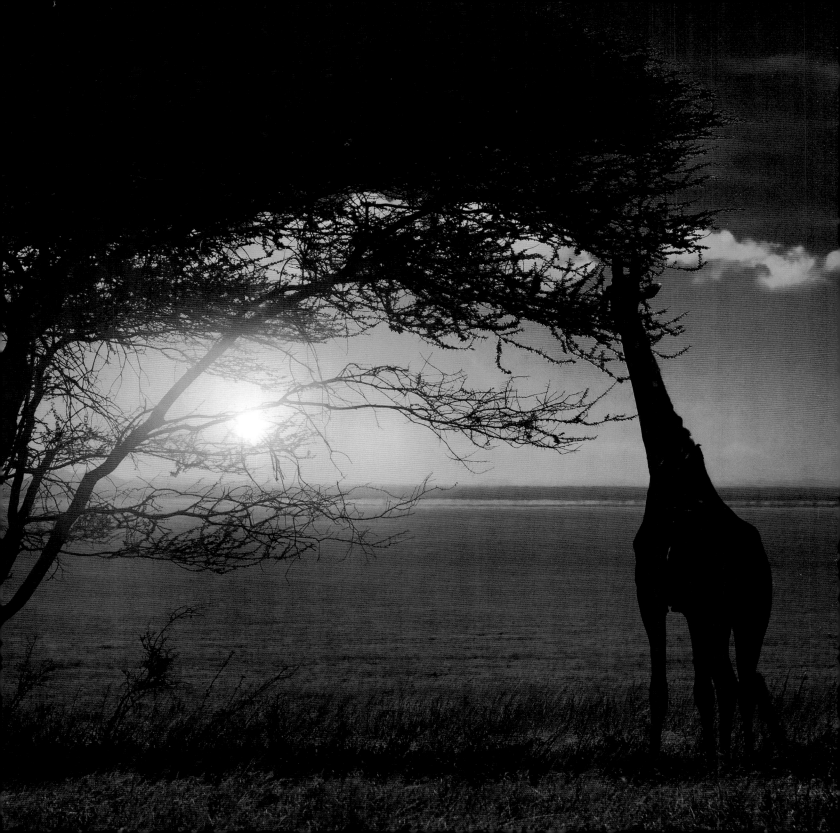

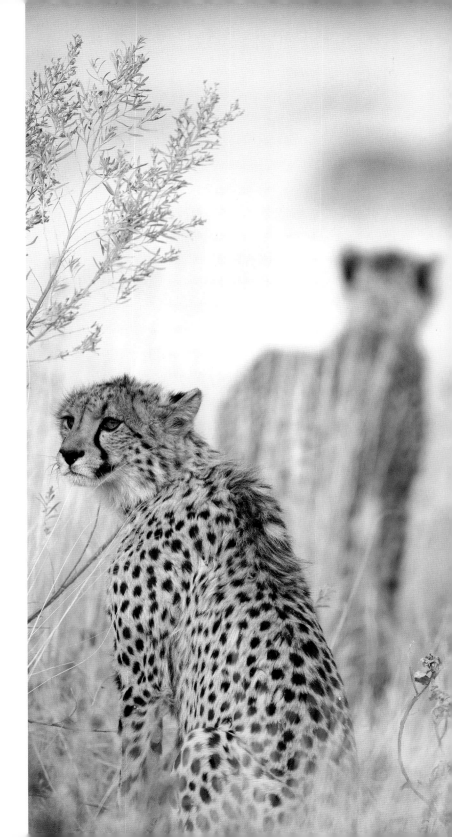

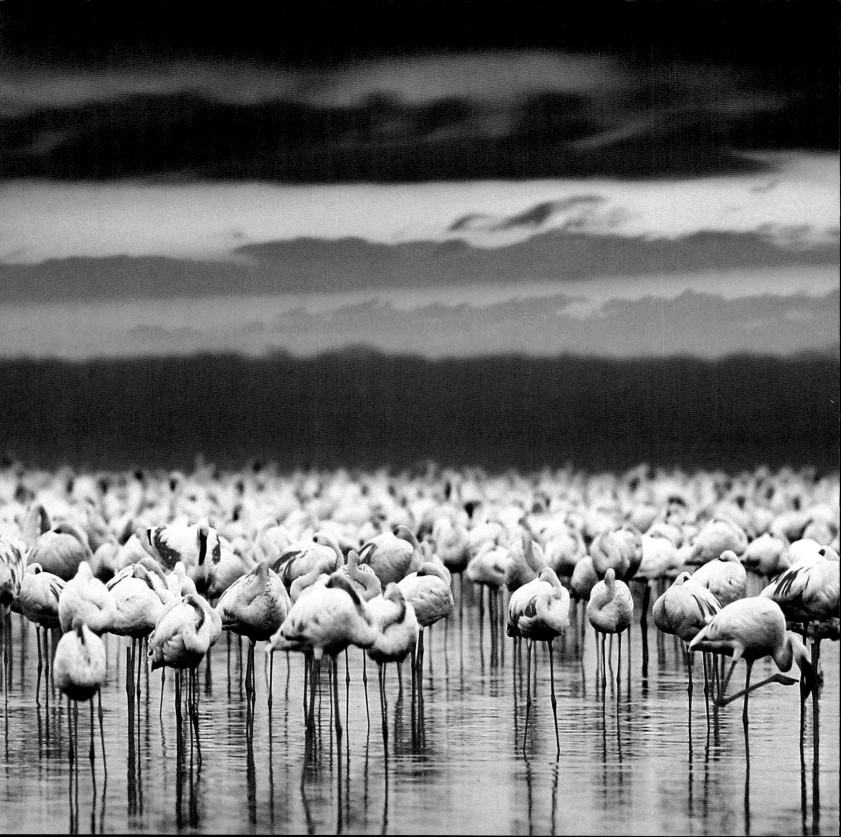

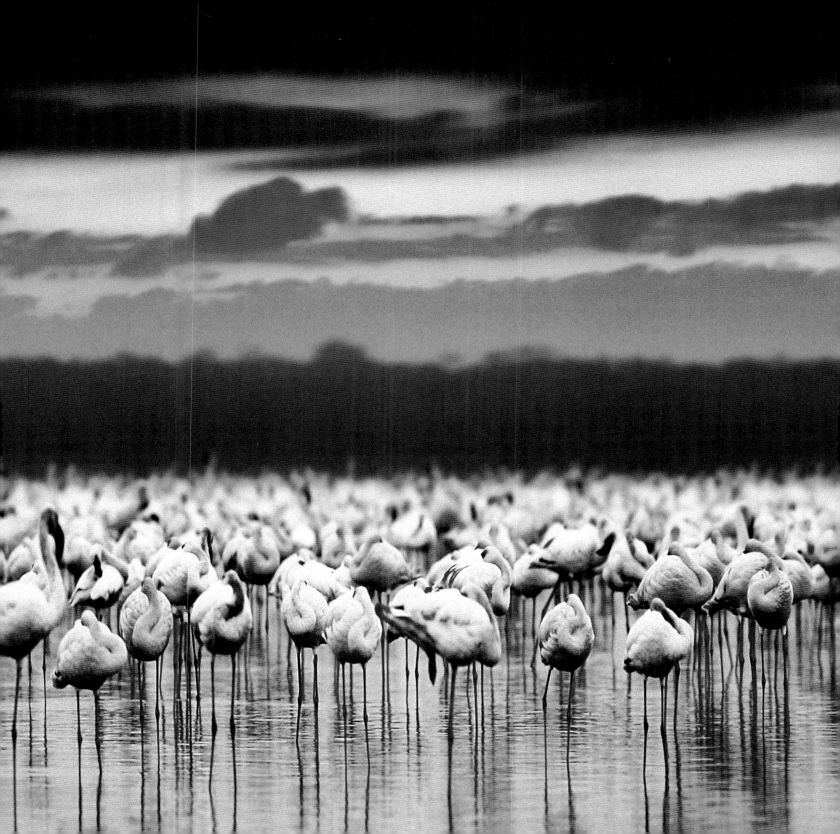

1 Great Bear Rainforest	27 Wolong Nature Reserve	52 Amboseli N.P.	77 Narcisse Snake Dens
2 Torres Del Paine N.P.	28 Bosque del Apache	53 Oban	78 Tikal N.P.
3 Utila	National Wildlife Refuge	54 Chilkat Bald Eagle Preserve	79 Papua New Guinea
4 Makgadikgadi Pans	29 Kangaroo Island	55 Michoacán	80 Gir N.P.
5 Ein Avdat N.P.	30 Raja Ampat Islands	56 Hemis N.P.	81 Lower Zambezi N.P.
6 Eungella N.P.	31 Białowieża Forest	57 False Bay	82 St Kilda
7 Great Smoky Mountains N.P.	32 San Ignacio Lagoon	58 Andalucia	83 Tortuguero N.P.
8 Valdés Peninsula	33 Kruger N.P.	59 Canastra N.P.	84 Galápagos Islands
9 Moremi Game Reserve	34 Denali N.P.	60 Yellowstone N.P.	85 Ol Pejeta Conservancy
10 Little Rann of Kutch	35 Esteros del Iberá Wetlands	61 Kaikoura	86 Bergslagen
11 Carpathian Mountains	36 Gombe Stream N.P.	62 Ranthambore N.P.	87 Los Llanos de Moxos
12 Falkland Islands	37 Palau	63 Ngorongoro Crater	88 Everglades N.P.
13 Minneriya N.P.	38 Rottnest Island	64 Greenland	89 Hokkaido
14 Cocos Island	39 Wrangel Island	65 Bahamas	90 Serengeti
15 Pantanal	40 Chitwan N.P.	66 Algonquin Provincial Park	91 Monterey Bay
16 Etosha N.P.	41 Mallorca	67 Iguazu Falls Rainforest	92 Iceland
17 Waitomo Caves	42 Ruaha N.P.	68 Kakadu N.P.	93 Iwokrama Forest
18 The Azores	43 Johnstone Strait	69 Yala N.P.	94 Gunung Mulu N.P.
19 Taman Negara N.P.	44 Canaima N.P.	70 Murchison Falls N.P.	95 Nunavik
20 Katmai N.P.	45 South Georgia	71 Lieska	96 Banc D'Arguin N.P.
21 Colca Canyon	46 The Maldives	72 Saguenay-Lac-Saint-Jean	97 Komodo N.P.
22 Isla Contoy	47 South Luangwa N.P.	73 Eduardo Avaroa	98 Jasper N.P.
23 Danum Valley	48 Badlands N.P.	Andean Fauna National Reserve	99 Madagascar
24 Cape Cross	49 Monteverde Cloud Forest	74 Chang Tang Nature Reserve	100 Svalbard
25 Dovrefjell N.P.	50 Christmas Island	75 Bwindi Impenetrable N.P.	
26 Trinidad	51 Bako N.P.	76 Dolomites	

WILD TRAVEL

Humans aren't the only creatures who travel. Whether by hoof, wing or fin, the animals on our great big planet move. They move to survive, to follow the life-giving rains and the lush grasses which sprout in their wake, or to birth their young in safe, tranquil harbours. They move along Mother Nature's arteries, some embarking on perilous journeys thousands of miles long, others venturing no further than their wild backyard. It is a natural instinct, an unquenchable and primal drive to survive which spurs humpback whales to undertake the longest mammal migration on earth 26,000 kilometres (16,000 miles) from the cool water feeding grounds of the Arctic and Antarctic to warm tropical waters to breed. To the thunderous sound of pounding hooves and clouds of African dust filling the air 1.5 million wildebeest and 600,000 zebra and gazelle migrate en masse through the Serengeti in one of the planet's most astounding wildlife events, and tiny bar-tailed godwits undertake the longest non-stop flight of any bird from New Zealand to China. The stories of survival are breathtaking, salmon embarking on their brutal journey upstream to spawn, elephants marching stoically trunk to tail in search of water holes in an otherwise parched land, and 50 million red crabs spreading like a blanket of blood a few mere kilometres from jungle to beach to mate.

'An understanding of the natural world and what's in it is a source of not only a great curiosity but great fulfilment'

– David Attenborough

Migrations are a stark reminder of a time when humans didn't dominate the earth, and provide us with an affinity with our animal companions. Once we moved for the same reasons, to survive and exist. Yet today our wanderlust is fuelled by a different impetus. In a world where bucket list activities and once-in-a-lifetime experiences are more possible than ever before, it is the wilds of the natural kingdom and its majestic and often eccentric inhabitants that drive travellers. African safaris might have long lured early explorers to witness first hand lions and elephants, giraffes and rhinoceros, but today the opportunities to see animals in their natural environments span the globe far beyond the king of the jungle.

Perhaps we venture in search of wildlife for the simple joy of the wild, of seeing animals free and feral in their fast-disap-pearing natural habitats. To stand amongst millions of curious penguins and bellowing walruses on an Antarctic South Georgian beach in the densest concentration of animals on the planet is a humbling and thrilling sensation. Or perhaps it's to see with your very own eyes some of the very last individuals of a species which may terrifyingly not exist in a few short years – just 700 gentle mountain gorillas and 5,000 black rhinos remain in the wild. But maybe it's to challenge yourself, to glimpse the most elusive snow leopard in the harsh Himalayan foothills, or to set eyes on the ghostly white Kermode bear which ambles through Canada's Great Bear Rainforest.

Whatever our drive to seek out and observe wildlife, the need to do so responsibly is paramount. Our travels must contribute to the longevity of a species, not play a role in its demise. Throughout this book we bring you inspiration and adventure combined with practical, sustainable wildlife themes. From tracking jaguars in Brazil to snorkelling with whale sharks in Honduras, and from hiking in Transylvania's Carpathian Mountains in search of European brown bears to cruising the Azores to spot blue whales, the opportunities are boundless and alluring. 100 carefully chosen destinations will take you on a journey across oceans and polar ice caps, rainforests and mountain peaks in search of the most astounding creatures on the planet.

The IUCN Red List of Threatened Species provides taxonomic, conservation status, and distribution information on species that are facing a high risk of global extinction. An icon accompanies each destination entry showing the IUCN Red List status:

 Critically endangered Near threatened

 Endangered Least concern

 Vulnerable Data deficient

KERMODE BEARS IN THE GREAT BEAR RAINFOREST
CANADA

In Canada's British Columbia, a 400 kilometres (250 miles) stretch of temperate rainforest sprawls between Vancouver Island and the southern fringes of Alaska. Glacier-cut fjords and cold, dark ocean waters teeming with orca and sea lions give way to moss-blanketed mountains and ancient forests. It is a true unblemished wilderness of mist-shrouded valleys, tumbling waterfalls and 1,000 year-old trees. At 64,000 square kilometres (24,700 miles²) the Great Bear Rainforest is part of the largest remaining coastal temperate rainforest on the planet, and is home to the rare Kermode bear.

In a place where the streams writhe with fat, silvery-pink salmon, bears are sure to follow. Brown bears grow to mammoth size here – up to 450kg (1,000lbs) – and black bears thrive on the plentiful feasts. Bald eagles, coastal grey wolves, Sitka deer, cougars and mountain goats live amongst the spruce, silver fir and cedar trees that grow to 100 metres (328ft) high.

Yet the most celebrated residents are the creamy-white Kermode bears. Known as 'spirit' bears to the Tsimshian Coastal First Nation communities whose villages dot the great forest, they number just 400. Neither polar nor albino, Kermode bears are a type of black bear, with just one in ten being born with pale, sand-coloured fur. Although they are found in their greatest numbers on Princess Royal Island – also home to the Kitasoo Spirit Bear Conservancy – catching a glimpse of one of these curious creatures requires luck and the expert tracking skills of a local First Nation guide.

In Search of Ghosts
The Great Bear Rainforest was given its name by environmental groups – led by the Nature Conservancy – who ran a historic land-use campaign throughout the 1990's to stop logging in more than 5 million acres. Today, bears and other wildlife share the remote and mostly inaccessible rainforest with the First Nations whose deep spiritual connections to the land and sea are evident in the totem poles and artwork that adorn their communities in Bella Bella, Bella Coola and Klemtu.

In Klemtu, in the deep heart of the forest, and accessible only by float plane and boat, the Spirit Bear Lodge exudes cultural charm. Owned and run by Kitasoo/Xaixais First Nation it makes for an idyllic base from which to venture into the bear-laden lands, and dolphins and sea lions are regular visitors to the waterfront lodge.

The salmon are the life of the forest, and come late summer millions run the glacier-fed streams to complete their epic journey to spawn. It is the perfect time to set off in search of grizzlies and black bears, and to watch as they fish, expertly swatting their giant paws into clear, frigid streams. And just maybe, a ghostly white spirit bear will amble out of the undergrowth, and you will be one of the few to witness the rare and revered white black bear.

TAKE ME THERE

How to Visit: All-inclusive lodges offer float plane trips to the forest, along with daily wildlife-watching trips. Alternatively, summer ferries connect Bella Coola to other ports in BC. Bear-viewing is best from mid-June to mid-October.

Further Information: Spirit Bear Lodge (**www.spiritbear.com**) is an ecotourism venture run by the Kitasoo/ Xaixais First Nation. They offer 3 to 7 night bear-viewing packages. Useful resources include British Columba Tourism (**www.hellobc.com**), BC Ferries (**www.bcferries.com**) and the Nature Conservancy (**www.nature.org**).

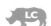

Did You Know? The Kermode bear is named after Francis Kermode, a zoologist and director of the Royal B.C Museum who studied them extensively.

Wildlife:
- Brown bear
- Grey Wolf
- Salmon
- Mountain Goat
- Sitka Deer
- Orca
- Sea lion
- Bald Eagle
- Cougar (puma)
- Humpback Whale

GUANACOS IN TORRES DEL PAINE NATIONAL PARK
CHILE

To say that the guanaco – a wild ancestor of the llama – is a hardy animal, is somewhat of an understatement. Not only do they traverse some of South America's most arid and mountainous terrain, they withstand whipping winds, fierce storms and sub-zero temperatures – all with just a soft, dense cinnamon-coloured coat for protection. Guanaco blood contains four times the amount of oxygen than that of a human in order to be able to withstand the low oxygen levels of the high Andes, and they can run at 56 kilometres (34 miles) per hour to outmanoeuvre pumas. They are also rather adept swimmers.

Despite its vast biodiversity, South America's mammals don't get much bigger than the guanaco. It lives throughout the long Andean ridge, although its numbers have diminished since the 19th century when great tracts of land were fenced off for sheep farming. In Torres del Paine, however, the removal of farmsteads and the establishment of a national park has created a sanctuary for the guanaco, and it is one of the best and most breathtaking places in the world in which to see them.

Soaring vertically for 2,800 metres (9,000ft) above the Patagonian steppes, craggy granite peaks loom over milky turquoise lakes, roaring icy rivers, electric blue glaciers and golden grasslands. In its heart, the *Cuernos* (meaning 'horns') erupt skywards like three jagged towers, around which Andean condors and black-chested buzzard eagles float on the bracing winds. The rolling steppes are home to ostrich-like rheas, foxes and the guanaco's only predator, the puma.

Trekking at the Bottom of the World

The weather in Torres del Paine can be savage and unpredictable. Blue skies and a burning orange sun are often accompanied by fierce winds that screech through the rocks. Yet somehow it adds to the feral charm and breathtaking beauty.

The seasons each bring with them a changing colour palette, the sultry reds and deep burgundies of autumn, the whitewash of snowy winter and the golden grasses of summer. In spring, wildflowers poke their heads through the pampas grass, vivid red firebush and delicate orchids managing to withstand the weather. And the region's wildlife gives birth to their young. It is a wonderful time to visit, to see young guanacos tottering about on bandy legs, not yet exuding the grace and elegance of their mothers.

Outdoor pursuits abound in the national park, from hiking to horse-riding and kayaking, ice-walking, mountaineering and climbing. For the more intrepid explorer, launch yourself into the heart of the park with a five day guided trek along the W Trail, where you bed down in rustic *refugios* (lodges) at night and by day traverse the guanaco's magnificent territory. Alternatively, eco-pods and cosy hotels provide a perfect base for embarking on wildlife safaris, puma tracking trips and photography tours.

TAKE ME THERE

How to Visit: The national park is accessed from Patagonia's Punta Arenas. A range of hotels, eco-pods and *refugios* are available, as well as a plethora of outdoor activities. It is possible to visit year-round.

Further Information: The park website (www.conaf.cl) is in Spanish, but www.torresdelpaine.com and www.gochile.cl are good resources. Las Torres Hotel (www.lastorres.com) offers all-inclusive stays, and for multi-day trekking, horse-riding or wildlife photography tours try Ecocamp Travel (www.ecocamp.travel), Chile Nativo (www.chilenativo.com) or Andes Mountain (www.andesmountain.cl).

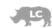

Did You Know? Pumas have the largest range of any land mammal in the western hemisphere. They also hold the record for the most amount of names (about 40) including cougar and mountain lion.

Wildlife:
- Puma
- Andean condor
- Rhea
- Chilean flamingo
- Black-chested buzzard eagle
- Chilla fox
- Chilean guemal
- Andes skunk
- Magellanic woodpecker
- Spectacled duck

3 WHALE SHARKS IN UTILA
HONDURAS

Whale sharks hold a tender place in the hearts of Utila's residents, and are known to fishermen as Old Tom after a legendary, barnacle-encrusted whale shark that once plied the island's waters. In doorways of the stilted, pastel-coloured houses of Honduras' Bay Islands they still tell rum-heartened tales about the great beast which they say reached 18 metres (60ft) in length.

It would be logical to assume that finding the largest fish on the planet couldn't be too difficult, but despite their size – some reach 14 metres (46ft) in length – and their distinctive blue spotted markings, whale sharks can be extremely elusive. The gentle, plankton-feeding sharks frequent warm, tropical seas around the world, but Utila's waters are a major stopping point on their little understood migrations. For whale sharks have left scientists baffled, the explanations for their 8,000 kilometres (5,000 miles)-long ocean migrations and the mystery of where they give birth as yet unanswered. While the best time to view these gentle giants is in March and April, Utila is unique in that sightings are possible year-round.

As plankton-feeders whale sharks spend much of their time at the surface. Tilting their powerful bodies vertical they open their wide mouths to gorge, creating a feeding frenzy as small tuna join the feast. Known as boils, the tuna writhe in the water, their splashes alerting sea birds and eager snorkelers to their presence just below the surface. Snorkelling alongside is the best way to experience these magnificent creatures, and a humbling example of the sheer vastness of the oceans and the life within it.

Swimming with Giants

As a diving haven, Utila draws the backpacker crowd in search of budget diving courses, heathy fish-laden reefs and a laid-back Caribbean culture. Wooden houses jumble upon each other, rickety docks jut into the water and spiny-tailed iguanas roam wild. Dive centres outnumber supermarkets, all offering the opportunity to head to the island's deep north shore, the best place to encounter and snorkel with solitary whale sharks as they saunter through the clear navy blue waters.

The Utila Whale Shark Research Centre – a non-profit conservation organisation dedicated to preserving Honduras' whale sharks – offer responsible encounter trips. As the captain kills the boat's engine, small groups slip into the sea alongside the sharks, the great animals sashaying quickly and elegantly below as their huge pointed tails propel them at effortless speed. Sightings are often fleeting, the timid creatures descending into the blue abyss, their white-spotted bodies camouflaging with the sun-dappled Caribbean Sea. Yet for the lucky ones, the sharks open their cavernous mouths and feed, completely unperturbed by their admirers.

TAKE ME THERE

How to Visit: Flights from Miami and Houston go to San Pedro Sula from where buses or domestic flights continue to La Ceiba. A twice daily ferry makes the journey to Utila. Accommodation ranges from dive centre hostels to laid-back resorts and beachfront cabins.

Further Information: The Whale Shark and Oceanic Research Centre (**wsorc.org**) offers conservation projects and snorkelling trips, and most dive centres will make stops in between dives to look for sharks. For further information on the Utila Iguana Conservation Project visit (**www.utila-iguana.de**).

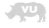

Did You Know? The Utila Spiny-Tailed 'Swamper' Iguana is indigenous to the tiny island, and is one of the world's rarest lizards. The iguanas – which can grow to 76cm (30in) in length – have a distinctive turquoise tinge and can be seen lazing in the sun.

Wildlife:
- Utila Spiny-Tailed iguana
- Hawksbill turtle
- Pelican
- Devil ray
- Spinner dolphin
- Rough tooth dolphin
- Spotted eagle ray
- Seahorse
- Land crabs
- Barracuda

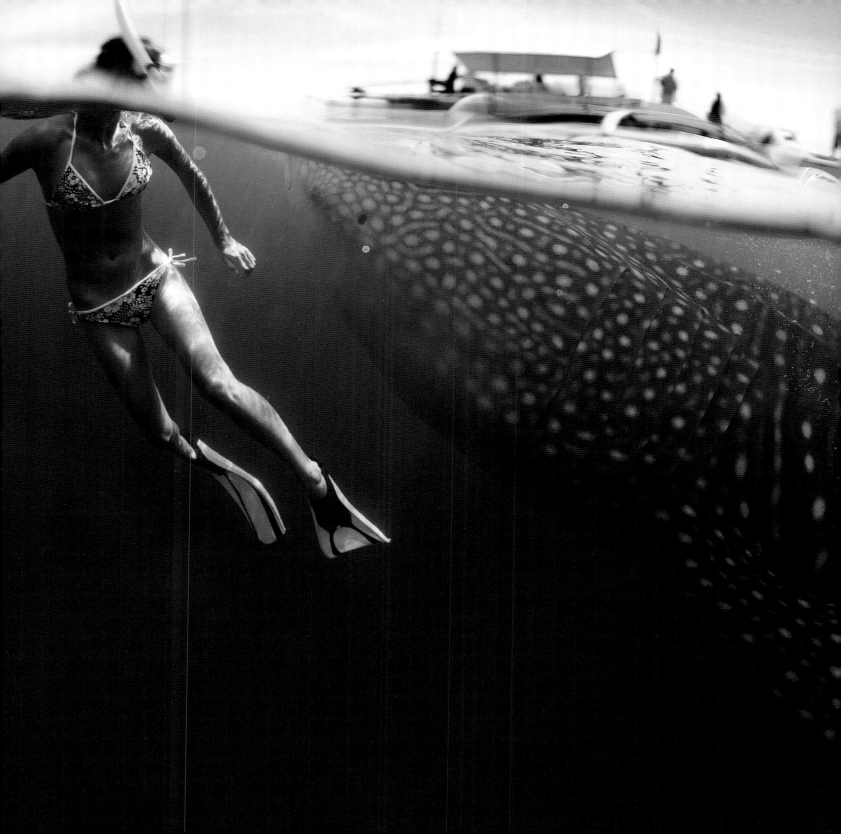

4 MEERKATS IN MAKGADIKGADI PANS
BOTSWANA

In the heart of the wild Kalahari Desert, the last remnants of an ancient super lake the size of Switzerland stretch shimmering white into the interminable distance. Only great lonely baobab trees provide a landmark in the otherwise barren landscape, having once guided 19th century explorers on uncharted expeditions across a gruelling terrain. This place is the Makgadikgadi Pans, a collection of blinding, hard salt pans and sandy desert which together create one of the largest salt flats on the planet.

In this harsh and inhospitable realm, very little grows, although salt marshes and savannah stretch from their fringes, providing respite to the region's limited dry season fauna, including its resident communities of meerkats. For Makgadikgadi in fact exudes two very different personalities, each determined by the life-giving rains which flood the parched region come January to March. For a few short months, the pans spring to life, grasses shooting above ground and hundreds of thousands of salmon-coloured flamingos arriving to nest. Vast herds of wildebeest and zebra arrive following ancient migration routes, behind them predators, elephants and giraffe.

Yet for most of the year, Makgadikgadi is waterless and arid. Hot winds blow across the cracked ground and only a few hardy species remain behind to do their best in these testing conditions. While ostriches and tortoises, aardwolves, wildcats and jackals can occasionally be spotted trotting across the featureless landscape, it is one of the best places in the world to meet the highly social clans of meerkats.

Up Close and Personal in the Kalahari

Gregarious and active, meerkats live in tight-knit communities, their network of burrows providing respite from the sweltering heat and overhead predators. Standing on their tiny back legs they strain to see across the horizon, on a constant look-out for swooping hawks and eagles. While usually highly skittish, four clans have been carefully habituated near to the famed Jack's Camp luxury lodge – set up by the legendary African adventurer Jack Bousfield.

Just a spattering of lodges inhabit a region untouched for 65 million years. Under the blackest of skies lit only by shooting stars, soak up the complete silence as you languor amidst the afro-chic lodges – the beautiful Nata lodge is Botswana's first community-led conservation project. By day, travel across a true wilderness where fossils litter the parched pans, elephant bones and prehistoric artefacts having lain here for decades or centuries. As you sit still and silent amidst the isolation and contemplate how life exists in this barren place, a small face emerges, followed by several more. Inquisitive and unafraid, the meerkats clamber atop their well-received new lookout posts until a sharp shriek signals danger and, as quickly as they appeared, they disappear back under the parched ground.

TAKE ME THERE

How to Visit: The national park is between the towns of Maun and Nata, and there are a handful of accommodation options. The best time to see the meerkats is during the dry season April to September. April to July is good for game-viewing.

Further Information: Botswana Tourism (**www.botswanatourism.co.bw**) is a good resource. Uncharted Africa (**www.unchartedafrica.com**) offers a trio of luxury camps, while the community-based Nata Lodge (**www.natalodge.com**) and Planet Baobab (**www.planetbaobab.co**) complete the region's options.

Did You Know? The first crossing by car of the Makgadikgadi Pans National Park was shown in a 2007 episode of the British TV show *Top Gear*.

Wildlife:

Dry Season	Wet Season
● Brown hyena	● Flamingo
● Aardwolf	● Wildebeest
● African wildcat	● Zebra
● Mongoose	● Elephant
● Ostrich	● Giraffe

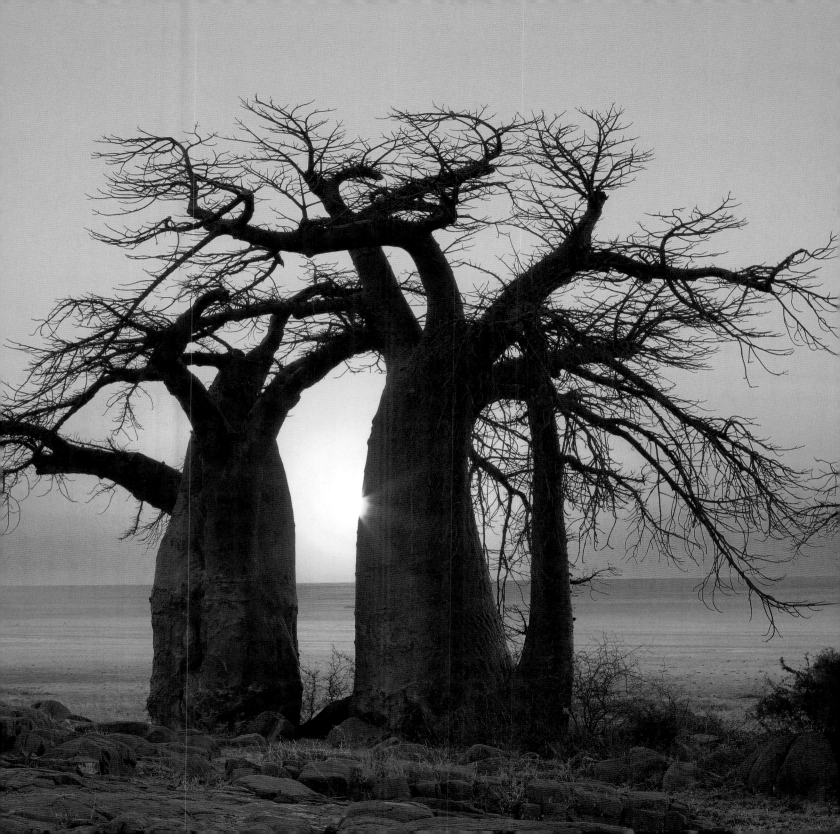

5 NUBIAN IBEX IN EIN AVDAT NATIONAL PARK
ISRAEL

Israel's dry and dusty Negev Desert stretches for half of the country, its lunar landscape of wrinkled hills and vast craters gouged from the chalky soils. History abounds, and the path of the ancient Nabatean Spice Route once wove its way through the peaks and troughs en route from the city of Petra to the Mediterranean Sea. The ruins of prosperous Nabatean cities rest under the blistering sun, ambitious vineyards and isolated kibbutz dot the main highway, and Biblical animals once again roam the lands.

In the heart of an expanse of never-ending pale brown, a flash of green slices through the landscape. Here, the Zin Stream carves its way through the dramatic Zin Canyon, its ice cold waters giving life to the arid soils. It is a true desert oasis, a haven for the region's hardy wildlife who take respite in the shade of Euphrates poplars and caves carved into the cliffs by Byzantine monks.

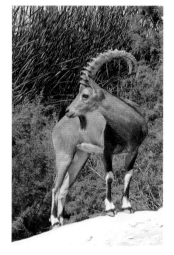

Animals that once roamed these Biblical lands have been reintroduced through a conservation programme run by the Israel Nature and Parks Authority. Onagers and rheas have been successfully released, and jackals, striped hyenas and gazelle thrive in the inhospitable conditions. It is the Nubian Ibex though which has come to represent the country's conservation efforts, and Israel is today home to the largest herds in the world, with between 200 and 300 animals roaming the Negev Highlands. The crucial water source of Ein Avdat makes it one of the best places to see ibex, and up-close encounters are likely.

In the Footsteps of the Nabateans
Step back in time and journey through an ancient desert cloaked in history as you search for the desert's often elusive wildlife. A nearby camel ranch makes a perfect base, where the legendary Bedouin hospitality comes by way of sweet tea and home-cooked food. Swing in shaded hammocks as inquisitive camels watch you from under their long lashes, and embark on a trip on one of the ships of the desert to nearby Mamshit, the magnificent ruins of one of the Nabatean's most important cities.

When the sun is high and hot in the piercing blue sky, join the region's fauna in the Ein Avdat oasis, and it won't be long before your first ibex is spied teetering on impossibly steep canyon walls or climbing nimbly over unstable scree. A 15 metre (50ft)-high waterfall crashes through the narrow gorge, its lower pools attracting scuttling Syrian rock hyrax, and birds and dragonflies which dart across the surface. Climbing higher into the canyon, poplar groves fringe stepped pools and, on quiet days in the park, you can sit amongst herds of ibex, the silence of the desert broken only by their bleats.

TAKE ME THERE

How to Visit: The park is open year round but for better wildlife encounters avoid school holidays and weekends. There is limited public transport in the region and a car is necessary to get around. The town of Mitzpe Ramon offers accommodation, amenities and desert tourism opportunities.

Further Information: The Israel Nature and Parks Authority (www.parks.org.il) provide information on visiting Avdat and Ein Avdat. For accommodation and camel trips try Camel Land (www.cameland.co.il). For further information on visiting Israel see **www.goisrael.com**.

Did You Know? Both male and female ibex have horns. The males can grow to 1.5 metres (5ft) in length.

Wildlife:
- Jackal
- Syrian rock hyrax
- Striped hyena
- Gazelle
- Rock dove
- Swift
- Bustard
- Dragonfly

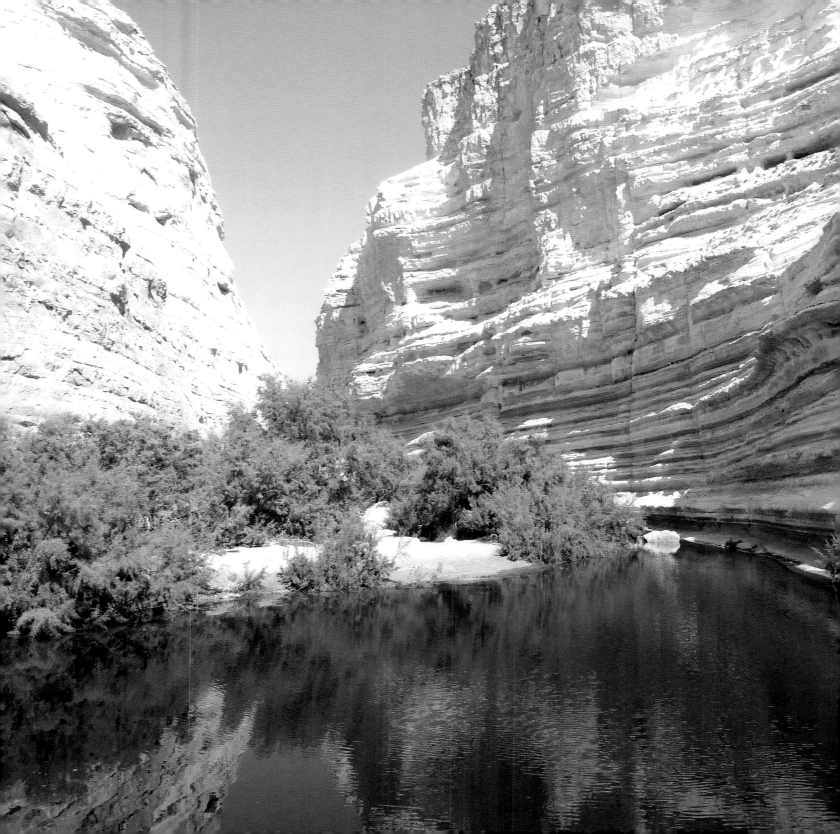

Set within the lofty, mist-shrouded Clarke Range, Eungella is Australia's largest sub-tropical rainforest and one of its most ecologically diverse parks. Waterfalls tip into emerald pools fringed by thick vegetation and overhanging ferns, azure kingfishers and Ulysses butterflies swoop low over trickling streams, and endemic frogs such as the Eungella gastric-brooding frog croak noisily. It is also the best place in the country to see Australia's most bizarre and unlikely mammal; the platypus.

Scouring the bottoms of the clear, rain-fed pools for crayfish, insects and worms, platypus can hold their breath for several minutes, storing their finds in their cheek pouches behind their iconic bills. With this duck-like bill and webbed feet, the fur and body shape of an otter, and the large flat tail of a beaver, they are truly unusual creatures perfectly honed to their watery environment. Yet their bizarre attributes don't stop there and they are only one of two mammals on the planet which lay eggs.

At Eungella's Broken Creek, a maze of footpaths radiate out into the dense forest from where patience and quiet is rewarded with sightings of the shy platypus foraging and diving. Rugged gorges dissect the park, swamp mahoganies hang lazily over the paths and birds such as the newly discovered Eungella honeyeater flutter through the canopy.

Bushwalking in Australia's Largest Rainforest
In the Aboriginal language Eungella means 'Land where cloud lies over mountains', a testament to the 2,000mm (78in) of rain that falls on the region each year. Reaching a height of 1,280metres (4,200ft) at the summit of Mt Damrymple it then plunges into the verdant Pioneer Valley below in the heart of the Clarke Range. Despite covering an area of 500 square kilometres (200 miles²), much of the virgin rainforest is out of bounds, preserving the delicate and abundant ecosystem that it supports.

At Broken Creek, 22 kilometres (13 miles) of trails provide the perfect opportunity to bushwalk past the streams and pools, home to platypus and snapping turtles and visited by dozens of species of birds. Eungella is the perfect place for a back-to-nature experience, and it is an easy place to visit independently. Pitch a tent amidst the eucalyptus trees and hanging, moss-covered vines and spend your days quietly treading the footpaths in search of one of the world's most elusive creatures. On cloudy days, in the early morning or at dusk, hunker down with a picnic to wait for the tell-tale bubbles that rise from the bottom of the pool indicating the imminent popping up of a little beaked head.

TAKE ME THERE

How to Visit: Located 80 kilometres (50 miles) west of Mackay (and 1,000 kilometres/620 miles from Brisbane International Airport) Eungella can be visited independently with a rental car or as part of an organised tour. There are a handful of accommodation options at Broken River including a retreat and campsites. The best time to see platypus is from May to August although they are present year-round.

Further Information: The Queensland Tourism website (www.queendland.com) and Department of National Parks, Sport and Racing (www.nprsr.qld.gov.au) are good first resources. There are several tours running out of Mackay including Reeforest Adventure Tours (www.reeforest.com.au).

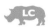

Did You Know? While both male and female platypus have sharp ankle spurs only the males can release a highly toxic venom.

Wildlife:
- Azure kingfisher
- Northern snapping turtle
- Eungella Gastric Brooding Frog
- Grey-headed flying fox
- Red fox
- Brushtail possum
- Eungella honeyeater
- Feral cat
- Feral pig
- Eungella spiny crayfish

7 SYNCHRONOUS FIREFLIES IN THE GREAT SMOKY MOUNTAINS NATIONAL PARK
USA

A swathe of forest–blanketed mountains straddles the border between Tennessee and North Carolina, where cold streams pour down great sharp ridges into gently undulating hills. Like an unbroken chain, the Southern Appalachian Mountains stretch along the border, encompassing a vast tract of wilderness 2,114 square kilometres (816 miles²) in size, known as the Great Smoky Mountains National Park.

The American black bear might be the symbol of the Smokies – indeed, estimates are that 1,500 bears amble through the thick forests – yet the park's biodiversity is staggering. Abundant rains soak the soils and give life to a vibrant and ever-changing vegetation which creates a sanctuary for wildlife. At 300kg (700lbs), elks are the park's largest inhabitants, while some of the smallest are the 30 species of salamander which have awarded the park the nickname of 'The Salamander Capital of the World'. Whitetail deer, chipmunks, raccoons, opossums, wild turkeys and skunks are regularly spotted in the forests, and brook and rainbow trout number amongst the 50 species of fish that swim through 1,120 kilometres (700 miles) of crystal clear streams.

Yet come late spring, when wildflowers cover the deciduous forest floor and a mist hangs over the treetops, a strange phenomenon occurs in the Smokies which has left scientists scratching their heads. Synchronous fireflies, one of 19 species of firefly found in the park, begin a two-week long mating dance. Differently to other species, however, they glow in unison, creating waves of light through the violets, orchids, irises and lilies.

Camping in a Glittering Forest

To watch as the forest floor lights up like a sparkling carpet is one of nature's most enchanting sights, a true wilderness fairyland. The window to see the fireflies is short, and they do this special dance for just two weeks a year around the end of May or beginning of June. To protect their delicate balance, the National Parks Authority restricts road access to the Elkmont area of the park where the concentration of beetles is highest, and shuttles transport visitors from Sugarlands Visitor Centre.

There are no lodges inside the Great Smoky Mountains National Park, and wild camping under the shelter of the hardwoods with ambling black bears, scuttling squirrels and the call of birds for neighbours is a true back-to-nature experience. The Elkmont campsite is one of the park's most popular and, while competition is fierce during the firefly show, those lucky enough to secure a spot get front row seats. Pitch a tent or pull up an RV and hunker down for a week spent hiking the back country, wildlife watching in favoured bear haunts such as Cataloochee or Cades Cove and, as the sun sets, wandering the nature trails that glow with the light of a million fireflies.

TAKE ME THERE

How to Visit: The National Park Association releases dates for the firefly dance in April, and shuttle tickets and the campsite get booked up quickly afterwards. There are a number of campsites in the park as well as lodges located on the outer edges.

Further Information: For more information on the Great Smoky Mountains National Park as well as dates for the firefly synchronisation visit **www.nps.gov/grsm**. Shuttle passes and campsites can be booked through **www.recreation.gov**.

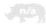

Did You Know? No-one knows for certain why these particular firefly beetles flash their bioluminescent light together – competition between males is a possibility, with each wanting to be the first to flash and attract a female.

Wildlife:
- Black bear
- Elk
- Salamanders
- Woodpeckers
- Whitetail deer
- Racoon
- Chipmunk
- Opossum
- Rainbow trout
- Wild turkey

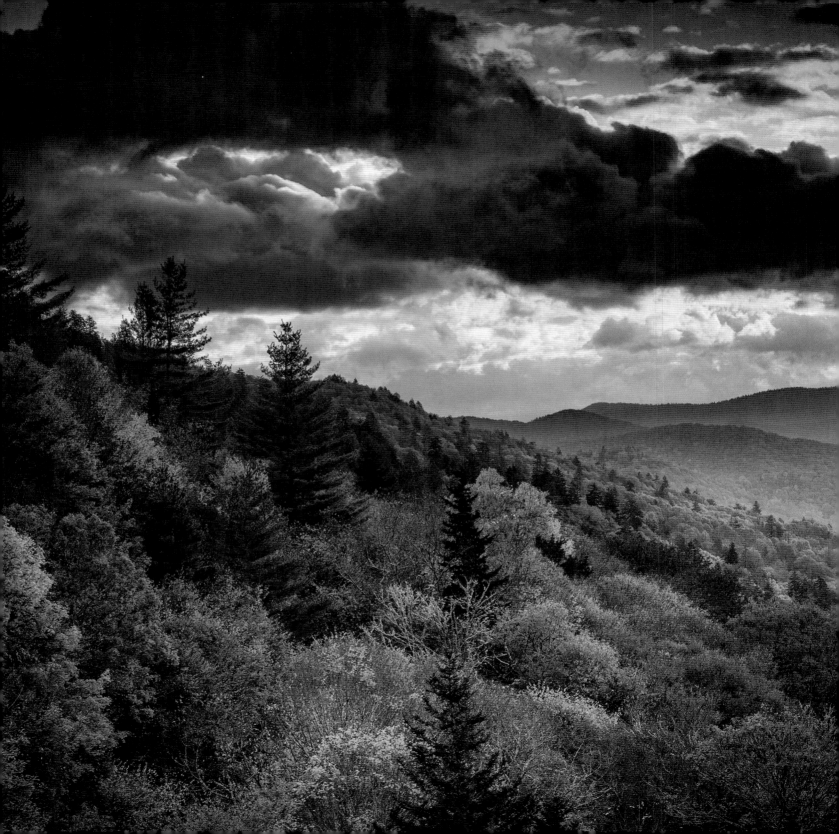

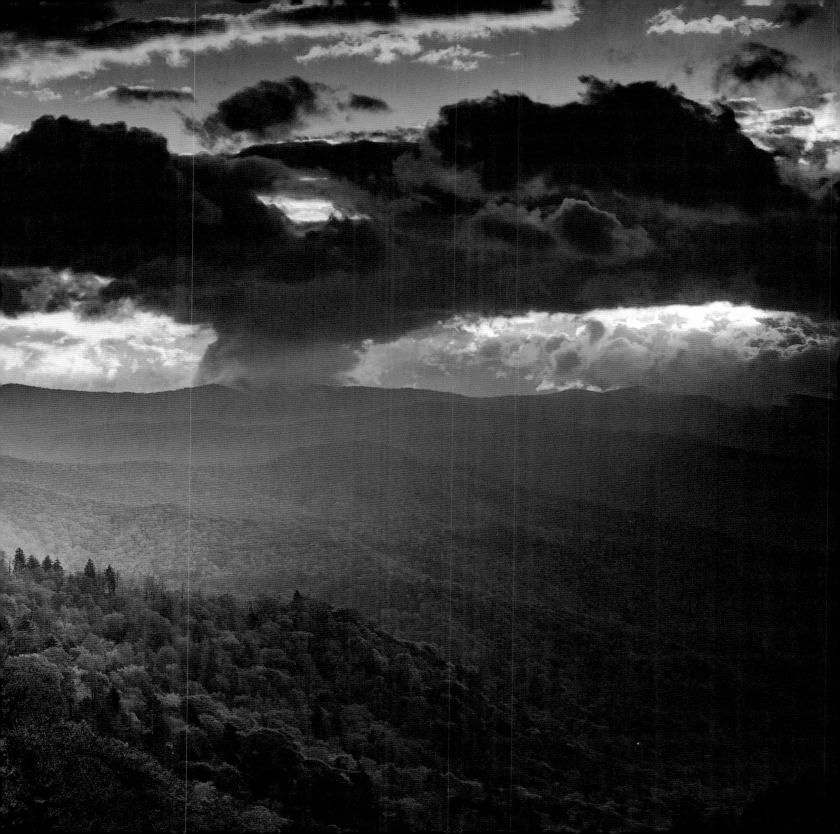

ELEPHANT SEALS IN VALDÉS PENINSULA
ARGENTINA

When a group of 150 Welsh immigrants arrived in Patagonia on 28th July 1865, they came not in search of gold nor to conquer. They came to this remote and wild land on the other side of the world to start a new life and preserve their threatened traditional values. What they would have found was a desolate and windswept region inhabited by indigenous tribes – with whom they traded peacefully – and strange creatures that roamed in great numbers.

The town of Puerto Madryn owes its origins to the Welsh, today standing as the gateway to the protruding peninsula of Valdés. The barren 3,600 square kilometre (1,390 miles²) promontory juts out into the cold South Atlantic Ocean, its 400 kilometres (248 miles) shoreline a series of rocky cliffs, gulfs and shallow bays. Sand dunes rise from the pebble and sandy beaches and only salt and mud flats, and a handful of sheep *estancias* (farms) interrupt the expanse of flat land.

It might be wild, windswept and devoid of lush greenery, but to the region's wildlife, Peninsula Valdés is a haven. It is home to the southern elephant seal's northernmost colony – and the only one in the world to be increasing. At its peak, over 1,000 huge lumbering animals lay on the pebble beaches, from where they dive into the frigid, fish-laden waters to hunt. Yet dangers await them, and Valdés is famous for its pod of highly skilled orca who race up shallow channels to beach themselves and snatch elephant seals, sea lions and fur seals.

Back to Basics in Remote Argentina

In Valdés it is possible to stand on the shore and watch southern right whales and their calves breach in the calm, protected gulf between the peninsula and the mainland. It is possible to get up close to half a million burrowing Magellanic penguins who arrive here to nest, and to watch huge herds of guanaco and rhea tear across the central plains.

Choose to stay in one of the far-flung estancias, away from the trappings and hubbub of modernity, and soak up the wildness of the landscape. Set off each morning on guided jeep trips around the peninsula, from where you can listen to the roar of a vast male elephant seal defending his territory – at 6 meters (20ft) long and weighing up to 4,000kg (8,800lb) males are 8 to 10 times larger than females, the biggest weight difference of any animal. You can watch, heart in mouth, as orcas use their extraordinary hunting skills before your very eyes, and gaze skyward to see giant petrels, oyster-catchers, vultures and eagles soaring on the strong breezes. The seasons play a vital role in life here, each bringing with it different species and new experiences.

TAKE ME THERE

How to Visit: An airport in Trelew connects to Buenos Aires, and nearby Puerto Madryn offers plenty of accommodation options and day tours. On the peninsula, Puerto Pirámides and several remote haciendas offer places to stay and trips. Wildlife seasons vary: elephant seals August to November, whales May to December, penguins September to March, orca March to April, sea lions January to May.

Further Information: The tourism authority (**www.turismo. gov.ar**) and welcomeargentina.com (**www.welcomeargentina. com**) are good resources. Accommodation on the peninsula includes Estancia Rincon Chico (**rinconchico.com.ar**) and Faro Punta Delgada (**www.faropuntadelgada.com**).

Did You Know? Elephant seals regularly dive to depths of between 400 and 1,500 metres (1,300–5,000ft). They can also sleep underwater.

Wildlife:
- Southern right whale
- Orca
- Sea lion
- Fur seal
- Magellanic penguin
- Guanaco
- Rhea
- Mara
- Turkey vulture
- Giant petrel

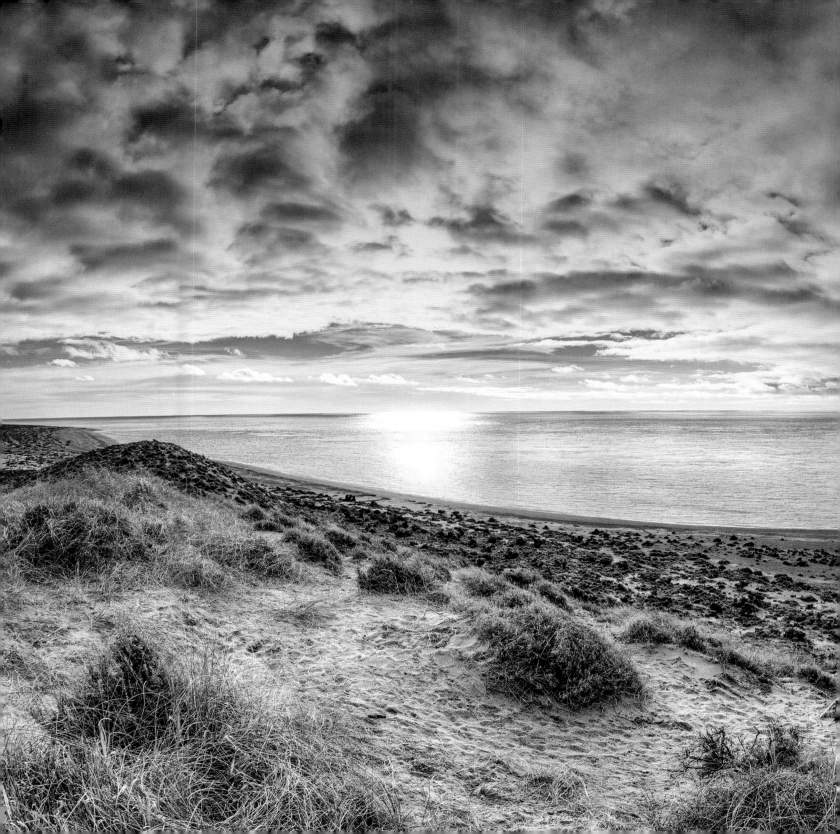

AFRICAN WILD DOGS IN MOREMI GAME RESERVE
BOTSWANA

Even amongst Africa's glittering treasure trove of national parks and reserves, Botswana's Moremi Game Reserve manages to stand out. Sitting at the heart of the gargantuan Okavango Delta, it was the very first reserve on the continent to be established by the local people, the Batawana people of Ngamiland, who declared it a game reserve in 1963 in a valiant attempt to protect their ancestral lands. Today the big five (including reintroduced black rhinos) are joined by giraffes and cheetah, warthogs and 400 species of bird.

Moremi is a patchwork of picturesque floodplains, where the line between land and water is blurred to insignificance. Lagoons and pools give way to grasslands and forests, stout baobabs are silhouetted against the crimson evening skies and hippos and crocodiles wallow in papyrus-fringed marshes. Savannah game are plentiful, where prides of lions devour their latest kill in the golden grasslands and elephants take shade under umbrella-like acacias. In the pools and wetlands, birds flock in their thousands and antelope fight for territory in the shallow waters.

Roaming the open plains and sparse woodlands of sub-Saharan Africa, African Wild Dogs are one of the most endangered animals on the planet and only an estimated 6,600 individuals exist in the wild. Threatened by habitat loss, hunting and disease they have found solace in Botswana's Moremi Reserve and neigh-

bouring Chobe National Park, where dozens of packs hunt the bountiful game in formidable coordination. Reaching speeds of 70 kilometres per hour (44 mph) they tackle small mammals and, with successful ambition, antelopes and wildebeest too.

Self-drive Safari in the Great Delta
To spy one of Africa's painted wolves (*Lycaon Pictus*) is a sad rarity on most southern African safaris. Yet Moremi's forests and open plains are a different story. Up to 200 wild dogs roam over vast territories, their multi-coloured coats, big, rounded ears and long legs unmistakable as they trot across the horizon.

Luxury tented lodges and rustic safari campsites are thinly scattered within the reserve, from where guided or self-drive trips venture into the heart of the watery delta. Traverse the rudimentary roads and trails under your own steam in a hardy 4x4 for an exhilarating adventure. Pitch a rooftop tent during the resplendent Okavango sunset and drift to sleep to the musical sounds of nature, waking early with the first orange light to venture into the great delta in search of wild dogs and some of Africa's most staggering wildlife. Or lay your head amongst plush pillows in a luxury lodge, from where guided trips by jeep and *mokoro* (dug-out canoe) will take you to Moremi Tongue and Chief's Island which rise above the flooded pans and plains.

TAKE ME THERE

How to Visit: Maun is the gateway to the Okavango Delta. There are several campsites and luxury lodges inside Moremi as well as surrounding private reserves. The best time to visit is July to October, when seasonal pans dry up and wildlife concentrates on the permanent water.

Further Information: Botswana Tourism (**www.botswanatourism.co.bw**) offers good trip planning information. Luxury accommodation includes Khwai River Lodge (**www.belmondsafaris.com**) and Camp Moremi (**www.desertdelta.com**). Embark on guided and self-drive safaris with Safari Drive (**www.safaridrive.com**) and Drive Botswana (**www.drivebotswana.com**).

Did You Know? Unlike other large carnivores, wild dogs very rarely fight amongst themselves. Together they help care for the young, old, sick or injured pack members.

Wildlife:
- The Big Five
- Giraffe
- Cheetah
- Antelope (Impala, Kudu, Waterbuck, Red Lechwe, Sitatunga)
- Zebra
- Baboon
- Warthog
- Hippopotamus
- Pel's Fishing Owl
- Fish Eagle

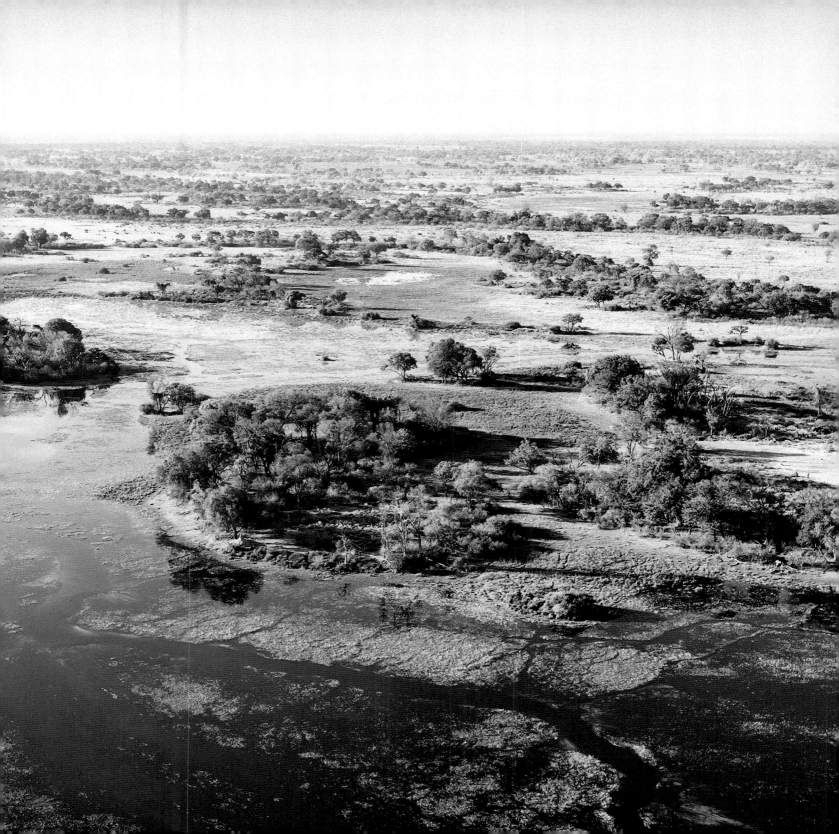

ASIATIC WILD ASSES IN LITTLE RANN OF KUTCH
INDIA

In Gujarat, India, flanking the border with Pakistan, the Rann of Kutch is a geological phenomenon. A never-ending expanse of pancake-flat salt desert stretches into the hazy horizon. Parched, blindingly white salt pans and clay mudflats are relieved of their extreme aridity when the month-long monsoon rains flood the region every summer, creating a haven for migrating birds; cranes and pelicans, and millions of flamingos.

It is one of the hottest places in the country. Summer temperatures as high 49.5°C (121°F) squeeze the moisture from the ground, so that by autumn miles and miles of cracked, salt-crusted land is broken only by green thorny bushes, lonely salt farms and a cloudless blue sky. Once an arm of the Arabian Sea, the featureless landscape is today a harsh yet alluring place, home to proud indigenous communities and India's last remaining population of Khur, or Asiatic Wild Ass.

Where they once roamed the great tracks of Mongolia, China, Central Asia and as far as the Arabian Peninsula, today Asiatic Wild Ass exist in isolated pockets. The Indian Khur – one of five sub-species – number just 4,000 in this last stronghold known as the Little Rann of Kutch Wild Ass Sanctuary. Somewhere in between a donkey and horse, they are tough and sturdy animals, able to withstand extreme temperatures, scarce food and life in one of the most challenging environments on the planet.

Horse-riding the Remote Desert

It is a region explored by few, a strange, harsh last frontier where traditions, cultures, horsemanship and crafts have changed little over the centuries. To visit the vast sanctuary is to be a pioneer, an adventure not for the feint at heart.

Like tangible versions of the mirages that shimmer on the heat-hazed horizon, a handful of lush eco-camps offer a base from which to venture out into the desert lands. Hammocks hang amongst eucalyptus trees, welcome plunge pools offer respite from the heat, and traditional mud cottages and huts are decorated with the region's famed embroidery which glitters with mirrors in the brilliant sun.

The khur share this bleak land with a surprising variety of wildlife, from Indian wolves, desert foxes and jackals to large nilgai antelope, spiny-tailed lizards and several species of snake. Jeep or camel trips venture into the baking desert, but to sit astride an indigenous breed horse is to truly be a part of a deep-rooted heritage. You wander through the intense silence, disrupted only by the rustling sounds of life eking out an existence in the scant brush until, on the impossibly long horizon, a small herd of khurs race past at a thundering 50 kilometres (30 miles) per hour.

TAKE ME THERE

How to Visit: Ahmedabad is the nearest international airport to Little Rann of Kutch, and it is also served by train from Mumbai. Eco-friendly camps offer accommodation of varying levels as well as guided trips into the sanctuary. The best time to visit is October to March, after the monsoon, when the weather is coolest.

Further Information: Gujarat Tourism (**www. gujarattourism.com**) is a good first resource. Traditional, eco-friendly cottages and huts include Rann Riders (**www.rannriders. com**) and Little Rann Eco-Camp (**www.littlerann.com**).

Did You Know? Spread over 4,954 square kilometres (3,078 miles²) the Indian Wild Ass Sanctuary is the largest wildlife sanctuary in India.

Wildlife:
- Indian wolf
- Greater and lesser flamingos
- Indian gazelle/chinkara
- Blackbuck antelope
- Nilgai antelope
- Desert fox
- Hyena
- Spiny-tailed lizard
- Black cobra
- Indian bustard

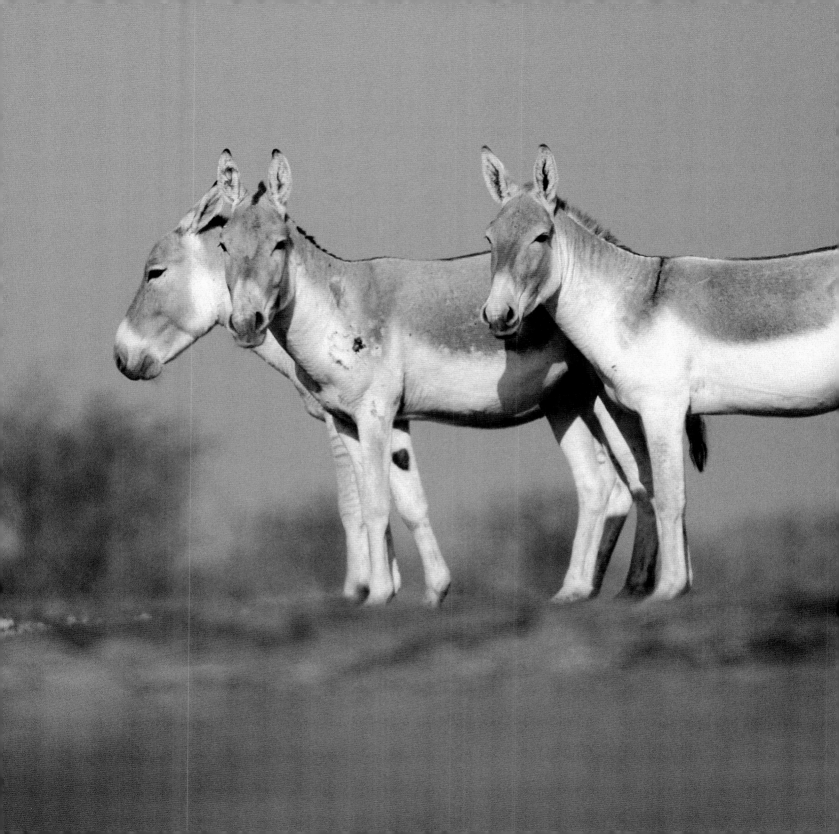

EURASIAN BROWN BEARS IN THE CARPATHIAN MOUNTAINS
ROMANIA

The Carpathian Mountains form a dramatic sweeping arc through the heart of Eastern Europe, and Romania is home to the lion's share of the towering peaks and undulating valleys. Lions, however, aren't the predators in this alpine landscape, but rather brown bears, wolves and lynx who roam in their thousands through the meadows and thick woodlands. Some 35 per cent of European brown bears live in Romania, a number that stands at over 4,000 animals.

The mountains form a protective arm around the historical province of Transylvania, where tales of Dracula emerge from the eerie, conical-turreted Bram's Castle and medieval villages seem frozen in time. In the heart of the mountains, clear trout-laden streams course through meadows filled with vibrant wildflowers and butterflies. Bucolic Alpine villages with their wooden houses and horse and carts enjoy a life of quiet subsistence, and shepherds tend their herds in the higher fields guarding them protectively against wolf attacks.

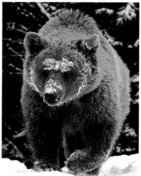

Birds aplenty live in the humid lowlands, where the streams and rivers funnel into the great Danube Delta, and alpine marmots and Chamois inhabit the higher hills. Red and roe deer skip across the meadows, and martens, weasels and foxes join the impressive predator list in the dark, ancient forests. Ranging from grasslands to gorges, subterranean caves to volcanic lakes, the varied landscape of the mountains – including the largest surface of virgin forests in Europe outside of Russia – supports this abundant ecosystem which just waits to be explored.

Tracking Bears in Dracula's Lair

The very experience of tracking bears in the sun-dappled Carpathian Mountains is as much the adventure as actually finding one. And despite their elusiveness, the chances of encountering a lumbering 350kg (770lb) brown bear are fairly high when you set off with an experienced guide.

Setting out of the picture-postcard city of Brasov, embark on a four-day hiking tour that will take you past jagged limestone peaks, in search of Medieval cave churches nestled into the hillsides, and across a landscape that has throughout history been marched by Tatars, Goths, Huns and Slavs. Today the region's wildlife rules the roost and, after cosy nights spent in hospitable guesthouses you set off in the early hours or late evenings to seek out the tell-tale scratch marks in the bark of trees and to wait patiently for the emergence of the bears. And emerge they often do, to mate, tend their cubs and forage for food in the open. In Romania bears are sometimes called *Podoaba padurii*, which means 'treasure of the forest', and they thrive in the protected national and natural parks that are scattered across the Carpathians. Where once brown bears roamed all of Europe, today Romania is one of the last strongholds of this awesome predator.

TAKE ME THERE

How to Visit: International visitors arrive via Bucharest Airport, the city of Brasov forms the main jumping off point to the Carpathians from where many multi-day walking and cycling tours begin. Accommodation ranges from guesthouses to rustic lodges. The best time to visit is May to September.

Further Information: The national (**romaniatourism.com**) and local (**www.brasovtravelguide.ro**) tourism websites offer trip-planning information. Multi-day walking tours can be booked through a range of operators including Wildlife Worldwide (**www.wildlifeworldwide.com**) and Untravelled Paths (**untravelledpaths.com**).

Did You Know? Brown bears were present in Britain until around 1000AD, but disappeared due to over-hunting.

Wildlife:
- Wolf
- Lynx
- Chamois
- Red deer
- Roe deer
- Weasel
- Alpine marmot
- Gray owl
- Marten
- Beaver

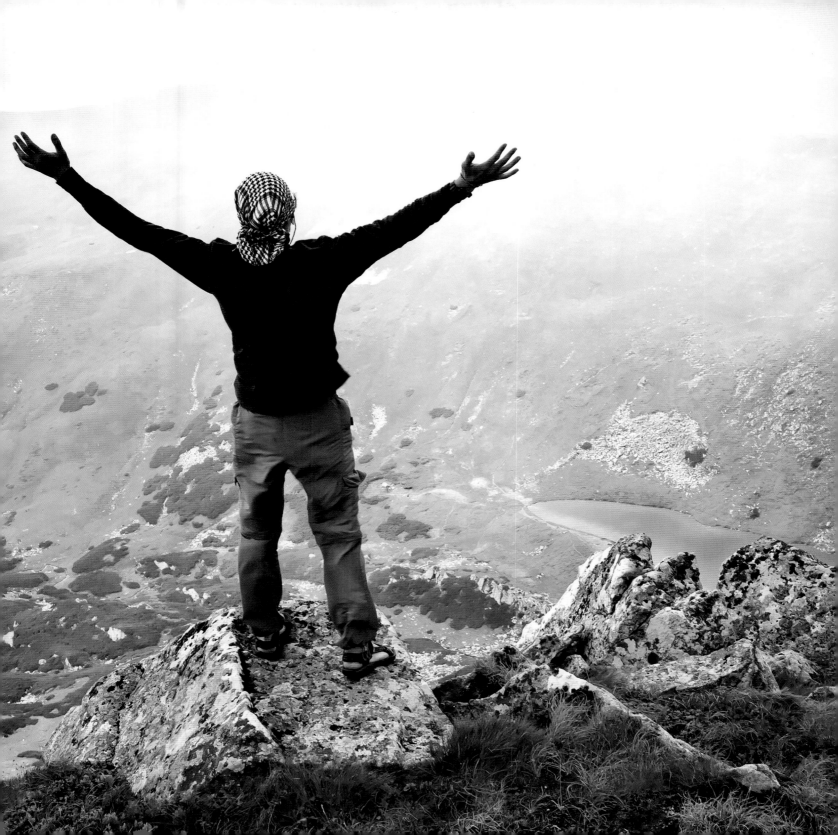

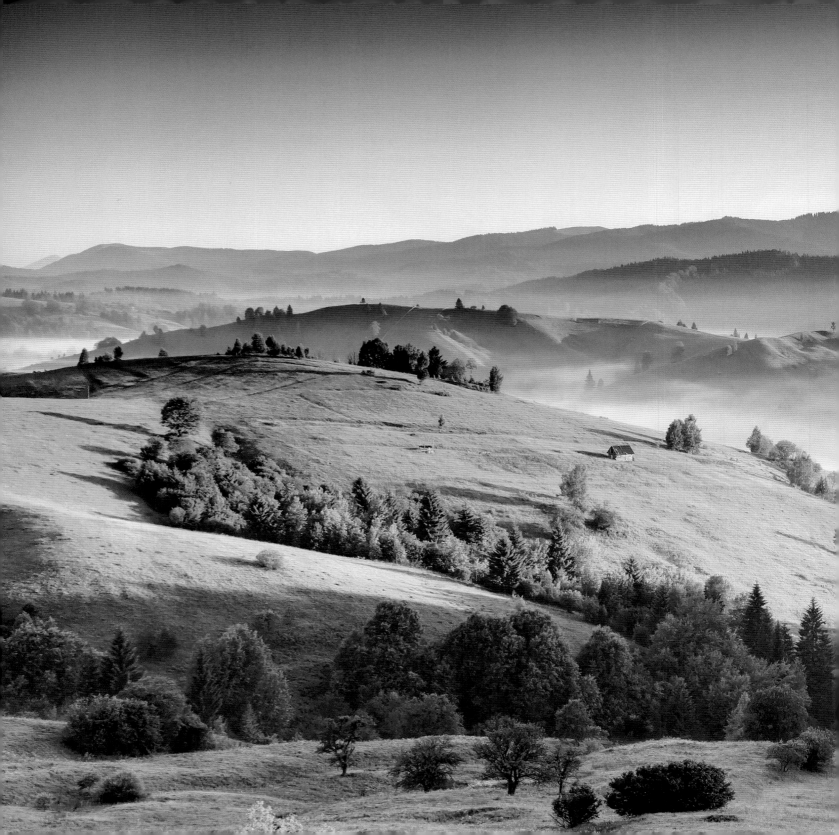

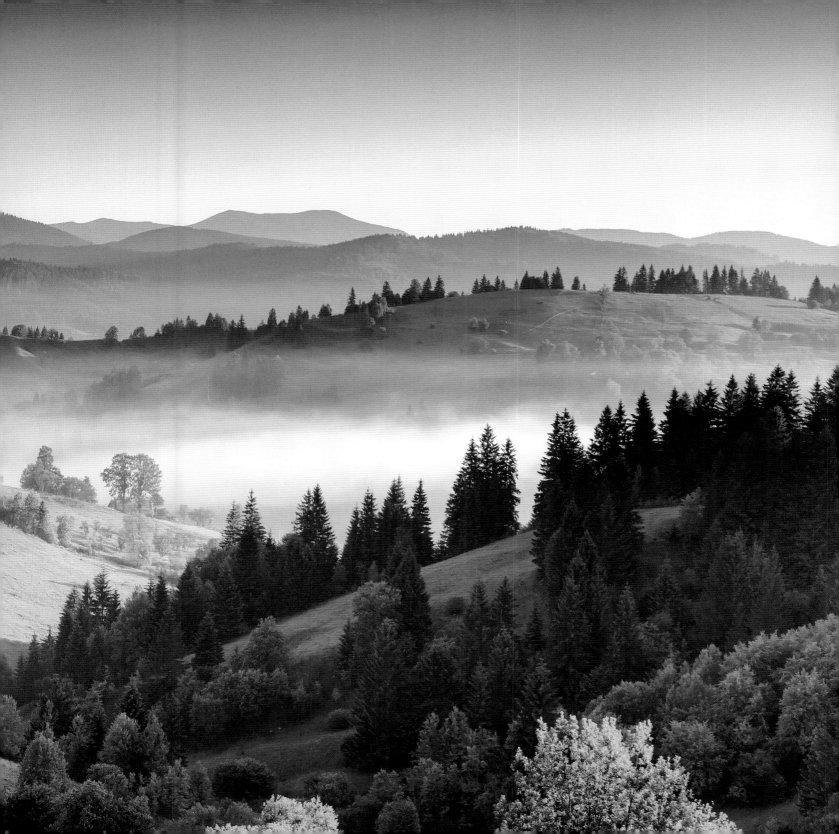

12 BLACK-BROWED ALBATROSS IN THE FALKLAND ISLANDS
FALKLAND ISLANDS

In the heart of the southern Atlantic Ocean a scattering of 420 remote and windswept islands – most uninhabited – spread across 12,173 square kilometres (4,700 miles2) of tumultuous, white-capped waves. Just 3,000 people live permanently on the two main islands, East and West, their ancestry tracing back centuries in a land that, despite its geographical distance, pays homage to its British heritage. In the only town of Stanley, red telephone boxes, public houses and Union Jacks contrast starkly against the abounding nature that dominates the landscape.

While from afar the Falklands might be better known for their politics, the islands are in fact an unblemished nature's paradise. The seas are teeming with 25 species of rare whales and dolphins, where blue, minke, fin, humpback, sperm and southern rights swim alongside spectacled porpoises, dusky and hourglass dolphins, and Gray's and Arnoux's beaked whales. Amongst the 219 species of birds, 40 per cent of the world's southern giant petrels come here to nest on the barren rocky outcrops, and the rare and beautiful Queen of the Falklands Fritillary butterfly flutters through the wind-battered grasses.

The stars of the show however are the penguins, seals and the black-browed albatross – indeed, the Falklands are home to two thirds of the albatross population, some 50,000 pairs who arrive to nest in their conical-shaped mounds.

In Search of the King of the Skies

At every turn wildlife dominates the Falklands. Sea lions, fur seals, and elephant seals hide in the tall swaying tussac grass, and over one million Gentoo, King, Magellanic, Rockhopper and Macaroni penguins crowd the sweeping white sand beaches in numbers so dense it has awarded the islands the nickname 'the penguin capital of the world'.

While the summer season proffers the friendlier weather, black-browed albatross – known locally as 'mollymawks' – arrive every year in September to take up residence in the same nest as the year before on the islands of Steeple Jason and Beauchêne Island. It is a staggering sight to behold, as they swoop overhead with wingspans of 210–250cm (7–8ft) to nest amongst the Rockhopper penguins.

Embark on a true adventure to the bottom of the world and experience nature at its most raw and uninhibited. Seek out the albatross on 4x4 jeeps, light bush aircraft and small launches, kayak with orcas, cuddle up to inquisitive penguins, fish salmon from the streams and bird watch in the long grasses. Cruise ships ply the waters en route to Antarctica, but the Falklands are a magnetic wildlife destination in their own right and truly deserving of an adventure.

TAKE ME THERE

How to Visit: Many people visit as part of an Antarctica cruise however visiting independently is possible with flights from Chile and RAF Brize Norton, UK. Several international and local tour operators can arrange holiday packages. The best time to see albatross is September to April.

Further Information: Start with the Falkland Islands Tourist Board (**www.falklandislands.com**). International tour operators include Nature Trek (**www.naturetrek.co.uk**) and Journey Latin America (**www.journeylatinamerica.co.uk**) and local operators include Falkland Islands Holidays (**www.falklandislandsholidays.com**), Penguin Travel (**www.penguintravel-falklands.com**) and International Tours and Travel (**www.falklandislands.travel**).

Did You Know? The world's largest population of Gentoo penguins nests in the Falkland Islands, with over 121,500 breeding pairs recorded.

Wildlife:
- Gentoo penguin
- King penguin
- Rockhopper penguin
- Magellanic penguin
- Macaroni penguin
- 219 species of bird
- Seals (southern, fur, leopard and elephant)
- 6 species of dolphin
- Whales (southern right, pygmy right, sei, minke, blue, humpback, sperm, orca)
- Southern giant petrels

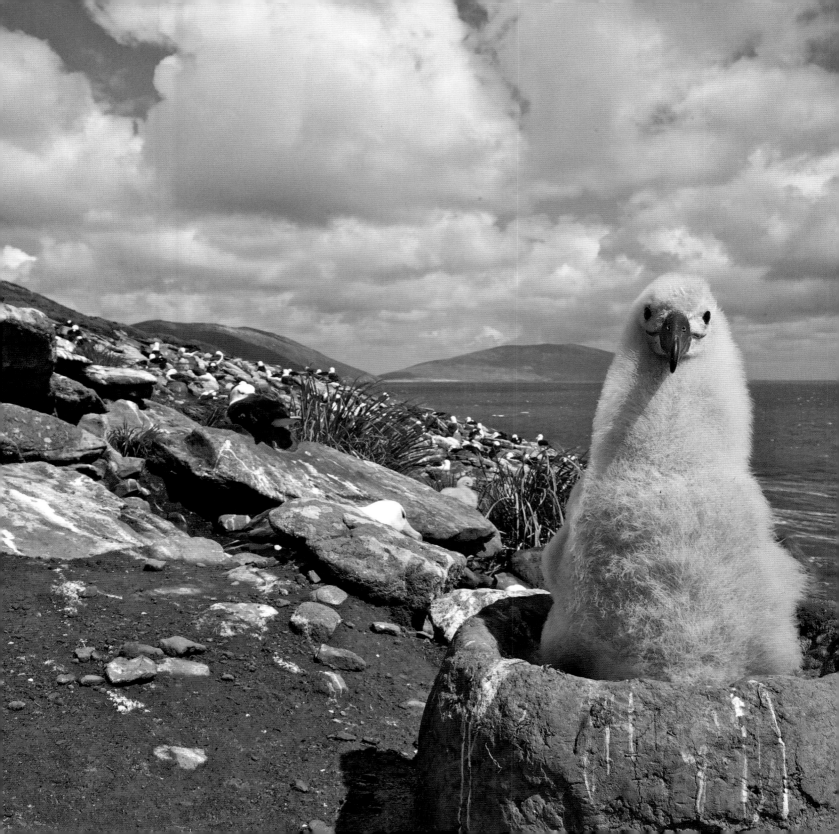

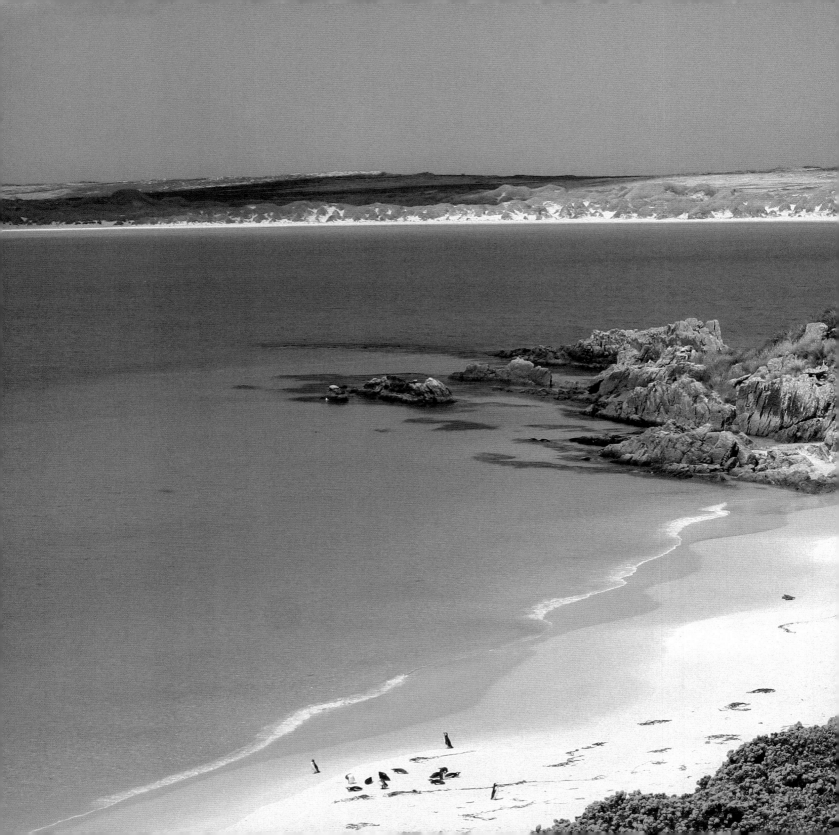

13 ASIAN ELEPHANTS IN MINNERIYA NATIONAL PARK
SRI LANKA

It is a phenomenon known as 'The Gathering'. As the dry season lays an arid hand over Sri Lanka's central region more than 300 Asian elephants converge on the shores of a vast reservoir in what is the biggest concentration in the world.

Built in the third century AD by the famous tank builder King Mahasen who ruled the Anuradhapura Kingdom, the Minneriya Tank is part of a network of ancient reservoirs and today provides a critical water source to Sri Lanka's wildlife, most notably the huge herds of wild elephants. At the heart of a region known as the Elephant Corridor, the 8,890 hectare Minneriya National Park links to Kaudulla and Wasgomuwa national parks, forming the most important migratory habitat for the endangered wild Asian elephant. 'The Gathering' takes place between May and November, peaking in August and September when it is possible to watch herds grazing and lazing about, bathing and drinking from the refreshing waters of the reservoir and interacting socially.

The park is also an important site for wading birds, and over 170 species frequent the area. Little cormorants dry their black wings on the shores in flocks 2,000 strong, painted storks, herons and pelicans fish in the shallow wetland waters and endemic parrots, hornbills and jungle fowl add to the cacophony. In the montane forests and scrublands that encircle the great lake, sambar and spotted deer roam, toque macaques and purple-faced langur monkeys screech through the trees, and elusive sloth bears and leopards make infrequent appearances.

Jeep Safari to the Heart of the Herd
Jeeps bounce across the rugged landscape in the hot, dry afternoon as guides keep their eyes trained to the shores of the great Minneriya Tank and the shelter of the nearby forests. Emerging from the shade after the blistering heat of the day has started to abate, vast herds of Asian elephants congregate just metres from you. You sit and watch as babies play excitedly, watched by their powerful matriarch mothers. Young bulls tussle for dominance and chomp their way through 150kg (330lbs) of bark, roots, leaves and stems.

More than 100,000 Asian elephants existed at the start of the 20th century, but numbers have dropped by 50 per cent over the last thirty years, and today the wild Asian elephant is considered endangered. Where they once roamed across much of Asia, their ranges now occupy only 15 per cent of what they once were – the Sri Lankan elephant in particular is restricted to a few parts of the island. To see them in these vast numbers is a true rarity, and, at the right time of the year, an easy yet hugely rewarding half day safari.

TAKE ME THERE

How to Visit: There is no accommodation within the park itself but a range of hotels and lodges in the nearby towns of Sigiriya, Polonnaruwa, Habrana and Giritale from where safari jeep tours will take you to see the elephants. The best time to visit is the dry season from May to September.

Further Information: For more information on planning a trip to Sri Lanka visit the official tourism website (**www.srilanka. travel**). Most of the luxury hotels can arrange safari excursions and there are many independent guides and operators in the nearby towns.

Did You Know? Asian elephants may live up to 60 years old in the wild.

Wildlife:
- Sambar deer
- Spotted deer
- Toque macaque
- Purple-faced langur monkey
- Sloth bear
- Leopard
- Spot-billed pelican
- Sri Lanka grey hornbill
- Little cormorant
- Painted stork

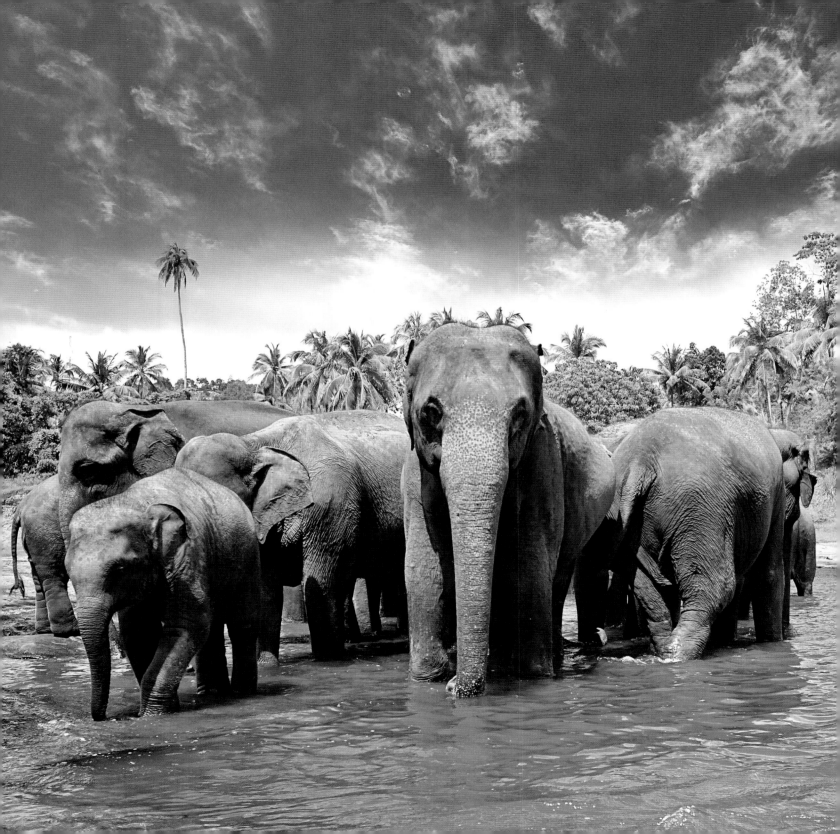

14 SCALLOPED HAMMERHEAD SHARKS IN COCOS ISLAND
COSTA RICA

Jacques Cousteau once declared Cocos Island; 'The most beautiful island in the world'. Like a storybook treasure island it erupts from the navy blue Pacific Ocean, 550 kilometres (365 miles) off the coast of Costa Rica, resplendent in thick tropical vegetation and waterfalls that plunge off sheer cliffs. A rare cloud forest covers the mountain peaks, and an abundant rainfall feeds the lush foliage inhabited by 87 species of bird, 362 species of insect, two endemic lizards and a few descendants of pigs, cats and goats left behind by buccaneers and sailors. It is completely uninhabited by humans, bar the national park rangers.

The tiny island – it measures just eight by three kilometres (five by two miles) – might be steeped in pirate lore and stories of hidden treasures, yet the true treasures for modern day explorers are found beneath the waves in the Cocos Island Marine Park. Vast schools of endangered scalloped hammerhead sharks sashay through the cold waters, their hunting grounds teeming with yellowfin tuna and jacks. Bottlenose dolphins, whitetip reef sharks, sailfish and giant manta rays are common visitors, while hawksbill, green and Olive Ridley turtles emerge onto the slithers of sandy beaches.

Cocos Island represents one of the most extraordinary marine ecosystems on the planet, where there are 7,800 kilograms (17.100lbs) of fish per hectare – a figure few, if any, other places in the world can match. It was declared an UNESCO World Heritage Site, and its waters vital to the study of marine ecosystems.

Scuba Diving in an Untouched Ecosystem

Visiting Cocos Island is an adventure few undertake, a journey to an unspoilt Pacific island whose marine biodiversity and untouched, rugged beauty is unparalleled. To follow in the wake of pirates past, set sail from Costa Rica aboard dive expedition cruise ships for the 36 hour crossing and spend a week scuba diving in waters teeming with life.

The diving here can be quite challenging, and an advanced certification is required. Yet to look up and see the silhouettes of hundreds of powerful scalloped hammerheads is to feel part of the ocean and the life within it. Silky and silvertip sharks are frequently sighted, along with California sea lions, giant moray eels and the endemic rosy-lipped batfish, and whale sharks and humpback whales make occasional appearances.

Scramble ashore and explore the island's 70 waterfalls and verdant peaks, keeping an eye out for clues as to the fabled lost Treasure of Lima – a legendary hoard stolen by a British trader, Captain William Thompson, in 1820 and today valued at £160 million.

TAKE ME THERE

How to Visit: A fleet of live-aboard dive boats make regular expeditions to Cocos Island with around 20 guests per voyage. All scuba diving, food and excursions are included in the cruise price and boats depart from Puntarenas (with pick-ups in San Jose).

Further Information: Undersea Hunter (**www. underseahunter.com**) are pioneers in Cocos Island expeditions and also have a submersible for further exploration. UNESCO World Heritage (**whc.unesco.org**) offers further information on the biodiversity of the island and marine park.

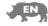

Did You Know? Hammerhead sharks use their distinctive wide heads to attack stingrays by pinning them against the sea bed.

Wildlife:
- Whitetip reef shark
- Bottlenose dolphin
- Giant manta ray
- Hawksbill, green and Olive Ridley turtles
- Whalesharks
- Yellowfin tuna
- Sailfish
- Humpback whale
- Pilot whale
- Spotted eagle ray

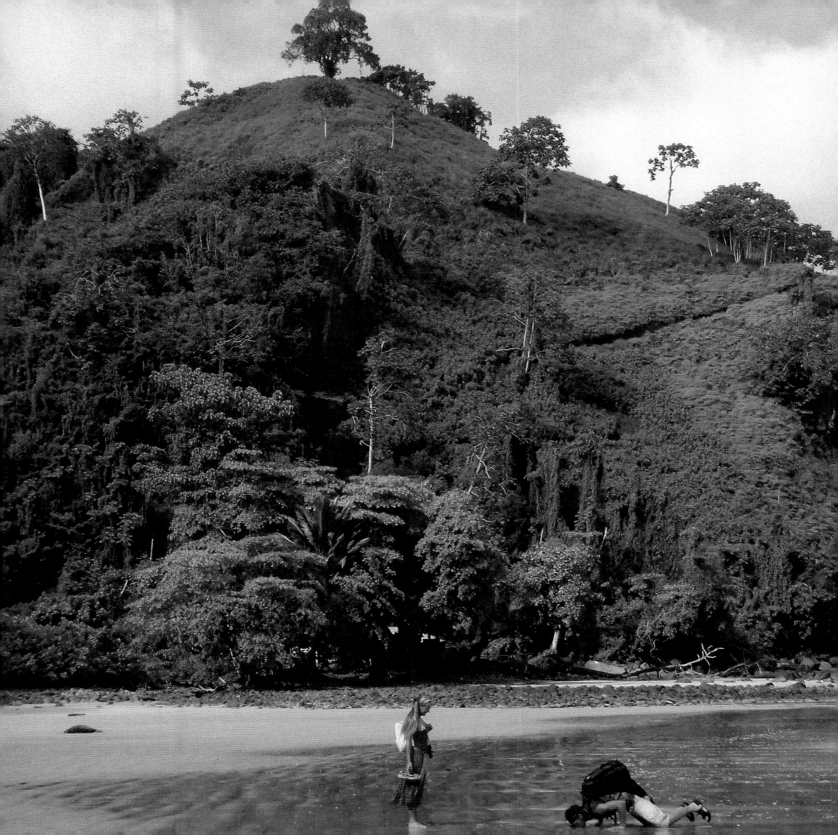

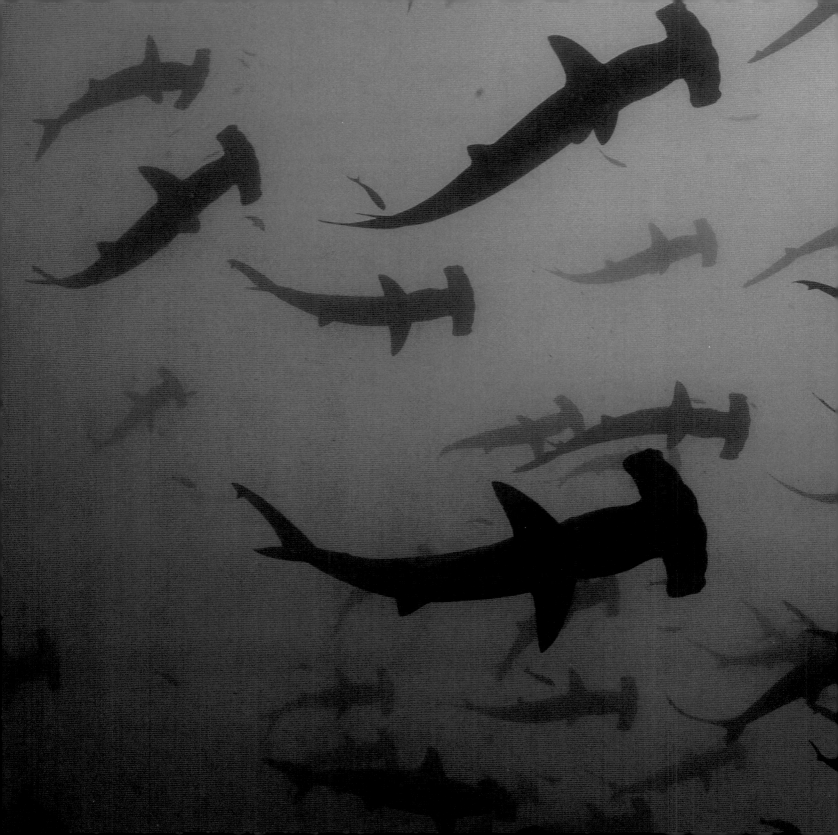

15 HYACINTH MACAWS IN THE PANTANAL
BRAZIL

The Pantanal, located in Brazil's southwest, is a vast and savage wetland, the largest on the planet and over 10 times the size of Florida's Everglades. An enormous landlocked river delta, its waters rise and fall with the seasons creating one of the most biologically rich environments in the world. In contrast to the Amazon Rainforest, where birds, animals and reptiles remain elusive in the dense jungle, the Pantanal's open wetlands, rivers and marshes make it one of the planet's best wildlife-spotting regions, a perfect and abundant circle of life second only to Africa's teeming reserves.

Caiman alligators lounge lazily in the evening warmth, illuminated only by a twinkle of fireflies, Labrador-sized capybara – the world's largest rodent – amble to and from their dens, and toucans and vivid green parrots flap through the balmy air. Yet amidst the safari park-like region it is the majestic hyacinth macaw that has become the symbol of the Pantanal. Measuring a metre in length, it is the largest species of flying parrot in the world, its gentle nature having seen it succumb to poaching and a loss of habitat. Indeed, in the 1980s, it is estimated that at least 10,000 birds were taken from the wild.

Cattle ranches inhabit the few raised areas offering rustic and authentic accommodation for hardy visitors. Horses are the main mode of transport, their hooves specially adapted to wading through pools adorned with great lily pads and ambling past sunbathing anacondas wrapped powerfully around branches. Capuchin

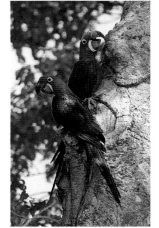

and howler monkeys swing through the tree tops, tapirs can be spotted in the watery fields, jaguars hunt in elusive silence, peccaries (wild pigs) grunt and splash through the swamps and giant otters ply the rivers in search of their favourite food, red-bellied piranhas.

Volunteering with Projecto Arara Azul

The story of the hyacinth macaw might seem bleak but conservation efforts have seen a huge growth in the number of these bright blue and yellow parrots in recent years and the IUCN have declassified it from endangered to vulnerable. Not only is it now a CITES (Convention on International Trade in Endangered Species) protected species it also has in its corner the Projecto Arara Azul which has worked tirelessly under the management of wildlife biologist Neiva Guedes to conserve the magnificent bird.

Volunteer opportunities at the project's headquarters, Refugio Ecologico Caiman, offer the chance to get up close to and learn more about the dangers the macaws face. Donations go directly to the project, and you will have the opportunity to assist biologists and conservationists with their daily work. A five-day experience can be combined with the chance to set off deeper into the Pantanal on a wildlife safari where horse-riding, swimming, otter watching, piranha fishing and bird-watching await.

TAKE ME THERE

How to Visit: Volunteer opportunities with the Projecto Arara Azul offer both the chance to learn about the macaws and embark on five-day wildlife safaris. Wildlife-watching trips can be arranged from the cities of Campo Grande and Cuiabá. Accommodation varies from rustic ranches to top end eco-lodges.

Further Information: Volunteer trips with Projecto Arara Azul can be arranged with several outfits including Southern Cross Tours and Expeditions (scte-brazil.com). For more information visit **www.projetoararaazul.org.br** (in Portuguese only). There are dozens of wildlife watching tour companies in both cities.

Did You Know? Black caimans amass around every water hole in the Pantanal, often reaching densities of 150 caimans per square kilometre, the highest levels in the world.

Wildlife:
- Jaguar
- Black caiman alligator
- Anaconda
- Red-bellied piranha
- Capybara
- Giant river otter
- Toucan
- Jabiru stork
- Howler monkey
- Rhea

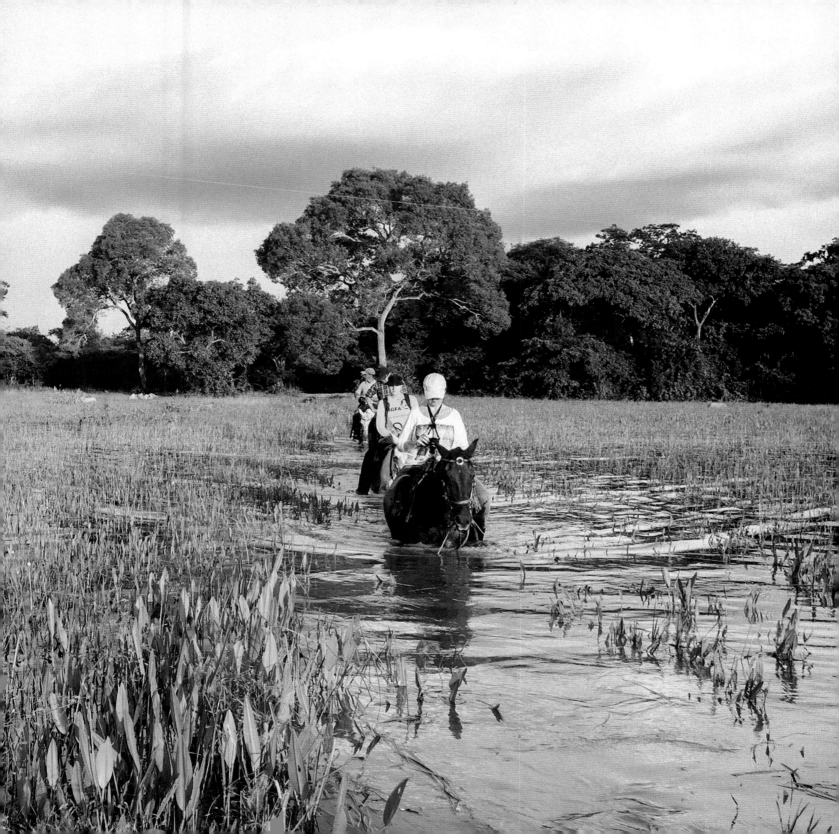

CHEETAHS IN ETOSHA NATIONAL PARK
NAMIBIA

Namibia's premier wildlife-watching sanctuary is a bleak and arid place. Savannah and thorn scrub stretch out from a 5,000 square kilometre (1,930 miles²) salt pan, a silver-white depression so startling it can be seen from space. For a few days a year, rains flood the vast saline desert, creating a lagoon which writhes with up to a million flamingos and pelicans.

Outside of Africa's largest salt pan, acacias and Mopane trees provide scant shelter amongst the golden grasslands for the thousands of animals that thrive in this stark and desolate place. Over 30 waterholes lure wildlife, where zebra and springbok mingle with oryx and antelope, and elephants bathe in the pools. They arrive not in their dozens but in their hundreds, lazy prides of lions padding through the blistering sunshine and giraffes bending gracefully to drink. Ostrich race across the endless horizon, a plume of dust rising behind them, and the world's heaviest flying bird, the 15kg (33lb) kori bustard, shares the skies with more than 340 species of bird.

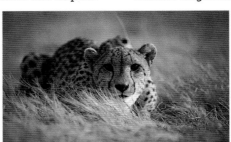

Sightings of endangered gemsbok, black-faced impalas and black rhinos are common, and in the western dolomite hills, the rare mountain zebra has found a haven. Of all Etosha's residents however, the cheetah is the Holy Grail of sightings. These graceful and shy cats, famed as the fastest creature on the planet with top speeds of 110 kilometres (68 miles) per hour, are also the world's most endangered big cat. With only 10,000 left in the wild, Etosha is one of the best places to spot them languishing in the grasslands or, for the lucky few, using their long slender legs and powerful rudder-like tails to hunt.

Self-Drive Safari in a Parched Land

Etosha's magic lies in the ease of its wildlife-watching opportunities, and embarking on a self-drive safari is an incredible adventure not reserved for the truly intrepid. You wake early each morning in one of the parks' four camps, before the hot African sun has spread its orange rays across the parched land, and make your way to a waterhole. As day breaks, animals will emerge from the shadows, first tentatively and then in ever greater numbers. So as to avoid competition with lions and leopards, cheetahs hunt during the day, often in the quiet early morning, and this is the best time to sight these elegant and solitary creatures.

Make Etosha part of a longer self-drive tour of Namibia and visit the towering, apricot-coloured Sossuvlei sand dunes, deep Fish River Canyon, the wildlife of the Kalahari Desert or, for guaranteed sightings of cheetahs and big cats, the Okonjima Reserve, home to the AfriCat Foundation for rescued and released animals.

TAKE ME THERE

How to Visit: Etosha is one of Africa's easiest safari destinations. Self-drive or guided trips start in Windhoek, and accommodation options in the park include campsites and chalets. The best time to visit is the dry season June to November.

Further Information: The park website (**www. etoshanationalpark.org**) offers trip planning information, as does Namibia Tourism Authority (**www.namibiatourism.com.na**). Self-drive safaris are arranged through operators including Safari Drive (**www.safaridrive.com**). The Cheetah Conservation Fund (**cheetah.org**) and Africat Foundation (**www.africat.org**) are good resources.

Did You Know? Until three months of age cheetah cubs have a silvery-grey mantle down their back which camouflages them by imitating the look of the highly aggressive honey badger. Despite this only 10 per cent of cheetah cubs make it to adulthood.

Wildlife:
- Black rhino
- Elephant
- Lion
- Black-faced Impala
- Kori Bustard
- Giraffe
- Flamingo
- Gemsbok
- Mountain Zebra
- Roan antelope

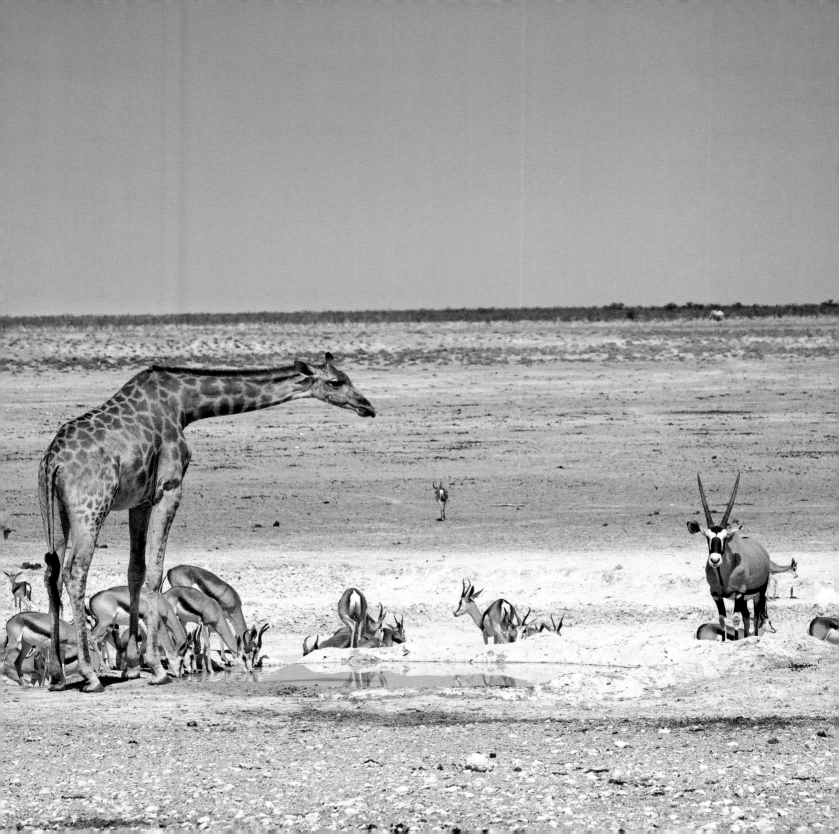

17 GLOW WORMS IN WAITOMO CAVES
NEW ZEALAND

Deep underground in New Zealand's north island a magical phenomenon unfolds. In the great caves and sinkholes which pocket the landscape a turquoise blue light pervades the darkness like a million fairy lights. Hanging from the maze of stalactites glow worms shine like miniature torches, together creating an ethereal glow.

The word Waitomo comes from the Maori language – *wai* meaning water and *tomo* meaning a sinkhole – and it was in 1887 that the caves were first explored by local Maori Chief Tane Tinorau and English surveyor Fred Mace. What they found when they delved beneath the earth's surface was a wonderland of geological formations. Over 300 known limestone caves have been carved into the landscape over the past 30 million years, passing water having created a labyrinth of stalactites and stalagmites which, growing but a mere one cubic centimetre every 100 years, have still managed to join together to craft great limestone pillars.

Yet it was the first cave they entered, what has become known as the Glow Worm Cave, which mesmerised them the most. Looking into the water from their raft it seemed as though the night sky was reflected back at them. Looking up they realised the ceiling of the cave was alight with the light of millions of tiny glow worms dangling like threads.

New Zealand glow worms live all over the country, in forests and overhanging stream banks. Yet the damp, dark conditions inside the Waitomo Caves provide the perfect conditions for these mosquito-sized insects to thrive. Their bluish green light is made from a biochemical reaction called bioluminescence which they use to attract insects and mates.

Gliding Through a Fairy Wonderland

As one of the country's most famous attractions it is unlikely you will ever have the Waitomo Caves to yourself. Yet as you board a small boat and drift serenely through the subterranean darkness it doesn't seem to matter. It is a natural phenomenon that takes the breath away, a glowing galaxy of miniature lights.

There are dozens of tours you can take to explore the caves, and everything from extreme black-water rafting, zip-lining and caving adventures to gentle floats through lesser-known caves can be arranged. Meander underground along the Waitomo River, delight in the echoing acoustics of Cathedral Cave or stare in amazement at formations with names such as the Catacombs, the Pipe Organ and the Banquet Chamber.

Above ground and the green landscape belies the mini city of caverns which weave beneath it. It is a region that inspired the set for *The Lord of the Rings* Middle Earth, rolling green hills studded with small farming communities and a proud indigenous heritage, tumbling waterfalls and some of the country's most dramatic scenery.

TAKE ME THERE

How to Visit: As one of New Zealand's most popular tourist attractions there are dozens of tour operators and adventure outfits offering a variety of trips through the caves. The caves are located about two hours south of Auckland on North Island. They can be visited year round.

Further Information: There is a wealth of visitor information on the Waitomo (**www.waitomo.com**) and New Zealand tourism (**www.newzealand.com**) websites and plenty of accommodation options around the park.

Did You Know? To catch small flying insects glow worms use a snare of sticky silk threads, some of which can grow up to half a metre in length.

Wildlife:
- Albino cave ants
- Giant crickets
- Long-tailed bat

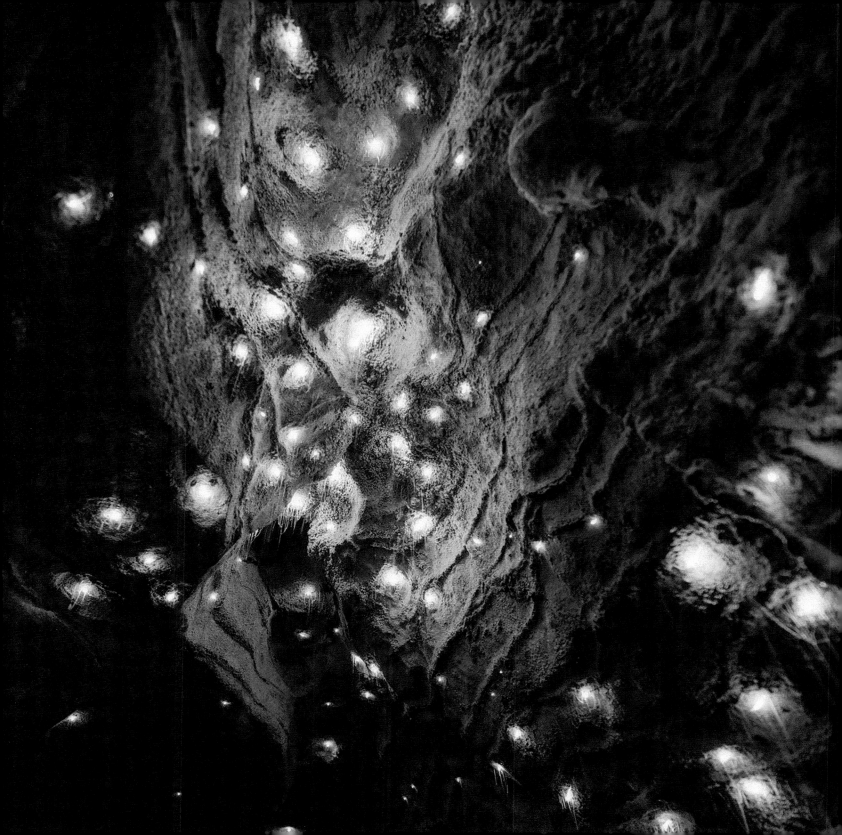

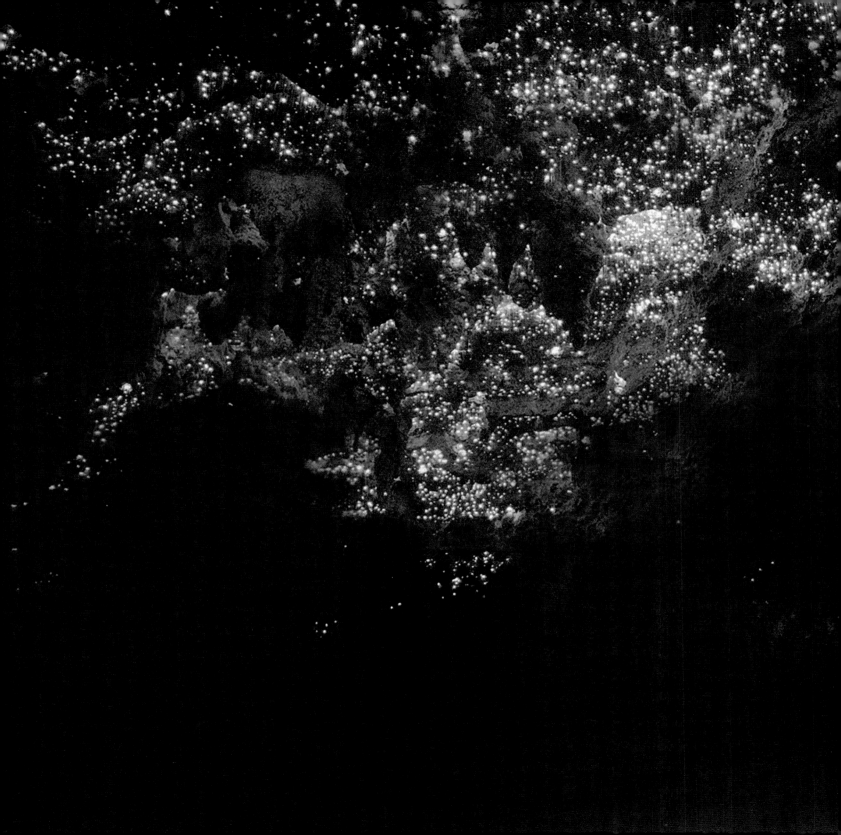

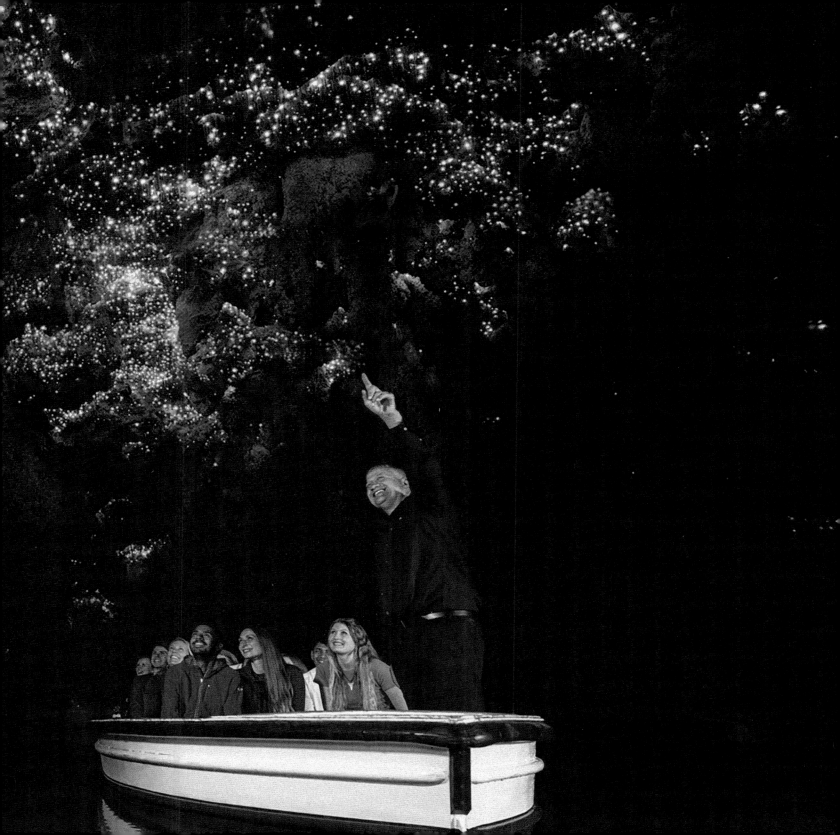

BLUE WHALES IN THE AZORES
PORTUGAL

Just 30 metres (100ft) off the shore of the Azores' volcanic islands, the inky-black water plummets to five kilometres (3 miles) deep. Jagged peaks erupt from the depths of the Atlantic Ocean, the isolated Portuguese archipelago standing at the point where the Eurasian, American and African tectonic plates collide.

It is perhaps unsurprising then that in this remote and wild place where the waters teem with krill and squid, whales and dolphins arrive in their thousands to feast. Alongside the resident sperm whales, other whales – fin, sei, orca, humpback, Bryde's – and seven types of dolphin migrate from colder climes. A total of 27 different species have been spotted here, one third of all that exist worldwide. Yet come early summer, the watchtowers – once a crucial part of a centuries-old whaling heritage – scour the ocean's surface for the unmistakable cloud of misty breath belonging to the largest creature ever to have lived on the planet; the blue whale.

Weighing up to 181,437kg (200 tons) and measuring 30 metres (100ft) in length they are both the largest and heaviest creature in the world. Indeed, their bodies contain hearts the weight of a car, and tongues the weight of an elephant. These days the ocean giants are rare sights, their numbers having dwindled dangerously to between 10,000 and 25,000 worldwide. In the Azores however, they are arriving in ever greater numbers.

Boating the Inky Oceans

The mid-Atlantic islands might offer an all-inclusive buffet to ravenous ocean giants, but they have managed to escape commercial tourism and retain a charming authenticity. Mountain peaks rise into the clouds, and volcanic crater lakes twinkle pale blue amidst the black basalt rocks. Thermal pools and waterfalls spout from in between the lush vegetation and traditional houses cluster in tiny villages.

The Blue Whale is entwined in the history of the Azores, the whale-hunting odysseys here inspiring Melville to pen the legendary tales of Moby Dick. It's been more than 20 years since the Azores banned whaling, and today the starkly beautiful islands have become one of the premier whale-watching destinations. More than a dozen responsible outfits offer the opportunity to get so close to the giant cetaceans that you can feel the spray of water on your face as a vast tail flicks its farewell.

Against the backdrop of the archipelago's nine islands, small yet sturdy boats embark on three-hour whale-watching trips. Sightings of whales or dolphins are almost guaranteed, yet catching a glimpse of a blue whale can be more of a challenge – despite their gargantuan size they are shy and elusive. Patience is required and multi-trip packages are offered by most outfits, which can be combined with opportunities to swim with dolphins or to scuba dive with turtles, manta rays, mako and blue sharks.

TAKE ME THERE

How to Visit: Blue whales migrate through the Azores between May and June, and although there are many year-round cetacean residents, weather prevents boats from heading out until April. Flights from Portugal and the UK arrive into São Miguel's Ponta Delgada airport, and there is a plentiful B&B, guesthouse and hotel accommodation to be found.

Further Information: There are a number of operators organising whale-watching trips, lectures, activities and accommodation packages including Espaço Talassa (**www.espacotalassa.com**).

Did You Know? The sperm whale's large head contains the world's largest brain and a substance called spermaceti. Whalers once believed it to be sperm but scientists remain unsure as to its purpose.

Wildlife:
- Sperm whale
- Fin whale
- Orca
- Mako shark
- Blue shark
- Sei whale
- Humpback whale
- Dolphins (common, bottlenose, Risso's, rough toothed, Atlantic spotted, striped)
- Pilot whale
- Loggerhead turtle

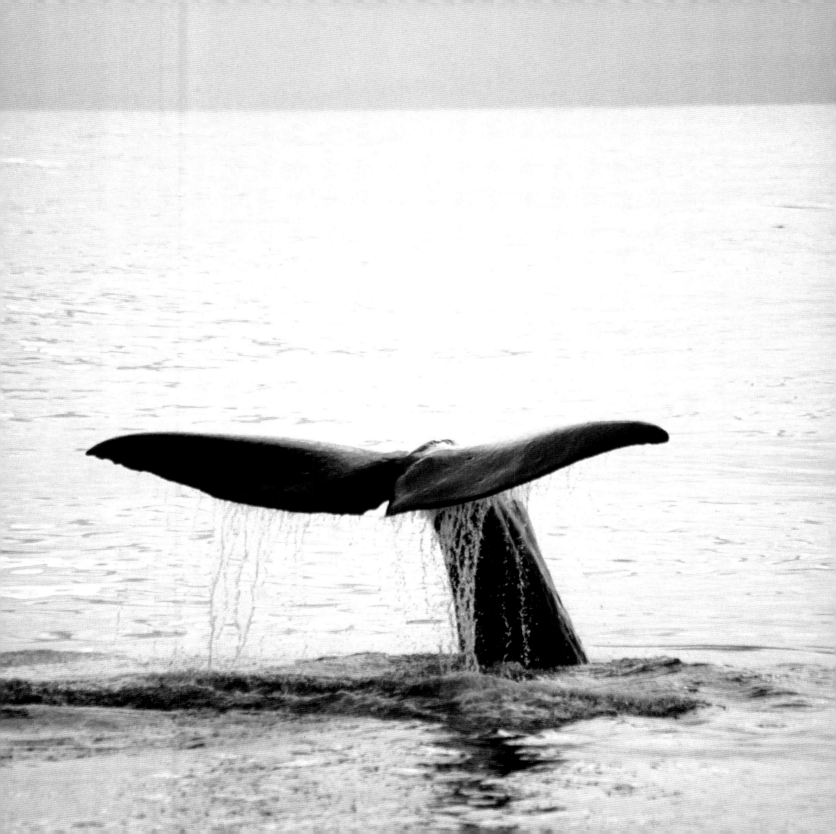

19 RHINOCEROS HORNBILLS IN TAMAN NEGARA NATIONAL PARK
MALAYSIA

In the heart of the Titiwangsa Mountain range, which runs like a jagged ridge down mainland Malaysia, lies a vast and ancient forest. Believed to be 130 million years old, it is one of the oldest forests on the planet, a raw and pristine ecosystem where flora and fauna flourish amidst the mountain peaks, dense lowland rainforest and montane woodlands.

The national park stretches for over 4,000 square kilometres (1,500 miles2), and is one of the country's most important wildlife sanctuaries. Yet only a small section is accessible to visitors, the rest preserving the native environment and offering a safe-haven to a myriad of exotic Asian species. Many are rarely seen, Sumatran tigers, sun bears, leopards and Sumatran rhinos hiding out amidst the tangle of impenetrable, sweaty jungle made up of large buttressed trees, bright orchids and the world's largest flower, the giant rafflesia. Some make more regular appearances, monkeys and snakes, lizards and tapirs, and the occasional Asian elephant amongst them. What visitors will encounter however is a circus of 360 species of exotic birds flapping and squawking through the canopy, amongst them the dramatic and beautiful rhinoceros hornbill.

With its huge red, orange and yellow casque, the rhinoceros hornbill is the most flambuoyant of the hornbills. At almost the size of a swan, it isn't an easy bird to miss even in the depths of the rainforest, and is renowned for its noisy, distinctive calls. Despite being Malaysia's national bird it has come under threat from loss of habitat and is hunted for its meat and beak which is made into ornamental statues.

In Search of the Hornbill
Taman Negara is South East Asia's largest national park, a sprawling wonderland of fast-flowing rivers, gushing waterfalls and a dark forest shaded from the sunlight by a thick canopy. While most of the park is off limits to visitors there are plenty of adventures waiting to be embarked upon.

Taman Negara is no safari destination, and animals here do their best to remain incognito, lurking in the shadows far from human eyes. A fleeting visit will offer fleeting wildlife sightings, so the more time and patience you can dedicate the more you will get out of your trip. To see the brightly coloured rhinoceros hornbill and its fellow avian species, trek the winding trails (whether it's a 2 kilometre (1.2 mile) day hike or a mammoth 55 kilometre (34 mile) trek), tiptoe along the canopy walkway or embark on a leisurely boat trip along the tree-fringed river. Night hides and safaris offer the possibility of spotting the park's larger mammals, while fishing, white water rafting and caving add a splash of adrenaline to a visit.

TAKE ME THERE

How to Visit: The park headquarters are at Kuala Tahan which is accessible form Kuala Lumpur by shuttle bus, boat or self-drive vehicle. There is a range of accommodation outside of the park including a luxury resort, guesthouses and hostels. The best time to visit is the dry season (February to September).

Further Information: To start planning a trip to Malaysia visit the official tourism website (**www.wonderfulmalaysia.com**). There is plenty of information on Taman Negara National Park on **www.tamannegara.asia**. The Mutiara Resort offers upmarket accommodation (**www.mutiarahotels.com**).

Did You Know? Hornbills make their nests in tree trunks which the males seal with mud from the outside, leaving a small hole through which to feed the female and chicks.

Wildlife:
- 350 species of bird
- Asian tapir
- Asian elephant
- Muntjac
- Giant squirrel
- Wild oxen (seladang)
- Sun bear
- Sumatran tiger
- Sumatran rhinoceros
- Five-bar Swordtail butterfly

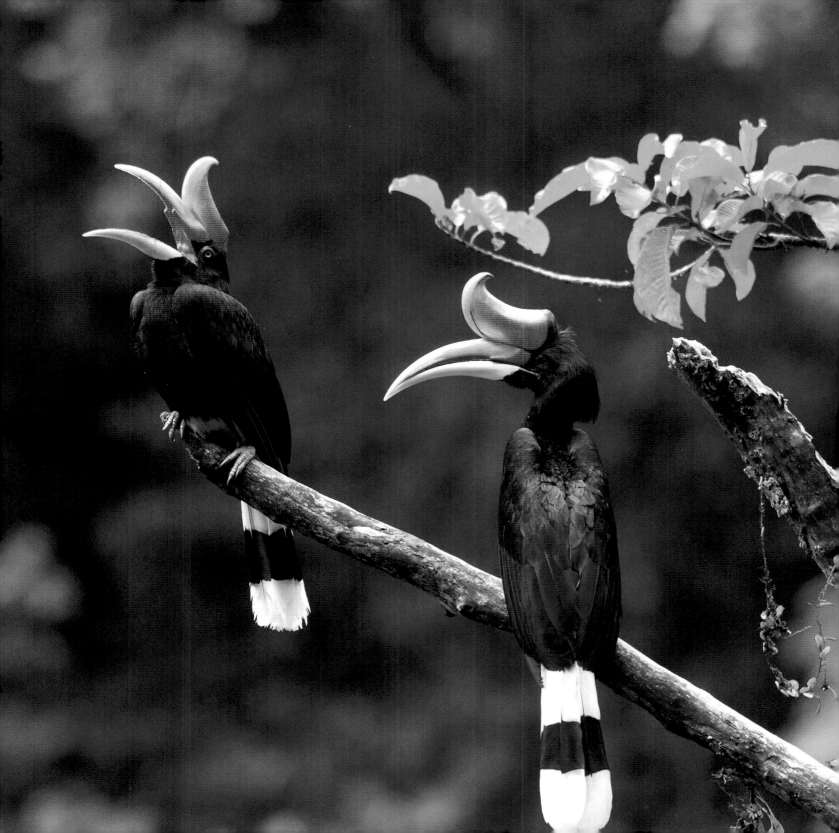

BROWN BEARS IN KATMAI NATIONAL PARK
ALASKA

Every year millions of fat pink sockeye salmon burst from the Bering Sea into the streams of the Katmai National Park, writhing their way upstream and creating a feast for the region's brown bears. For in this wild, virtually uninhabited corner of Alaska over 2,200 of the world's largest grizzlies dine on the summer glut, scooping the leaping fish with giant padded paws.

More bears than people live in Alaska, and the Katmai National Park has some of the largest densities of bears ever recorded. Weighing up to 550kg (1,212lbs) they are top of the food chain predators, fiercely territorial and immensely powerful. Katmai is the world's premier bear-viewing country, a place where steaming volcanoes pump smoke into the chilly blue sky and icy streams weave between snow-covered mountain peaks. As many bear populations around the world decline, Katmai offers an unblemished haven for these giant carnivores to fish and forage, mate and fight.

The waterfalls of Brooks Falls are one of the most iconic bear-viewing spots on the planet, the image of grizzly bears catching flying salmon a familiar one (up to 70 individual bears have been identified in a single month). Yet throughout the park huge concentrations of bears converge on the rich pickings, including the coastal regions where protected bays harbour clams and fish. They are true backcountry locations where bears dig for shellfish in the mudflats, laze in the open wildflower meadows or amble alongside salmon streams.

Backcountry Bear-Viewing

The adrenaline rush of standing a few metres from an Alaskan brown bear is comparable to few other wildlife experiences. And here in the Katmai National Park the bears have little to fear of humans, allowing for hair-raisingly close encounters and incredible photography opportunities. Whether they are splashing unceremoniously in the waters, napping in the sun or battling it out for the best fishing grounds the bears seem almost apathetic to their spectators.

To get an up-close encounter set off on a float plane from Anchorage or Kenai's Soldotna and, after soaring over the grey Cook Inlet below, enter a world of towering jagged peaks, smoking volcanoes and glinting streams. Brooks Falls is the hub of bear-viewing activities, where strategically placed viewing platforms allow for incredible encounters with dozens of bears at any one time. Jet boats or float planes transport you to the deep backcountry, landing on wide sandy beaches deserted by all but the vast lumbering bears. Hiking, fishing and canoeing opportunities abound around Brooks Falls where sumptuous lodges or a back-to-basics campsite are the perfect place to rest your head.

TAKE ME THERE

How to Visit: Trips to Brooks Falls and Katmai National Park depart from Anchorage and Soldotna in float planes and can be day or multi-day trips. Accommodation is in one of a handful of high quality lodges dotted across the park or a campsite at Brooks Falls. The best time to see the bears is during the salmon run between July and September.

Further Information: The Alaska Tourism website (**www.alaska.org**) lists several outfits offering trips to Katmai including Katmailand (**www.katmailand.com**). The National Parks Service (**www.nps.gov**) offers lots of bear-viewing and park information.

Did You Know? In autumn a brown bear may eat as much as 40 kilograms (90lbs) of food every day, weighing twice as much before hibernation as it does when it emerges in spring.

Wildlife:
- Grey wolf
- Beaver
- Porcupine
- Moose
- Marten
- Sea otter
- Sea lion
- Orca
- Beluga whale
- Grey whale

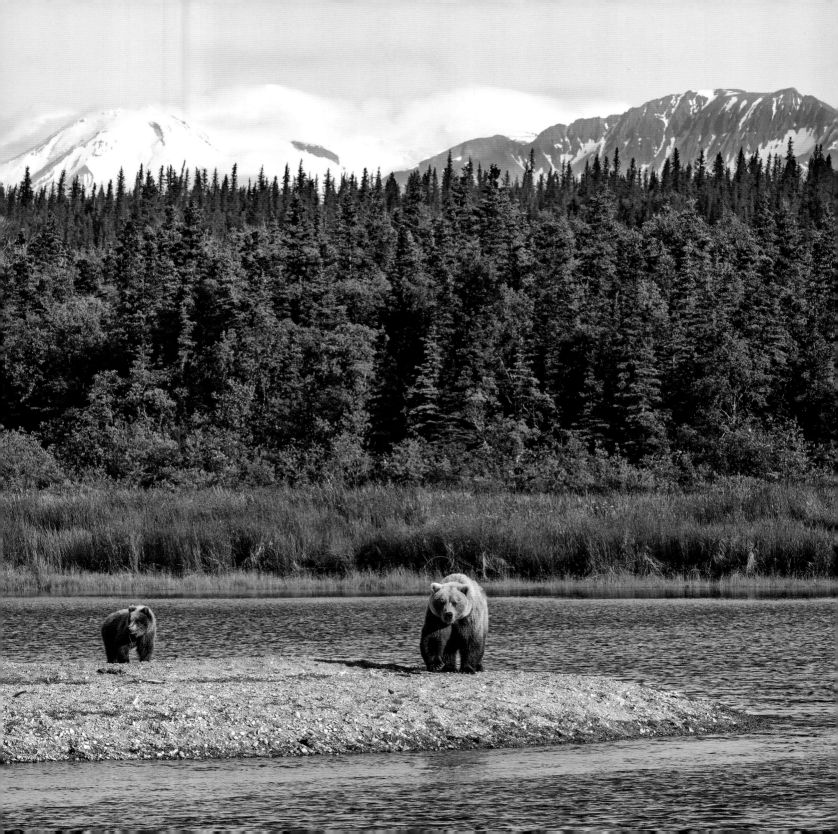

To peer down into the great abyss that is the Colca Canyon is stomach-churning. At almost 1 kilometre (0.6 mile) in depth from its upper rim to its river-threaded base it is one of the largest canyons in the world, a vast green and verdant crack in the earth. In the higher elevations of the great valley, llama and alpacas graze on fertile soils, and stepped terraces – vestiges of their pre-Incan heritage – are carved into the lower reaches. Small villages dot the impossibly steep slopes, their Collagua and Cabana inhabitants proudly preserving their ancestral traditions where folklore and mythology revere one of the largest flying birds in the world, the Andean condor.

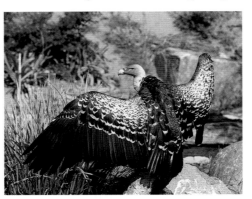

Keeping a body that weighs up to 15 kilograms (33lbs) aloft is no easy feat, even for a bird with a wingspan of up to 3.2 metres (10.5 feet). Swirling through the currents that form above the canyon, condors are unmistakable, an unbroken shadow created by their jet black plumage – broken only by a small white band around their necks and their iconic bald heads. Despite their status as a national symbol, Andean condors are highly threatened, and have been the focus of worldwide conservation efforts. Today, the Colca Canyon supports one of South America's healthiest populations where these giant scavengers, who can live to the age of 50 and mate for life, soar on the swirling currents.

Trekking an Ancient Landscape

There is a spot known as the Cruz del Condor (Condor's Cross), a lookout which perches a dizzying 1,200 metres (3,960 feet) above the valley floor, from where you can stand and watch as the great birds swoop and soar. It is one of the most rewarding and guaranteed places on the continent from which to get a condor close-up as they skim past the canyon edges and come to rest with regal elegance on narrow ledges.

To see the condors from this vantage point shouldn't be missed, but delve further into the canyon on a three day guided trek to experience the real land of the condor. Accompanied by headdress-toting llamas, you pick your way cautiously down the narrow paths carved into the cliff face. Vizcacha (a rabbit-sized relative of the chinchilla), deer, fox and vicuña can be spotted, and giant hummingbirds, Andean goose and Chilean flamingos share the skies with the king of Colca. To sleep under canvas and cook under the stars is to truly envelop yourself in this ancient and beautifully preserved landscape, as yet unmarred by tourism.

TAKE ME THERE

How to Visit: Arequipa is the jumping off point to the Colca Canyon, from where tours begin and end. Within the valley, the small town of Chivay offers rustic accommodation. Tour operators offer multi-day private or group treks as well as shorter trips to the Cruz del Condor.

Further Information: Real World Holidays (**www.realworldholidays.co.uk**) arrange tailor-made trips to Peru and trekking in the Colca Canyon. Peru-based guided tours include Pablo Tour (**www.pablotour.com**) and Carlitos Tours (**www.carlitostours.com**).

Did You Know? As large as it is, the Andean Condor's vast wingspan is superseded by the wandering albatross (3.6m/12ft)

Wildlife:
- Vicuña
- Viscacha
- Deer
- Fox
- Andean flamingo
- Andean goose
- Giant hummingbird

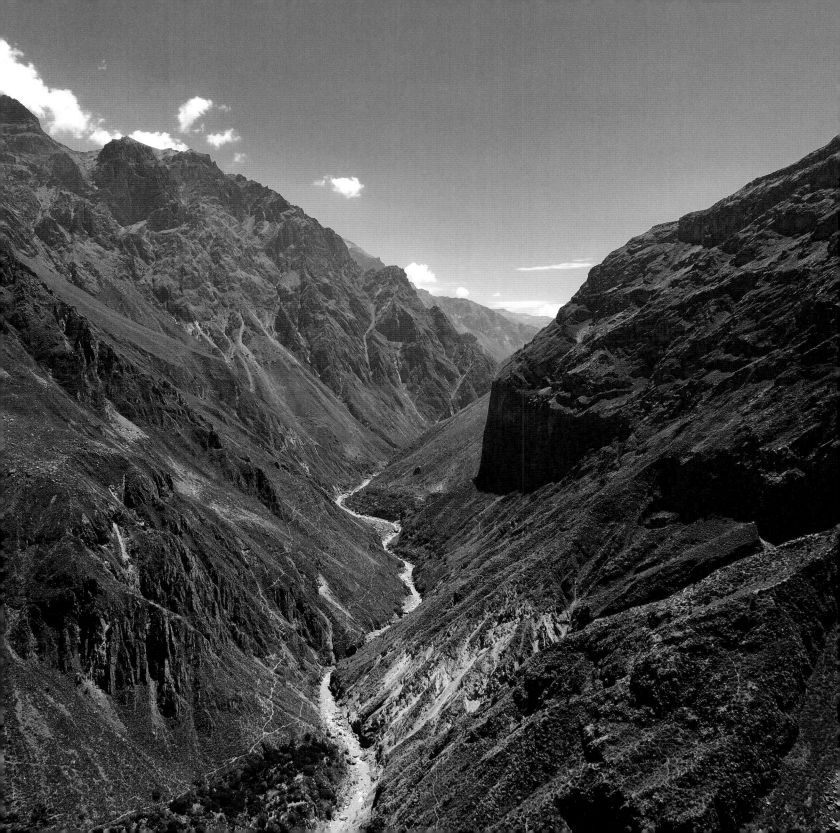

SAILFISH IN ISLA CONTOY
MEXICO

Where the Caribbean Sea meets the Gulf of Mexico, a sliver of green-tufted island erupts from gin-clear waters like a story-book desert island. And while it may be true that no people live on Isla Contoy, a lush island a mere 8 kilometres (5 miles) long and barely 1 kilometre (0.6 miles) wide, it is far from uninhabited. Seabirds arrive here in their millions, and the island's status as the Mexican Caribbean's most important sea bird nesting site has awarded it highly protected national park status – indeed, just 200 people are allowed to visit on organised tours each day to ensure the delicate ecosystem remains undisturbed.

While over 150 species of birds swoop over sand dunes 20 metres (70ft) high and come to roost in the swaying palm trees, in the sparkling, nutrient-rich oceans a swirl of life thrives. Some 234 species of fish dart through the bright coral reef, including the largest fish in the world, the whale shark, and the fastest marine predator on the planet, the sailfish. Reaching speeds of 109 kilometres (68 miles) per hour sailfish arrive to Isla Contoy's waters in winter to feast on the great schools of silvery sardines. Using their long, powerful bodies and majestic sail-like dorsal fins they use their incredible speed to circle and disorient their prey.

Dolphins, manta rays, schools of Atlantic bonitos and huge wahoos join the sardine feast, and loggerhead, green, leatherback and hawksbill turtles find nesting refuges on the pristine beaches. Over 5,000 frigate birds circle the blue skies with their 3 metre (10ft) wide wingspans. Brown pelicans drop dramatically from the sky to scoop unsuspecting fish into their huge bills, and gulls, petrels, cormorants, ducks and flamingos join together to create a melodic and constant orchestra of calls and cries.

Snorkelling with Torpedos

Isla Contoy's magic lies in its isolation. Located 30 kilometres (18 miles) north of the pretty, laid-back little island of Isla Mujeres, perched just off the tip of Cancun, it is a world away from the bustling resorts that line the Yucatan Peninsula. Specialist guides will take you in search of the sailfish, and boat trips allow for time to make sand angels on the warm beaches, explore the nature trails and bird watch.

Snorkel in place as you drop quietly into the warm sea and wait. Dolphins might make a cheeky appearance, spiny lobsters scuttle along the reef and the sea swarms with shimmering schools of fish big and small. They arrive seemingly in the blink of an eye, and you watch spellbound as 1.5 metre (5ft)-long sailfish fly through the water in a blur of bluish grey, their fins protruding like the sail of a classic schooner and their needle-sharp bill throwing their prey into a frenzy of panic.

TAKE ME THERE

How to Visit: Isla Contoy is uninhabited so base yourself in Isla Mujeres or Cancun where there is a wealth of accommodation options. Boat trips run daily to the island. The best time to see sailfish is December to March.

Further Information: The national (**www.visitmexico. com**) and regional (**cancun.travel**) tourism websites are helpful planning tools, as is Amigos de Isla Contoy (**www.islacontoy.org**). Several tours run from Cancun and Isla Mujeres with Eco Travel Mexico (**www.ecotravelmexico.com**) and Planet Scuba (**www. planetscubamexico.com**) offering specialist sailfish excursions.

Did You Know? Sailfish, which are not usually found near land, can grow to more than 3 meters (10ft) and weigh up to 100 kilograms (220lbs).

Wildlife:
- Turtles (leatherback, green, hawksbill and loggerhead)
- Brown pelican
- Frigate bird
- Manta ray
- Dolphin
- Whale shark
- Spiny lobster
- Sardine
- Flamingo
- White heron

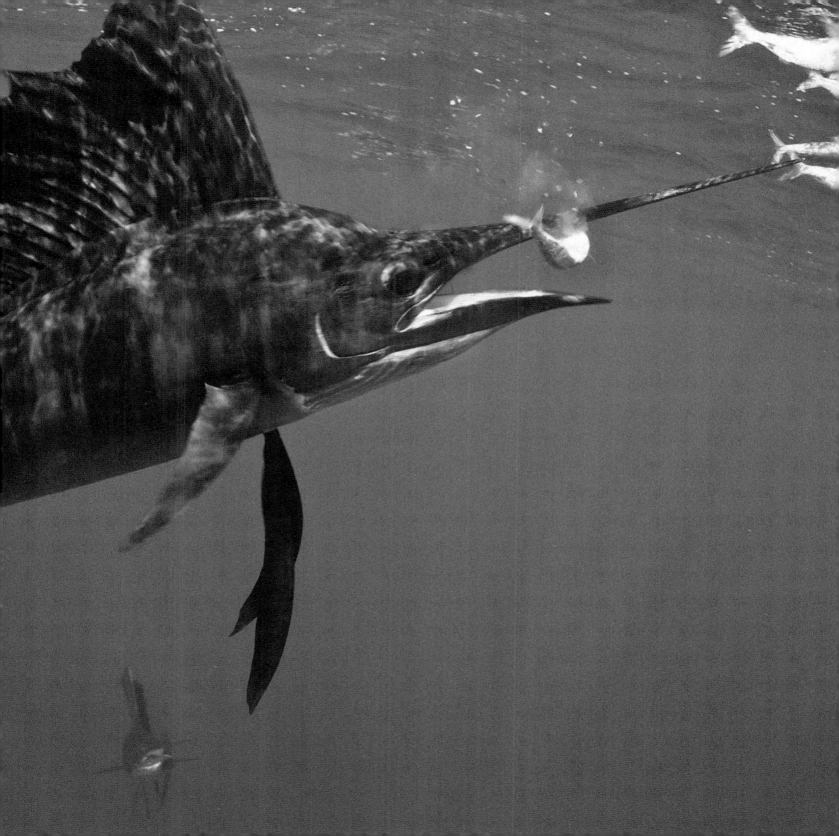

Their name means 'Wild Men', a sad irony as the fate of the Orang-utan's habitat is hanging precariously in the balance. The orange-furred, long-limbed primates – the largest tree-dwelling mammal in the world – have come to symbolise South East Asia's conservation struggles and successes. In the last 60 years, the orang-utan population has declined by 50 per cent, and today just 45,000 Bornean Orang-utans are left in the wild. In 10 to 30 years both Bornean and Sumatran orang-utans could be extinct, threats from intense logging and poaching for the pet trade their greatest dangers.

Yet in the heart of Borneo, islanded by plantations and bare land where once stood thick rainforest, Danum Valley Conservation Area is one of the last havens, not just for the orang-utan, but for a whole cast of jungle-dwelling wildlife. It is one of the last refuges of the endangered Sumatran rhinoceros, which ambles through the thick undergrowth with its pale grey armour-plated body. There are cartoon-cute pygmy elephants, their rotund bodies and babyish faces standing them apart from their Asian cousins, and elusive clouded leopards. Malayan sun bears, the smallest of the world's eight bear species, exist here, and insects and reptiles inhabit every square inch. To put it in context, 61 species of land snail alone were found in a 1 kilometre (0.6 mile) plot.

The Danum River flows through the 438 square kilometre (170 mile²) reserve, carving its way between the undulating hills and valleys. Mist and cloud swirls through the treetops like a soft white blanket, drenching the land in hot humidity. The air is filled with the sounds of noisy hornbills cackling through the canopy, the trickle of waterfalls as they splash into pools, and the unmistakable call of the lonely male orang-utan defending his turf.

Volunteering in the Heart of a Tropical Rainforest
There are few wildlife encounters that evoke such emotion as coming face to face with an adult orang-utan hanging nonchalantly between trees by their two metre (7ft) arm span. A mild look of curiosity flickers in their eyes as they take in their admirers, before they turn and swing effortlessly through the jungle.

Danum Valley offers the best chances of encountering the flame-haired primates (for a guaranteed close-up pay a visit to the Orang-utan Rehabilitation Centre in Sepilok). There is a single luxury lodge, where guided trips reveal the secrets of the rainforest. Navigate the heart-stopping canopy walkway that weaves through a realm inhabited by birds, gibbons, Proboscis monkeys and orang-utans, or trek the nature trails through the forest floor. Spend afternoons lazily tubing down the Danum River, or nights in search of giant flying squirrels and leopards.

For a genuine immersion experience, stay at the rustic Danum Valley Field Centre – one of the world's leading research centres in Old World tropics – and embark on a 10-day volunteer project to assist a team of scientists as they study the effects of logging and climate change in one of the planet's most complex ecosystems.

TAKE ME THERE

How to Visit: Lahad Datu is the nearest town and has direct flights from Kota Kinabalu and Kuala Lumpur. There are two lodging options, the luxury Borneo Rainforest Lodge (www.borneonaturetours.com) and the Field Centre (www.searrp.org/danum-valley).

Further Information: Sabah Tourism (www.sabahtourism.com) has good trip-planning information. Accommodation and tours can be booked directly, or through tour operators including Borneo Adventure (borneoadventure.com). Earthwatch (earthwatch.org) offer 10-day volunteer programmes.

Did You Know? Species recovery is hampered by the fact that female orang-utans give birth only once every eight years—the longest time period of any animal.

Wildlife:
- Pygmy elephant
- Sumatran rhino
- Malayan sun bear
- Clouded leopard
- Proboscis monkey
- Horsfield's tarsier
- Bornean Gibbon
- Mousedeer
- Hornbill
- Giant flying squirrel

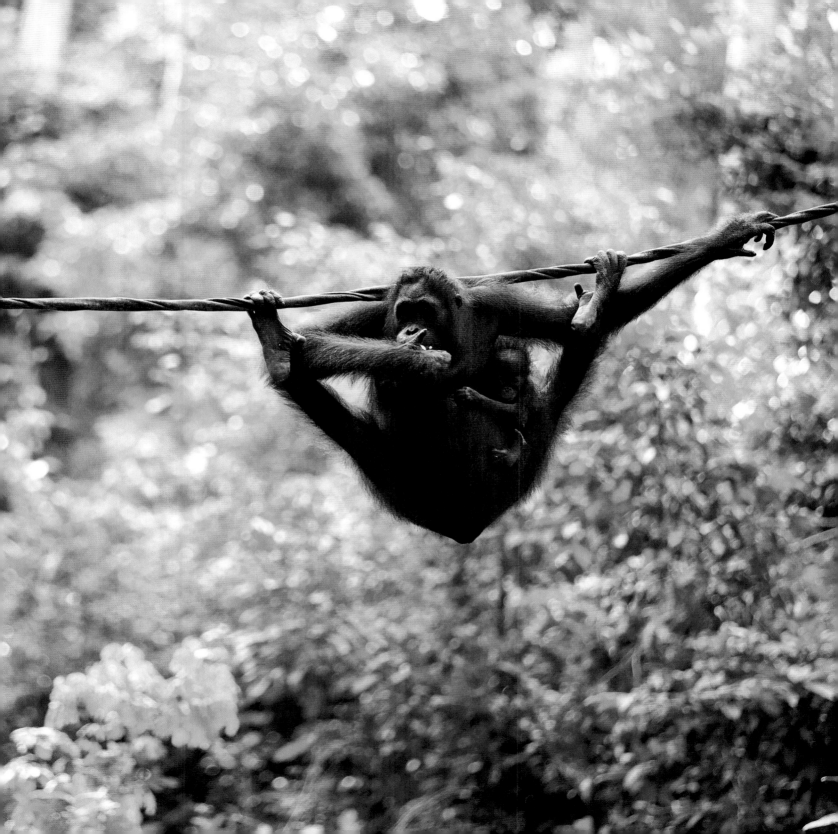

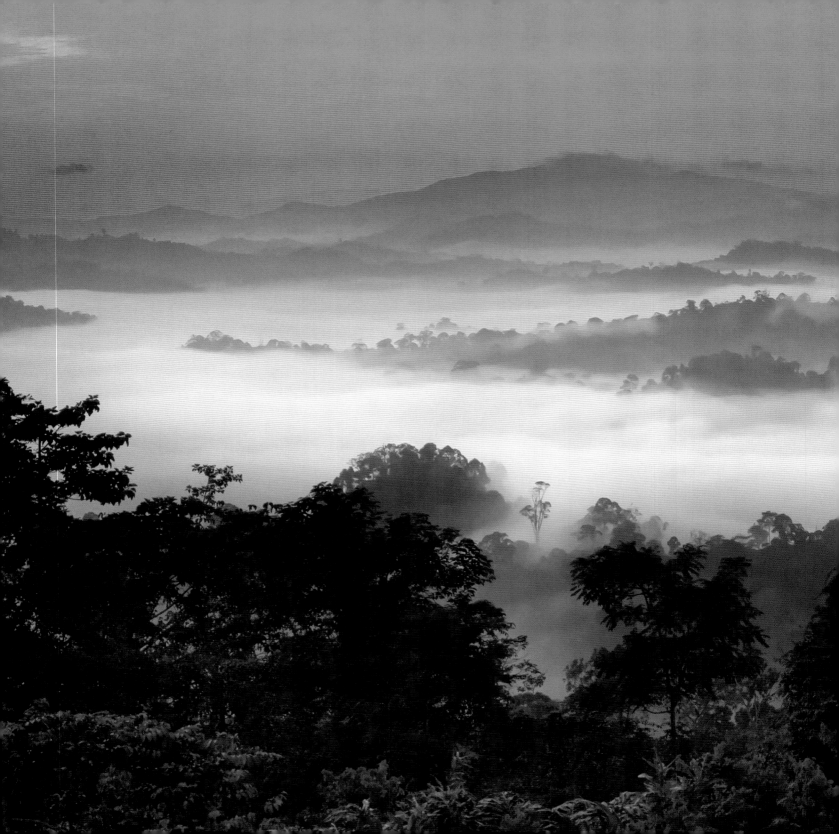

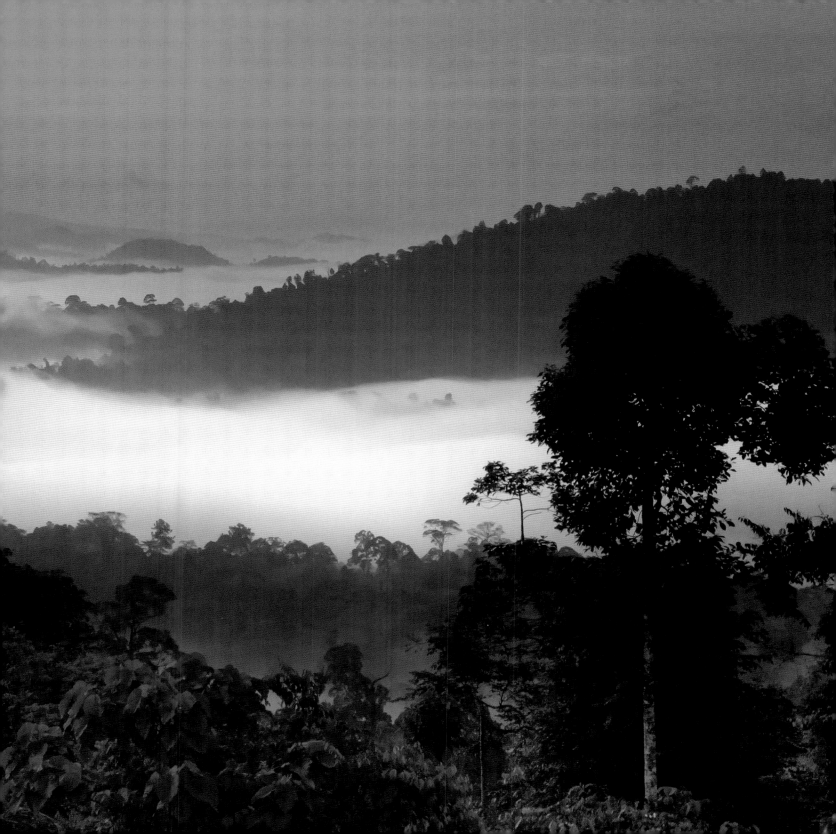

On the eerie and mysterious beaches of Namibia's Skeleton Coast, where sun-parched whale carcasses and rusted ships create a haunting beauty, is a breeding colony of 150,000–210,000 Cape fur seals. The pungent smell of guano hangs in the air and the bleating, barking and roar of thousands of seals fills the barren landscape on the edge of the world's oldest desert, the Namib.

At first glance, the Namib is a barren and lifeless corner of the planet, the 2,000 kilometres (1,242 miles) expanse of rolling dunes and gravel plains stretching along Africa's south Atlantic coast. The carcasses of ships wrecked by unforgiving fogs lay in their dozens along the notorious Skeleton Coast, and great crescent-shaped sand dunes roll down to meet the crashing grey waves.

Yet owing to its antiquity – the desert has existed for 55 million years – the Namib supports one of the world's richest desert ecosystems. Herds of desert-dwelling springbok roam, the cackle of hyenas echo across the dunes and the cold ocean water supports great schools of fish for the colonies of fur seals. The largest of these colonies is the Cape Cross Seal Reserve, where territorial fights are fiercely battled out, mating happens and pups are born.

Although called a seal, Cape fur seals are in fact a sea lion, the males weighing between 187kg (412lbs) and 360kg (793lbs). In the chilly waters Cape horse mackerel, Cape hake and pelagic goby school in bountiful numbers creating a fattening feast. Yet orcas and sharks roam the waters too and, together with the jackals and hyenas that patter along the beaches, are the main threats to the young pups.

Exploring a Grisly Coast

Visiting the small headland of Cape Cross, and ambling along the 200 metre (650ft)-long walkway, is a true assault on the senses. The sight of thousands of writhing seals, the almost overwhelming smell and the cacophony of sounds combine to form a unique wildlife experience. Day trips, whether self-drive or as part of a tour, head out of the nearby resort town Swakopmund, providing the opportunity to visit to the seal colony and learn about the profound history of the region.

For in 1486 Portuguese seafarer Diego Cão landed on this bleak headland as the first European explorer. He erected a stone cross in honour of the King of Portugal and today a replica of his original stands in the same position. Shipwrecks litter this treacherous stretch of wild Atlantic coastline in their dozens – hence the name Skeleton Coast – and at Cape Cross the famed wreck of the *Winston*, a fishing boat that ran aground here in 1970, remains forever more.

TAKE ME THERE

How to Visit: The southern gateway to the Skeleton Coast and Cape Cross is the town of Swakopmund from where you can embark on a day trip to the seal colony. There is one lodge and campsite at Cape Cross. Males rut towards the end of October and seal pups are born at the end of November/early December.

Further Information: Contact the Namibia Tourism Authority (**www.namibiatourism.com.na**) and Namibia Wildlife Resorts (**www.nwr.com.na**) for further information on visiting, accommodation options and activities. Accommodation is limited to the Cape Cross Lodge (**www.capecross.org**).

Did You Know? Cape fur seals are so named for their thick pelt and the pups have been hunted for their fur for centuries.

Wildlife:
- Black-backed jackal
- Brown hyena
- Orca
- Springbok
- Gemsbok
- Zebra
- Lion
- Leopard
- Elephant
- Seabirds

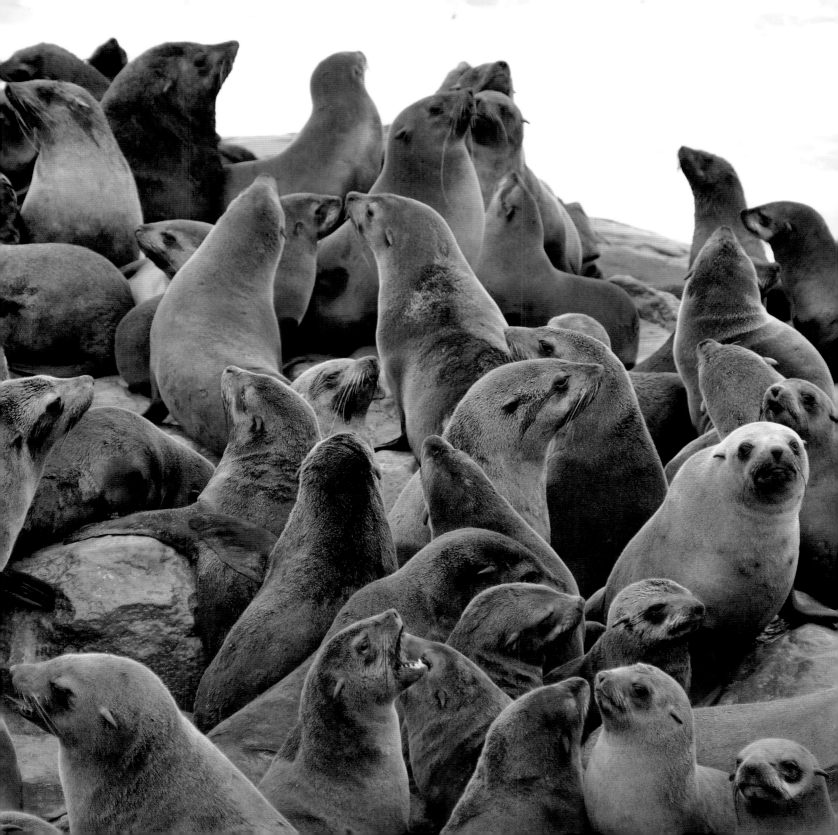

MUSK OXEN IN DOVREFJELL NATIONAL PARK
NORWAY

A noise like a great crack of thunder sounds across the mountains and valleys of Dovrefjell National Park as two mighty male musk oxen clash head to head in a stoic battle. When these 400kg (880lb) shaggy arctic creatures, survivors of the last ice age, collide at 100 kilometres per hour (60 mph), their solid head plates crash together to create a sound straight from the heavens. Yet for centuries these long-haired mammals were absent from their ancestral lands, until a programme to re-introduce them from Greenland in 1932 once again brought musk oxen to Norway's picturesque Døvrefjell mountain plateau. Today they number some 300,000 appearing like great lumbering rocks on the distant horizon.

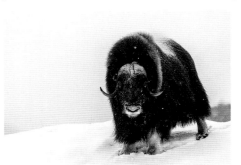

In the shadow of the landmark mountain of Snøhetta, musk oxen roam the alpine lands, and Europe's last remaining population of wild Fennoscandian reindeer timidly tiptoe through the open, rolling terrain. It is a region steeped in history, where travellers, hunters and miners have played their part in shaping the landscape. It holds a tender place in the hearts of Norwegians, a land from where legends, myths, poetry and music celebrate a mystical realm.

There are only a few places in the frozen Arctic where musk oxen roam, their long shaggy hair protecting them from the frigid conditions. And, despite being one of Norway's most off-the-beaten-path mountain destinations, Dovrefjell is possibly the most accessible place on the planet in which to have a virtually guaranteed encounter with an ancient musk oxen.

Walking the Mountains With Prehistoric Beasts

There is something wild and rugged about Dovrefjell. Just a short distance from the great coastal fjords and the gushing waterfalls of the Eikesdalen valley, it is a place that begs to be hiked and explored. Guided musk ox and reindeer walking safaris set out from the tiny villages that dot the region, where mild summer temperatures and mountains blanketed in wildflowers make for a gentle and rewarding experience.

While chances of seeing musk oxen are high, reindeer can be more elusive. Huge antlered moose (elk), red deer, arctic foxes and wolverine share the park with golden eagles and a small and rarely sighted population of bears. For chances of encountering reindeer and other wildlife, head deeper into the park on an adventurous self-guided trek. Amble amongst mountain birch and cranberries, hunker down in no-frills huts at night and revel in the true solitude of this raw mountain landscape inhabited by a creature that has walked the earth for 20,000 years.

TAKE ME THERE

How to Visit: The park is located 370 kilometres (230 miles) north of Oslo. Several towns and villages offer hotels, inns, cabins and lodges and wild camping/caravanning is permitted. The Norwegian Trekking Association (DNT) maintains mountain cabins/lodges for back country hiking. June to August are the best time for seeing musk oxen.

Further Information: The national (**www.visitnorway.com**) and regional (**midtnorsknatur.no**) tourism websites provide a wealth of trip-planning information. Tours depart from the towns of Hjerkinnus (**www.hjerkinnhus.no**), Dombås (**www.dombasmotel.com**) and Oppdal (**www.oppdalbooking.no**) and (**www.moskussafari.no**).

Did You Know? The under wool of the musk oxen is called *qiviuq*, and it is one of the softest and most expensive wools on earth, said to be ten times warmer than sheep's wool.

Wildlife:
- Wild reindeer
- Moose/elk
- Golden eagle
- Red and roe deer
- Wolverine
- Mountain fox
- Mink
- Lynx
- Hare
- Grouse

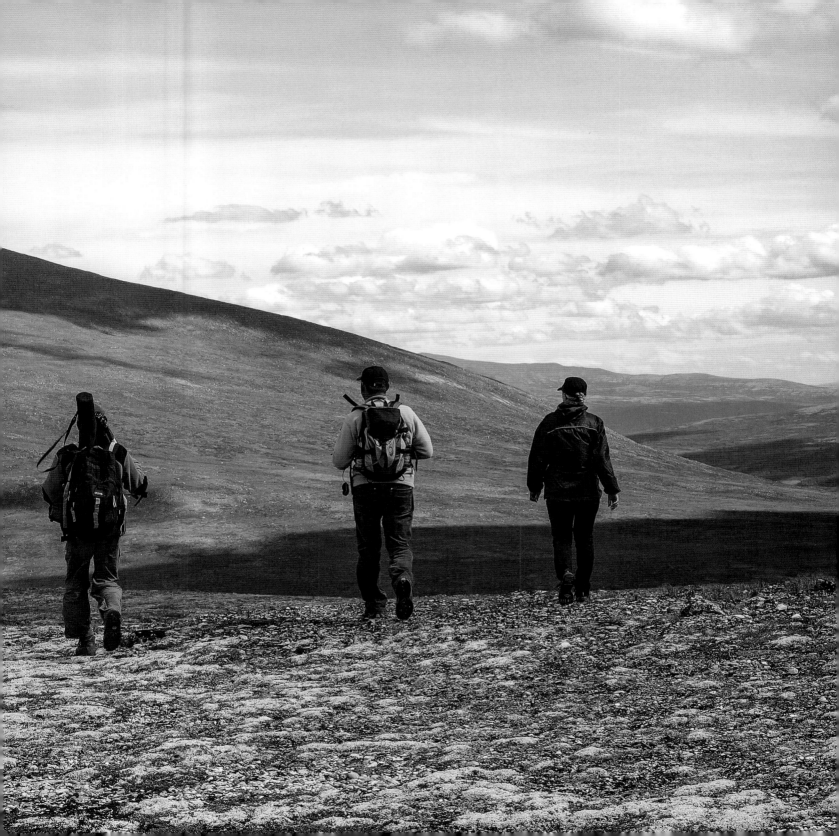

Every year, more than 10,000 leatherback sea turtles travel on long migrations across the cold Atlantic Ocean to nest on Trinidad's eastern beaches. Under the light of the moon they haul their 900kg (2,000lb) bodies onto the beaches and use their powerful flippers to dig nests in the warm sand where they lay 80–100 tennis-ball sized eggs. Yet, the most densely nested site for leatherbacks on the planet hasn't always been so, and the island nation has made an astounding comeback in the past few decades.

More than half of all adult leatherbacks on the planet have been lost since 1980, hunted almost to oblivion for their meat and eggs. Indeed it is estimated just tens of leatherbacks frequented the beaches of Grand Riviere and Matura on Trinidad's surf-washed shores a few short years ago. Thanks to extensive conservation efforts however, the situation is now looking far more promising for these huge ancient creatures – they can measure up to 1.8 metres (6ft) in length – and at the height of the nesting season over 700 turtles can make their way onto the beaches in a single night.

It is an ancient ritual that has played out since the time of the dinosaurs, hundreds of black-shelled turtles – the largest on the planet – emerging from the seas glistening in the moonlight and jostling each other for the prime nesting spot.

When the time is right, tiny hatchlings will emerge from their shells to scuttle back down the beach and into the mercy of the ocean.

Volunteering to Save the Leatherback

The resurgence of the leatherback in Trinidad is a true conservation success story, and the best way to truly appreciate the efforts and delicate balance that these organisations maintain is to spend a few weeks volunteering.

By day you explore the rain forested hillsides and mangrove swamps, home to an exotic collection of South American wildlife (Trinidad sits just 11 kilometres (7 miles) off the coast of Venezuela). West Indian manatees and Risso's dolphins, howler monkeys and collared peccaries, 400 species of bird and 600 of butterfly swirl through the landscape. Soak up the vibrant culture as you stay with a local family, attend carnival or work with local children on conservation projects.

By night however, you walk the 800 metre (2,600ft)-long beach, weighing and measuring the vast animals, looking for signs of disease or injury and counting eggs. It is imperative data to the future survival of the leatherback, and a wonderfully immersive way to see Trinidad.

TAKE ME THERE

How to Visit: Volunteering is a rewarding way to learn more about the turtles and get up close as they nest. There are several organisations offering two to four week volunteering opportunities. Casual visitors can also visit the turtle-nesting beaches of Matura and Grande Riviere on organised trips. The best time to visit is April to July.

Further Information: The tourism website (**www.gotrinidadandtobago.com**) offers a good introduction and you can find information on turtle conservation at Turtle Village Trust (**www.turtlevillagetrust.org**). There are several volunteering organisations including Nature Seekers (**www.natureseekers.org**), Earth Watch (**www.earthwatch.org**) and SOS Save Our Seaturtles Tobago (sos-tobago.org).

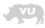

Did You Know? Leatherback turtles are air-breathing reptiles that can dive to ocean depths of more than 1,200 metres (4,000ft) and remain underwater for an hour.

Wildlife:
- West Indian manatee
- Risso's dolphin
- Tree sloth
- Guyanan Red Howler Monkey
- Collared peccary
- Red Brocket deer
- 400 species of bird
- 600 species of butterfly
- Green anaconda
- Green iguana

GIANT PANDAS IN WOLONG NATURE RESERVE
CHINA

The giant panda is the most iconic of the world's endangered animals. Gentle, peaceful and shy they inhabit the central mountain forests of China in 50 separate nature reserves. It is believed there may only be around 1,800 individuals left ambling through the wild, untouched landscape, and in Wolong, the most famous of the reserves, an estimated 150 pandas have been tagged.

As part of the UNESCO designated Sichuan Giant Panda Sanctuaries (which also includes Mt Siguniang and the Jiajin Mountains) Wolong is part of the largest remaining contiguous habitat of the giant panda, a sprawling 200 thousand hectares of towering mountains, dense forests, ferocious rivers and jagged canyons. Dark ancient woods and trickling springs meet the mint green of swaying bamboo seas – one of the most important panda breeding areas – and deep canyons and valleys are filled with an ethereal mist. Over 4,000 different species share this verdant, virgin forest with the giant pandas. Endangered red pandas, golden monkeys, white-lipped deer and clouded leopard take refuge alongside rare Asian black bears, Asiatic golden cats and cinereous vultures. It is botanically one of the richest sites in the world outside of the tropical rainforests, where spring blossoms explode with colour, and precious ingredients for Chinese medicine are sourced.

Considered a national treasure in China the panda survives almost wholly on bamboo, needing to eat as much as 11 to 38kg (26 to 84lbs) of it every day (indeed, they eat for 12 hours out of every 24). In the cool, wet central mountains of Sichuan, great bamboo forests thrive in the humid conditions, their pale green leaves swaying gently.

GPS Tracking in Bamboo Seas

Despite their lack of camouflage, giant pandas are difficult to spot in the wild, their elusive and solitary lifestyles making sightings rare. Yet in spring, when the rolling hillsides are blanketed in blooms of rhododendrons, the males will emerge from their feeding places to seek out females who are fertile for a short couple of days. With the aid of guides and GPS trackers, you can set off on a panda tracking adventure to experience them in their truly natural environment.

While pandas are the main focus of this adventure, the primitive forests are bursting with flora and fauna. Flowing springs and cascading waterfalls pour through the humid region, and snow-covered mountains with their jagged glaciers loom in the distance. Indigenous villages are dotted throughout the mountains, home to Tibetan and Qiang ethnic minority groups and their traditional way of life. Visit their villages and experience an ancient culture and local food delicacies before continuing on the trail of the much-loved and elusive panda.

TAKE ME THERE

How to Visit: The nature reserve is accessible from Sichuan's capital of Chengdu by bus, and the small town of Wolong offers simple hotels and eateries. Tours offer trips to the region where GPS-toting guides are well-equipped at wildlife-spotting. The best time to visit is April during mating season.

Further Information: UNESCO (whc.unesco.org) offers extensive background information on the region and there are numerous Chengdu-based tour operators offering multi-day trips through the region.

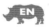

Did You Know? A new born panda is about the size of a stick of butter—about 1/900th the size of its mother.

Wildlife:
- Red panda
- Golden monkey
- White-lipped deer
- Clouded leopard
- Tibetan macaque
- Dhole
- Asian black bear
- Asiatic golden cat
- Sambar deer
- Cinereous vulture

SANDHILL CRANES AND SNOW GEESE IN BOSQUE DEL APACHE NATIONAL WILDLIFE REFUGE
USA

The wetlands and forests of New Mexico's Bosque del Apache National Wildlife Refuge form the grand stage for a beautiful avian ballet that unfolds every winter. Some 14,000 Sandhill cranes arrive from Western Canada, their grace and poise, long slender necks and intricately choreographed mating dances awarding them prima donna status in this kaleidoscope of birds. Like any good supporting cast, Snow and Ross's geese swoop in on cue, 20,000 arriving from an arduous migration from their nesting grounds in Canada's Northwest Territories more than 3,200 kilometres (2,000 miles) away.

On the northern edge of the Chihuahan Desert, the reserve sprawls for 232 square kilometres (90 miles²) along the Rio Grande. Native American Apaches once camped at this riverside forest, ringed by arid, multi-coloured mountains and flat mesas. Today, birds in their millions flock to the fertile marshes and farmlands of the river floodplain. Tens of thousands of ducks join the cranes and geese in their long flights south, the odd migratory bald eagle observes from the limbs of a dead tree, and wild turkeys, greater roadrunners and great blue herons number in the 300 species that frequent the region.

Mammals, fish, reptiles and amphibians play an important, albeit less conspicuous, role. Mule deer, coyotes, beavers, porcupines and raccoons are frequently sighted, and pronghorn sheep, black bears and pumas challenge with their elusiveness. Yet it's the birds that take centre stage here and, come late autumn when the colours are turning rustic and there is a chill in the air, they arrive like a great squawking snowstorm.

Photographing Nature's Dance

Sunrise and sunset in Bosque del Apache is a time of great activity. The land is bathed in pastel pinks and vibrant blues. The air is filled with the squawk and chatter of birds, which rises to an excitable crescendo as they take flight into the salmon-coloured sky in a great puff of white. Sandhill cranes wheel overhead, their 1.8 metre (6ft) wingspan guiding them on the autumn breeze to land daintily in the marshes and fields for the night. Snow geese join them, their unmistakable honks subsiding to a sociable din as they land and search for food amongst the grasses.

Bosque del Apache is a gentle and tranquil place, offering sweeping vistas and quiet marshes to explore. There are hiking trails and viewing platforms galore, boardwalks traverse the wetlands, and a 19 kilometres (12 miles)-long driving loop road offers excellent wildlife-watching.

In the chilly early mornings and late afternoons of autumn and winter, join photographers and enthusiasts as they wait in anticipation for the magical dance to begin. Or join a local photography course and discover how to capture one of planet Earth's most magnificent performances.

TAKE ME THERE

How to Visit: The nearby towns of Socorro and San Antonio offer a range of hotels, B&B's and RV parks, and Albuquerque has an international airport. The reserve is open year round, but the sandhill crane and snow goose season lasts from October to March, and peaks in December and January.

Further Information: The US Fish & Wildlife Service (www.fws.gov/refuge/bosque_del_apache) offers trip planning information and a weekly bird count, as does Friends of the Bosque (www.friendsofthebosque.org). Scenic Aperture (scenicaperture.com) holds 5-day photography workshops.

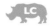

Did You Know? By 1916 snow geese had been hunted to dangerously low levels in eastern United States. Thanks to a hunting ban, the population has recovered by 300 per cent.

Wildlife:
- Great blue heron
- Bald eagle
- American white pelican
- Wild turkey
- Greater roadrunner
- Mule deer
- Coyote
- Beaver
- Black bear
- Mountain lion (puma)

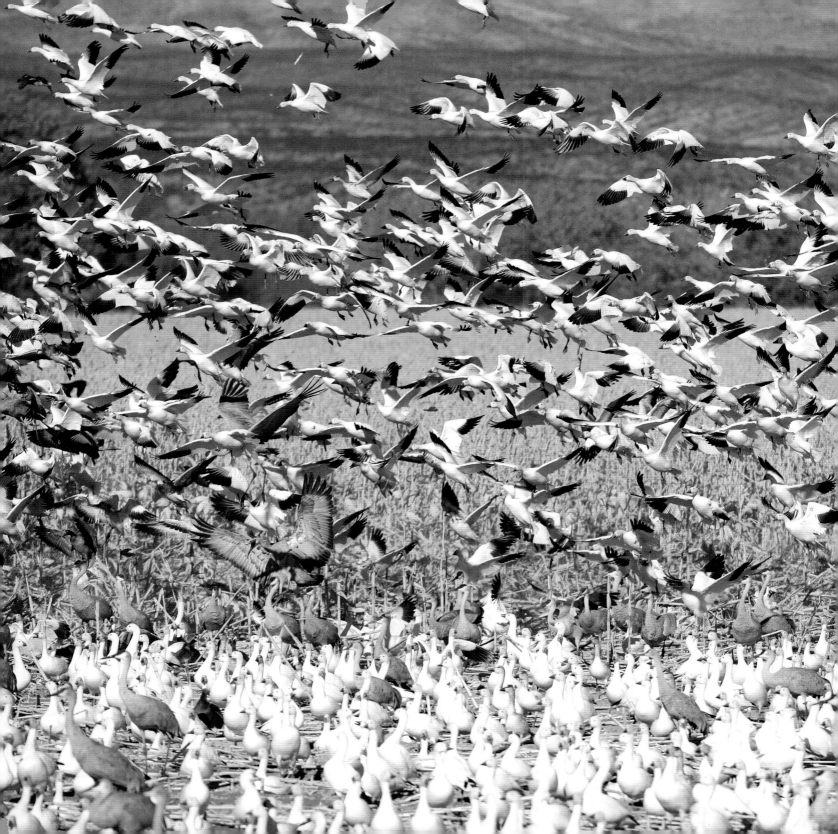

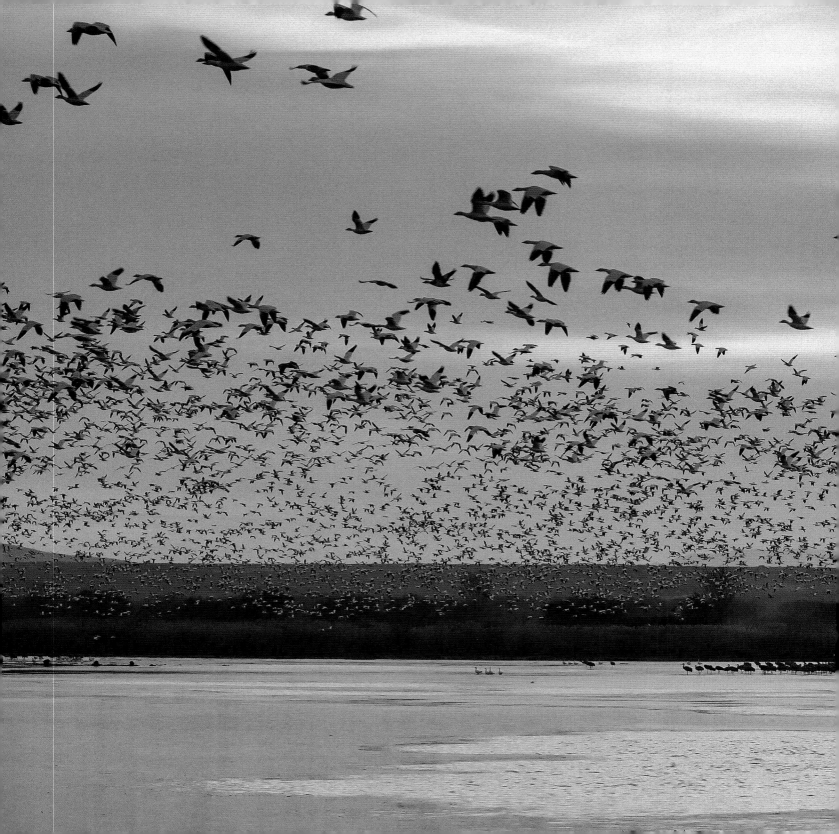

29 KANGAROOS ON KANGAROO ISLAND
AUSTRALIA

The kangaroo is the symbol of Australia, the hopping endemic marsupials numbering in the millions across the vast continent. From the two metre (6.5ft) tall, 90kg (14lb) red kangaroos – the largest marsupial on the planet – which bounce across the arid heart of the country, to the eastern and western grey kangaroos which feast on the fertile lands sometimes in numbers of 100 per square kilometre, they are a common and well-loved sight.

On Kangaroo Island however, a unique sub-species has evolved. Trapped when the island separated from the mainland just off the Adelaide coast some 9,500 years ago, western grey kangaroos have become the aptly named Kangaroo Island kangaroos. Small and sturdy, they have no natural predators on this wildlife haven 150 kilometres (93 miles) long and 90 kilometres (56 miles) wide, making them also the slowest of the kangaroos.

They live a charmed existence. More than two-thirds of the island (Australia's third largest) is made up of national parks and wildlife reserves, where native Australian wildlife thrives. The kangaroos, great colonies of sea lions and squawking clouds of shore birds inhabit the deserted white sand beaches of the rugged 540 kilometres (336 miles)-long coastline, and wallabies, echidnas and koalas can be spotted in the sprawling native bushland. Characterised by steep headlands and rolling farmland, great sand dunes and boutique wineries, it is an island at one with nature, where wildlife easily outnumbers the 4,500 inhabitants.

Ambling Through an Australia of Yesteryear

A slow, rural pace of life prevails on Kangaroo Island, famed as much for its wildlife as for its sumptuous local produce, where you can sample everything from organic lamb to pure Ligurian honey, the freshest of seafood (abalone, oysters and marron) and rich sheep cheese.

Setting off on a trip to Kangaroo Island is like a step back in time to an Australian landscape of yesteryear. Amidst the national parks and reserves, take your pick of romantic accommodation, whether it's a lighthouse keeper's cottage, a traditional homestead, an eco-friendly retreat or a luxury lodge, and spend your days exploring the kangaroo-laden lands.

Small, bespoke 4x4 tours offer wildlife experiences, where elegant barbecue lunches are taken on pristine beaches surrounded by croaking sea lions and hopping kangaroos. Swim with dolphins in the glittering blue sea, experience the annual migration of the southern right whale, listen for the call of the glossy black cockatoo or walk in the bush. Discover rugged rock formations, explore underground caves, swim in the tepid seas or meet the wildlife of the most famous of the national parks, Flinders Chase.

TAKE ME THERE

How to Visit: Ferries or flights leave from Adelaide. There is a wide range of accommodation options from guesthouses to luxury lodges and holiday cottages. A variety of small wildlife tours can easily be arranged. The island can be visited year round.

Further Information: The national (www.australia.com) and regional (www.southaustralia.com, www.tourkangarooisland.com.au) tourism websites are a good starting point for planning a trip. There are many tour outfits to choose from including Kangaroo Island Odysseys (www.kangarooislandodysseys.com.au) and Exceptional Kangaroo Island (www.exceptionalkangarooisland.com).

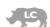

Did You Know? The kangaroo can leap up to 12 metres (39ft) in a single hop and reach speeds of 60 kilometres per hour (37mph).

Wildlife:

- Australian sea lion
- New Zealand fur seal
- Echidna
- Koala
- Tammar wallaby

- Platypus
- Glossy black-cockatoo
- Dolphin
- Southern right whale
- 267 species of bird

When scientists from Conservation International conducted the first ever survey of the coral reefs around Indonesia's Raja Ampat Islands in 2006, what they found threw the islands into the scientific limelight and called for an immediate need for their preservation. For below the gently shimmering crystal clear waters that swirl around the more than 1,500 islands, islets and cays was not just a rich marine environment, but the greatest coral reef diversity in the world. Over 1,400 species of fish, 700 molluscs and more than 550 types of coral – 75 per cent of all of those found in the world – thrive in the warm, unpolluted waters. Put into context, the whole of the Caribbean is home to just 70 species of coral.

The natural beauty of the archipelago, whose name means 'Four Kings', is undeniable. Sparsely populated, jungle-clad islands emerge from the clearest of turquoise waters where white sand beaches are tucked into sheltered coves and hidden lagoons await exploration. The richest coral reef ecosystem on the planet thrums just below the surface where the Indian and Pacific Oceans collide, where deep-sea currents funnel nutrients into the food chain to feed a spectacular diversity of marine life. Large groups of manta rays and white tip reef sharks soar through the blue water drop offs, and schooling jacks, barracudas, goatfish and angelfish combine to form a circus of colours. Pygmy seahorses, groupers and giant morays hide in the cracks and crevices and, come April to September,

leatherback turtles arrive from their migrations across the Pacific to nest on the West Papuan beaches, the largest site in the Pacific Ocean.

Diving in a Kaleidoscope of Colour

The only way to fully appreciate the abundance of marine life that thrives here is to get wet. While canoeing and kayaking, sailing and boating are on offer at the resorts and lodges that jut into the emerald waters from the mostly uninhabited islands, donning a set of scuba gear or a snorkel and mask and delving beneath the waves is to truly be at one with a different world.

The coral reefs of Raja Ampat are ablaze with colour and life, and simply beg to be explored. Set off from the town of Sorong on a week-long liveaboard boat and venture to the remotest of dive sites, or settle yourself into a luxury resort cabin from where you can spot dolphins and sharks without even dipping your toe in.

Swim past hard and soft corals in shades of pink and lilac, fiery orange and deep green which sway like giant fans in the currents or grow razor-sharp in jagged rock-hard formation like great elk horns. Amidst the blue tube sponges, red sea whips and purple sea squirts, the bizarre-looking Wobbegong shark can be spied in masterful camouflage and titan triggerfish chomp on the hard corals.

TAKE ME THERE

How to Visit: Resorts dot the islands, all of which offer diving and snorkelling opportunities. There are several dive liveaboard boats which depart from the main hub of Sorong. Flights to Sorong depart from Jakarta, Bali or Singapore.

Further Information: A good resource for trip-planning is **www.stayrajaampat.com** and the tourism website (**indonesia.travel**). Resorts and liveaboards include The Aggressor Fleet (**www.aggressor.com**), the Raja Ampat Dive Lodge (**rajaampat-divelodge.com**) and the Misool Eco Resort (**www.misoolecoresort.com**).

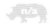

Did You Know? Despite the high surface sea temperatures, Raja Ampat's reefs seem to be resistant to the coral bleaching and coral disease destroying other reefs around the world.

Wildlife:
- Wobbegong
- Manta ray
- Black manta
- Leatherback turtle
- 700 species of mollusc
- 1,427 species of fish
- Titan triggerfish
- Whitetip reef shark
- Dolphin
- Bumphead parrotfish

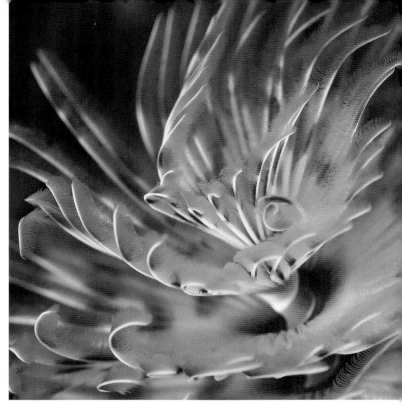
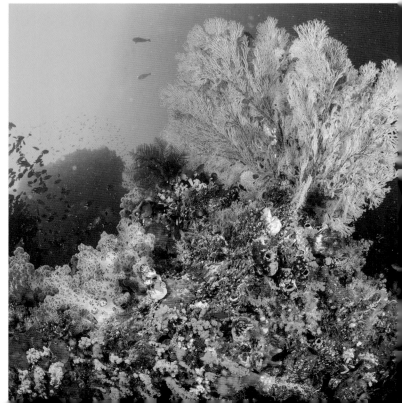

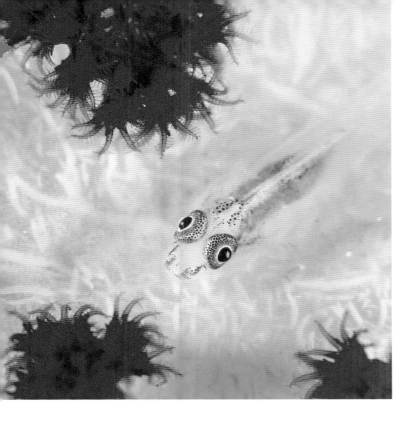

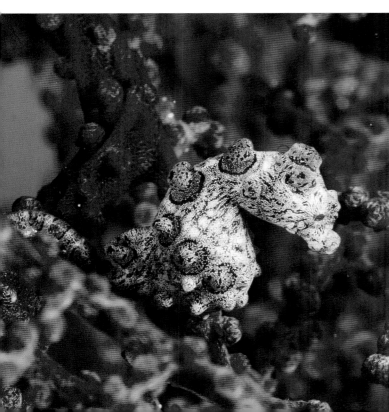

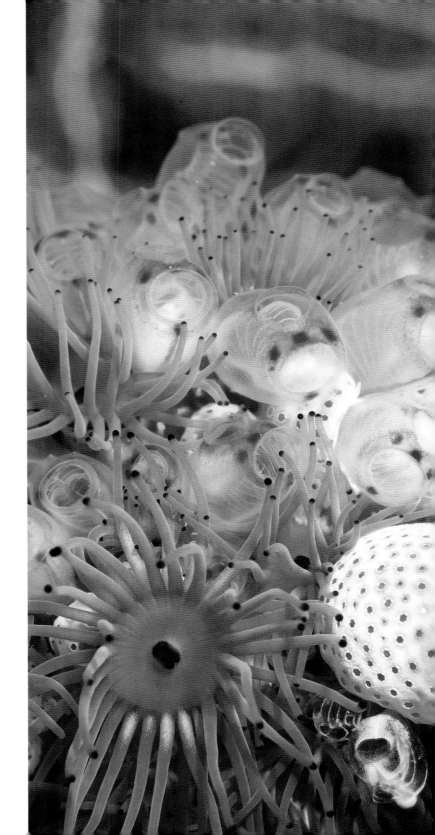

31 EUROPEAN BISON IN BIAŁOWIEŻA FOREST
POLAND

The central expanses of Europe were once swathed in dense forests roamed by bears, wolves, elk and lumbering great bison. Today that ancient forest has long disappeared, all except for a patch of untouched, primeval woodland in the heart of Poland's Białowieża National Park. Here, in the midst of a huge forest which stretches across the Belarus border, Poland's oldest national park envelopes a hauntingly beautiful woodland virtually untouched by man for 800 years. Oak, spruce, lime and alder trees tower above the forest floor where vivid green moss and lichens cling to fallen trees.

It was here, in the Białowieża Forest, that the very last bison was shot and killed in 1912. World War I saw the bison population decimated after centuries of protection from Polish kings and Russian tsars who used the forest as royal hunting grounds. It is however, a unique story of success. In 1921 four bison were reintroduced to the park and by 1939 the herd had expanded to 16. Today, 900 individuals live in the Bialowieża Forest – almost 25 per cent of the world's total population. In Poland's national park, 470 of these make up the largest free-living herd in the world.

While the bison might be the king of the forest – weighing up to 800kg (1,760lbs) they are Europe's largest land mammal – it is by no means alone. Taking shelter in the undergrowth are grey wolves and lynx, Eurasian elk and wild boar. Over 250 species of bird create a cacophony of calls throughout the canopy. Some 12,000 invertebrates thrive in the damp conditions, half of which live off the dead wood of fallen trees.

Cycling Through Primeval Forests

There is something timeless about Białowieża, where the pace of the rest of the world is seemingly meaningless. Seasons come and go, decades and centuries pass by, and little has changed inside the ancient forest. To fully appreciate the region, go back to basics and spend time slowly cycling or hiking the numerous trails in search of the surprisingly shy bison.

To visit the oldest and most untouched part of the forest, known as the 'Strictly Protected Area', you must be led by a local guide. From the quaint village of Białowieża in the midst of the national park, tours set out in search of wildlife that hide among oak trees 34 metres (111ft) in height and 7 metres (23ft) in circumference.

If you don't spot one of the naturally timid bison while cycling in the park, pay a visit to the European Bison Show Reserve where you can also encounter elk, wild boar, wolves, roe deer and żubroń, a cross between a bison and cow.

TAKE ME THERE

How to Visit: The starting point for excursions into the national park is the village of Białowieża, 85 kilometres (52 miles) southeast of Białystok, where there are several accommodation options and bicycle rental shops. It is possible to visit the reserve year round however it can get swampy March to April.

Further Information: The national park website (**www. bpn.com.pl**) offers a wealth of trip planning information, and the Polish Tourist Country-Lovers' Society (**pttk.bialowieza.pl**) provides experienced guides from their offices in Bialowieza. For more information on the wildlife of the region visit the Mammal Research Institute in Bialowieza (**www.zbs.bialowieza.pl**).

Did You Know? European bison are slightly smaller, have shorter hair and are less easily domesticated then their more famous American cousins.

Wildlife:
- Grey wolf
- Lynx
- Eurasian beaver
- Eurasian elk
- Wild boar
- Peregrine falcon
- Golden eagle
- Nine species of woodpecker
- Red and Roe deer
- Pygmy owl

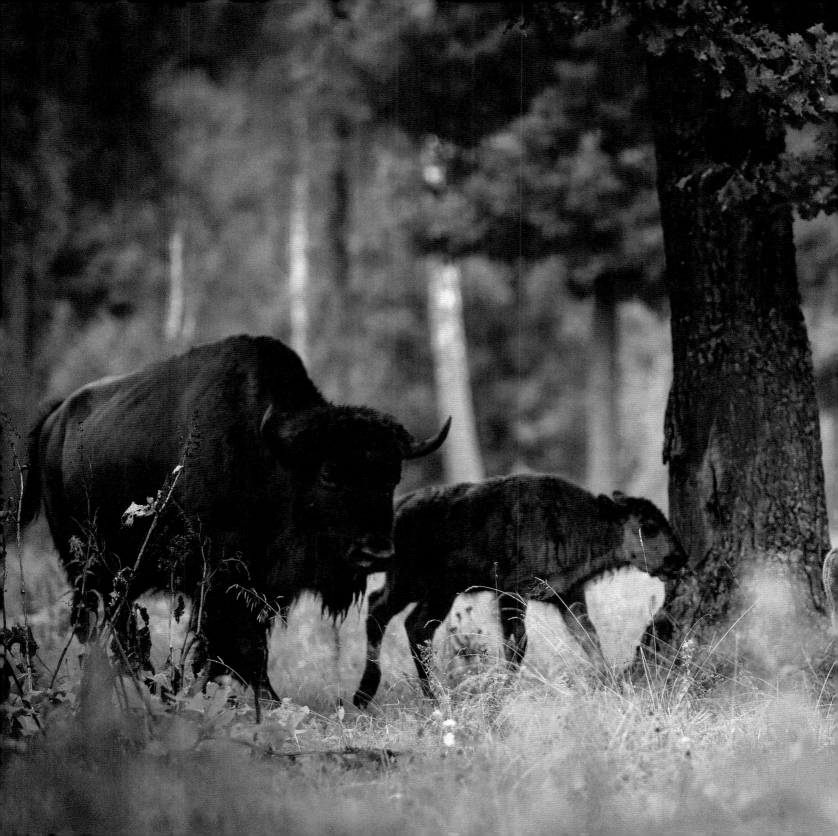

GREY WHALES IN SAN IGNACIO LAGOON
MEXICO

It is one of the longest migrations in the world when eastern Pacific grey whales leave their summer feeding grounds in Alaska's Bering and Beaufort seas and travel 20,000 kilometres (12,000 miles) to the coastal lagoons of Mexico. San Ignacio Lagoon is one of three protected, shallow bays on Baja California's long coast where the whales come to give birth to their young, nurse and interact in huge numbers. It is a spectacular sight to behold, especially because of the apparent friendliness of the whales to their human spectators.

The lagoon is part of the El Vizcaino Biosphere Reserve, an undeveloped and pristine bay circled by the stark beauty of the desert. Hardy desert fauna exist here including the near extinct prong-horned antelope, big horn sheep, mule deer and coyotes. Yet it's the ocean sanctuary where life truly thrives, and endangered leatherback, hawksbill, green and Olive Ridley turtles live alongside northern elephant seals, California sea lions and, come December to April, the mass arrival of the grey whales.

Once almost hunted to extinction (indeed estimates are that there were but a few thousand whales left in the world), the grey whale has made a dramatic comeback since the 20th century and today it numbers an estimated 25,000 worldwide. And it is here, in this undeveloped nursery that the future of their survival unfolds each year as mothers give birth to their calves, proudly showing them off to inquisitive visitors.

Close Encounters with Friendly Behemoths

It is a whale-watching experience like no other. A relationship between man and leviathan that cannot be explained by science. For all the rules (keeping a good distance from wildlife and not touching them) are flouted, and all by the instigation of the whales who come within arm's reach of the small boats that buzz around them and demand to be touched. Lifting their barnacle-encrusted heads from the surface they nudge the boats, receiving pats and strokes with an apparent enjoyment.

Tourism here is undeveloped and raw, and there are no large scale hotels lining the pristine shores of the bay – indeed, the local community numbers just 100 people. A handful of cabañas and camps offer whale-watching from the door of your tent, and it is a truly magical experience to watch mothers and babies surface against the setting sun. Small boats head into the bay by day to be greeted in excitement by grey whales who have not fear or trepidation but a seemingly genuine curiosity for those that have travelled to this remote place to experience one of the world's greatest migrations.

TAKE ME THERE

How to Visit: Located in Baja California, San Ignacio Lagoon is accessed by plane and car. Loreto is the closest international airport. The town of San Ignacio is 53 kilometres (33 miles) from the lagoon, where back-to-nature camps and cabañas are located on the beach. The migration occurs in spring (December to April).

Further Information: There are dozens of outfits offering boat tours to see the whales and all-inclusive accommodation packages including Pachicos Eco Tours (**www.pachicosecotours. com**), Baja Discovery (**www.bajadiscovery.com**) and Natural Habitat Adventures (**www.nathab.com**).

Did You Know? Unlike its eastern cousin, the western Pacific grey whale is critically endangered. It is estimated there are only 100 left in the wild.

Wildlife:
- Prong-horned antelope
- Turtles (Leatherback, hawksbill, green and Olive Ridley)
- California sea lions
- Dolphins
- Northern elephant seals
- Desert bighorn sheep
- Mule deer
- Ospreys
- Coyotes
- Cormorants

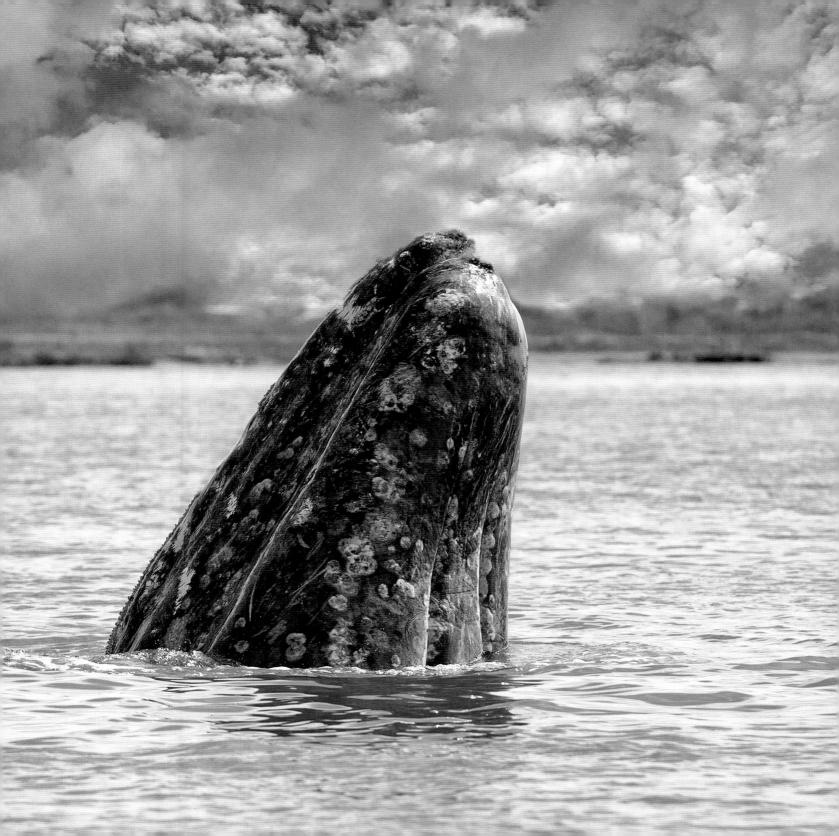

The term 'the Big 5' came from macabre origins, when 20th century hunters classifying elephants, lions, buffalo, leopard and rhino as the most dangerous of Africa's big game to track and kill. Thankfully today this is no longer the case, and the Big 5 have become the ultimate safari bucket list representing some of the most impressive or most elusive wildlife on the continent.

While there is so much more to Kruger National Park than just five species, it has become famed as the best place in the world for spotting great numbers of the Big 5. It is South Africa's flagship park, sprawling for almost 20,000 square kilometres (7,70 miles²) and stretching 414 kilometres (257 miles) from Pafuri Gate in the north to Malelane Gate in the south – all along paved roads. Some 1,500 lion, 12,000 elephant, 2,500 buffalo, 1,000 leopards and 5,000 rhino

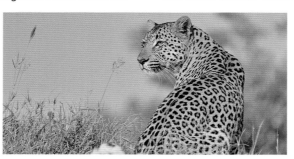

(black and white) share the great savannahs, mountains and tropical forests with a staggering density of wildlife. Sixteen eco-zones – each with their own geology, rainfall, altitude and landscape – support over 500 species of birds and 147 mammal species. Spotted hyenas and endangered African wild dogs roam the great plains alongside zebra, giraffe, cheetah and 21 species of antelope.

Stout baobabs are an iconic sight on the heat-hazed horizon, and thorn, fig, jackalberry and mopane trees number amongst 2,000 plant species which together create the beautiful patchwork of Kruger's landscapes. And it is amongst this varied and flourishing ecosystem that some of Africa's best-loved safari giants can be spotted.

Self-drive Safari

One of the best things about Kruger – apart from its sheer abundance of wildlife – is the opportunity to embark on self-drive safaris. While guided jeep trips might offer the chance to take advantage of the keen eyes of a local guide (and spotting the most elusive of the Big 5, the leopard), heading into the wilderness under your own steam is an invigorating adventure.

Whether you're searching for safari chic luxury lodges or a back-to-basics campsite in the midst of the bush, Kruger happily obliges on all fronts. Well-paved roads weave through the park offering endless opportunities to seek out the Big 5 which in the dry winter months can often be found not far from the critical watering holes. Huge lumbering herds of elephants are never far from water, and are able to drink 180 and 400 litres per visit. Buffalo graze on the open savannas of the Central Region, their bulky frames comprising a quarter of Kruger's total biomass. The world's largest population of white rhinos occurs in the southern portion of the park where water is in more abundance, while the predators, the prides of lions and elusive leopards follow the herds of impalas and antelope.

TAKE ME THERE

How to Visit: Kruger National Park is well geared towards visitors with a wide range of accommodation options and guided or self-drive safaris. There are daily flights from Johannesburg and Cape Town to nearby regional airports. The dry winter season is the best time to visit when wildlife congregates around watering holes and the heat is not as intense as summer months.

Further Information: The South African National Parks website (**www.sanparks.org**) provides comprehensive travel planning information including details of the dozens of campsites and luxury lodges in the park, most of which offer guided safaris.

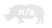

Did You Know? By 1896 white rhino were extinct in the Lowveld (later to become Kruger National Park). Successful conservation re-introduced 337 rhino from 1961, and the park now safeguards the world's largest population.

Wildlife:
- Giraffe
- Zebra
- Hippopotamus
- Warthog
- African wild dog
- Hyenas (spotted and brown)
- Cheetah
- 22 species of antelope
- Crocodile
- 517 species of bird

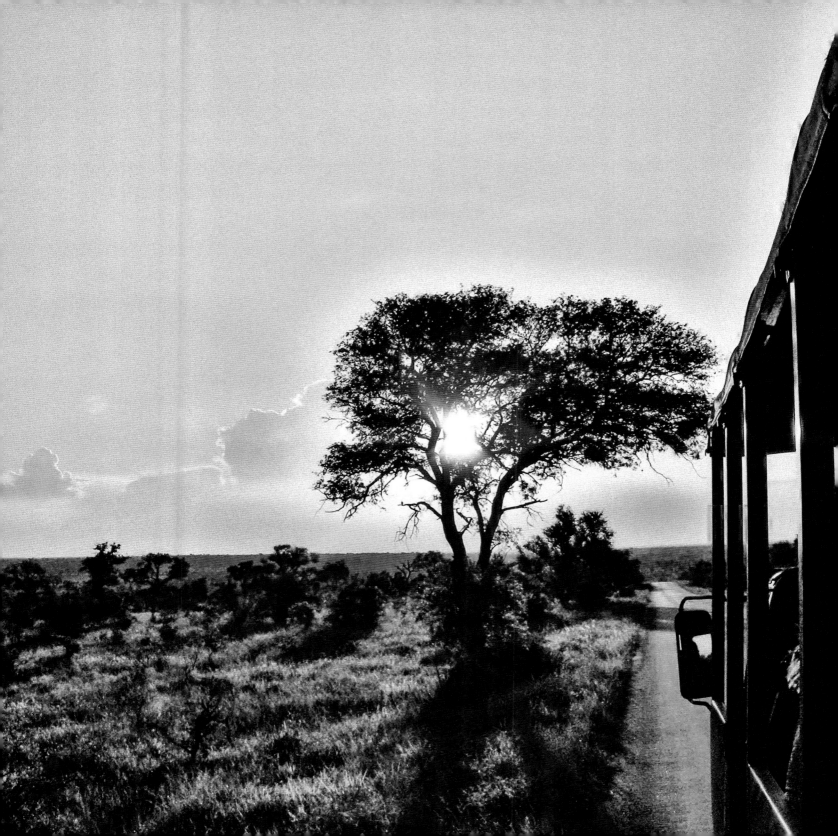

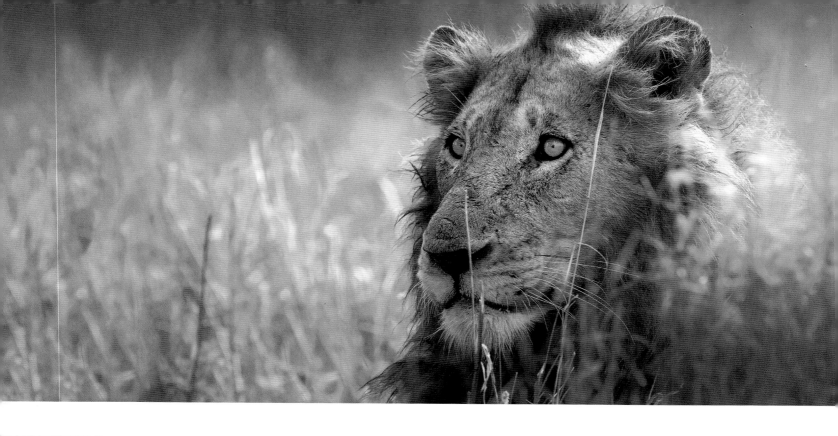
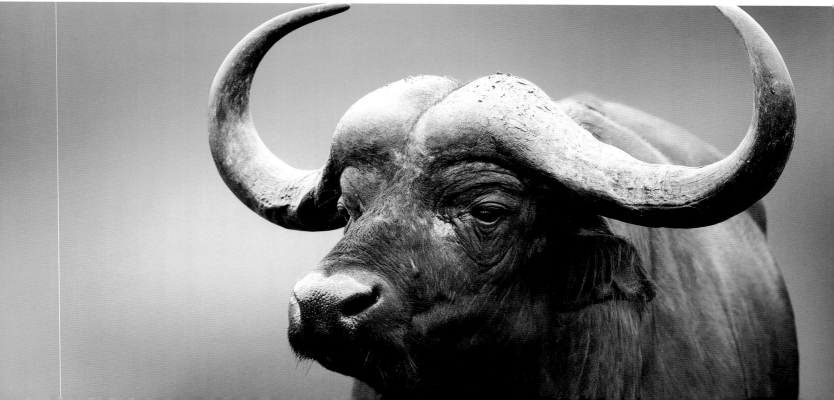

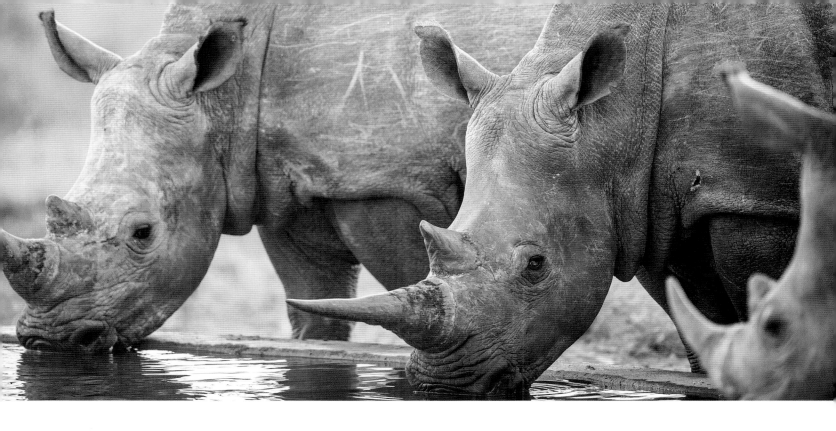

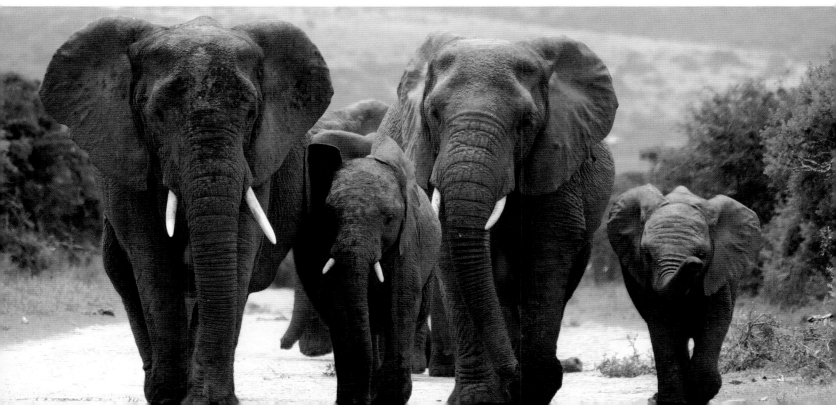

THE OTHER BIG 5 IN DENALI NATIONAL PARK
USA

On the opposite side of the planet from southern Africa's Big Five safaris, a very different type of Big Five wildlife list awaits. Across Alaska's vast rugged interior, brown bears, wolves, caribou, moose and Dall sheep roam in bountiful numbers in a wild and untouched place. That place is Denali National Park, a vast expanse of wilderness left to the hand of nature, the fierce elements and the animals that call it home.

Inside the formidable park there are no politely signposted hiking trails and gift shops. There is however, 24,500 square kilometres (9,500 miles²) of untamed wilderness, where back country hiking is undertaken at your own risk and Yogi Bear really is the ranger. All-American buses shuttle visitors along the park's single, hair-raising road, a ribbon of tarmac in an otherwise expanse of wide green valleys threaded by glinting streams. Towering over the park, its sharp and angular peak often shrouded behind a curtain of cloud, is Mount McKinley, the United State's highest mountain at 6,194 metres (20,320ft).

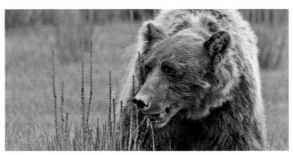

Taiga forests give way to high alpine tundra and the snow-dusted Alaska Mountain range looms ever-present. In this wild and tranquil environment bears and their cubs make appearances, moose laze in the long grasses and pine forests, and caribou tiptoe across frozen ponds. Like white specks on the craggy summits, timid Dall sheep withstand the harsh weather, and wolves challenge visitors with their elusiveness. In addition to the coveted Big Five, the park teems with wildlife big and small. Comically cute arctic ground squirrels watch visitors inquisitively, golden eagles soar through the mountain peaks and martens, lynx and wolverine make rare guest appearances.

Wild Camping and Back County Hiking

Denali's buses trundle out of the main visitor centre and traverse the 146 kilometres (91 miles)-long unpaved road, stopping at three far-flung spots and providing some of Alaska's easiest and most comfortable Big Five spotting (although the wolves often remain incognito). Mountain hiking, guided hikes, flight-seeing and, come winter when the land is blanketed in deep snow, husky-sledding and snow-shoeing will get you off the road and deep into the park.

For a true back-to-nature experience, spend a few days camping in one of Denali's four wild campsites and hiking through the back country. At Teklankika, Sanctuary and Igloo campsites, red squirrels and snowshoe hares are regular visitors and bears, moose and caribou wander by unperturbed by their human neighbours. Deep within the sprawling, unfenced lands – and 11 hours by bus – Wonder Lake campsite is buried in the solitude of Denali. As the sun rises in the early morning, and you step outside of your tent, gaze towards Mount McKinley – if you're lucky she may make a dramatic appearance, peeping out from the clouds, golden in the morning sun.

TAKE ME THERE

How to Visit: The best time for camping and hiking is between June and September. Day or multi-day bus passes provide a hop-on/hop-off service. There is a wealth of accommodation options around the park. Sanctuary River site is by walk-in only and cannot be pre-booked.

Further Information: To plan a visit to Denali, the National Park Association website (**www.nps.gov/dena**) should be the first stop. Bus passes can be booked at **www.reservedenali.com**. The official Alaska Tourism website (**www.travelalaska.com**) provides lists of adventure tour operators and accommodation in the area.

Did You Know? There are 169 different bird species, 39 mammal species, 14 fish species, and one species of amphibian known in Denali.

Other Wildlife:

- Brown bear
- Dall sheep
- Wolf
- Moose
- Caribou
- Golden eagle
- Arctic ground squirrel
- Wolverine
- Lynx
- Snow-shoe hare

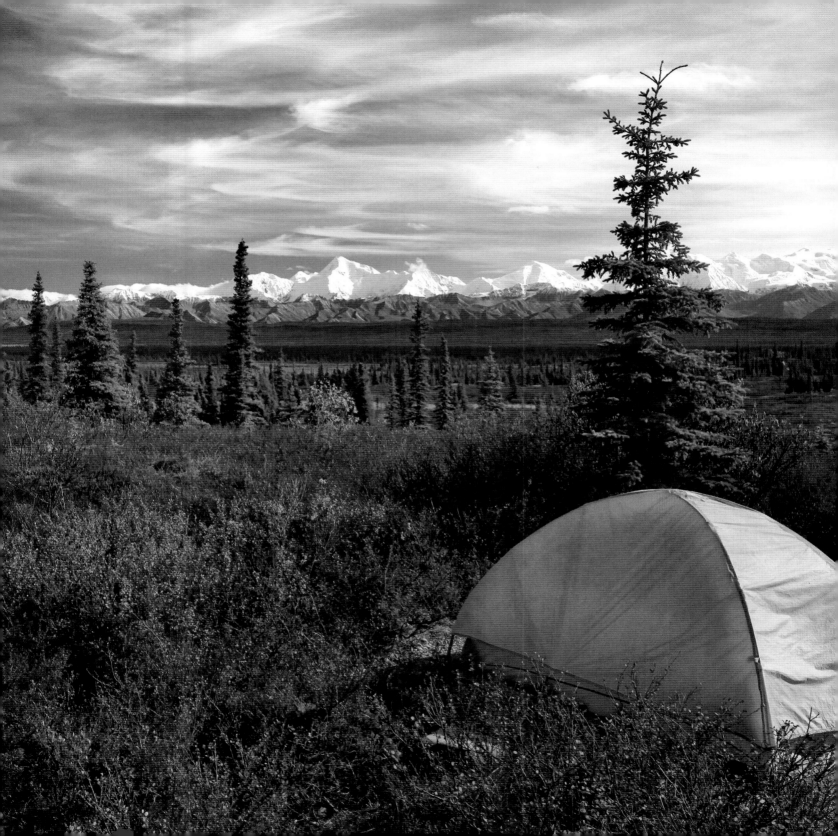

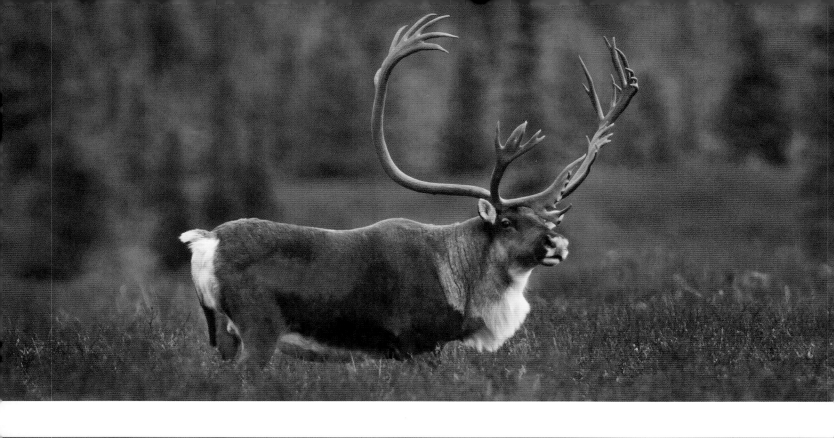
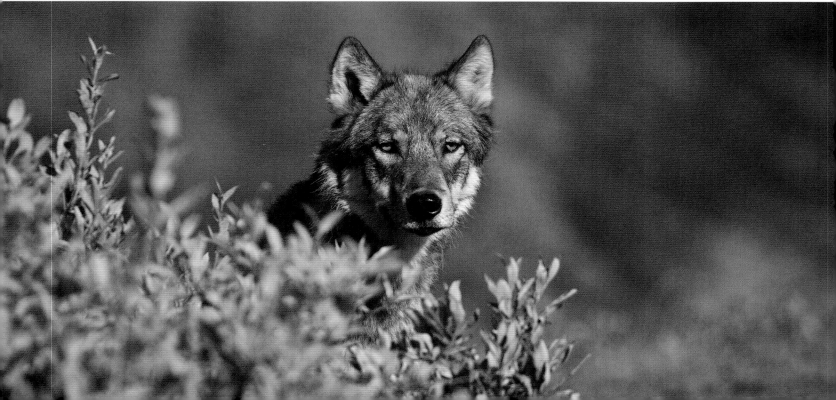

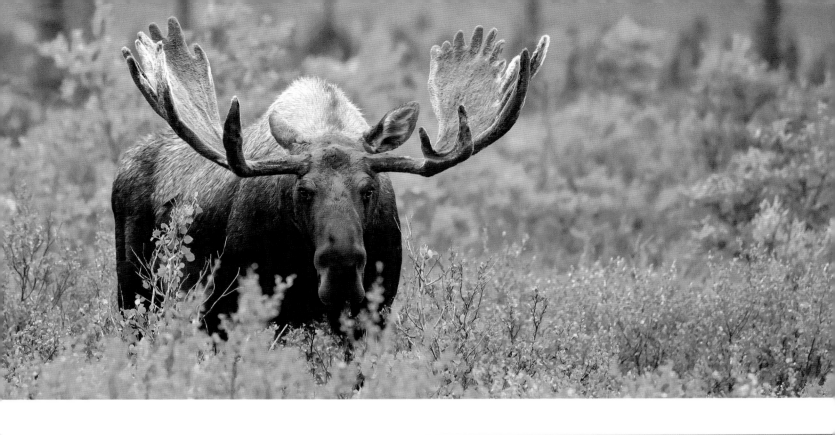
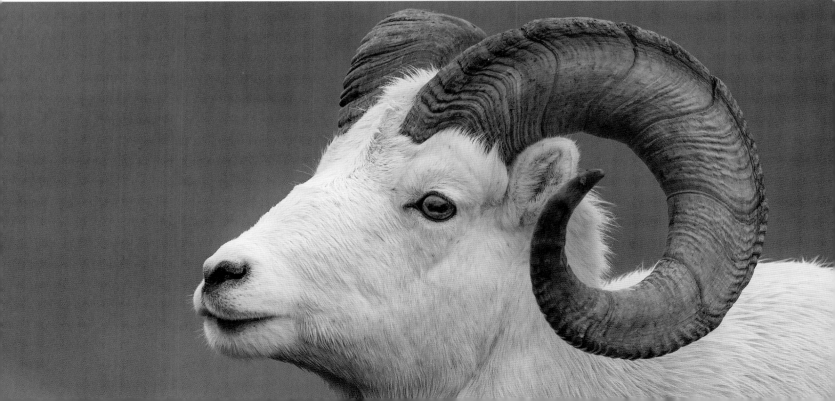

There is little question that the capybara is a strange yet endearing-looking creature. Like a large dog-sized hamster with the body of a shaggy-haired pig and the face of a beaver, they can both bark and purr. They are in fact the largest rodent on the planet, standing over half a metre (2ft) tall and directly related to guinea pigs. Yet differently to their smaller cousins, capybara spend the majority of their lives in water, wallowing in shallow mud pools to keep cool in the hot South American sun and hiding from predators beneath the protective surface – they can stay submerged hippo-style for up to five minutes.

They inhabit riversides and marshes, ponds and pools east of the Andes, their diet of short grasses satiated in the lush watery regions. Fulfilling all of the capybara's real estate requirements is the little visited Esteros del Iberá wetlands in Argentina's northern Corrientes province. It is the second largest wetland in the world after Brazil's Pantanal, where a decoupage of swamps, bogs, rivers, stagnant lakes and lagoons covers an area the size of Belgium. Great floating hyacinth beds create an illusion of land, the islands drifting across the shallow lakes and providing homes to a rich and diverse wildlife.

Lazy, leathery caimans lounge on the banks in their hundreds, and the flighty marsh deer wades through the swamp with its web-like hooves. Birds of every feather flock to this watery haven, herons and eagles, woodpeckers and kingfishers, hummingbirds and the 1.4metre (4.5ft)-tall jabiru stork. Rheas, South America's answer to the ostrich, race across the dry plains and maned wolves and wildcats emerge under a cloak of darkness.

Boating Through Reed-Laden Wetlands

Venture into the heart of the reserve through the dusty, charming little village of Colonia Carlos Pelligrini. Colonial-style *posadas* (ranches) line the unpaved roads, laid out in a cross-hatch pattern in surprising uniformity amongst the untamed wilderness that surrounds it. Horse-riding trips wade through the shallow pools, and short walking trails navigate the few dry areas from where you are watched closely by inquisitive and noisy howler monkeys. Yet in this watery land there is no better way to get within arm's reach of a caiman alligator or hear the indignant grunt of a capybara as it scampers into the tortora reeds than by boat.

Drifting between the water lillies and reeds, as ominous bubbles erupt from the dark water beneath, it is hard to imagine this bustling wildlife metropolis stretches for 250 kilometers (155mi) almost to the Paraguay border. It is untamed and raw, unspoilt and undomesticated – a place of 10 metre- (32ft) long anacondas, piranha-laden waters and over-sized rodents.

TAKE ME THERE

How to Visit: Small planes connect Colonia Carlos Pellegrini with Posadas, and private 4x4's or public buses link Posadas and Mercedes, which in turn connect to Buenos Aires. There is a range of accommodation including luxury posadas and rustic dormitories. The best time to visit is October and November or March and April.

Further Information: The Argentinian tourism website (www.welcomeargentina.com) offers plenty of trip-planning information. Ranches such as Posada Tupasy (**www.posadatupasy. com.ar**), Agape Lodge (**www.iberaesteros.com.ar**), Rancho de los Esteros (**www.ranchodelosesteros.com.ar**) and Ñandé Retá (**www.nandereta.com**) can also arrange tours.

Did You Know? Capybara live in groups of up to 20. They are very social and vocal animals and use a variety of grunts, barks and whistles to communicate.

Wildlife:

- Caiman alligator
- Marsh deer
- Anaconda
- Maned wolf
- Black howler monkey
- Greater rhea
- Jabiru stork
- Piranha
- Giant anteater
- Jaguar

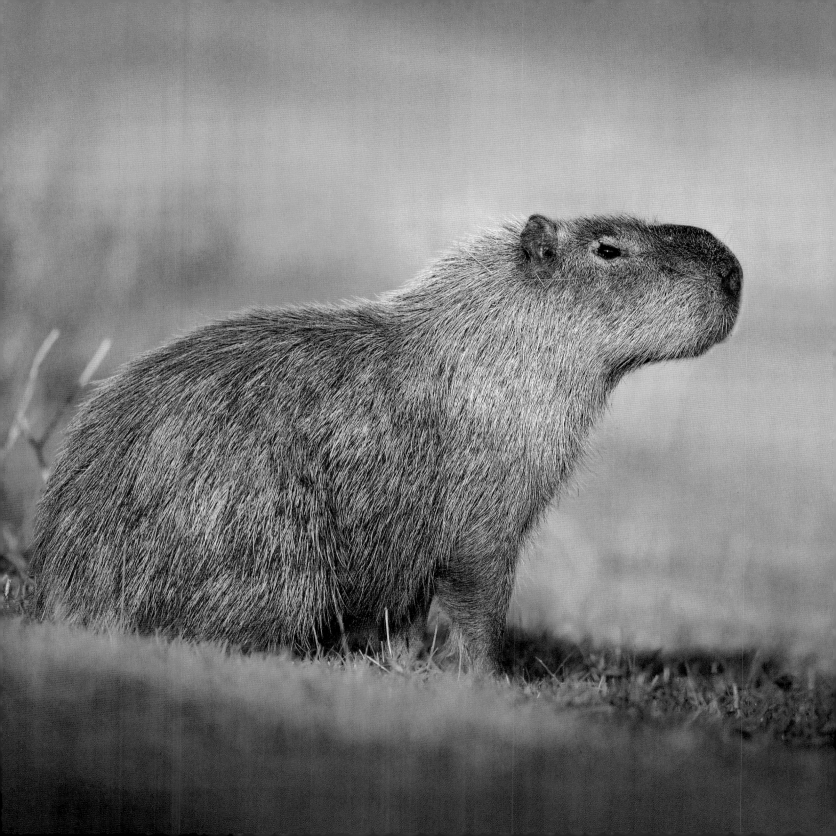

CHIMPANZEES IN GOMBE STREAM NATIONAL PARK
TANZANIA

On the sandy northern shore of Lake Tanganyika a thin strip of land straddles the steep slopes and river valleys of Tanzania's smallest national park. In Gombe Stream the forest vegetation ranges from sprawling grasslands to alpine bamboo to tropical rainforest, the perfect habitat for chimpanzees whose cacophony of pants, hoots and screams echoes through the canopy.

When British researcher Jane Goodall first travelled to Gombe Stream in 1960 it was a little-known game reserve, lost amongst Tanzania's glittering safari parks. There she spent years tracking and observing the elusive chimpanzee troops whom she affectionately named and was ultimately accepted as one of the group. Today, thanks to her pioneering and on-going studies Gombe Stream is not only a national park but the best place in the world to witness the complex social interactions of chimpanzees in their natural habitats. Over the 15 years Jane spent living with the chimpanzees she proved the intellect and sophistication of animals – chimpanzees in particular – and her ground-breaking studies saw the foundation of the Gombe Stream Research Centre (GSRC) in 1967 (the longest running animal research programme) and the Jane Goodall Institute in 1977.

When the legendary explorer Sir Henry Morton Stanley uttered his famous phrase 'Dr Livingstone, I presume' it was on the northern shores of Lake Tanganyika, the world's second largest and deepest lake. Well-studied and habituated olive baboons comb the beaches, dhow boats fish for the myriad of colourful cyclid fish and red-tailed and red colobus monkeys – regularly hunted by chimpanzees – stick to the forest canopy.

Tracking Jane Goodall's Chimps
The relatively few visitors that venture to this undeveloped, pristine mini park can walk in Jane Goodall's footsteps and track the 150 chimpanzees that live their complex lives in the forests that fringe the great lake. And having been habituated to humans, sightings are almost guaranteed. During the rainy season (February to June and November to mid-December), the chimps don't roam far and can be easier to find, sometimes venturing down to the sandy shores. Yet better travel opportunities arise during the dry season July to October and late December.

Stay in one of the lakeside campsites or single luxury tented camp and trek into the road-less park beneath the dense canopy. The deafening chatter of families of chimps fills the air, interspersed by squawks from the more than 200 species of birds. Swim or snorkel in the clear, fish-laden, crocodile-free waters of the lake, hike to the top of Kakombe Waterfall or visit Jane's old chimp-feeding station.

TAKE ME THERE

How to Visit: Kigoma is the closest town and is connected to Dar es Salaam and other Tanzanian cities by air, rail and road. It's possible to visit the park independently or as part of a Tanzania tour package. Accommodation includes a luxury lodge, hostel and campsites. The best time to see the chimps is September to October.

Further Information: Visitor information can be found on the national parks website (**www.tanzaniaparks.com**) and luxury lodges such as Gombe Forest Lodge (**www.mbalimbali.com**). For more information on the research and conservation of Jane Goodall visit **www.janegoodall.org** or The Jane Goodall Institute Research Centre (**gombechimpanzees.org**).

Did You Know? Chimpanzees share 98 per cent of their DNA with humans.

Wildlife:
- Olive baboons
- Red-tailed monkeys
- Red colobus monkeys
- Fish eagle
- Bushpigs
- Vervet monkeys
- Leopards
- Buffalo
- Hippopotamus
- Over 200 bird species

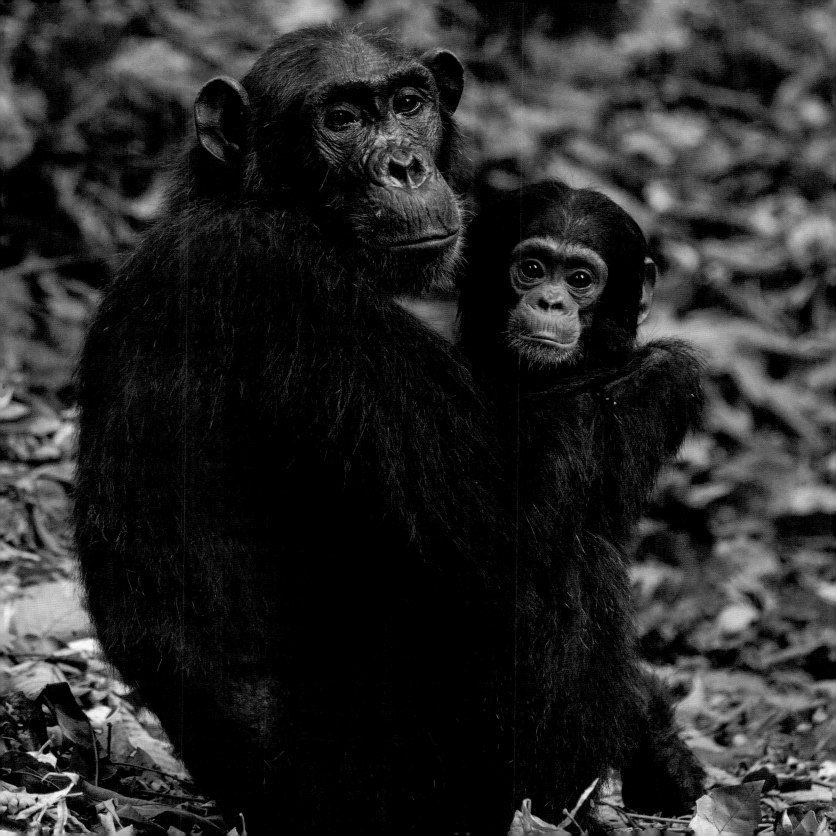

Palau is a tiny island nation buried in the heart of the Pacific Ocean. Hundreds of forested green rock islands erupt like mushrooms from the crystalline waters stretching away from the main island of Koror, a place where left-hand drive cars tootle down right-hand drive roads, where Japanese-influenced restaurants serve food in American-sized portions and where large, friendly locals delight in getting tourists to sample the local delicacy of whole fruit bat soup.

Located in the heart of the Asia Pacific region, hundreds of miles from the nearest land, the tiny island country provides the perfect conditions for one of the world's healthiest reefs. Thriving, colourful corals swirl around the shores of the rock islands, their marine populations teeming with bounty just begging to be snorkelled, kayaked or scuba dived. Indeed, not a dive site list exists that doesn't rank Palau's Blue Corner amongst the top three sites on the planet. Manta rays, turtles and sharks thrive in the world's first shark sanctuary and in the deep lagoons the scars of the ferocious World War II battles that took place on these shores lay as rusting wrecks.

While the allure of the rock islands and its bountiful waters are undeniable, a trip to Palau would be incomplete without clambering through an innocuous-looking island to swim amongst thousands of stingless jellyfish. Predator-less and cut-off from the sea 12,000 years ago, thousands of golden and moon jellyfish have long forgotten their stings, surviving on algae in a forest-ringed lake.

Snorkelling Through an Alien World

There are over 70 saltwater lakes hiding amidst the dense forests of the rock islands, yet just one holds a secret. Arriving by fast launch from the main island of Koror you scramble ashore Eil Malk Island and, with mask and fins tucked under your arm, start the climb over the lip of the hill. From the summit the small, dark, eerie lake sits like a glimmering onyx below, and a sense of excited foreboding descends over you. Slipping into the water is like entering an alien world. Gentle and soft, the jellyfish drift past you caressing your arms and legs as they cluster in the sunniest corners of the lake where the algae concentrates. Using a type of jet propulsion, the teacup-sized jellyfish follow the early dawn sunlight, migrating around the lake throughout the day.

A trip to Palau is one of watery explorations. Swim through wrecks of war ships and planes, enter caves inhabited by circling reef sharks or dive the vibrant coral reefs where manta rays soar. Kayaking, snorkelling and diving opportunities abound on the rock islands whose tropical paradise beauty is steeped in Pacific culture and tales of great battles.

TAKE ME THERE

How to Visit: Palau's Airai International Airport hosts flights from the United States via Guam, and from Asia and Europe via Manila, Seoul or Tokyo. The handful of dive operators offer snorkelling trips to Jellyfish Lake as part of dive trip packages or independently.

Further Information: The Palau Tourism Authority website (www.visit-palau.com) has a wealth of travel information, while local dive centres can help you plan your activities. There are several dive operators including Fish n Fins (www.fishnfins.com) and Sam's Tours Dive Centre (www.samstours.com).

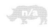

Did You Know? The president of Palau has announced plans to make the entire territorial waters of Palau – an area the size of France – a 100 per cent marine sanctuary.

Wildlife:
- Grey reef shark
- Mariana fruit bat
- Manta ray
- Giant clam
- Bull shark
- Leopard shark
- Whitetip reef shark
- 1,400 species of reef fish
- Green and hawksbill turtles
- Giant grouper

When Willem de Vlamingh, an early Dutch visitor, arrived on the small Indian Ocean island just off Australia's western coast in 1696 he was confronted with a miniature army of marsupials. Mistaking them for rats he named the island Rattenest (Rat's Nest), which was later adapted to Rottnest. What he had actually encountered was quokkas, and to this day the island is the main stronghold for a species under threat on the mainland from introduced species such as foxes, dogs and cats.

The quokkas of Rottnest number between 8,000 and 12,000, their cartoon-cute faces, small black noses and rounded ears delighting the visitors who arrive to revel in the A-class nature reserve – the highest designation in Australia. For Rottnest is a model for environmental conservation. Marine sanctuaries ring the 19 square kilometre (7 mile2) island, the limestone coral reefs teeming with bountiful fish stocks, bottlenose dolphins, humpback whales, New Zealand fur seals and Australian sea lions. Wind turbines generate electric power to the 100 permanent residents and more than half a million visitors who come to explore by foot or bicycle the pristine white sand beaches, salt lakes, brackish swamps, woodlands and heaths.

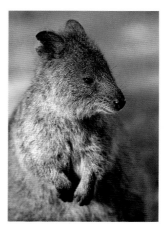

Rottnest has had a long and colourful life which began long before it separated from the mainland some 7,000 years ago. Aboriginal people once inhabited this strip of the mainland and, long after the sea levels rose and turned it into an island, it has acted as an Aboriginal prison, a boy's reformatory, a prisoner of war camp and strategic military base during the World Wars. Today however, the quokkas are the most famous residents and roam the sun-dappled island in their thousands.

Exploring by Pedal Power

There are no cars allowed on Rottnest, and a tranquillity and peacefulness pervades. Day trips run from Perth, but to fully soak up the natural beauty of the island plan to spend a few days. Each sunny morning embark on a gentle bicycle trip around the tiny island to explore its many landscapes and historic remains, all the while keeping a close eye out in the long grasses for feeding quokkas. Cycle past pink salt lakes, rolling sand hills and wind-sculpted trees. Visit the sprawling powdery sand beaches and delve into the crystal clear azure waters in search of ancient wrecks and rainbow-coloured fish. Or climb the Wadjemup Lighthouse for a panoramic look across the entire island.

Despite being generally nocturnal, quokkas can be spotted opportunistically feeding during the day when they emerge lazily from shady bushes and dense vegetation to forage for seeds, leaves, roots and grasses. They are naturally trusting and curious creatures, often approaching visitors. During the autumn and winter months (March to August) joeys may be seen peeking from their mothers' pouches and in spring (September to November) hopping around in their new world.

TAKE ME THERE

How to Visit: Rottnest is located 18 kilometres (11 miles) from Fremantle in Western Australia and there are daily ferry services to Perth. Accommodation ranges from self-catering villas to cottages, cabins, hotels, backpacker hostels and campsites. The best time to visit is during the summer months (December to March).

Further Information: There is a wealth of trip-planning information on the Perth (**www.experienceperth.com**) and Rottnest Island tourism websites (**www.rottnestisland.com**). Numerous bicycle hire shops can be found on the island.

Did You Know? If necessary, quokkas can survive for long periods without food or water by living off the fat stored in their tails.

Wildlife:
- Humpback whale
- Bottlenose dolphin
- Southern right whale
- Blue whale
- New Zealand fur seal
- Australian sea lion
- Shorebirds
- Southern blind snake
- Skinks (bobtail and King's)
- Dugite snake

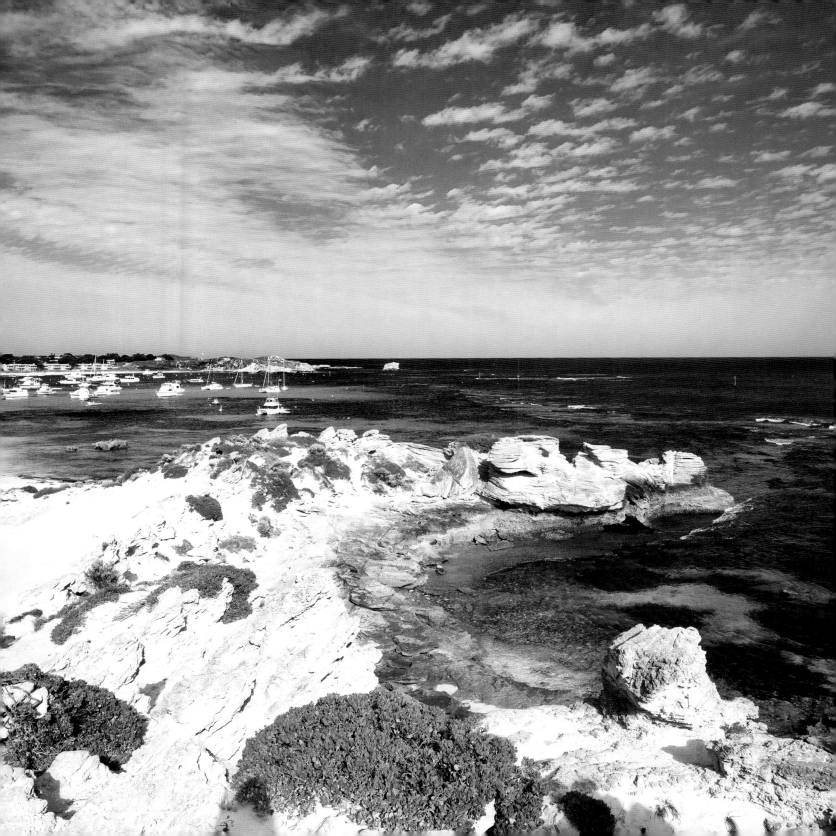

WALRUSES IN WRANGEL ISLAND
RUSSIA

Woolly mammoths survived on this isolated Arctic refuge for 6,000 years longer than anywhere else on the planet, the remains of their long curved tusks still littering the deserted gravel beaches and streambeds. But while the mammoths may be long gone, an astonishing abundance of wildlife thrives on this far-flung, frigid island in the heart of the Russian Arctic. Here, at the top of the world 140 kilometres (87 miles) off the coast of Siberia, is not only the world's largest denning ground for polar bears, but the largest population of Pacific walruses.

The world's northernmost UNESCO World Heritage site is also one of Russia's most closely protected wildlife refuges. A handful of scientists and reserve staff live alongside 100 Eastern Siberian Yupik and Chukchi people in a land that has remained unchanged since the Pleistocene period. Because it was never fully glaciated it has managed to retain a pristine tundra which supports a surprising biodiversity, and is home to more plant species than any other Arctic island.

It is hauntingly beautiful, snow-capped mountains whipped by the dry, cold air and the bleak tundra studded with trees. Towering bird cliffs support great colonies of migratory seabirds and the ice-strewn waters are an important feeding ground for the grey, beluga and bowhead whale. On the gravel beaches, walruses congregate in numbers not seen elsewhere on the planet, up to 100,000 of the long-tusked mammals bellowing and puffing in vast coastal rookeries. It is a staggeringly impressive sight to behold, thousands of one and half tonne bodies vying for space and territory.

Venturing to the Top of the World

Travelling to the end of the earth is no easy feat, and to step foot on Wrangel Island is to tread on prehistoric soils few have walked before you. In this raw and powerful place 7,600 square kilometres (2,900 miles²) in size, polar bears and walruses rule the land – as many as 400 polar bear mothers have been known to arrive here to raise their young. Snowy owls and arctic foxes feast on the abounding lemming population, snow geese come to nest in Asia's only colony and domestic reindeer and re-introduced musk ox roam the tundra.

To get to Wrangel Island involves embarking on an expedition cruise ship from Alaska or the port town of Anadyr, Russia. Spend two weeks at sea as you ply the frosty waters of the Arctic, visiting and hiking the remote peninsulas of Kamchatka and Chukotka before arriving at Wrangel. Unlike the many seafarers and explorers throughout history who failed in their attempts to find the legendary island, you make your way through mist-shrouded ice to step foot on a wild and untamed land dominated by polar bears and walruses. It is a true voyage of discovery as, accompanied by researchers, you explore a landscape few have ever seen and even fewer can imagine.

TAKE ME THERE

How to Visit: Wrangel Island is one of the most difficult places on the planet to visit, but specialised expedition ships now offer two week cruises to the region which include a visit to the island. Cruises depart from Nome, Alaska or Anadyr, Russia. It is only possible to visit in summer.

Further Information: A handful of operators offer scientist-led expeditions including Heritage Expeditions (**www.heritage-expeditions.com**), Steppes Travel (**www.steppestravel.co.uk**) and Green Tours (**www.greentours.co.uk**).

Did You Know? Walrus tusks are actually canine teeth and can grow to a metre (3ft) long. They use them for clambering out of the water, breaking ice and fighting.

Wildlife:
- Polar bear
- Seal
- Lemming
- Snow owl
- Arctic fox
- Beluga whale
- Bowhead whale
- Grey whale
- Musk ox
- Reindeer

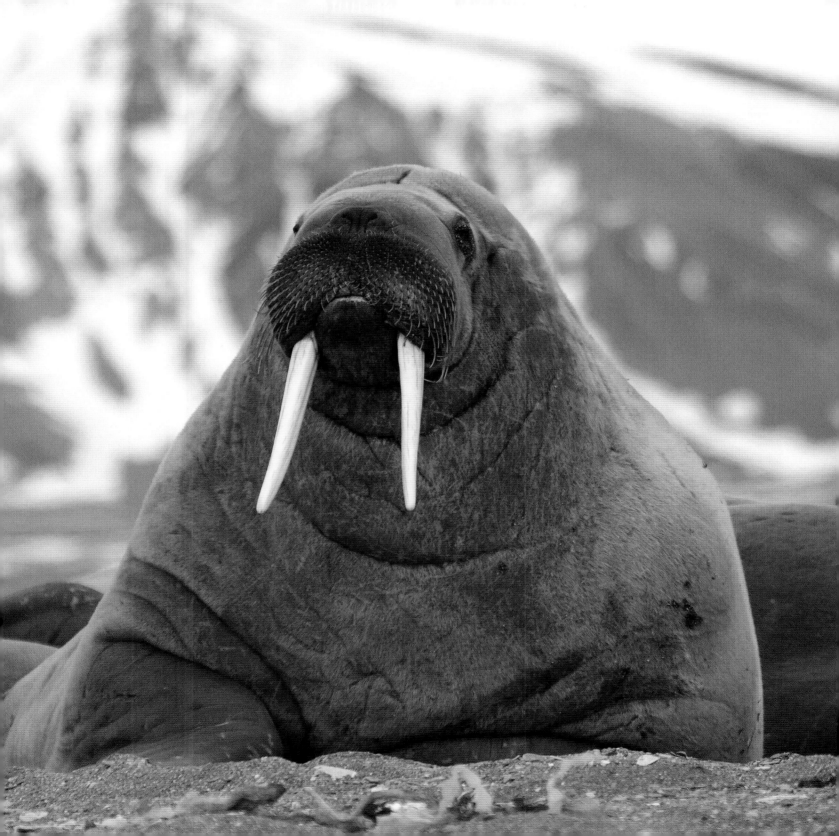

40 ONE-HORNED RHINOCEROS IN CHITWAN NATIONAL PARK
NEPAL

In the early 20th century, the future of the one-horned rhino hung in the balance, extreme poaching bringing it precariously close to extinction. Where once they roamed the entire Indo-Gangetic Plain from Pakistan to Myanmar, by 1975 only an estimated 600 wild rhinos existed in small pockets of India and Nepal. Fast forward to 2014 and conservation efforts have seen rhino numbers boom to a vulnerable yet stable 3,000. While half the population live in India's Kaziranga National Park, Nepal's Royal Chitwan National Park provides some of the best chances of seeing these 2,700kg (6,000lb) animals in the wild.

The name Chitwan means 'heart of the jungle'. Tucked into a great valley in the foothills of the Himalayas, it is one of the last undisturbed stretches of Terai landscape, a place where riverine forests, marshlands and swaying grasslands entice some of Asia's most endangered species. Elephants amble through the tall grasses, Royal Bengal tigers slink through the deciduous Sal forests, and endangered fish-eating gharial crocodiles and Gangetic dolphins cruise the Narayani River.

A collage of ox-bow lakes and hills, forests and floodplains draw birds in their millions, and over 500 different species have been recorded, including 22 which are globally threatened. Leopards, sloth bears, pangolins, pythons, four-horned antelopes and rhesus monkeys, all sadly endangered, thrive in the 932 square kilometre (360 miles²) park whose stringent protection resulted in not a single rhinoceros poaching in 2014 – by comparison, South Africa lost almost three per day.

Exploring the Heart of the Jungle
While they're designed like a small armoured tank, one-horned rhinos are in fact rather shy, and spotting one as it bustles through the undergrowth is a lucky experience. Elephant safaris are one of Chitwan's most popular activities, yet the ethics of this have long been debated. While they provide a safe and crucial role in patrolling the park against poachers, and bring valuable funding for conservation from tourism, it is a grey area so if you do choose to go ahead be sure to select a reputable company.

On the doorstep of the park, wilderness retreats exude Nepalese hospitality and architecture. From the luxurious surroundings, dug out boat trips venture along the reed-lined river and jeep tours head into the park from where you can spy wild dogs and barking deer, monitor lizards and marsh mugger crocodiles lurking in swamps. As you venture through a primitive landscape teeming with hidden predators, woodpeckers, hornbills and parakeets flutter in the trees above, a tiger pads along the track ahead and, emerging tentatively from the shelter of the forest, you glimpse the unmistakable unicorn horn of the world's largest rhino.

TAKE ME THERE

How to Visit: Chitwan's headquarters are at Kasara, accessed by road or air from Kathmandu. There is a variety of lodges on the outskirts of the park, most of which arrange tours. The best time to visit is between September and April.

Further Information: Nepal's tourism (**www.visitnepal. com**) and national park websites (**www.chitwannationalpark. gov.np**) offer trip-planning information. Tours can be arranged through lodges including Tiger Tops (**www.tigertops.com**) or as part of Nepal holidays with Intrepid Travel (**www.intrepidtravel. com**). For further information about rhino conservation see Save the Rhino (**www.savetherhino.org**).

Did You Know? Despite their bulky frames and heavy bodies one-horned rhinos can charge at speeds up to 48 kilometres (30 miles) an hour.

Wildlife:
- Royal Bengal tiger
- Gharial crocodile
- Asian elephant
- Indian gaur bison
- Sloth bear
- 525 species of bird
- Pangolin
- Gangetic dolphin
- Barking deer
- Python

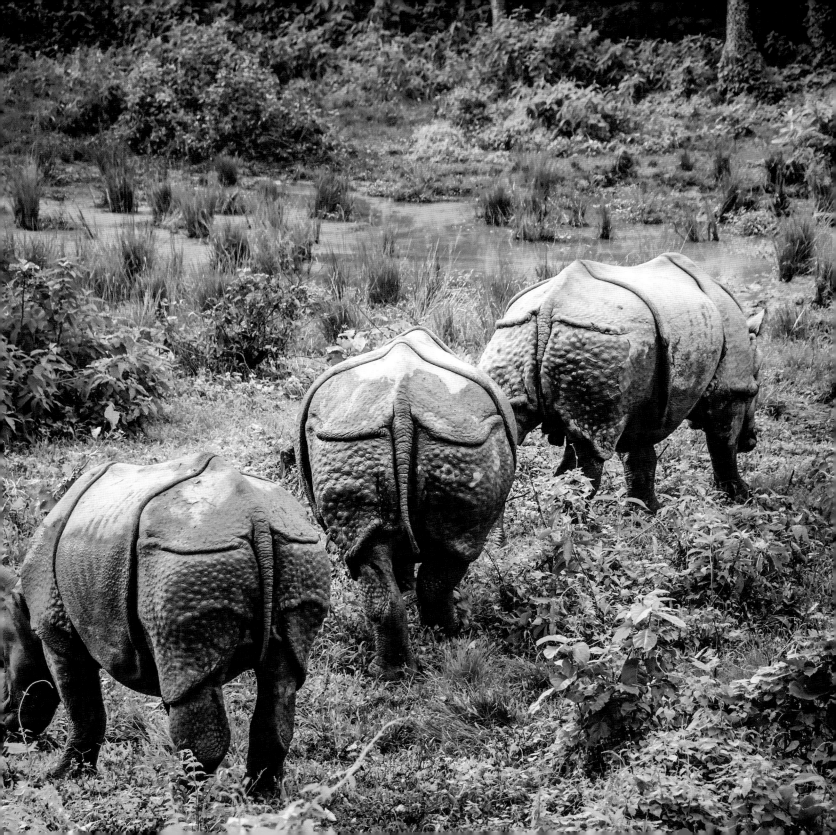

41 BLACK VULTURES IN MALLORCA
SPAIN

The great Tramuntana Mountain range is a part of the island of Mallorca where a sense of yesteryear pervades. A world away from the tourist resorts, it is a place where stepped terraces herald from Moorish times, where gnarled old olive trees bear plump autumn fruits, and where the sounds of sheep bells drift on the warm, fresh air. Springtime wildflowers blanket the lower slopes, and amidst the dense pine forests are nestled highland wineries and grand *fincas* (farm houses).

In this old worldly corner of the Mediterranean, floating on the currents above the high peaks and dramatic cliffs that drop into dark, sparkling blue waters, the largest of the Old World raptors soars. Black vultures (also known as cinereous vultures), with their soot-coloured plumage and a wingspan that stretches more than a man's height – up to three metres (9ft), in fact – are flourishing in this protected mountain range. Today they number some 130 individuals, a promising rise up from a critically low 20 in the 1980's. Found in pockets throughout Eurasia, the huge raptor is a rare sight in Europe, and its thriving in Mallorca is thanks to dedicated conservation efforts. In the shadow of Puig Major, the island's highest peak, black vultures drift over the pastel blue reservoirs of Cuber and Gorg Blau, easily distinguished from the commonly sighted Griffon and Egyptian vultures, Eleonora's eagles and Booted Eagles by their majestic silhouette.

Hiking Amongst Olive Trees

Hiking trails weave through the mountains and along coastal cliffs, where sweet-smelling rosemary and pine permeate the air. Embark on a self-guided trek along the mid-section of the GR221 Dry Stone Route that snakes 135 kilometres (83 miles) from south to north, all the while keeping your eyes skyward for a glimpse of Europe's largest raptor.

For a more guaranteed sighting, and to learn more about the ecology and conservation of the birds, guided hikes are run by ProNature Travel, a sustainable rural tourism project created by the Black Vulture Conservation Foundation and the Mediterranean Wildlife Conservation Foundation. Together with several boutique rural hotels and local farmers, they offer a programme of specialist holiday activities, the proceeds of which fund future conservation of the black vulture in the Mediterranean.

From their base in the picturesque village of Campanet (also a home to rescued vultures), day trips venture into the mountains, where feeding sites ensure plentiful food and the future survival of the vultures. As you sit and wait, binoculars in hand, smaller raptors arrive to indulge on the fresh carcasses. Yet your heart skips a beat when a black shadow crosses above, moving ever closer as it lands with an elegant flourish, scattering its smaller cousins. For here in the beauty of Mallorca's mountains, black vulture sightings – all but impossible in the rest of Europe – are almost commonplace.

TAKE ME THERE

How to Visit: Palma de Mallorca airport is widely served by airlines throughout Europe, notably budget carriers. Boutique rural accommodation in restored manor houses can be found throughout the island's interior and Tramuntana Mountains. The vultures can be seen year round but spring and autumn are the best times for hiking in the mountains.

Further Information: Day trips and boutique rural accommodation can be arranged through ProNature Travel (**pronaturetravel.com**). Good introductory information on hiking the GR221 Dry Stone Route can be found at **www.gr221.info**.

Did You Know? Mallorca is home to the indigenous Balearean goat, which is easily identified from domestic goats by its bright reddish brown coats, long black beards and spiralled horns.

Wildlife:
- Balearean goat
- Eleonora's falcon
- Griffon vulture
- Egyptian vulture
- Booted eagle
- Mallorcan midwife toad
- Pine marten
- Herman's tortoise

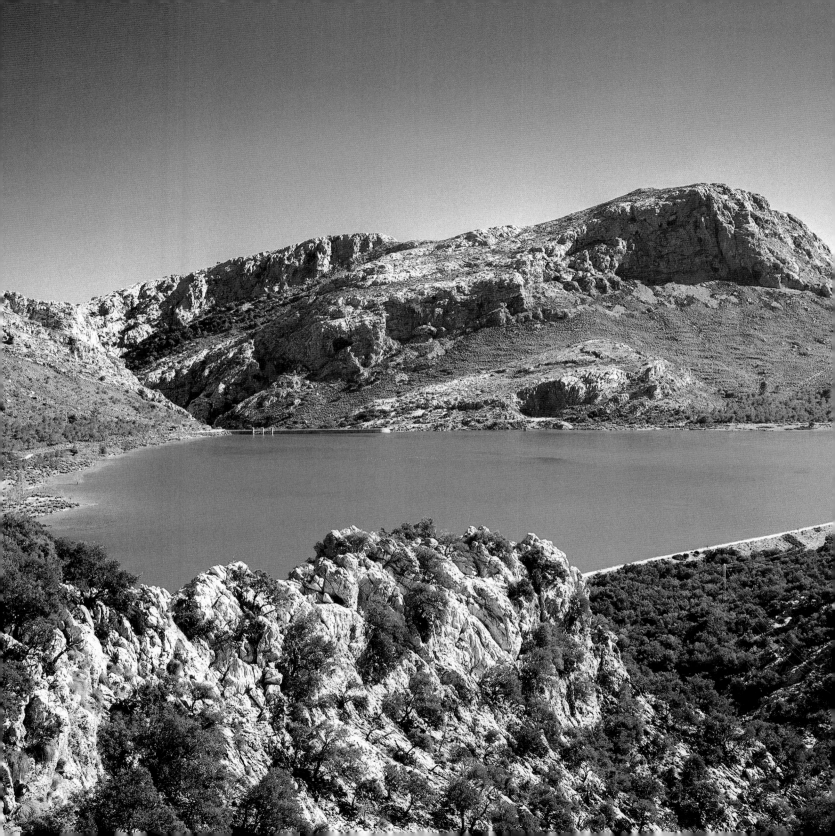

It is Tanzania's largest yet least visited national park, a vast expanse of pristine land straddling the transition zone between the East African savannahs and the miombo woodlands of the south. At its heart is the Great Ruaha River, a massive thundering cascade during the heavy rains which dwindles to a few small pools in the dry season and provides a lifeline to the abundant wildlife that call Ruaha National Park home. Rocky outcrops protrude from undulating plateaus ringed by high mountains, sweeping plains stretch interminably, and the unmistakable silhouette of baobab groves dot the horizon.

Some 10 per cent of the world's remaining lion population lives amidst the wilds of the Ruaha National Park, an area at least as big as the much-visited Serengeti. Often wandering in large prides of more than 20 they hunt on the open plains, chasing gazelle, hartebeest and impala with their muscular bodies. Cheetahs, leopards and the endangered African wild dog fall into the predator ranks, alongside spotted and striped hyenas and black-backed jackals. Abundant food roams the plains, waterbuck, impala and the world's most southerly Grant's gazelle risking their lives to drink from the dry season pools. Herds of zebra and giraffe, buffalo and bushbuck share the land with the more elusive roan and sable antelope, and the Greater and Lesser Kudu display their impressive horns in one of the few places these two species can be seen together.

Ruaha National Park is also home to the largest elephant population found in any Tanzanian national park with some 12,000 elephants migrating through the ecosystem each year. It is an impressive accolade to hold just three decades on from the ravaging poaching that occurred in the 1980's.

In the Footsteps of the Mighty Lion

The king of the jungle (or savannah) brings out a primal sense of excitement, fear and awe in us. To see the continent's top predator in rip-roaring action, its shaggy mane billowing in the warm breeze and its huge barrel-chested body striding purposefully, is the ultimate safari experience.

Despite the fame that accompanies the prides that roam the Masaai Mara and Serengeti, Ruaha is in fact one of the top places in Africa to spot lions, an experience you're likely to have all to yourself. Time your visit to coincide with the hot, dusty dry season, when the animals venture along sand rivers to the shrivelled pools in search of respite from the droughts of the plains. A handful of luxury camps dot the remote, untamed park offering 4x4 safari drives into the heart of a park 20,000 square kilometres (7,700 miles2) yet one which receives just 6,000 visitors a year. Sightings of lions are almost guaranteed, the animals habituated to the few safari vehicles that traverse the rugged landscape.

TAKE ME THERE

How to Visit: Flights depart from Dar es Salaam or Arusha, or it is possible to drive from Iringa. A handful of luxury lodges offer all-inclusive stays and safari options. The best time to visit is during the dry season from May to October.

Further Information: The Tanzania national parks website (**www.tanzaniaparks.com**) offers a good introduction. There are several excellent camps inside the park including Jongomero (**www.selous.com**), Mwagusi (**www.mwagusicamp.com**) and Kwihala (**kwihala.asiliaafrica.com**).

 VU

Did You Know? When an adult male lion roars it can be heard up to 8 kilometres (5 miles) away.

Wildlife:
- Elephant
- African wild dog
- Cheetah
- Giraffe
- Leopard
- Kudu (greater and lesser)
- Antelope (sable and roan)
- Buffalo
- Zebra
- Grant's gazelle

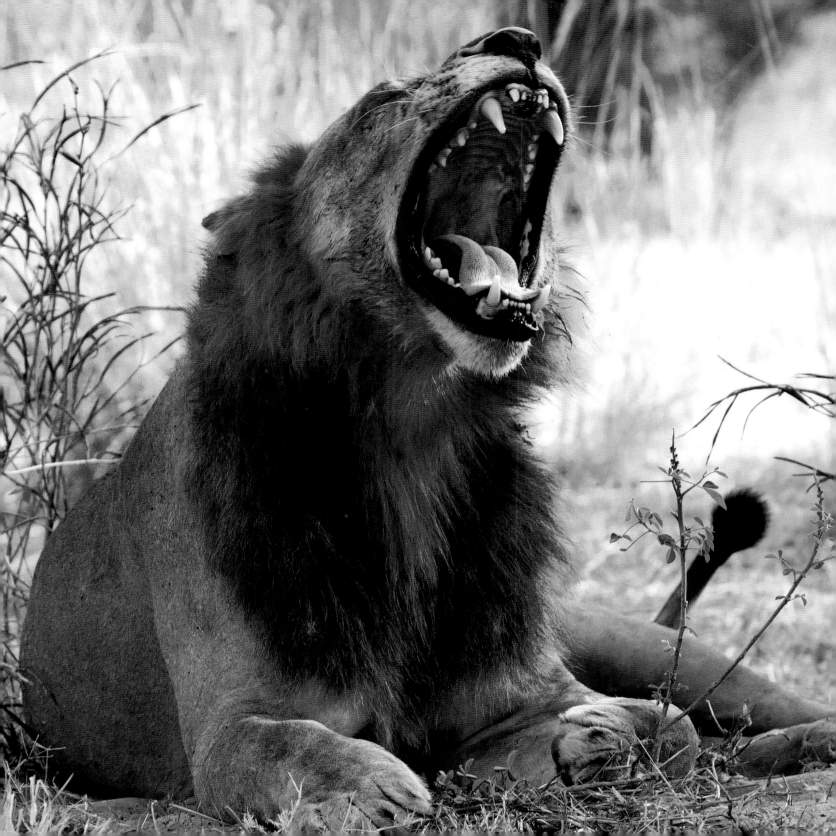

43 ORCAS IN JOHNSTONE STRAIT
CANADA

Summer along Canada's Vancouver Island brings with it long, hazy days, balmy weather and, in the glass-like waters of the vast Johnstone Strait which stretches along its northeast shore, the great salmon spawn. In the wake of the writhing mass of silvery pink fish a circus of marine wildlife follows, the most famous of which are the resident pods of 250 orcas.

Snow-capped mountain peaks and great swathes of old growth forest tumble down to meet the clear rippling waters of the 110 kilometres (68 miles) long strait. Islands dot the waterway, which stretches up to 5 kilometres (3 miles) across, their smooth, rounded boulders and secluded beaches interspersed by narrow passageways and a true sense of remoteness.

Totally inaccessible by car, this northern part of the strait is wild and rugged. On land black bears amble through the temperate pine forests and bald eagles perch aloofly on high branches. In the chilly waters porpoises and dolphins, inquisitive sea lions and bus-sized humpback whales join the summer melee, the stars of which are undoubtedly the resident orcas.

Scientists including Michael Bigg and Paul Spong have been studying the orcas of Johnstone Strait since the 1970's and their studies have given rise to research stations such as the clifftop OrcaLab and Robson Bight Ecological Reserve located within the strait. For it is here that the orcas display a unique trait of rubbing their bellies against the smooth stones on the bottom of the water – something not observed anywhere else in the world.

Kayaking with Killer Whales

Boat trips follow the playful pods of orcas and their marine associates throughout the summer, offering one of the best and most guaranteed killer whale watching experiences in the world. For a true wilderness adventure however, set off on a multi-day kayaking expedition along an unblemished coastline teeming with wildlife.

As the morning fog lifts to reveal the ethereal beauty of the strait you paddle gently along. Brightly coloured sea stars glow through the clear waters, whiskered sea lions peer curiously at you from smooth rocks and dolphins dance in the distance. By night, camp under the brightest of stars and awake each morning to gaze across the glacier-calved waterway whose thriving wildlife simmers just below the surface. Hike the forests and learn about the First Nation aboriginal cultures that once inhabited the region, and spend long evenings by roaring campfires. The trip is a true adventure, but to witness the stars of the show, the great orcas, raise their majestic dorsal fins and feel the great billow of puff on your face is the epitome of the experience.

TAKE ME THERE

How to Visit: Boat and kayaking trips head out of towns located along north Vancouver Island such as Port McNeill. Kayaking tours can range from half a day to six days which involve often luxury camping facilities. The only time to see the orcas is between June and October.

Further Information: The regional tourism website (www.hellobc.com) is a good starting point for planning a trip. There are countless kayaking outfits offering trips of differing length including ROW Sea Kayak Adventures (www.rowadventures.com) and Spirit of the West Adventures (www.kayakingtours.com). For more information on the Johnstone Strait orcas try orcalab.org.

Did You Know? Corky is the longest-surviving captive orca in the world, having spent 42 of her 46 years in San Diego's Sea World after being captured in British Columbia. OrcaLab is campaigning to get her semi-released into the wild.

Wildlife:
- Humpback whale
- Minke whale
- Sea lion
- Bald eagle
- Pacific white-sided dolphin
- Black bear
- River otter
- Dall's porpoise
- Harbour porpoise
- Sockeye salmon

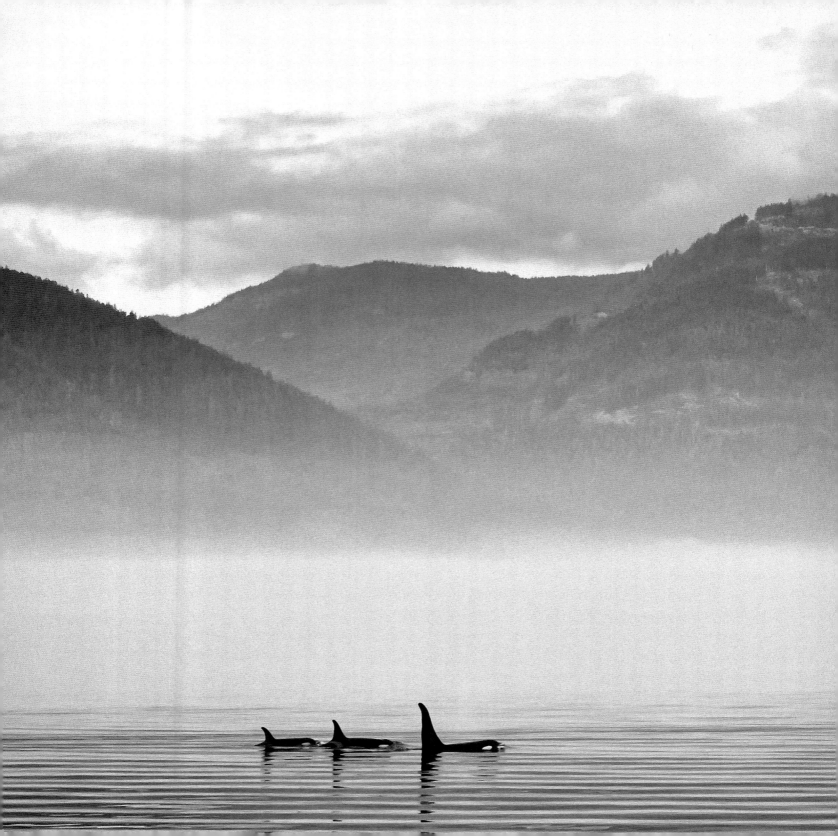

GIANT ARMADILLOS IN CANAIMA NATIONAL PARK
VENEZUELA

In the north west of Venezuela is a wild and impenetrable region known as the Canaima National Park, an UNESCO designated, three-million-hectare expanse of jungle from which erupt vast, flat-topped mountains known as tepui's. The landscape is bizarre, ancient and untouched. Indigenous plants and animals have adapted to the harsh environments atop the tepuis and great rainbows swirl through the sky as hundreds of streams pour off the plateaus. Originating from between 1,500 and 20,000 million years ago, the rocks are one of the oldest geological formations in the world.

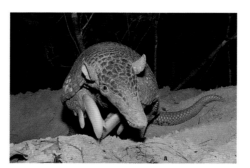

Amidst a swirl of rivers, jungles and savannas is Angel Falls, the world's highest waterfall that cascades off Auyantepui and, at the other end of a park the size of Belgium, stands Mount Roraima – the tallest of the table mountains and the inspiration for Arthur Conan Doyle's 'The Lost World'. The savannah portion of the park is inhabited by the indigenous Pemòn people and amidst its varied topography a strange and abundant wildlife exists.

And it doesn't get stranger than the giant armadillo, the sturdy dinosaur-esque animal relatively unstudied and mysterious even to scientists. Despite being famed for curling into a tight ball when threatened, and protected by a rock-hard armour, armadillos are elusive and shy, spending their days hiding in burrows. With their long claws they dig for prey in the form of termites, and despite a wide territory range (they can be found through much of northern South America) they are locally rare, the species having become threatened due to hunting for meat and a loss of habitat.

Trekking Through a Lost World
Solitary and nocturnal, giant armadillos are notoriously hard to spot, yet for the most patient of visitors it is possible to spy one of these tank-like creatures in Canaima. Trips delving into the heart of the remote, wild region traversed not by roads and paths but by rivers and streams offers the opportunity to get to one with the abounding nature. Camp under the stars, trek to the summit of Mount Roraima, fly over a land studded with tepuis and stand beneath the impossibly high torrent of Angel Falls, all the while keeping a close eye out for the myriad of wildlife that roams through the undergrowth. It is not a trip for the feint at heart, a colossal exploration of one of the most feral and untouched regions in the world.

Harpy eagles soar through the skies and rainbow mists. Toucans, macaws and parrots sing their noisy songs in the dense forests in which hide jaguars, ocelots and cougars. Monkeys (white-faced and brown-backed bearded sakis) swing through the vegetation with their unmistakable masks, and giant otters and giant anteaters join the armadillos as elusive behemoths.

TAKE ME THERE

How to Visit: Multi-day trips into the park include excursions to Angel Falls, a Mount Roraima trek and exploration of the national park. Trips often begin with a flight to the Canaima National Park Airstrip from Caracas or Ciudad Bolivar, and then a scenic flight or a boat trip into the heart of the park.

Further Information: The Venezuela tourism website (www.think-venezuela.net) is a good source of travel information and tours can be booked through a number of operators including Latin Odyssey (www.latinodyssey.com) or Journey Latin America (www.journeylatinamerica.co.uk).

Did You Know? Giant armadillos have around 80 to 100 teeth, which is more than any other terrestrial mammal, and extremely long front claws, including a sickle-shaped third claw.

Wildlife:
- Giant otter
- Giant anteater
- Jaguar
- Cougar
- Harpy eagle
- Two-toed sloth
- Red-shouldered macaw
- Green iguana
- White-faced saki monkey
- Yellow-banded poison dart frog

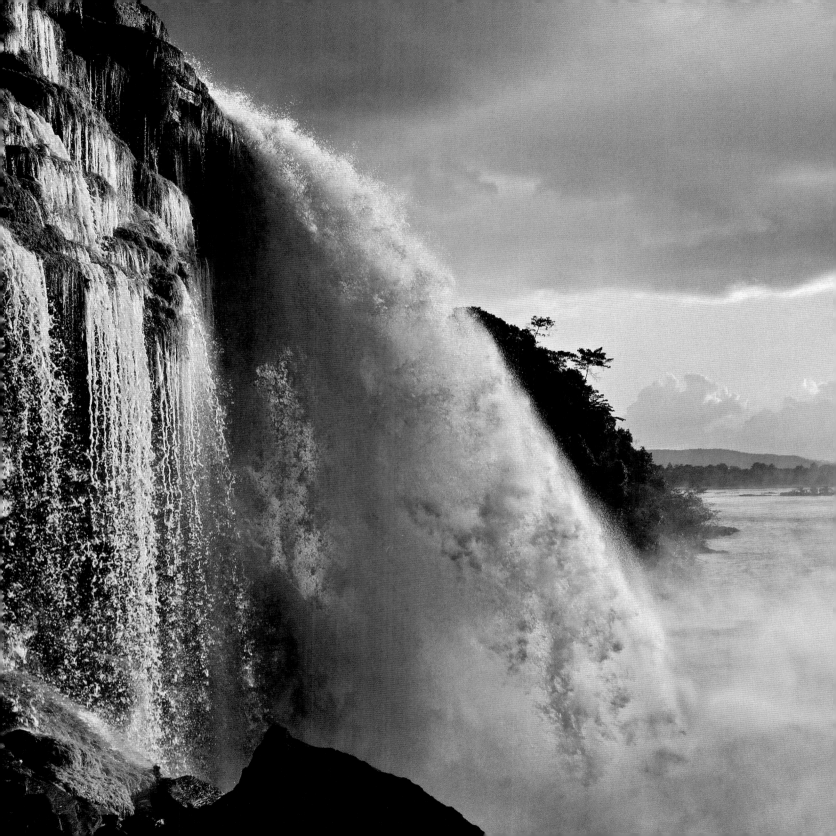

South Georgia has an inglorious past. For decades, sealers and whalers ravaged the wildlife-laden lands and surrounding waters of the island, decimating what was once one of the most abundant whale and seal habitats on the planet. While the whale populations have yet to make a full recovery, 95 per cent of the world's fur seals once again arrive here every summer alongside great lumbering elephant seals, Weddell seals and leopard seals. Some five million blanket the beaches of the uninhabited, 170 kilometres (105 miles) long island in the midst of the southern Atlantic Ocean. Despite the staggering numbers of seals, South Georgia is also known as the 'Penguin Capital of the World', with thousands of proud little birds standing shoulder to shoulder on the island's windswept, isolated beaches.

Over 400,000 pairs of regal three foot-tall King penguins vie for space with the elephant seals amidst a cacophony of sounds and a pungent aroma. The yellow-tufted Macaroni penguin numbers two million and there are thousands of tiny Chinstrap and cheeky Gentoo penguins to add to the melee. The island is literally heaving with wildlife, some 50 million seabirds (albatrosses, petrels and prions amongst them) flocking to the cold shores and towering cliffs which plummet into the grey, turbulent southern ocean sea.

The island is rugged and wild, vast glaciers, ice caps and snowfields covering more than three quarters of the tree-less land. In winter, a snow blanket reaches to the shores which then drop some 4,000 metres (13,000ft) to the sea floor. Southern right and humpback whales frequent the deep bays and orcas, blue and sperm whales are occasionally sighted.

Antarctic Explorations

Many believe that St. Andrew's Bay on South Georgia has a greater density of wildlife than any other place on earth. To stand on the beach is a true sensory overload as the King penguins and elephant seals squawk and roar, chatter and puff in their millions. They regard the few that venture to this wildlife-dominated wonderland with inquisitive looks, often wandering in for a closer look at their unusual spectators.

Getting to South Georgia is no easy feat. There is no airstrip, no roads traverse the mountainous, glaciated island and, bar a few summer museum curators, no humans live there. To reach the island you need to set sail aboard a sturdy ice-breaker on a cruise of the southern Atlantic and Antarctica. It is a true voyage of exploration, where you venture into the rugged lands on foot and clamber ashore beaches teeming with wildlife from small launches. Wandering Albatrosses, the largest sea bird in the world, swoop overhead, great cliffs seem to buckle under the weight of colonies of seabirds and the sea swarms with seals and whales. Yet penguins take centre stage here, their mischievous personalities and cartoon-cute faces winning over the hearts of all those who make the great trip to the bottom of the world.

TAKE ME THERE

How to Visit: With no airport and no accommodation, the only way to visit South Georgia is by boat and visitors usually arrive as part of an Antarctic cruise onboard icebreaker vessels. The best time to visit is November to March.

Further Information: For more information on the heritage and wildlife of the island visit South Georgia Heritage Trust (**www. sght.org**) and (**www.sgisland.gs**). Expedition cruise companies include Oceanwide Expeditions (**www.oceanwide-expeditions. com**) and Quark Expeditions (**www.quarkexpeditions.com**).

Did You Know? A breeding pair of King penguins will take it in turns to incubate their egg for 60 days, doing shifts of 5 to 22 days.

Wildlife:
- Wandering albatross
- Grey headed albatross
- Southern elephant seal
- Antarctic fur seal
- Southern right whale
- Humpback whale
- Leopard seal
- Fin whale
- Long finned pilot whale
- Orca

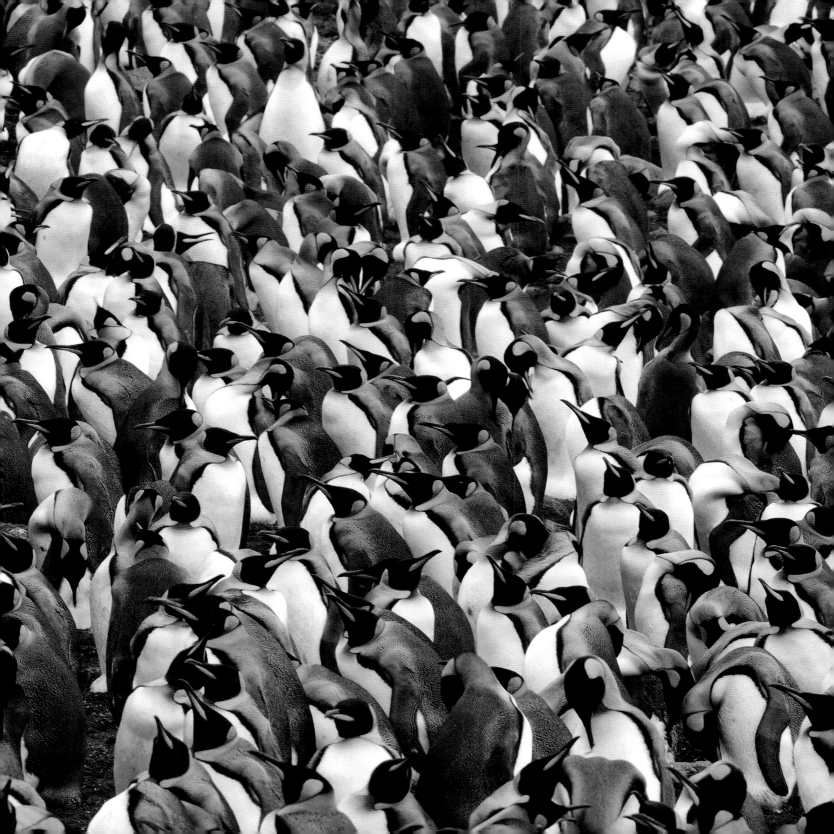

A ribbon of tiny, sand-ringed coral atolls swirls through the heart of the Indian Ocean, its warm, Vodka-clear waters home to a dazzling array of tropical marine life. They are mere blips above the surface of the gently shimmering sea. Together these 1,200 – mostly uninhabited – islands spread over 90,000 square kilometres (35,000 miles²) forming one of the world's most geographically diverse nations.

It is perhaps unsurprising then that the Maldives are one of the world's best scuba diving and snorkelling destinations. Powdery white sand beaches overhung with palm trees which sway lazily in the warm breeze give way to a thriving under-water world. Clear, tepid lagoons harbour juvenile fish which dart through the corals; sharks and turtles soar along the great walls which drop into the deep blue; gentle whale sharks – the world's largest fish – sashay slowly by; and one of the planet's biggest gatherings of manta rays (around 7,000 individuals) inhabits the waters year-round.

A rich soup of plankton provides fodder for the mass manta ray feeding sessions that occur in sheltered lagoons of isolated islands. Migrating across the atolls with the changing monsoons they follow seasonal patterns, gathering in groups up to 100 strong in bays such as Hanifaru when the lunar tide is high.

The Maldives evoke a sense of tropical perfection few other places can compete with. Sitting atop a vast ridge which runs 960 kilometres (596 miles) beneath the ocean, the miniscule islets are home to world famous luxury resorts, their stilted, palm-thatched bungalows jutting enticingly into the sea, promising honeymooners and sun-worshippers opulence and staggering natural beauty far from the crowds.

Swimming in an Aquatic Theatre

Swirling and swooping effortlessly through the warm green waters, manta rays seemingly soar like great aquatic birds, their 4 metre (13ft) wingspans slowly flapping as they circle each other in an intricate dance. To dive or snorkel amongst them as they gather in some of the largest schools in the world is to enter a peaceful and tranquil watery theatre.

In Hanifaru, a small lagoon next to one of the many uninhabited tropical islands, these great, harmless creatures congregate during the south-west monsoon season between May and November. Feeding near the surface they are inquis-itive about their human observers, allowing for long, close-up encounters. Watch as they feed on the almost microscopic plankton or lay patiently in cleaning stations as smaller fish dart in and out of their gills.

Stay at a nearby luxury resort from where day trips venture to the cove in search of manta rays or embark on a week-long dive liveaboard, traversing some of the most pristine reefs, isolated islets and untouched dive sites in the country.

TAKE ME THERE

How to Visit: Flights to the Maldives land at the Mahle International Airport from where ferries or float planes shuttle visitors to other islands. Resorts can be booked directly or through tour operators, and for independent visitors there is a ferry network and independently-run guesthouses. Dive liveaboards and resorts near to the manta hub of Hanifaru offer day or week-long trips. The best time to spot manta rays is June to November.

Further Information: The Maldives Tourism website (www.visitmaldives.com) is a good source of information. For more information on the manta rays visit the Manta Ray Trust (www.mantatrust.org).

Did You Know? A coral massif grows just 2mm (0.08in) a year. In the Maldives, the depth of coral on the reef is as much as 2,100 metres (6,400ft), showing its staggering antiquity.

Wildlife:
- Whale shark
- Grey shark
- Turtles (hawksbill, leatherback, green, Olive Ridley)
- Eagle ray
- Dolphins (spinner, bottlenose, Risso's)
- Short-finned pilot whale
- Blue whale
- Sperm whale
- False killer whale
- Seabirds

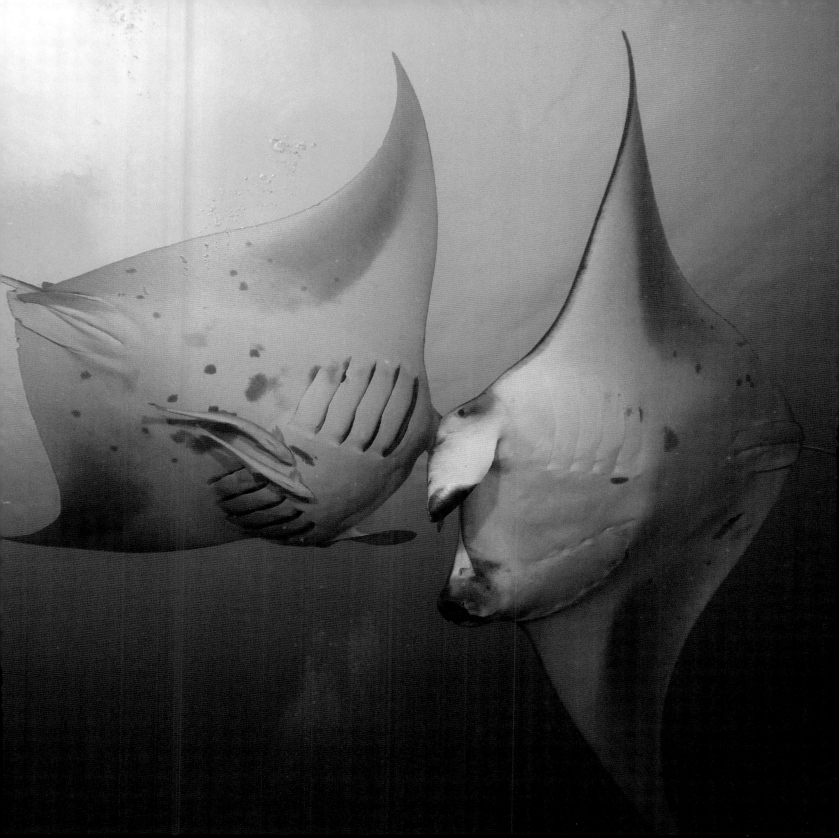

LEOPARDS IN SOUTH LUANGWA NATIONAL PARK
ZAMBIA

They are masters of camouflage and stealth, treading softly through the night to hunt with their muscular grace and speed. And while the solitary leopard might hold a place on the coveted Big 5 list, these nocturnal predators are notoriously elusive and the hardest of Africa's top mammals to spot. In Zambia's South Luangwa National Park however – often considered the leopard capital of the continent – the chances of spotting the distinctive golden pelt with its black rosettes disguised against the long grasses are considerably higher. A large leopard population and the chance to embark on night safaris mean visitors are often rewarded with impressive sightings.

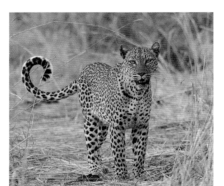

The Luangwa River sits at the heart of the park which spreads out into a wide fertile plain ringed by mopane forests where herds of elephants and buffalo hundreds strong wade through the marshes. The striking Thornicroft's giraffe, endemic Crawshay's zebra and antelope, especially impala and puku, skip around the lagoons and plains. Hippos and crocodiles line the sun-dazzled river banks in their thousands, and over 400 bird species – snake eagles, bateleurs and ground hornbills amongst them – flock to the watery landscape with its myriad of oxbow lakes. And, at the top of the predator list, large prides of lions and leopards hunt in the woodland savannahs.

Comparatively few visit this fertile valley, home to one of Africa's biggest concentrations of wildlife. The dry season (August to October), when the alluvial plains dry out and the animals gather at the remaining watering holes, proffers the best game viewing. Yet to catch a glimpse of the shy leopard is a challenge even here, one best left to the cover of darkness.

Night Safari
South Luangwa is one of the few national parks in Africa that allows night safaris, and it is this exhilarating adventure that heralds the best chances of catching sight of an agile leopard balanced in a tree with its prized meal, or for the lucky few, running at speeds of 58 kilometres per hour (35 mph) in pursuit of an impala.

Staying at one of the park's lodges is a luxurious step back in time to the traditional safari camps of the past. Dotted around the green river valley, game ambles past the wooden decks, from where 4x4 jeeps or serene walking safaris (accompanied by an armed guide) venture into big cat country where a leopard lazing in the thorny thickets might be waiting. As night falls you set off into the darkness, when Africa's nocturnal animals venture out to forage and hunt, peering into the black for the tell-tale flash of gold or the glimmer of amber eyes.

TAKE ME THERE

How to Visit: Flights go to Mfuwe at the entrance to the park from where you can drive yourself into the park or go as part of a package. There are a couple of campsites and several excellent lodges in the park, which offer a range of safaris and game drives/ walks. The best time to visit is between June and November.

Further Information: The Zambia Tourism website (www.zambiatourism.com) offers wealth of trip planning information including a list of all the lodges and campsites.

Did You Know? Leopards are strong swimmers and very much at home in the water, where they sometimes eat fish or crabs.

Wildlife:
- Elephant
- Lion
- Thornicroft's Giraffe
- Buffalo
- Hippo
- Crawshay's zebra
- Impala
- Puku antelope
- Spotted hyena
- 400 species of bird

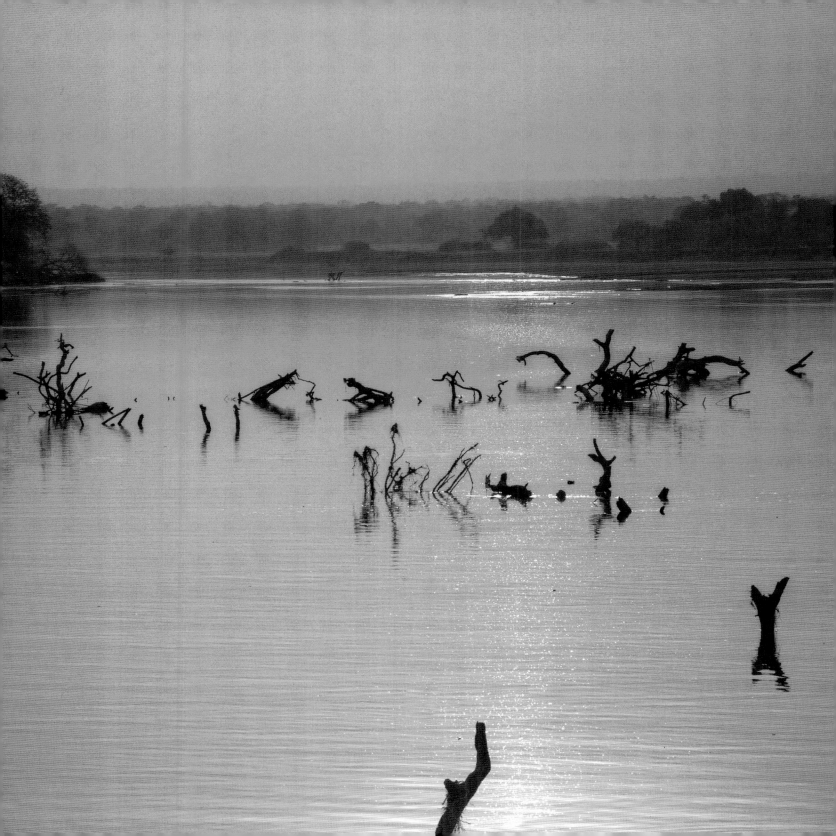

The Badlands are a harsh and desolate landscape. Ragged pinnacles and wrinkled hills have been sculptured by fierce winds and torrential rains to create a forbidding-looking place. 19th century French trappers described the other-worldly rock formations as *mauvaises terres à traverser* (bad land to traverse), and the Oglala Lakota Nation (whose Pine Ridge Indian Reservation forms the southern half of the national park) refer to it as *mako sica*, meaning 'land, bad'.

Yet the Badlands exude a savage beauty. Sprawling prairie grasslands envelope the sharp gullies and ridges, the inky black sky shines with great splashes of stars and a unique wildlife thrives amidst the solitude and serenity.

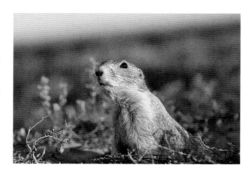

While fossils have revealed that prehistoric three-toed horses and sabre-toothed cats once roamed these parts, today a much smaller species is at the heart of the ecological community of the prairies. Prairie dogs' networks of burrows, known as towns, provide the highly social animals with protection from weather and predators. Others too, find crucial shelter in their towns, and badgers, bobcats, coyotes, swift foxes, and black-footed ferrets (North America's most endangered land mammal) rely on them for survival.

Sitting at an avian crossroads, Badlands National Park is visited by 206 species of bird. Amongst the prairie dog's numerous predators are the ferruginous hawk and short-eared owl, their approach resulting in a cacophony of alarm calls as the dogs dart underground. Bison herds roam the grasslands, accompanied by mule deer, pronghorn antelope and bighorn sheep, and spring wildflowers support butterflies including the two-tail swallowtail, whose yellow and black wings measure up to 12cm (5in).

Traversing the Prairies

American Indians, farming homesteaders and gold prospectors have each played their part in the long history of the Badlands, prairies and nearby Black Hills – home to Mount Rushmore. It is a region both steeped in stories of the past, yet one which retains a true serenity and wilderness.

By night, hunker down in cosy log cabins, and spend evenings stargazing on the ranger-led Night Sky Programme. By day set off into the park in search of wildlife and breathtaking scenery. Whether you drive the Badlands Loop Road, hike the trails or join a guided horse-riding expedition, one stop is a must: Roberts Prairie Dog Town along Sage Creek Rim Road. As one of the largest towns in the country, it offers up-close encounters with mischievous and entertaining prairie dogs. Ungulates, birds and butterflies inhabit the grasslands, and in the rugged hills keep a look out for summer swallows who make mud nests in the strange formations.

TAKE ME THERE

How to Visit: The main park entrance is at Ben Reifel Visitor Centre, 120 kilometres (75 miles) from Rapid City. An open backcountry policy means wild camping is permitted, and there is a campsite, RV park, log cabins and inn at Cedar Pass Lodge. The weather is best April to May and September to October.

Further Information: The National Park Service (**www.nps. gov/badl**) offers good trip planning information, as does South Dakota's Tourism Bureau (**www.travelsd.com**). Cedar Pass Lodge (**cedarpasslodge.com**) has various accommodation options and Dakota Badland Outfitters (**www.ridesouthdakota.com**) arrange guided horse-riding trips.

Did You Know? The largest recorded prairie dog town was in Texas and covered 65,000 square kilometres (25,000 miles²). It was home to an estimated four hundred million prairie dogs.

Wildlife:

- Bison
- Bighorn sheep
- Pronghorn antelope
- Black-footed ferret
- Two-tailed swallowtail butterfly
- Burrowing owls
- 206 species of bird
- Bobcat
- Coyote
- Porcupine

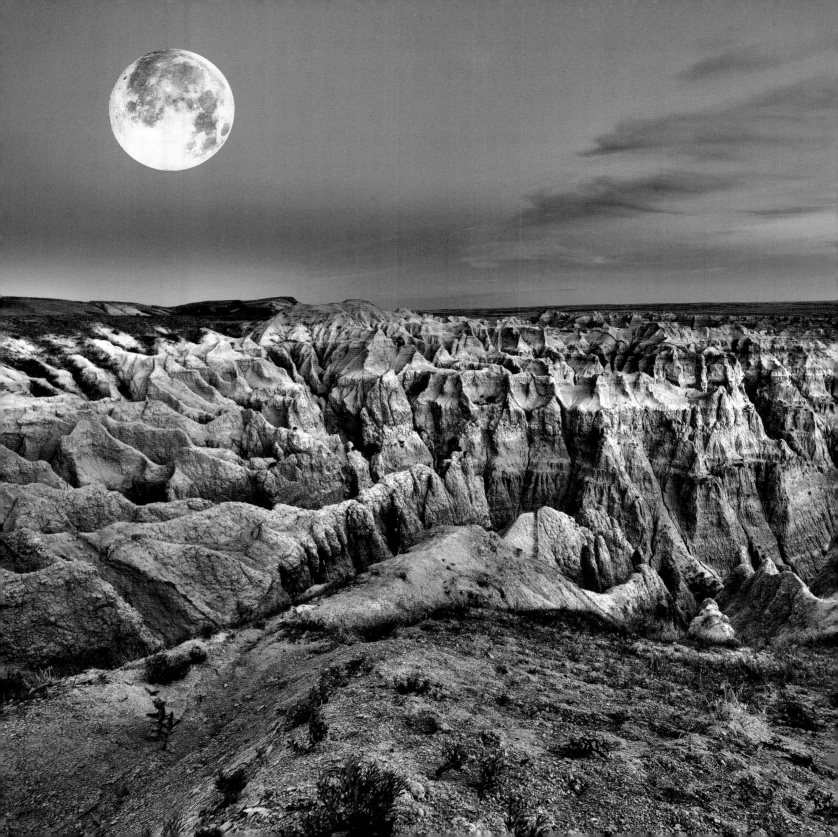

49 QUETZALS IN MONTEVERDE CLOUD FOREST
COSTA RICA

High in Costa Rica's Tilarán Mountains, in the region known as the Monteverde Cloud Forest Biological Reserve, mist swirls through moss covered trees, vines and creepers curl their way skywards, and creeks weave through the blanket of dense green vegetation. Set atop the country's continental divide, the virginal forest is teeming with life, home to 2.5 per cent of the world's biodiversity. Some 100 species of mammals, 400 species of birds, tens of thousands of insects, and over 2,500 varieties of plants exist here. Yet of all these, the most loved and famous is one of the world's most beautiful birds; the resplendent quetzal.

The ancient Mayas and Aztecs revered this sacred bird as the 'god of air', using the male's long iridescent tail feathers to adorn their headdresses (although never killing the birds). Indeed, the national bird of neighbouring Guatemala is the quetzal and their currency is named after it. They are elusive and shy, yet here in Monteverde their love for seasonal wild avocados sees them venture to lower altitudes at certain times of the year when it is possible to spot them in their turquoise, green and shimmering blue glory. The males are more dramatic in appearance, their fuzzy heads and 65cm (26 in) tail streamers helping attract a mate.

Monteverde is a model for community-run conservation, where organic farming and alternative energy sources are practised. When Quaker settlers first arrived in the region they dedicated themselves to preserving this unique ecosystem and today, with the help of environmental organisations, it is a true success story.

Walking Through Cloud Forests

National Geographic once declared Monteverde to be the best place to see the resplendent quetzal in all of Central America, and although their numbers might be higher in other parts of the isthmus (just 100 pairs mate in Monteverde), the maze of trails, roads and highly experienced tour guides means your chances of spotting one are pretty good.

Just after dawn you begin walking through a forest dripping with orchids, bromeliads, ferns and mosses. Monkeys swing through the treetops, salamanders slither through the undergrowth and the sounds of jaguars hunting echo through the stillness. It is the best time of the day to see the wonderfully exotic quetzal, aided by the trained eye of a tour guide.

Zip lines and suspension bridges snake through the part of the reserve open to visitors, allowing you to walk (or soar) high in the canopy of a cloud forest 1,440 metres (4,662ft) above sea level. Wildlife is abundant, and ocelots, possums, toucans and sloths can be easily spied in the towering trees. It is one of Costa Rica's most visited reserves, yet for good reason. Binoculars in hand, and with luck on your side, you might get to spot a bird so resplendent that its legacy has lasted for centuries.

TAKE ME THERE

How to Visit: The town of Santa Elena is the jumping off point to the reserve and there are lots of hotels, backpacker hostels and tour companies available. The dry season (late December to early May) is the best time to visit although the best time for viewing the quetzal is late February to July.

Further Information: The Costa Rica tourism authority (www.visitcostarica.com) offers lots of trip planning information including a list of accommodation options and tours.

Did You Know? The resplendent quetzal was considered divine in Pre-Columbian Mesoamerican civilizations and associated with the 'snake god' Quetzalcoatl.

Wildlife:
- Sloth
- Agouti
- Jaguar
- Ocelot
- Puma
- Possum
- Keel-billed toucan
- White-faced monkey
- Salamander
- Over 450 bird species

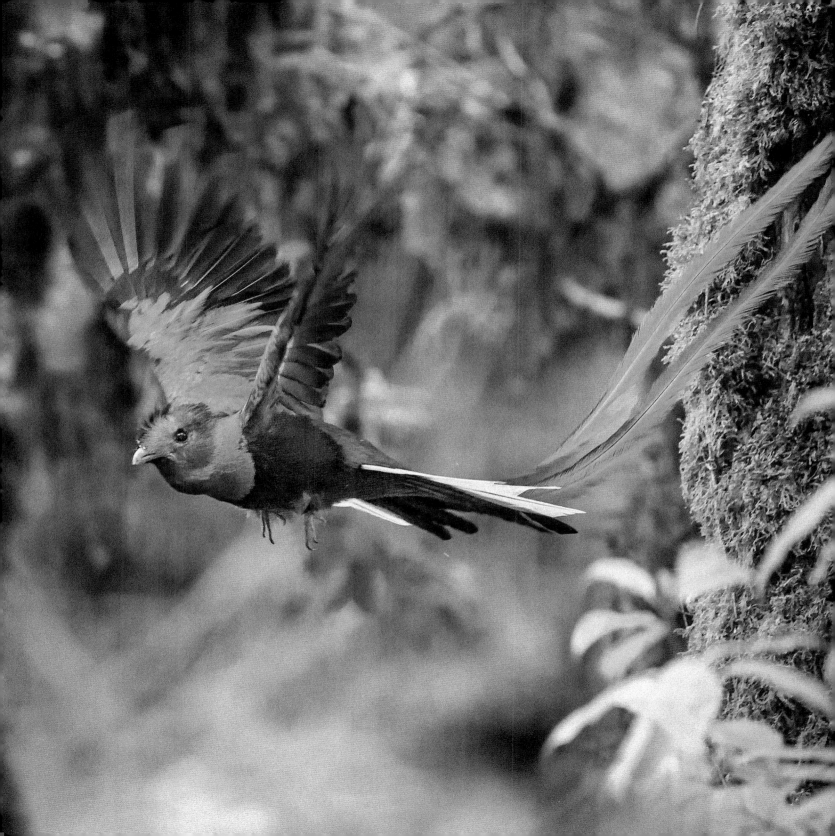

In the midst of the Indian Ocean, closer to South East Asia than it is to its home country of Australia, lies Christmas Island. Despite being just 135 square kilometres (52 miles²) and home to just 2,000 people, it is one of the world's ecological wonders. Rainforests and beaches, mangroves and caves support a surprising biodiversity, where crabs and seabirds are the star attractions.

Fourteen species of land crab scuttle through the dense forests, where ferns, orchids and vines wrap around branches in the humid world beneath the canopy. It is a diversity not seen anywhere else in the world, the crabbiest place on the planet writhing with red crabs, blue crabs and the giant Robber crab – which measures up to a metre (3.2ft), can weigh over 4kg (9lbs) and can open coconuts with its powerful claws.

Amidst Christmas Island's laidback charm and natural beauty, one of the world's greatest phenomena unfolds each year. As the wet season begins, the monsoon rains start to fall in great curtains and when the moon cycle is just right, tens of millions of red crabs emerge from the forest, pouring like a sea of red across the landscape on their way to spawn at the narrow beaches. Like an advancing army they scramble across fallen trees and roads, a great 8 million kilogram moving carpet on a mission.

Over 80,000 seabirds nest on the terraces, cliffs and forest trees. The endemic and endangered Christmas frigatebird can be spotted, red-footed and brown boobys thrive, and Abbott's boobys roost in the forest – their last nesting habitat in the world. The sea cliffs drop into crystalline waters where a coral reef buzzes with tropical fish. Just 200 metres (650ft) offshore the depth plummets to over 500 metres (1,640ft), putting whale sharks, spinner dolphins, manta rays and open ocean species on the island's doorstep.

Navigating a Sea of Red

The migration is a mesmerizing sight, where crimson rivers ooze from the shelter of the trees. In perfect synchronisation, the crabs leave their burrows which pocket every square metre of the shady forest floor, to march with spectacular purpose to the coast.

It can be difficult to coincide a trip with the migration. Spawning can happen as early as October or as late as January, although November and December are the more common months. The lunar phase and tides play a critical role and predictions can help coincide a visit.

While you wait for the flood gates to open and unleash a torrent of scuttling crabs, embark on a discovery tour of this tranquil Pacific island. Hire a four-wheel drive and venture to hidden beaches, trek the nature trails to refreshing waterfalls and fairy grottoes, bird-watch for the island's famed seabirds, or dive into to the warm waters to explore some of the world's longest drop offs and healthiest reefs.

TAKE ME THERE

How to Visit: There are flights from Perth, Kuala Lumpur and Jakarta to Christmas Island, and a good variety of accommodation options on the island. Timing a trip with the migration can be difficult but it is usually in October/November.

Further Information: The Christmas Island Tourism Association (**www.christmas.net.au**) offers a wealth of visitor guides, trip-planning information, accommodation options, scuba diving outfits and bird-watching guides. Parks Australia (**www.parksaustralia.gov.au**) provides further information on the migration.

Did You Know? It is estimated there are 40–50 million red crabs taking part in the migration every year.

Wildlife:
- Robber (Coconut) crab
- Blue crab
- Abbot's booby
- Red-Footed booby
- Christmas Island frigatebird
- Whaleshark
- Spinner dolphin
- Manta ray
- Reef fish
- Christmas Island fruit bat

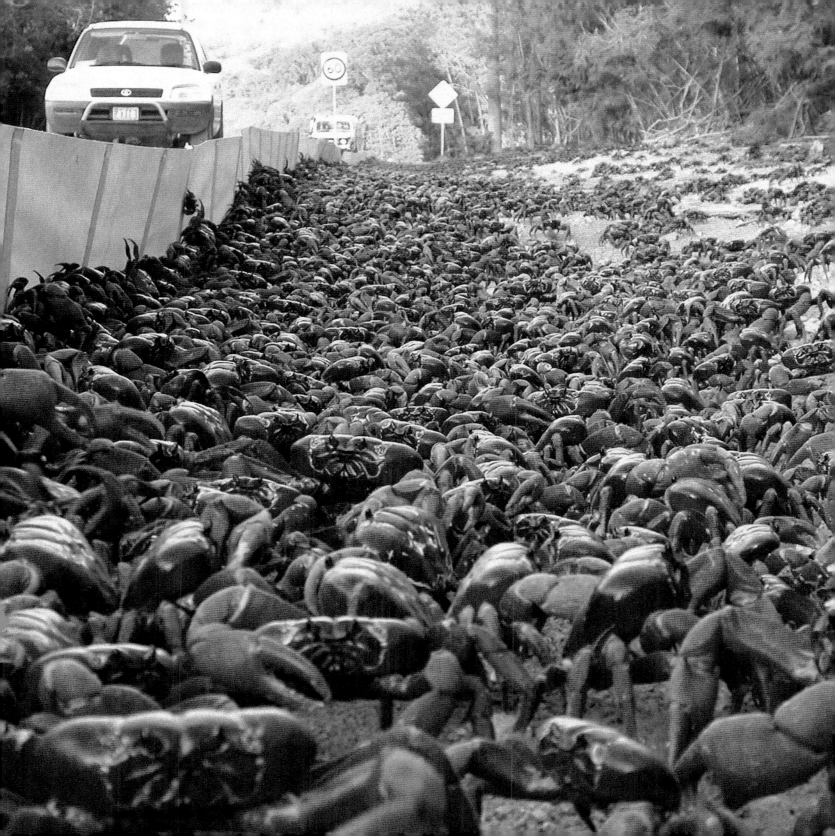

51 PROBOSCIS MONKEYS IN BAKO NATIONAL PARK
MALAYSIA

It is the smallest and oldest of the national parks in Malaysian Borneo's state of Sarawak, measuring a mere 27 square kilometres (10 miles²) in size. Yet packed into this compact jagged peninsula are seven complete ecosystems, together containing almost every plant found in Borneo, and some of its rarest wildlife. Along the wind-sculpted coastline precipitous sandstone cliffs and startling rock stacks are interspersed by small coves and sandy beaches. Gnarled mangrove swamps and forested bluffs give way to an inland landscape of classic lowland rainforest and heath forest snaked by streams and waterfalls. It is a micro-world of weird and wonderful flora and fauna, none more so strange than the 150 proboscis monkeys that call Bako home.

With their large fleshy noses, long limbs and protruding bellies proboscis monkeys are easily identifiable from their primate cousins. Endemic to Borneo they have been classified as endangered, the destruction of their natural habitat for palm oil plantations and hunting for meat having seen numbers dwindle drastically in recent years. Yet Bako is one of the last refuges of this unusual monkey who, despite its substantial size (males can weigh 23kg/50lbs) spends the vast majority of its life leaping from treetop to treetop.

Sharing the forest canopy with the proboscis monkeys are rare silver leaf monkeys and agile long-tailed macaques. Bornean bearded pigs snuffle through the ground vegetation as flying lemurs and several species of squirrel scuttle from branch to branch. Saltwater crocodiles – one of the proboscis monkey's main predators – occupy the brackish mangroves and large monitor lizards, nocturnal pangolins and over 150 species of bird add to the eclectic mix.

Trail-walking in Sarawak's Smallest Park

Bako is a delightfully easy place to visit, yet offers some of Borneo's most impressive wildlife watching opportunities. A series of marked trails weave through the varied landscapes, where even the shiest of animals make frequent appearances. Embark on a day trip from the city of Kuching or for a more immersive experience spend a few nights in the forestry-run campgrounds or bungalows in the heart of the park.

Spend leisurely days quietly tiptoeing through a thriving, living world, where paths are adorned by vivid orchids and carnivorous pitcher plants. Listen carefully for the unmistakable low nasal grunting and snapping of tree branches as comical proboscis monkeys leap through the canopy, and by night creep out in search of the park's bizarre nocturnal inhabitants.

The trails end dramatically at secluded beaches, where wondrously shaped arches and sea stacks coloured bright red by iron deposition make a startling contrast to the deep green of t miles jungle. Take a dip in the refreshing waters, lounge on the sand or hunker down in a rustic lodge ready for another day of exploring.

TAKE ME THERE

How to Visit: Bako National Park is located just 37 kilometres (23mi) from the main Sarawak city of Kuching. Access to the park is by boat from the village of Kampung Bako and there is a range of simple yet comfortable forestry-run campgrounds and bungalows inside the park. The best time to visit is between March and October.

Further Information: The national (www.wonderfulmalaysia.com) and regional (www.sarawaktourism.com) websites offer good travel-planning information. To book one of the campgrounds or bungalows visit the official forestry website (www.forestry.sarawak.gov.my).

Did You Know? With webbed hands and feet proboscis monkeys are the best swimmers in the primate world and can often be seen crashing into the water with an inelegant splash.

Wildlife:
- Long-tailed macaque
- Silver-leafed monkey
- Plantain squirrel
- Bornean bearded pig
- Monitor lizard
- Saltwater crocodile
- Flying lemur
- Slow loris
- Pangolin
- 150 species of bird

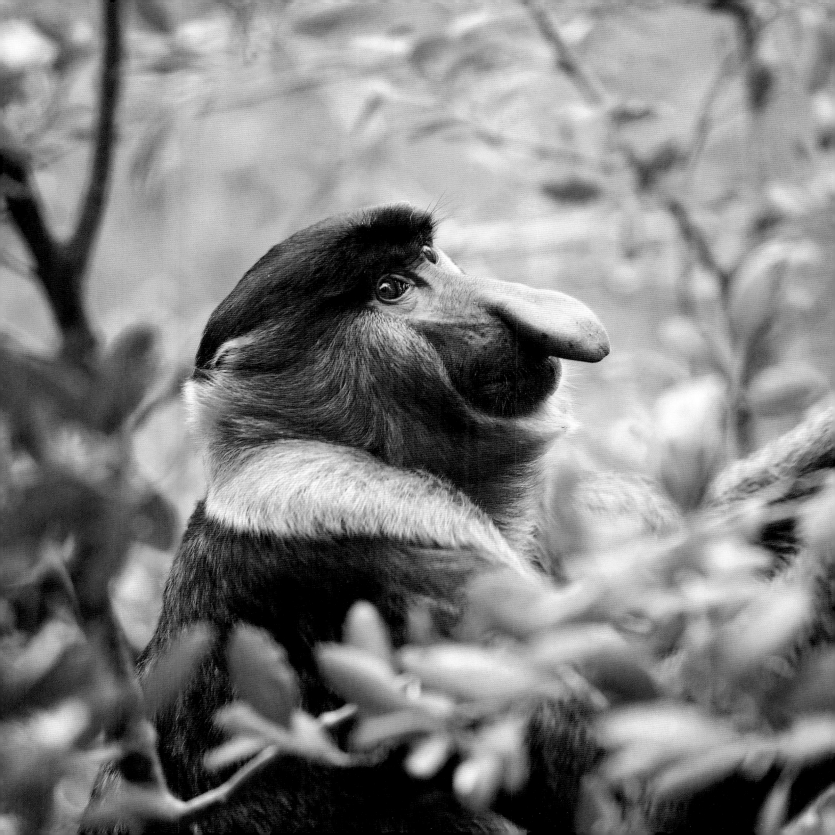

52 AFRICAN ELEPHANTS IN AMBOSELI NATIONAL PARK
KENYA

Mount Kilimanjaro protrudes from Amboseli's flat landscape like a perfect snow-dusted cone sitting on a ring of fluffy white clouds. It towers 5,895metres (19,340ft) over the ancestral lands of the nomadic Masaai below as Earth's highest freestanding mountain. In the heart of a colossal ecosystem which engulfs Kenya and parts of Tanzania is Amboseli, a national park a mere 392 square kilometres (151 miles²) in size, but whose vast herds of great-tusked elephants make it one of the most significant wildlife havens on the planet.

For 30 years the study of Echo, a matriarch elephant who lived her 65 years on these soils, gave the world its greatest insight into the complex and emotional lives of Africa's elephants. Along with her family she starred in numerous documentaries and movies, her trials and joys of life shared by millions around the globe. Echo passed away in 2009 but her legacy continues, and today some 1,400 African elephants roam the savannahs and open plains in herds up to 100 strong.

Not much rain falls in Amboseli – which means Salty Dust – the interminable dry months ravaging the parched ground and the wildlife that inhabits it. Yet life-giving springs from Mount Kilimanjaro's meltwater run-off erupt to the surface in the heart of the park creating a year-round oasis of lush, green marshes. In the dry months, when volcanic ash blows across the horizon, giraffe and zebra, cheetah and spectacular herds of elephants flock to the marshes. When the rains fall, almost in the blink of an eye the landscape changes, seasonal lakes and ponds filling with birds, and the vivid green grasses shooting skywards.

Safari Amongst the Masaii

African elephants are the largest animal to walk planet Earth, their 6,000kg (13,200lb) bodies lumbering yet elegant as they pad softly across the savannah. Here in Amboseli, some of the continent's largest and oldest elephants have become used to the presence of humans, flapping their flag like ears to keep cool in the blistering African heat and plunging themselves into refreshing swamps in total nonchalance.

The national park has long been one of Africa's most visited, and today hotels and lodges ring the perimeter. Yet the charm and romanticism of bygone days, when the sun set behind dusty mobile tents in a hue of coral and salmon and safari clad explorers embarked into lands walked by wildlife and Masaai, is still very much alive. Set up camp in a small boutique lodge or feel at one with the land in an all inclusive no frills campsite and venture into elephant territory on thrilling game drives and guided walks. And, as the sun sets behind Mount Kilimanjaro, follow in the traditions of explorers past with a sundowner cocktail and make a toast to Echo and her descendants.

TAKE ME THERE

How to Visit: Nairobi is the closest airport. Most visit through safari agencies or direct through accommodation which includes large hotels, luxury lodges and back-to-nature camps. The dry season (May to October and January to March) is best for wildlife spotting.

Further Information: The Kenya Wildlife Service (**www.kws.org**) and tourism website (**www.magicalkenya. com**) are good resources. Lodges and campsites include Tortilis Camp (**tortilis.com**), Ol Tukai Lodge (**www.oltukailodge.com**) and Porini Camp (**www.porini.com**). Cheli and Peacock Safaris (chelipeacock.com) and Audley Travel (**www.audleytravel.com**) arrange safari holidays. See also Amboseli Trust for Elephants (**www.elephanttrust.org**).

Did You Know? Elephants' trunks contain 100,000 different muscles which they use to eat 136kg (300lb) of food per day.

Wildlife:
- Leopard
- Cheetah
- Wild dog
- Buffalo
- Giraffe
- Burchell's zebra
- Yellow baboon
- White-bearded wildebeest
- Thomson's and Grant's gazelle
- 600 species of bird

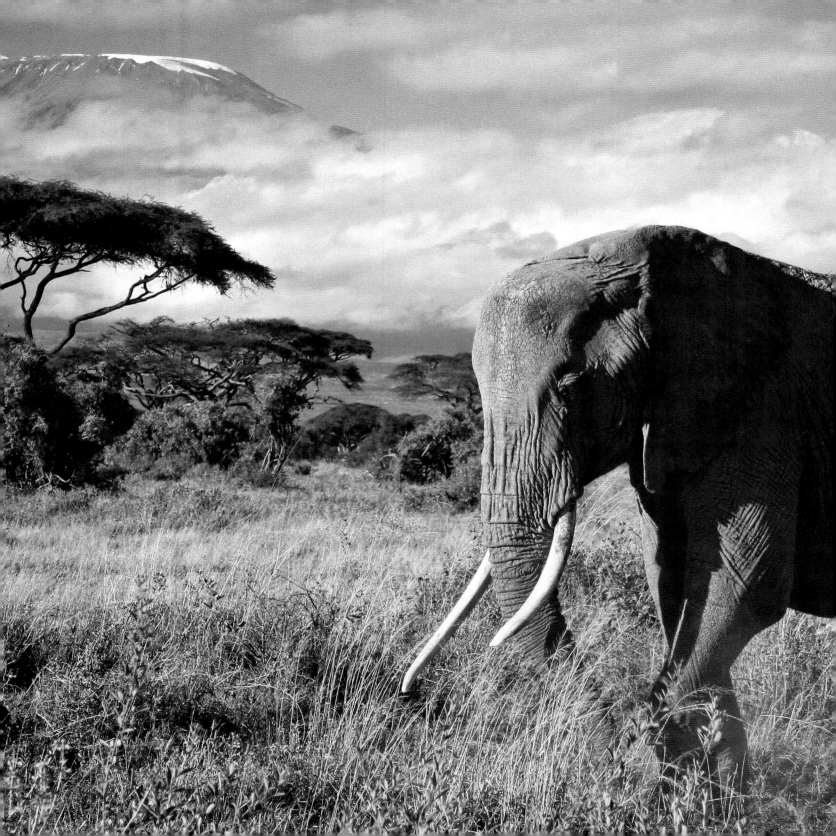

BASKING SHARKS IN OBAN
SCOTLAND

On Scotland's west coast the wild region of Argyll gives way to the Inner Hebrides. It is a place steeped in ancient history, where castles tell the stories of crowned kings and the towering peaks and rolling hills give way to glittering sea lochs and the rugged beauty of the islands. Every summer the quiet, serene little seaside town of Oban transforms into a busy, bustling tourist haven. Known as the 'Seafood capital of Scotland' and famed for its whiskey distilleries it acts as the jumping off point to the islands.

Yet it's not just tourists that come in search of a seafood meal and some of the country's most abundant waters. Between May and September, 10 metre (33ft)-long basking sharks arrive in great numbers to gorge on the explosive blooms of plankton that thrive in these rich, cold, sheltered waters. Weighing up to several tonnes and with a mouth a metre (3ft) wide, the second largest fish in the ocean (after the whale shark) is a gentle giant, feeding only on plankton which it filters through its distinctive gill rakers –a hungry basking shark can filter 1.5 million litres of water per hour.

Hunted both for the oil produced in their livers and for their fins, basking sharks are listed as vulnerable by the IUCN. However, their protected status in Scotland has meant that numbers are increasing and studies have spotted almost 100 individuals on a single day.

Snorkelling with Giants

Their gaping wide mouths and up to two metre (6ft) tall dorsal fins make basking sharks a daunting creature to swim alongside. Yet these gentle sharks are harmless to humans and snorkelling in the frigid Scottish waters is a breathtaking and exhilarating experience.

Heading out of Oban's perfect horseshoe bay protected by islands inhabited by millions of seabirds, shark trips offer the opportunity to swim not only with the basking sharks but to encounter seals and minke whales, dolphins and puffins. It is a wild and undeveloped corner of Scotland, a place where the world's second largest whirlpool of Corryvreckan slurps and gurgles, golden eagles soar over the craggy rock isles and crystal clear turquoise lagoons beg to be swum in.

Accommodation, restaurants and historic buildings abound in Victorian Oban, which makes for the perfect base from which to venture on multi-day shark-snorkelling excursions and forays into the wilds of the Inner Hebrides. Highly experienced guides will scour the ocean's surface for tell-tale signs of the great basking shark before you get kitted up to slip into the chilly waters to come face to face with one of the world's most powerful creatures.

TAKE ME THERE

How to Visit: Multi-day excursions to see and/or swim with basking sharks are based from the town of Oban where there is a wealth of accommodation and tourism options including ferries to the Inner Hebrides. The best time to see the sharks is May to September.

Further Information: There are several operators offering excursions to snorkel with the sharks and explore the outer islands including Basking Shark Scotland (**www.baskingsharkscotland.co.uk**). For more travel information visit the national (**www.visitscotland.com**) or regional (**www.oban.org.uk**) tourism websites.

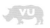

Did You Know? Basking sharks hold the record for the broadest foraging range of any shark, and make regular vertical dives to a depth of up to 1,000 metres (3,280ft).

Wildlife:
- Minke whale
- Dolphin
- Grey seal
- Golden eagle
- Atlantic puffin
- Seabirds
- Orca
- Porpoise
- Harbour seal
- Atlantic salmon

54 BALD EAGLES IN THE CHILKAT BALD EAGLE PRESERVE
USA

The bald eagle is America's majestic national symbol, soaring through the skies with its two metre (7ft) wingspan. While they can be found throughout many of the lower 48 states, in Alaska's Chilkat Preserve they arrive in the largest concentrations on the planet to feast on the late salmon runs.

Bald eagles have lived in the Valley of the Eagles for as long as the Tlingit Natives can remember where, from their village of Klukwan, they live in close harmony with the birds. Between 200 and 400 eagles live year-round amidst the stunning natural beauty of the preserve, where snow-capped mountain peaks, ice blue glaciers and lush forests surround 195 square kilometres (75 miles²) of river bottom land of the Chilkat, Kleheni, and Tsirku Rivers. Yet come the winter months, over 3000 eagles congregate on the flats to feed on the spawning salmon – the largest gathering of bald eagles in the world. It is a late run for salmon that spawn here, encouraged by the upwelling of warm water which stops the river freezing. For over eight kilometres (5 miles) the Chilkat River runs as an alluvial fan reservoir, the flat plains turning into a vast lake when the spring meltwater floods the region.

Virtually every portion of the preserve is used by the eagles throughout the year. Yet it's the great migration that draws the birds in their thousands, an event celebrated by the Alaska Bald Eagle Festival during November in the town of Haines.

Floating Through the Valley of the Eagles

It is a remarkable sight to behold hundreds of bald eagles lining the branches of bare trees, sometimes six or more to a single branch. Swooping down to the snow-dusted river banks they feast on the dying salmon before taking to the skies once again. Grizzlies, black bears and wolves join them, the late salmon run providing a much-appreciated banquet for Alaska's wildlife before the harsh winter sets in.

While it is possible to drive along the Haines Highway and stop at specially-designed pull-outs for photography opportunities, the best way to feel at one with this unique landscape is to embark on a float trip along the Chilkat River. Departing from the nearby town of Haines you set off on a serene nature trip through the river flats as bald eagles watch you with regal interest and 2,000 metre (7,000ft) mountains tower above you. At the confluence of the three rivers you pass the native village of Klukwan, where locals fish for salmon and smoke their catch at the river's edge. It is a grand landscape, where moose leave footprints in the virgin snowfall, trumpeter swans navigate the swollen rivers and eagles' nests adorn the leafless trees.

TAKE ME THERE

How to Visit: Haines is the closest town to the preserve but float trips also run from Skagway. There are plentiful accommodation options in both. The eagles can be seen year round but the best time is October to February.

Further Information: The Alaska Tourism (**www.travelalaska.com**) and Division of Parks and Outdoor Recreation (**dnr.alaska.gov**) websites offer good visitor information. There are several float trip outfits in Haines and Skagway including Alaska Float Trips (**www.alaskafloattrips.com**), Chilkat Guides (**chilkatguides.com**) and Skagway and Haines Excursions (**skagwayexcursion.com**).

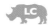

Did You Know? Eagles can fly at 50 kilometres per hour (30mph) and dive at 160 kilometres per hour (100mph). Their incredible eyesight allows them to spot fish up to a kilometre and a half (1 mile) away.

Wildlife:
- Brown bear
- Black bear
- Moose
- Wolf
- Trumpeter swan
- 5 species of salmon
- Mountain goat
- Arctic tern
- Lynx
- River otter

It is a migration that has baffled scientists. Every year hundreds of millions of monarch butterflies undertake an arduous journey 4,800 kilometres (3,000 miles) long from Canada and the United States to their wintering grounds in Mexico. Here they cluster on the branches of the oyamel and fir trees, their sheer numbers causing the boughs to bend under the weight of a butterfly that alone weighs a mere 0.5grams. The skies of Mexico's Michoacán state dance with orange and black butterflies, the fluttering of their wings reminiscent of the light patter of spring rain.

A number of protected sanctuaries within the UNESCO designated Monarch Butterfly Biosphere Reserve have ensured that the important habitats required by the insects are protected and preserved. Covering 560 square kilometers (216 miles²), the forested reserve is high and steep, a haven of dense trees that harbour between six and sixty million butterflies per hectare.

Adult monarchs live only three to four weeks, yet one generation each year – those born in late summer or early autumn – make the migration from the east coasts of Canada and the United States. Yet by the time next year's winter migration begins, several summer generations will have existed and it will be the ancestors of last year's migrators that make the great journey. How they know to follow the same route – some even returning to the very same tree – is the greatest unanswered question of the Monarch butterfly.

Walking in the Kingdom of the Monarchs

It is one of nature's most spectacular events. To stand amidst clouds of butterflies as they flutter through the warm air and land, snuggling into great clumps on the trees is a sight to behold.

There are four sanctuaries in the reserve, the two most visited being El Rosario and Sierra Chincua. Visit under your own steam or as part of a tour, but be prepared for a hike up steep and narrow mountain paths to an altitude above 3,000 metres (10,000ft) where the air is thin and cool. A week long cultural festival, the Festival Cultural de la Mariposa Monarca, takes place at the end of February when the traditional cobblestone towns with their red-roofed buildings celebrate the great arrival of the butterflies.

Travelling at 80–120 nautical miles per day the butterflies glide on warm air currents, coming to land on the trees where they will spend the winter. For the best experience visit when the weather is mildest and the air warms. It is then that millions of 10cm (4in) long butterflies take to the air, their pumpkin-coloured wings engulfing you in their delicate dance.

TAKE ME THERE

How to Visit: The two most frequented sanctuaries are El Rosario near the town of Ocampo and Sierra Chincua near Angangueo. Long day trips are possible from Morelia or Mexico City. The reserves are open daily from mid-November to March. January and February are popular months to visit because the Monarch population is at a peak at this time.

Further Information: Michocan Tourism website (in Spanish only) (**turismomichoacan.gob.mx**) or UNESCO (**whc.unesco.org**).

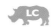

Did You Know? Monarch butterflies were transported to the International Space Station and bred there.

Wildlife:
- White-tailed deer
- Coyote
- Long-tailed weasel
- Grey fox
- Horned owl
- Turkey buzzard
- Hummingbird

They are one of the world's most elusive mammals, found only in the most remote recesses of Central Asia's Himalayan foothills. Yet to catch a glimpse of a perfectly camouflaged snow leopard as it pads elegantly through the wild landscape is one of the most astounding wildlife encounters possible.

In winter the enigmatic cats descend from the high Himalayas to the lower slopes and valleys in the wake of the Bharal (blue sheep). The feral and isolated Hemis National Park is the best place to spot these ghostly big cats, south Asia's largest national park (and the only one in India north of the Himalayas) offering a landscape of snow-blanketed glens, gorges and high altitude mountain ranges. While the world's highest concentration of the endangered snow leopards lives within the refuges of the national park, spotting one is an epic pilgrimage of patience and endurance, where the thin air (the region is 3,300–6,000 metres (10,820ft to 19,700ft) above sea level) and ruggedly beautiful landscape make for an extreme adventure.

To experience the Hemis National Park is more than a quest to encounter the snow leopard. Rare high altitude wildlife thrives in this long-forgotten corner of the world; Tibetan ibex, Argali sheep, wolves, lynx and Eurasian brown bears, and isolated Buddhist communities carve an existence much as they have done for centuries. The namesake of the park is the Hemis Monastery, home to a vibrant pilgrimage festival each year.

Trekking in the Himalayas

There are no driveable roads in the Hemis National Park, and to explore the wilderness is an epic adventure of trekking through a maze of natural pathways. Embark on a 10–14 day odyssey that will take you from Delhi to the town of Leh, the gateway to the national park and the treasures it hides. Staying in villager homestays, backcountry campsites or isolated monasteries, the trips have no fixed itineraries and routes follow the leopard's footprints in the snow.

It is not a trip for the faint-hearted. The weather is harsh and unforgiving, the terrain rugged and mountainous and the air thin. Local trackers and guides use their expertly-honed skills to stealthily trail the leopards and their favoured prey, setting up camp on ridges and embarking on day walks, binoculars in hand, to catch a glimpse of one of the world's rarest and most endangered animals. Under threat from illegal poaching for pelts and use in Chinese medicine, as well as a vanishing habitat, the Hemis National Park's protected boundaries offer a safe haven to the mysterious snow leopard.

TAKE ME THERE

How to Visit: Tour operators offer all-inclusive 10–14 day treks through the park from the town of Leh. Accommodation is camping and homestays. The best time to spot the leopards is late winter.

Further Information: There are several operators offering trips including Exodus (**www.exodus.co.uk**), Nature Trek (**www.naturetrek.co.uk**) and Responsible Travel (**www.responsibletravel.com**).

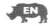

Did You Know? One Indian snow leopard is reported to have consumed 5 blue sheep, 9 Tibetan woolly hares, 25 marmots, 5 domestic goats, 1 domestic sheep and 15 birds in a single year.

Wildlife:
- Tibetan ibex
- Bharal (blue sheep)
- Wolf
- Red fox
- Griffon vulture
- Eurasian brown bear
- Woolly hare
- Tibetan argali
- Pika
- Lynx

Picturesque seaside villages and hamlets line the white sand beaches of False Bay in South Africa's southernmost tip. Brightly painted beach huts and quaint shops hark back to a forgotten era of simple charm and fun by the sea, where swimming, surfing and splashing in the waves while away the summertime hours. It is steeped in seafarer history, where tales of buccaneers, pirates and British Navy arrivals still tumble out of Simon's Town, and visitors share the pristine beaches with clusters of fearless little African penguins.

In the cold, fish-laden waters just off the coast however, the peace and tranquillity is forgotten in a thriving marine ecosystem at the very top of which is the apex predator, the great white shark. Approximately 35 kilometres (21 miles) south of Cape Town is Seal Island, home to thousands of plump Cape fur seals. In this stretch, where warm and cold currents collide, mako sharks and their larger white cousins survive in the ideal conditions, feasting on the plentiful seals.

Charismatic and intelligent, the legendary great white shark has long been feared as a ferocious man-eater. Yet the world's largest predatory shark is anything but, and the majority of attacks worldwide have been attributed to a case of mistaken identity or simple curiosity. They grow to an average of 4.6 metres (15ft) in length, though individuals over 6 metres (20ft) and weighing up to (2,268kg (5,000lbs) have been recorded.

Cage Diving with Great White Sharks

In the seal-laden waters off False Bay great whites breach in numbers not seen elsewhere in the world. Despite their huge size, their streamlined torpedo-shaped bodies and powerful tails can propel them through the water at speeds up to 24 kilometres (15 miles) per hour. Launching fatal attacks on unsuspecting seals they burst from the water in a great, splashing breach. It is an awe-inspiring sight to behold.

Embark on an exhilarating and not-for-the-feint-hearted adventure from Simon's Town in search of great white sharks and delve into their watery world. Look out for humpback and southern right whales on your way to False Bay where the ominous fins of white sharks protrude from the water as they scour the surface for seals. Wait with baited breath for a great splashing explosion as they leap into the air and crash back into the turgid seas with a loud crack. It is then time to get suited up and, scuba gear in place, step into a cage to meet the world's largest predator face to face. Cage diving is an unforgettable experience from where you can look into the eyes of a curious white shark, some of the world's biggest having been spotted in these very waters.

TAKE ME THERE

How to Visit: A short distance from Cape Town, False Bay can be visited as part of a day trip or there are plenty of excellent accommodation options in towns such as Simon's Town from where the majority of great white shark trips run. The best time to dive with the sharks is February to September.

Further Information: The Cape Town tourism website (**www.capetown.travel**) is a good first resource and there are dozens of reputable shark tour operators including Apex Shark Expeditions (**www.apexpredators.com**), Shark Explorers (**www.sharkexplorers.com**) and African Shark Eco-Charters (**www.ultimate-animals.com**).

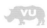 VU

Did You Know? Great white sharks can detect one drop of blood in 100 litres (25 gallons) of water and they can sense even a little blood up to 5 kilometres (3 miles) away.

Wildlife:
- Southern right whale
- Humpback whale
- Cape fur seal
- Mako shark
- Peninsula baboon
- African penguin
- Barracuda
- Hawk
- Buzzard
- Kestrel

IBERIAN LYNX IN ANDALUCIA
SPAIN

The Iberian lynx stands as the most endangered big cat on the planet. Verging on the brink of extinction it numbers just 300 individuals which inhabit isolated strongholds of Spain's remote Andalucian countryside. It once roamed the Iberian peninsula in great numbers, its striking spots and black ear tufts highly recongnisable. Yet by the early 2000's just 100 of the animals remained, their demise attributed to decreasing rabbit populations, habitat loss and illegal hunting. However, massive conservation efforts between the WWF and LIFE Iberlince has seen the lynx populations bounce back, and the IUCN has declassified them from critically endangered to endangered. There is still a long way to go before the Iberian lynx once again wanders further than the isolated pockets of Andalucia, but conservationists are determined to pull it back from being the first big cat to become extinct in 2,000 years.

Just two populations of lynx exist today, one residing in the wetlands and pine woodlands of the Coto Doñana National Park and the other amidst the Sierra Morena mountain range in the Sierra de Andújar Natural Park. On the banks of the Guadalquivir River, at its estuary on the Atlantic Ocean, Coto Doñana is a patchwork of habitats, and one of the most important wetlands in Europe. Some 50,000 waterfowl winter here amongst the marshes and lagoons, lakes and dunes, and wild boar, snakes, red deer and badgers take shelter in the pine forests.

In contrast is the gently rolling Sierra de Andújar, a vast expanse of Mediterranean forest and rocky hills through which threads the Yeguas River. Rare and endangered species exist here, the wolf, black vulture and imperial eagle amongst them.

Ambling Through a Traditional Spanish Landscape

With only a few individuals in existence, spotting one of the elusive cats is no easy feat. Yet patience is often rewarded for those who embark on guided tours of the two parks, where birds and other wildlife promise to entertain you until you catch sight of one.

Set off on a trip through an unblemished Spain, where traditional bucolic villages nestle into the landscape, and stone-built *fincas* (farmhouses) provide authentic accommodation. Under the setting Andalucian sun, dine on local delicacies and sip deep red wines as you prepare for days of tranquil wildlife watching in the national parks. In the mountains of Andújar, red and fallow deer, mouflon, otter and wild boar are commonly sighted, whereas birds take centre stage in the Coto Doñana wetlands where flamingos, herons, egrets, white and black storks, and spoonbills share the waters with thousands of wintering geese. It is an unspoilt part of the country, where sheep bells toll in the distance and the balmy air is thick with the scent of wild rosemary and lavender.

TAKE ME THERE

How to Visit: The best chance to see an Iberian lynx is with a professional guide as part of a two destination tour visiting both national parks. All inclusive tours go in search of lynx, birds and other wildlife, staying in local villages and rural hotels.

Further Information: The Andalucia tourism website (www.andalucia.org) is a good starting point. There are several tour operators offering specialist lynx and birding trips including Nature Trek (**naturetrek.co.uk**), Heather Lea (**www.heatherlea. co.uk**) and Iberian Wildlife Tours (**www.iberianwildlife.com**). For further information on conservation efforts visit UNESCO (**whc.unesco.org**) and WWF (**wwf.panda.org**).

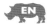

Did You Know? Cars are a huge threat to the Iberian lynx. In 2014, 22 animals were killed by vehicles – a very high number for a species with such a small population.

Wildlife:

- Wild boar
- Red deer
- Fallow deer
- Wolf
- Vultures (Griffon and Black)
- Spanish imperial eagle
- Otter
- Shorebirds
- European badger
- Egyptian mongoose

GIANT ANTEATERS IN CANASTRA NATIONAL PARK
BRAZIL

Seen from a distance the great massif of Serra da Canastra resembles a basket fit for a giant (canastra meaning basket). The national park in Brazil's state of Minas Gerais encompasses a strange and beautiful landscape of grassy, treeless plateaus bordered by gushing waterfalls, forested streams and emerging springs. Split in two by an enormous escarpment, the highland is rolling golden grasslands known as *cerrado* and, in the lower valley, the Rio São Francisco bubbles to the surface, lavishing life on an otherwise arid region of the country. It carves its way through the forests, leaving behind clear pools and waterfalls before continuing 3,161 kilometres (1,964 miles) to the Atlantic Ocean.

Cataguazes Indians once inhabited these lands, and 17th and 18th century prospectors made their fortunes from Minas Gerais' abundance of gold and diamonds. Today, however, nothing but wildlife inhabits the UNESCO World Heritage national park. It is an eclectic and alluring gathering of wildlife, yet the park is most famous for being one of the best places in the world to spot giant anteaters. With their long snouts to the ground, anteaters spend their days sniffing out ants and termites, their incredible 50cm (20in) long tongues flicking up to 160 times per minute and consuming 35,000 stinging insects a day.

Maned wolves tiptoe across the grasslands, their long limbs, red coats and dark bushy manes startling contrasts to the pale blonde grasses. Neither a wolf nor a fox, they are the only species in the genus Chrysocyon (meaning golden dog). The rare Pampas deer feeds on roadside grasses, striped hog-nosed skunks emerge under the cover of darkness, rattlesnakes and boa constrictors slither through the cerrado, and the odd-looking armadillo carts its armoured body through the brush.

Jeep Trips Through The Forgotten Savannah

The open savannah of the cerrado is a wildlife enthusiast's dream. In the early morning and late afternoon, animals emerge from the cover of the dark lower forests, inhabited by mighty waterfalls, fairy pools and a myriad of birds. The park is one of Brazil's best-kept secrets (only 2,500 people visit every year) and low-key tours by jeep, on foot or by horseback set out from the charming little towns on the fringes of the park.

Poor eyesight, bad hearing and an all-encompassing concentration on sniffing means anteaters are relatively easy to get up close to. Stay still and downwind and the two metre-long (6.5ft) animals – females often carrying babies on their backs – could wander right past in total oblivion. Maned wolves hunt in the early and late hours of daylight, great rheas tear across the horizon and armadillos attempt camouflage with their rock-like shells. In the forests, palms, bamboos and giant ferns hide hummingbirds, king vultures and one of the world's most endangered waterfowl, the Brazilian merganser.

TAKE ME THERE

How to Visit: São Paulo is the closest international airport from where there are domestic flights to the state of Minas Gerais. The town of São Roque de Minas is the gateway to the park and has several guesthouses. It's possible to visit the park independently or with a guided tour.

Further Information: Visit Brazil (**www.visitbrazil.com**) is a good starting resource, and UNESCO (**whc.unesco.org**) provides interesting information about the park. There are many tour operators including Refresh Ecotours (**www.refreshecotours. com**) and Nature Brazil Tours (**www.naturebraziltours.com**).

Did You Know? Slow and unaggressive though they may seem, anteaters can be feisty, rearing onto their back legs and lashing out with razor-sharp, 10cm (4in)-long claws.

Wildlife:
- Giant armadillo
- Maned wolf
- Striped hog-nosed skunk
- Pampas deer
- Rattlesnake
- Boa constrictor
- Greater rhea
- King vulture
- Hummingbird
- Brazilian merganser

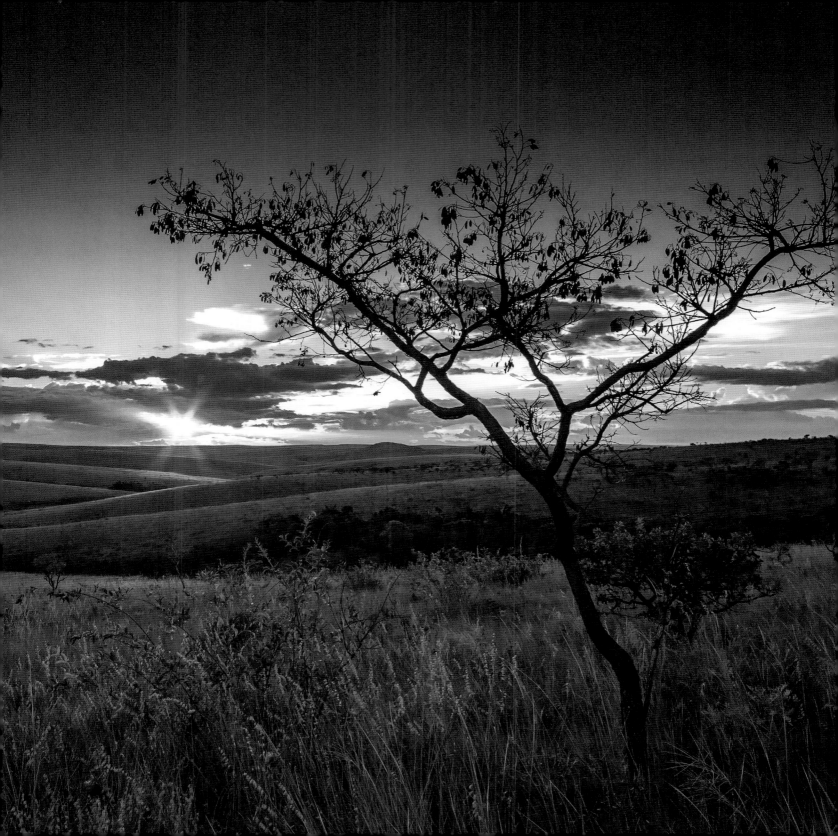

60 GREY WOLVES IN YELLOWSTONE NATIONAL PARK
USA

Yellowstone hasn't much changed since the days when the first white man, John Colter, stepped foot in a land mockingly called 'Colter's Hell' by those who disbelieved his accounts of a place of fire and brimstone. Herds of shaggy bison still roam the sprawling Wyoming grasslands in their thousands and steam spurts from holes in the earth's crust. It is a captivating landscape of bizarre geothermal activity, perfect alpine Rocky Mountain ranges, roaring rivers, tumbling waterfalls, and ancestral wildlife. While Native American Indians no longer hunt these lands, great herds of elk graze amidst the thick pine forests, bighorn sheep clamber on rocky precipices, and bears – grizzlies and black – amble through wildflower meadows. The most abundant wildlife in the lower 48 states thrives here, in a place that despite being visited by 3 million people a year remains a true wilderness of coyotes, badgers, red foxes, bobcats, raccoons, moose, beavers, otters, bald eagles and mule deer.

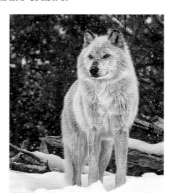

In the 1930's grey wolves were completely killed off in Yellowstone in an attempt to protect the elk from being preyed upon. The eradication might have worked in one sense, but a devastating ripple effect shuddered across the landscape affecting many of the region's species. In 1995 wolves were reintroduced to the park and the regenerative effects of their presence is astounding. Beaver colonies now flourish (with less pressure from rising elk populations on willow sources) and scavengers such as ravens, eagles, magpies, coyotes and bears enjoy the fruits of wolf-killed elk carcasses. It is one of the best places in the world to encounter wolves in their natural habitat, a wild and vast landscape roamed by one of the most fascinating predators on the planet.

Snow-shoeing in the Footprints of the Wolf

Yellowstone isn't the kind of place you can visit in a day. It is a place to savour and explore, a place where you should both venture off the beaten path and photograph the iconic sights. There are 1,800 kilometres (1,100 miles) of trails to be hiked in summer or skied in winter, stars to be camped under and streams to be fished. Kayak past lakeside geysers, horse-ride through herds of ambling bison and discover the park's long history from its Native American heritage to its dinosaurs and gold mining. Over 400 wolves inhabit most of the park, especially the northern ranges, and dawn and dusk is the best time to spot these impressive pack animals. Embark on an autumn or winter wolf-spotting tour with a trained biologist or naturalist from the Yellowstone Association Institute to learn about their reintroduction, habitat and life cycle. Pad in snowshoe-clad feet across a white landscape broken only by spouting geysers, vast canyons and gushing waterfalls as you search for tell-tale footprints of the grey wolf.

TAKE ME THERE

How to Visit: There are domestic airports in Cody, Jackson and Idaho Falls and the international airports in Salt Lake City and Denver. There is no public transport within the park but tour companies offer trips. There is a variety of accommodation options both inside the park and within the surrounding valley.

Further Information: The National Parks Service (www.nps.gov) offers a comprehensive visitor's guide, and there is a wealth of information on www.yellowstonepark.com. Wolf-spotting packages are offered by a variety of outfits including Yellowstone National Park Lodges (www.yellowstonenationalparklodges.com).

Did You Know? Half the geothermal features and two thirds of the all the geysers in the world are concentrated in Yellowstone National Park.

Wildlife:
- Bison
- Elk
- Bighorn sheep
- Bobcat
- Bald eagle
- Beaver
- Black bear
- Mule deer
- Brown bear
- Coyote

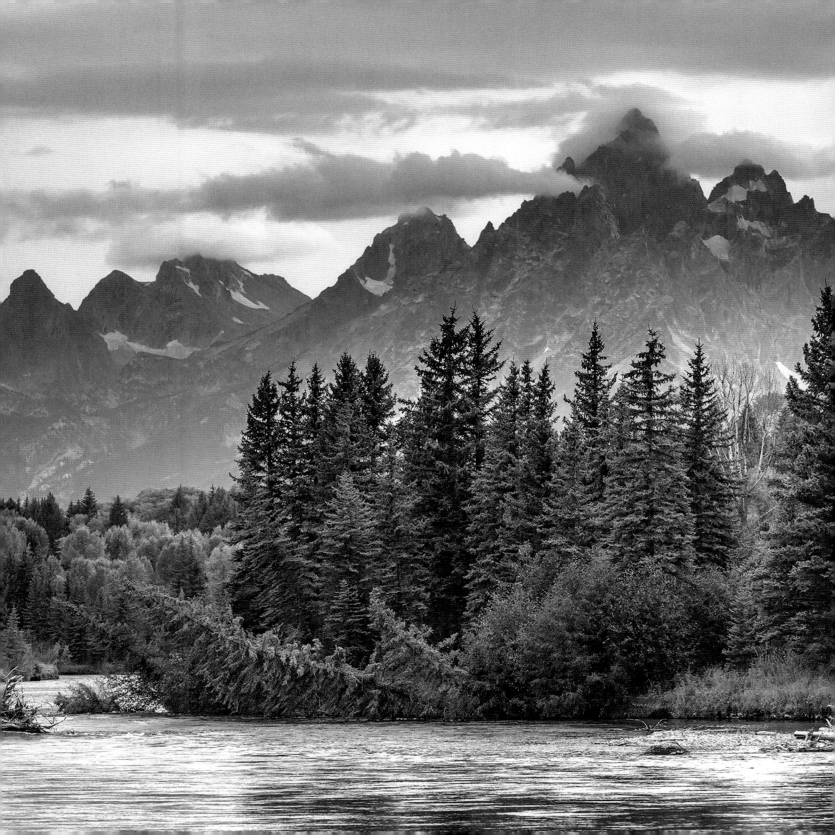

61 DUSKY DOLPHINS IN KAIKOURA
NEW ZEALAND

When a Maori man named Tama Ki Te Rangi arrived here several hundred years ago he discovered a vast abundance of crayfish in the chilly waters. He named the place 'Te Ahi Kaikoura a Tama ki Te Rangi' – the fire that cooked the crayfish of Tama ki Te Rangi. Today it is known as Kaikoura (kai meaning food and koura meaning crayfish), and the shellfish are still feeding the 3,800 residents, thousands of yearly visitors and the teeming populations of marine life.

The Kaikoura Peninsula is rugged and beautiful, a dramatic landscape where imposing, snow-capped mountain peaks tumble down to meet a patchwork of farmland which stretches to the shores. Here, in the choppy cold waters, tectonic plates collide and strong ocean currents converge, dropping off the continental shelf to depths of almost a kilometre. It is the perfect feeding ground, a rare combination of factors converging to form one of the healthiest marine environments on the planet.

In the sheltered, rugged bays of the Kaikoura Peninsula acrobatic and sociable dusky dolphins dance in pods up to 500 strong, flipping and twirling in the air. To swim with these creatures is a breathtaking experience, man and nature coming together to play and interact in a truly wild setting. Yet the dolphins are far from alone. Giant sperm whales vie for their spot in centre stage and playful fur seals inquisitively inspect snorkelers. An array of seabirds including albatross, petrels and shearwaters fill the skies, and the Little blue penguin – the world's smallest – waddles endearingly down the beaches.

Swimming with Wild Dolphins

Encased in a second skin of thick neoprene and with your mask and fins in place you take a deep breath before slipping off the boat into the frigid waters. All around you small dusky dolphins whizz in a frenzy of playfulness and curiosity. Shooting past you they spin around and return for a closer inspection, locking eyes with you and inviting you to join the game with an excited repertoire of clicks and whistles. It is an astounding and humbling experience to enter the realm of these intelligent and social animals, and have them reciprocate with such unabashed enthusiasm.

Kaikoura is the ultimate New Zealand eco-tourism destination, and visitors come to embrace the great outdoors and the wildlife that inhabits it. Whale-watching tours spot not just sperm whales but orcas and occasionally humpback, beaked, blue, minke, sei, fin and pilot whales too. Swim with seals, visit a penguin colony and listen to the chorus of squawks and calls of the millions of seabirds big and small. By night hunker down in a campsite or friendly B&B and join your newfound aquatic friends with a meal of fresh cold-water crayfish.

TAKE ME THERE

How to Visit: The town of Kaikoura on New Zealand's south island is a popular tourist destination and well geared towards visitors. Accommodation ranges from simple backpacker hostels and campsites to B&B's, farm stays and lodges. The dusky dolphins are year-round residents and so can be sighted at any time.

Further Information: The national (**www.newzealand.com**) and regional (**www.kaikoura.co.nz**) tourism websites offer a wealth of trip-planning information. There are several good dolphin, whale and seal spotting outfits including Encounter Kaikoura (**www.encounterkaikoura.co.nz**).

Did You Know? The dusky dolphin was originally going to be called the Fitzroy's Dolphin – a name given to them by Charles Darwin.

Wildlife:
- Sperm whale
- New Zealand fur seal
- 7 species of albatross
- Little blue penguin
- Humpback whale
- Orca
- Pilot whale
- Seabirds
- Hector's dolphin
- Blue cod

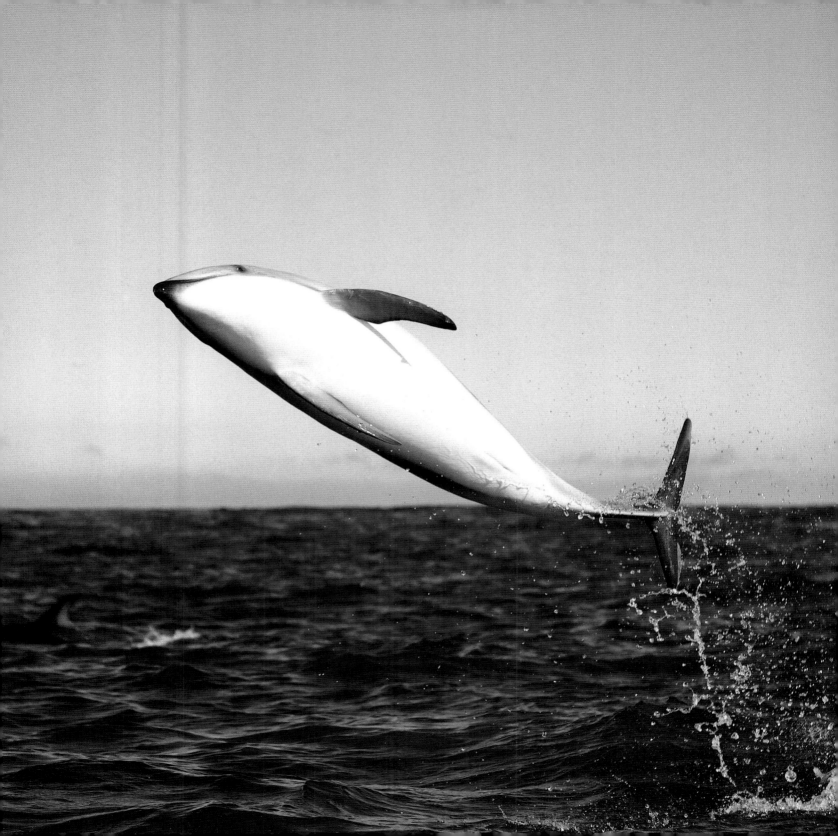

62 BENGAL TIGERS IN RANTHAMBORE NATIONAL PARK
INDIA

The name Ranthambore has long been synonymous with the majestic Royal Bengal tiger. In India's largest and most famous national park it roams in slowly growing numbers, carving out an existence amidst the wild jungle, ancient temples and lakes teeming with crocodiles. Once the royal hunting grounds of the Maharajas of Jaipur, Ranthambore sits at the edge of a plateau bound by coursing rivers. The 10th century hilltop fortress to which the park owes its name looms over the tangle of jungle below. In it lives a staggering diversity of wildlife.

Bengal tigers account for half of all the world's tigers, yet a question mark still hangs ominously over their fate. Hunted as trophies and for Chinese medicine, three of the eight subspecies of tiger became extinct during the 20th century, a practice which sadly continues. In 2014 just 2,226 Bengal tigers existed in all of India. But these figures are a promising improvement from the 1,706 in 2010, a result of the country's conservation efforts against poaching. Today the park is the best place in the world to witness these powerful, top-of-the-food-chain predators as they wander openly under the blistering Indian sun.

While the tigers are undoubtedly the kings of Ranthambore's forests, they are by no means alone. Leopards, striped hyenas, jackals and caracals join the predator list, and ungulates include chital, sambar and nilgai. Wild boars charge through the undergrowth, cobras, pythons and vipers slither silently, and the black, shaggy-haired sloth bear emerges timidly under the cover of dark.

Jeep Safari Amidst Royal Jungle Forts
To see one of the planet's most endangered animals padding just metres from your safari jeep is one of the premier wildlife experiences. While it is true that you will never have Ranthambore to yourself – indeed tours to the much sought-after 'core zone' can be booked months ahead – the presence of fellow humans cannot detract from the abounding nature.

Take a step back in time in one of the luxury camps on the fringes of the park, where canvas tents furnished in Edwardian décor will transport you to the 1920's and the romanticism of the era's safaris. In open-top jeeps you enter the heart of the jungle, passing giant banyan trees and ancient hunting pavilions which long ago succumbed to the ravages of the forest. Birds flutter overhead in their hundreds and deer tread daintily. It might not be on your first or even second safari, and for the unlucky few the tigers might not appear at all, but when the largest cat on the planet steps proudly out from beneath the canopy onto the dusty path in front of you, it is a sight never to be forgotten.

TAKE ME THERE

How to Visit: Sawai Madhopur is the gateway to the park and has a variety of accommodation options and a train station connecting to major cities. Jaipur 160 kilometres (100 miles) away is the closest airport. The sanctuary opens 1st October to 30th June, with prime wildlife-viewing November and May. Safaris can be booked through hotels.

Further Information: The tourism authority (www.incredibleindia.org) and national park (www.rajasthantourism.gov.in) provide good information. There are dozens of resorts and camps including Oberoi Vanyavilas (www.oberoihotels.com), Sher Bagh (www.sujanluxury.com) and Ranthambore Bagh (www.ranthambhore.com).

Did You Know? Although they often eat less, a hungry tiger can consume as much as 27kg (60lbs) of meat in one night.

Wildlife:
- Leopard
- Indian wild boar
- Sambar
- Striped hyena
- Sloth bear
- Nilgai
- Chital
- Marsh crocodile
- Cobra
- Desert monitor lizard

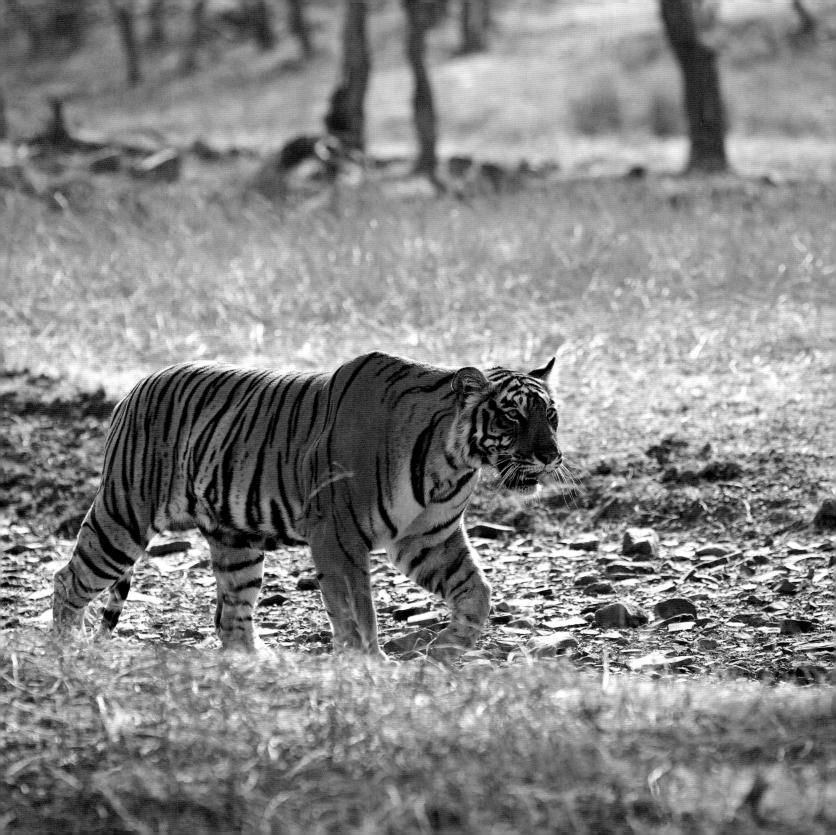

Two to three million years ago, in the heart of Africa's Great Rift Valley, a volcano so large it eclipsed even the mighty Mount Kilimanjaro exploded with such ferocity that it collapsed in on itself, creating a vast crater known as a caldera. It is 19 kilometres (12 miles) wide, a dormant and perfectly formed giant bowl of wilderness in which 25,000 animals roam in nature's very own reserve.

It is often dubbed Africa's Garden of Eden, for wildlife wanders the Ngorongoro Crater in numbers few other places on the great continent can rival. In the flat basin, where acacia trees provide shade from the hot African sun, it is the ungulates that number in the millions, black rhinos, elephants, zebras, eland, gazelles, reedbucks and warthogs grazing on the savannahs and grasslands. The rains bring life to this hot yet fertile cauldron, and streams wind their way from the upland forests through sprawling grasslands to feed lakes and swamps inhabited by lumbering hippos. Yet the most incredible sight is undoubtedly the great wildebeest migration. Come December, 1.7 million wildebeest, 470,000 gazelles and 260,000 zebras thunder across the Serengeti Plains on their route south, returning a few months later in June.

In the midst of this veritable feast Ngorongoro's predators are spoilt for choice, cheetahs, leopards and hyenas never short of an easy meal, while lions laze in the short grasses in close-knit prides in what is the densest population in the world. Further up the 610 metre (2001ft)-high crater rim, monkeys, baboons, elephants, buffalo and jackals take shelter in the thick montane forests.

Safari in a Snow Globe

Both the wildebeest migration and the possibility of seeing the Big 5 –the African buffalo, black rhino, elephant, lion and leopard – are the park's greatest draws. Yet the true marvel is the sheer numbers of animals that roam the basin floor, millions of individuals stampeding and grazing in herds thousands strong.

Safari lodges dot the perimeter of the gated park in a mixture of new and old, many dating to the 1930's and 40's when Europeans first started travelling to Ngorongoro. Green lawns mowed by grazing zebras stretch out before them and, as night falls, the air fills with the sounds of nature's calls. It is the perfect base from which to set off into the crater on a safari reminiscent of being trapped inside a wildlife-laden snow globe. All around you life thrives in a perfectly balanced ecosystem, skittish deer and antelope no match for the expert agility of the great predators, and lumbering elephants and stout rhinos and hippos plodding along.

TAKE ME THERE

How to Visit: Many people visit as part of a safari tour including the Serengeti. The town of Arusha is the gateway to the crater which can be accessed from Kilimanjaro International Airport or Nairobi Airport, Kenya. 4x4 vehicles will take you from Arusha into the crater. There are many hotels and lodges in the vicinity.

Further Information: The Ngorongoro Conservation Area (**www.ngorongorocrater.org**) is a good source of planning information, and UNESCO (**whc.unesco.org**) offers more background on the ecology, culture and conservation of the region.

Did You Know? It is believed that the Ngorongoro Crater volcano was originally taller than, or as high as Mount Kilimanjaro.

Wildlife:

- Cheetah
- Leopard
- Hyena
- Lion
- Monkey
- Baboon
- Elephant
- Buffalo
- Jackal
- Flamingo

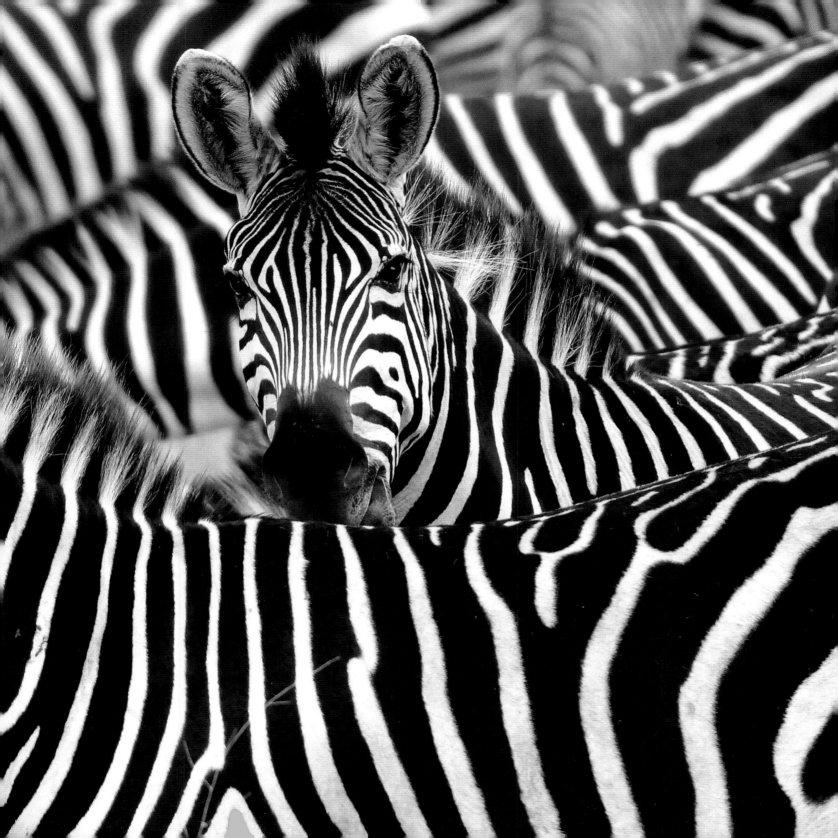

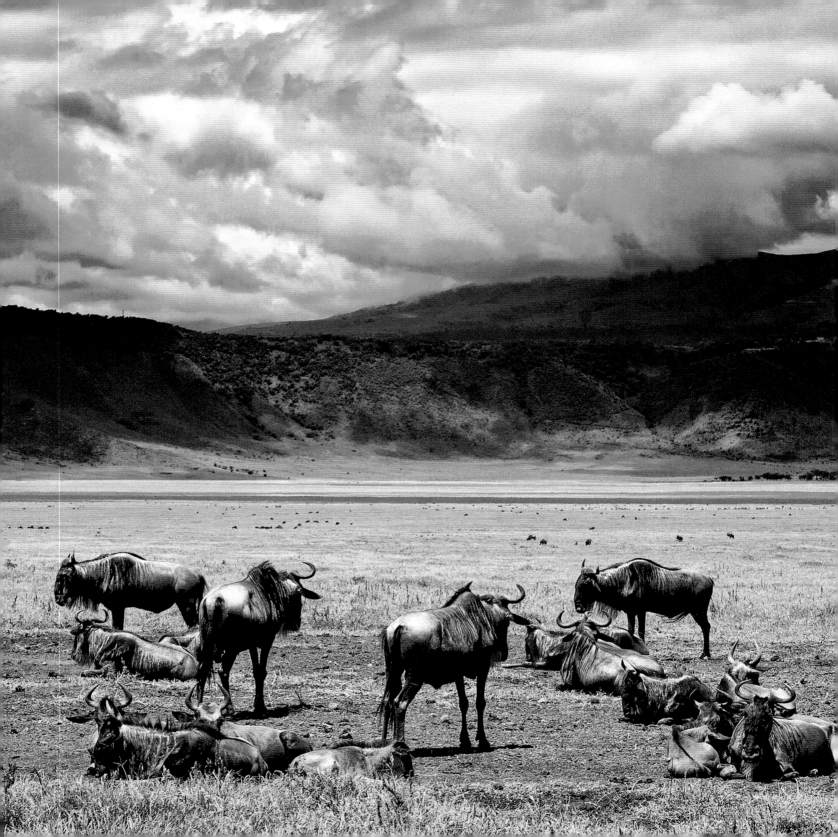

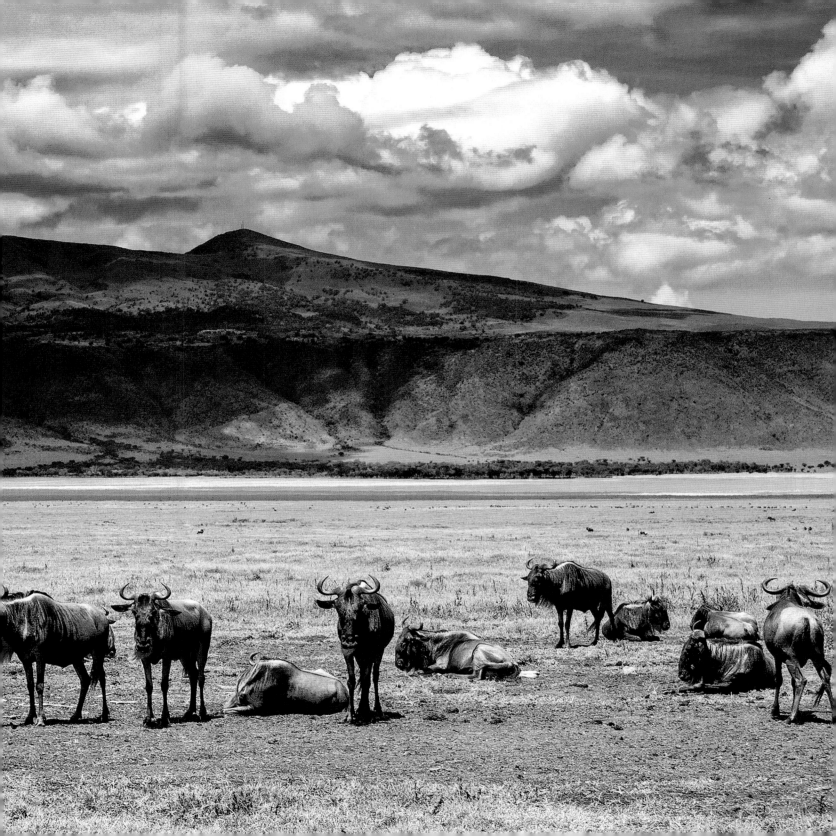

Greenland is unfathomably vast, the largest island in the world with an area of 2,000,000 square kilometres (772,204 miles²) – bigger than Great Britain, France, Germany, Spain and Italy combined. Dramatic and unspoilt it is a fascinating world of gargantuan ice rivers, swirling northern lights and thriving arctic wildlife.

On the west coast, the 56 kilometre (35 mile)-long Illulissat Glacier dominates the landscape, tearing down from the Greenland Ice Cap faster than any other in the world – at a rate of 40 metres (131ft) per day – and shedding great chunks of ice into the frigid seas of Disko Bay. For 4,400 years people have lived on the shores of Disko Bay, its nutrient-rich waters feeding great schools of halibut and shrimp and fuelling a flourishing fishing economy.

Under the surface of the bay, strewn with great discarded lumps of ice, the cold seas are teeming with life. The vast schools of fish bring with them seals and Greenland sharks, fin, minke and occasional blue whales. Yet in the winter and early spring months, just two species remain, the ghostly white beluga whale and the mystical-looking bowhead. The mighty Ice Whale – which is 20 metres (65ft) long and can live to a ripe old age of 200 – frequents the waters of Disko Bay for a few short months before heading off into Baffin Bay. A chunky, dark-coloured whale without a dorsal fin the bowhead lives entirely in the Arctic region, its thick blubber – the thickest of any whale at 50cm (20in) – helping it survive the frigid winters.

Sailing Through Disko Bay

Visitors to Ilulissat – whose names quite aptly means 'icebergs' – will find a remote, frosty and stunning wilderness, and a hospitable, modern people immensely proud of their home. Around 4,000 people and 5,000 husky dogs live in the charming little town of Ilulissat, making it Greenland's third largest town, although no roads lead here and, like much of the enormous country, it is accessible only by air and boat.

Embark on a week-long cruise aboard an elegant sailing schooner into the heart of Disko Bay in search of Bowhead whales and other arctic wildlife. Sail amidst the dramatic coastal glaciers and islands of Hunde and Kronprinsens Ejlands in the mouth of the bay, whose rich waters attract seabirds and whales. Cruise past the mighty Illulissat Glacier – one of whose icebergs is believed to have sunk the Titanic – or make Zodiac landings on Disko Island, steeped in old legends of seafarers and witches, or hike the mainland tundras where reindeer roam. While bowheads are the main attraction, and sightings are highly likely, the voyage encompasses the true spirit of exploration, where the mysteries of this Arctic realm and the creatures that inhabit it are revealed.

TAKE ME THERE

How to Visit: Flights go to Greenland's capital Nuuk from Reykjavík, Iceland and Copenhagen, Denmark, and from there on to Ilulissat. Luxury, adventure-filled week-long cruises explore Disko Bay and Aasiatt. May and June are the best times for finding bowhead whales.

Further Information: Visit Greenland (**www.greenland.com**) has a wealth of travel information to help with planning a trip. Several outfits offer sailing cruises including Wild Wings (**www.wildwings.co.uk**) and Aqua Firma (**www.aqua-firma.co.uk**).

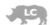

Did You Know? The Illulissat Glacier calves approximately 46 cubic kilometres (35 cubic miles) of ice annually – the melted equivalent would supply all of the USA's water needs for a year.

Wildlife:
- Humpback whale
- Beluga whale
- Harp seal
- Ringed seal
- Bearded seal
- Arctic fox
- Arctic hare
- Snowy owl
- King Eider
- Seabirds

Some 700 islands and 2,400 cays make up the Bahamas, the bottle-green Caribbean Sea swirling in between the mangroves and beaches, blue holes and coral reefs. It is quintessentially Caribbean, a place steeped in pirate lore – the infamous Blackbeard once lived here – and put on the map by Christopher Columbus. The bustling capital of Nassau exudes a feverish charm, and remote islets remain untouched and pristine. Visitors arrive in search of paradise, where the beaches are truly powder white, the sea ripples invitingly and the waters are teeming with all manner of aquatic life. For alongside turtles and dolphins, stingrays and a myriad of tropical fish the Bahamas are renowned as the shark capital of the world.

It was over 20 years ago that the Bahamanian government declared a fishing ban on all sharks, preserving the tepid clear waters for these awesome predators. Today the Bahamas' sharks are thriving, offering one of the best places on the planet in which to see them in their natural habitat. Caribbean reef sharks outnumber other species, clustering off Grand Bahama where co-ordinated feeding allows for up-close experiences. In Tiger Bay, also off Grand Bahama, inquisitive tiger sharks saunter their way over the sand banks in search of an easy meal to get hair-raisingly close to divers, while out in the deep blue near Cat Island, vast pelagic oceanic whitetips appear in April and May. From lemon sharks in the mangroves to the rare great hammerheads and bull sharks off the coast of remote Bimini Island, the variety of species and opportunities for diving with them are endless.

Diving in Glassy Waters

The unspoilt reefs, historic wrecks, spectacular walls, dramatic blue holes and shadowy caves of the Bahamas would alone make it one of the best diving destinations in the world. But add to that the chance to swim with (and probably get bumped by) some of the ocean's top predators and it takes on a completely new appeal.

Chumming is common practice at most shark sites and, carefully orchestrated by dive professionals, the sharks are lured in by the promise of a free and easy meal. Some dives venture along walls where other marine life flourishes, while others are choreographed to entice the sharks. Kneeling on the sand it is an awe-inspiring experience to have dozens of sharks writhing around you, bumping against you as they tussle for the best snacks. In the murkier waters of the fishing harbour at Bimini Island, cage diving is the safest way to get eye-to-eye with the bulky frame of a bull shark, and out in the deep azure waters oceanic whitetips wait patiently for a marlin to be reeled in to the boat before making an impressive lunge.

TAKE ME THERE

How to Visit: There is an international airport in Nassau and good domestic air and boat connections to other islands. From luxury resorts to modest guesthouses, every type of accommodation is on offer. There are many reputable dive operators offering a variety of shark dives.

Further Information: The official tourism website (www.bahamas.com) has a list of dive operators and detailed travel information. There are several good dive operators including Stuart Cove (**www.stuartcove.com**).

Did You Know? You are more likely to die from a falling coconut, lightning strike, cows, horses, falling out of bed and even vending machines than you are from a shark bite.

Wildlife:
- Caribbean reef shark
- Silky shark
- Nurse shark
- Tiger shark
- Great hammerhead shark
- Black tip shark
- Lemon shark
- Oceanic whitetip shark
- Bull shark
- Dolphin

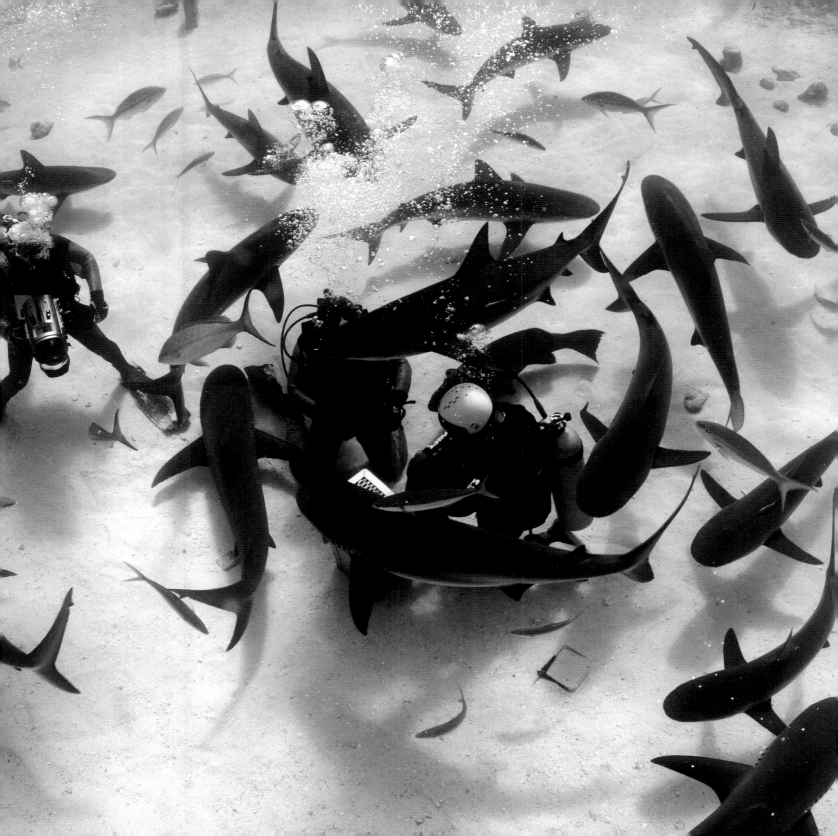

When the glaciers of the last Ice Age retreated in what is today Canada's Ontario Province they left behind a dazzling landscape. In the Algonquin Provincial Park – the country's largest park at 7,653 square kilometres (3,000 miles²) – jagged cliffs and rocky ridges protrude like pointed teeth from a swathe of thick, emerald-green pine forest, and trickling streams and deep, still rivers snake between more than 2,000 lakes.

For centuries it was left untouched to the delights of the region's abundant wildlife and the scattering of First Nation groups who came to fish, hunt and forage. It wasn't until the 1800's when the tranquil landscape saw a new phase of life, when pioneer loggers on the hunt for the much sought-after great White Pine trees arrived to fell the mighty logs and send them down the swollen rivers to and on to the British.

Established in 1893 it is Canada's oldest park, and today the serenity has once more been returned. Beavers and otters bask in the watery playground, trout, perch and pike fill the mosaic of lakes, black bears amble through the tangle of perfectly conical pines and wolf howls echo off the mountains.

The most famous of Algonquin's residents however, are the healthy populations of moose which plod along the Highway 60 and wade, neck-deep through the still green lakes. Almost comical in appearance, with long snouts and large flapping ears, they are big animals yet timid herbivores who can munch their way through 50kg (110lbs) of green vegetation in a single day.

Canoeing in the Backcountry
Attracted to the salty water that pools by the roadside after the winter gritting, it is possible to see moose simply by driving along the main park highway. But to experience them amidst the true Canadian wilderness, delve into the 'interior' of the park on a canoeing adventure. The vast, wooded interior is accessible only on foot or along 2,000 kilometres (1,250 miles) of charted canoe trails, where backcountry camping, gentle paddling and wildlife spotting while away the long summer days.

Either under your own steam or as part of a guided excursion you set off at a leisurely pace, the quiet plip plop of the paddles the only noise to warn moose and other wildlife of your presence. It is a back-to-nature experience of swimming in the clear lakes, cooking simple meals over a roaring campfire, hunkering down in a tent under the clear night sky and listening to the eerily beautiful sound of a wolf's howl.

TAKE ME THERE

How to Visit: Accessible from Toronto and Ottawa, the park has several entry gates and hundreds of campsites along Highway 60 and in the 'interior'. Canoe and hiking trails can be traversed independently or as part of a guided tour. The best time to see moose is during May and June.

Further Information: The official park website (**www.algonquinpark.on.ca**) is a valuable resource for planning and booking a trip. There are dozens of outfits offering moose-viewing canoe trips including Voyageur Quest (**www.voyageurquest.com**), Algonquin Adventure Tours (**www.algonquinparkcanoetrips.com**) and Algonquin Bound Outfitters (**www.algonquinbound.com**).

Did You Know? Moose antlers are the fastest type of growing bone known on the planet. They can grow a set of antlers weighing up to 25 kilograms (55lbs) in just five months.

Wildlife:
- Beaver
- White-tailed deer
- Otter
- Black bear
- Wolf
- Trout
- Yellow perch
- Common loon
- Red squirrel
- Chipmunk

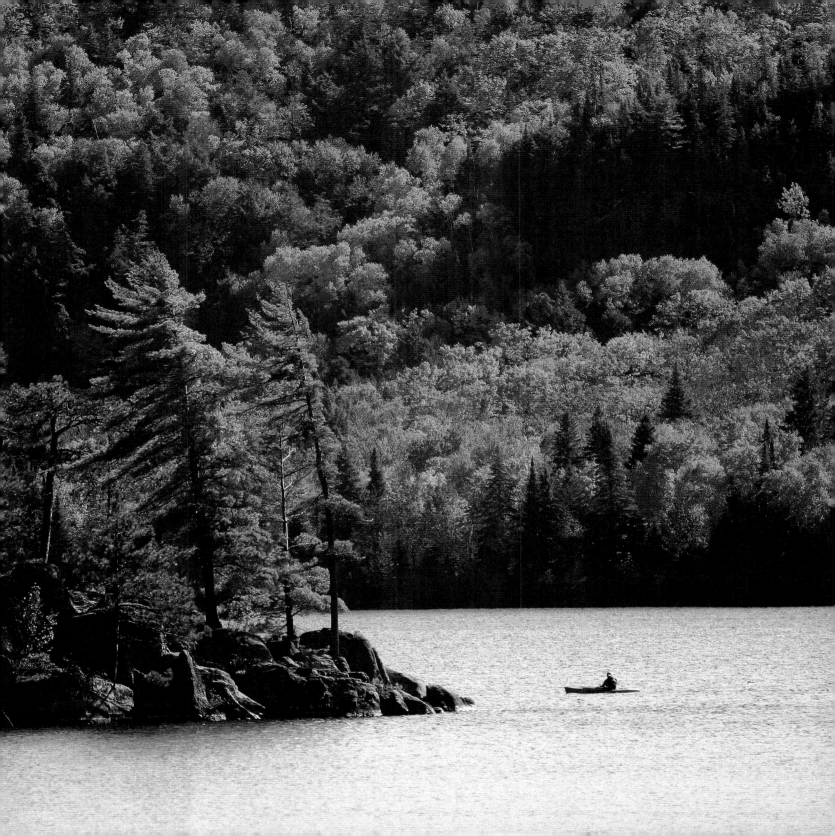

COATIS IN IGUAZU FALLS RAINFOREST
ARGENTINA/BRAZIL

The Paraná River snakes through South America's last tract of Atlantic rainforest, its waters flowing serenely for 4,880 kilometres (3,030 miles) across Brazil. As it reaches the border with Argentina, the serenity abruptly ends. Here, the water tumbles dramatically over the edge of the Paraná Shelf creating 275 separate waterfalls that run for almost 3 kilometres (1.8 miles). It is one of the world's most astounding spectacles, a seemingly synchronised performance of cataracts and falls, the largest of which is the ominous Garganta del Diablo (Devil's Throat). Almost half the river's water is swallowed into the narrow, U-shaped chasm 82 metres (269ft) high, the ensuing mist rising like smoke to bring life to 2,225 square kilometres (860 miles²) of sub-tropical rainforest and the wildlife that thrives within it.

Two World Heritage national parks share the falls, Argentina's Iguazú National Park laying claim to the lion's share. Thousands visit annually to walk the miles of suspended walkways that weave across the crashing cascades, and to stand at the heart-pounding precipice and look down into the Devil's Throat. Yet while the falls might claim the limelight, one of the parks' most famous inhabitants does a good job of trying to steal the show. South American coatis, relatives of the raccoon, walk brazenly amongst the visitors. Warning signs are aplenty, and the obvious impact of feeding the wild animals are clear, yet no-one has told the coatis. Whilst males live in solitary, females live in highly social groups and they can be seen ambling through the forests and along the walkways, their white-ringed tails high in the air and their long snouts to the ground.

Exploring Mist-Soaked Rainforests

The enormous popularity of the Iguazú Falls have given rise to a plethora of activities; white water rafting excursions, gentle river floats, kayaking trips, cycling and horse-riding tours and rappelling. Yet to feel at one with Iguazú's wildlife, head to Argentina's park in the early morning, long before the crowds arrive, and quietly walk the forest trails. Over 500 species of butterfly flutter through orchids and palm trees, toucans and parrots flap furiously overhead, and southern river otters and yellow breasted caimans saunter nonchalantly through rivers just metres before they plummet into a cloud of mist. More elusive jaguars, ocelots, pumas and white-eared opossum will unlikely make appearances, but black-capped capuchin monkeys are commonly spied in the trees.

Various trails weave through the park, from the popular Lower and Upper Circuits to the less crowded, six kilometre (3.7mile)-long Macuco Nature Trail. To stand still and listen as the sounds of more than 450 species of birds drown out the distant roar of the falls is to know you're in the heart of one of South America's most abundant forests. And along your explorations, it is highly likely that you'll be accompanied by an inquisitive little troupe of red-furred coatis, hoping that for just a moment, you'll leave your lunch unattended.

TAKE ME THERE

How to Visit: The falls can be reached from two towns on either side of the river; Puerto Iguazú in Argentina and Foz do Iguaçu in Brazil, and there is a range of accommodation options in both. The best time to visit is in spring or autumn when the crowds are significantly less.

Further Information: The national park websites in Argentina (**www.iguazuturismo.gov.ar**) and Brazil (**www.cataratasdoiguacu.com.br**) offer a wealth of trip-planning information.

Did You Know? Great dusky swifts can be seen plunging directly into the waterfalls. In fact, the little birds often create nests behind the curtains of water, seeking refuge from predators.

Wildlife:
- Toucan
- Parrot
- Black-capped capuchin monkey
- Jaguar
- Ocelot
- White-eared opossum
- Yellow breasted caiman
- Southern river otter
- Butterflies
- Great dusky swifts

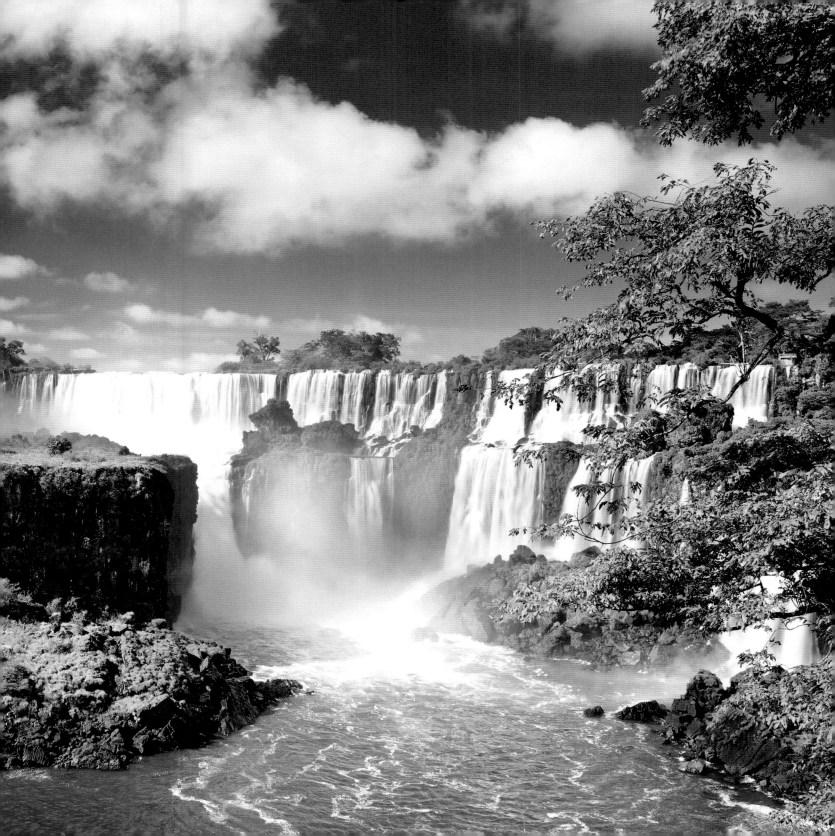

68 SALTWATER CROCODILES IN KAKADU NATIONAL PARK
AUSTRALIA

Kakadu National Park is a croc-infested stretch of land that covers over 20,000 square kilometres (7,700 miles²) – nearly half the size of Switzerland. In fact 10,000 saltwater (or estuarine) crocodiles inhabit Australia's largest national park, and while that may equate to one croc every 2 square kilometres (0.7 miles²) on average, at certain spots beady black eyes and dinosaur-esque ridged backs protrude from the water as far as the eye can see.

It is one of the best places in the world to see these giant predators. In fact warning signs littered throughout the park attest to the high chances of coming into close proximity with a saltwater crocodile and the inherent dangers involved. Growing to over 6 metres (20ft) in length some of the dominant males are highly territorial and will defend their patch with ferocity.

Salties might rule the roost but they're by no means alone in the varied landscapes of Kakadu. Freshwater crocodiles share the wetlands which, during the rainy season, stretch across a third of the park, and over 280 species of birds – more than a third of all those found in Australia – flock to the billabongs and floodplains, amongst them more than three million magpie geese. Stretching from the coast and estuaries in the north through the floodplains, lakes and lowlands to the rocky ridges and forests of the south Kakadu

is a kaleidoscope of terrains and ecosystems. Yet while it harbours extraordinary ecological and biological diversity it is also culturally rich. Ancient Aboriginal rock art adorns the landscape and the park's traditional owners live in and manage the park alongside Parks Australia.

Self-drive Adventure Through Croc Country
While many of the world's wildlife-watching experiences involve getting close enough to spot the animal of your affection, the opposite is true of saltwater crocodiles. In Kakadu, where there is water there are crocs, and extreme care must be taken not to get too close. Safe viewing platforms have been erected at sites such as Cahill's Crossing and boat trips will get you hair-raisingly close in a controlled and safe environment.

Yet to fully experience Kakadu, embark on a self-drive trip, staying in campsites overnight and waking amidst northern Australia's abounding nature. Discover 20,000 year old rock art and stone carvings left behind by ancient hunter-gatherers, hike the sandstone cliffs of the stone country, spot kangaroos and wallabies bouncing through the savannah lowlands and discover a landscape of waterfalls and lagoons, 6 metre (20ft) high termite mounds and a sky filled with a myriad of colourful feathers.

TAKE ME THERE

How to Visit: Darwin is the closest international airport and the town of Jabiru acts as the hub for the park. There is a selection of caravan parks, campsites and hotels. Either drive around the park under your own steam or embark on a boat trip to get up close safely to the crocodiles. The best time to visit is the dry season (August to October).

Further Information: There is a wealth of visitor information on the Parks Australia website (**www.parksaustralia.gov.au**) and plenty of tours and boat trip operators offering trips to see the crocodiles.

Did You Know? In Aboriginal culture, large crocodiles are respected but smaller ones are sometimes eaten. The intestines are reserved only for the elderly who fill them with crocodile fat and roast them.

Wildlife:
- Wallaby
- Kangaroo
- Dingo
- Dugong
- Flying fox
- Flatback turtle
- Partridge pigeon
- Magpie geese
- Quoll
- Freshwater crocodile

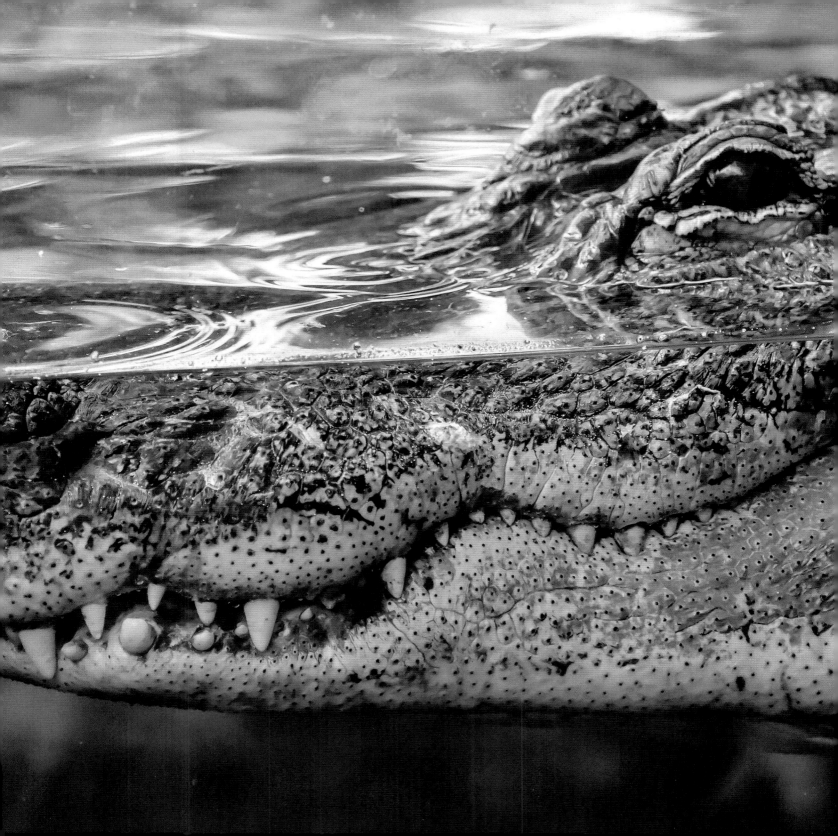

SLOTH BEARS IN YALA NATIONAL PARK
SRI LANKA

With their long lanky limbs and shaggy black fur in dishevelled disarray, the sloth bear is an endearing sight. Mostly nocturnal and solitary creatures they wander through the forests grunting and snorting as they ferret out fruit and carrion, ants and termites with their long, curved claws, sucking at nests to get to the coveted prize. While sloth bears are found in threatened numbers throughout the Indian subcontinent, in Sri Lanka a unique subspecies exists, with only 500 to 1,000 left in the wild. And the best place to spot them is in the country's second largest and best-loved national park, Ruhuna (more affectionately known as Yala).

Yala National Park sprawls for 979 square kilometres (378 miles²), although only a relatively small part of this is open to visitors. From the Indian Ocean coastline, frequented by all five species of sea turtles, it spreads in a patchwork of ecosystems which support an abundance of wildlife. Great herds of Sri Lankan elephants walk the grasslands, and it holds one of the highest densities of leopards in the world which can be spotted lounging lazily atop rocky outcrops scattered across the plains.

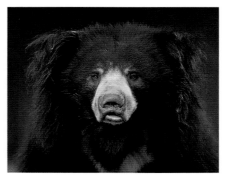

Colourful birds line the shores of the plentiful lagoons in their thousands, seemingly oblivious to the sunbathing crocodiles that wallow in the shallows. Monkeys – toque macaques and red slender loris amongst them – chatter in the canopy of the scrub and monsoon jungles, and wild water buffalo wade in the wetlands.

Go Rustic in Sri Lanka

Yala National Park isn't a well-kept secret and as one of the country's most visited wildlife sanctuaries you are unlikely to have it to yourself. But that doesn't seem to bother the animals, and wildlife-viewing here is first rate. To avoid some of the crowds opt to stay in one of the rustic eco-lodges or camps inside the park, frequented by elephants and wild boar. Enjoy a back-to-nature experience, where traditional meals are cooked on an open fire, electricity is long forgotten and simple living prevails. By day embark on guided or self-drive safaris in search of Yala's famed animals.

Despite being nocturnal, the Sri Lankan sloth bear has a weakness for the Palu berry which falls to the ground during Yala's dry season from May to July. During this time (which is also the best time for spotting the elusive leopard) sloth bears venture out during dawn and dusk to forage, making it the best time to spot them.

TAKE ME THERE

How to Visit: The park is located 275 kilometres (170 miles) from the capital Colombo. The town of Tissamaharama is the jumping off point to the park and access is by jeep safari only (which can be done as a self-drive excursion). Accommodation varies from all-inclusive camps to upmarket resorts. The best time to spot sloth bears is during the dry season (May to July).

Further Information: For trip-planning information try www.yalasrilanka.lk or the national tourism website (www.srilanka.travel). There is a range of accommodation to choose from including Tree Tops Jungle Lodge (www.treetopsjunglelodge.com) and Kulu Safaris (www.kulusafaris.com).

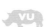

Did You Know? Although the sloth bear may appear to amble along at a slow pace, it is in fact an excellent runner and climber, and reasonably good swimmer.

Wildlife:
- Sri Lankan elephant
- Sri Lankan leopard
- Toque macaque
- Golden palm civet
- Red slender loris
- Fishing cat
- Turtles (leatherback, olive ridley, loggerhead, hawksbill and green)
- Crocodiles (mugger and saltwater)
- Wild water buffalo
- 215 species of bird

ROTHSCHILD GIRAFFES IN MURCHISON FALLS NATIONAL PARK
UGANDA

High in Uganda's mountains, the great River Nile starts its life as a tiny, trickling spring. It pours through the country, gaining momentum and snaking further than any other river on the planet – 6,853 kilometres (4,258 miles) to Egypt's Mediterranean Sea. As it courses on its journey it spreads life, animals and people relying on the great artery for survival. In Murchison Falls National Park, the Nile enters one of its most dramatic phases, the throbbing river channelled through a narrow gorge in the rift valley to crash 50 metres (164ft) below in a spectacular cloud of mist and rainbows.

Named for Sir Roderick Murchison (1851–1853), President of the Royal Geographical Society, the falls sit at the heart of Uganda's largest national park. On either side of the Nile, savannahs and woodlands, wetlands and tropical forests stretch endlessly. Hippos and crocodiles wallow on the green, reed-laden shores in their thousands, chimpanzees inhabit the thick forests and elephants, warthogs, buffalo and the rare and endangered Rothschild giraffe walk the grasslands.

In 2010 fewer than 650 Rothschild giraffe lived in the wild, 60 per cent of them in Uganda. A recent survey has shown around 750 individuals inhabit their native range of Murchison Falls – a positive step towards conservation but still a long way from species recovery. The Rothschild's distinctive coloured pelt – giraffe

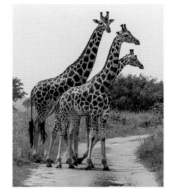

coat patterns are as unique as a human fingerprint – set them aside from reticulated giraffes which roam Africa in huge, unthreatened numbers.

A Timeless Safari

Follow in the footsteps of Ernest Hemingway, Winston Churchill, the Prince of Wales and Humphrey Bogart as you explore a part of Uganda which has seen its lion's share of trials and tribulations. During the 1970's and 80's, rhinos were hunted to extinction and many other species fared badly at the hands of indiscriminate poaching. Yet today the park is once again flourishing, game roams the landscape in ever bigger numbers, and rhinos are being bred in a nearby reserve ready for reintroduction – which will put Murchison Falls back on the coveted Big 5 list.

Timeless luxury lodges of bygone days or back-to-nature campsites offer a place to rest your head before setting off into the park in search of the graceful, long-legged giraffes who hold the fate of their species in their hooves. Head out into the savannah on a game drive or walk the nature trails of the thick forests. Or set off on an exhilarating launch trip towards the falls or downstream to the papyrus delta of Lake Albert – an incredible opportunity to observe wildlife as they lounge in the shallows or tentatively dip their heads to drink.

TAKE ME THERE

How to Visit: The park is located 300 kilometres (186 miles) from the capital Kampala. Accommodation includes campsites, cottages and luxury lodges from where safaris can be arranged. The best time for game-viewing is the dry season (December to February).

Further Information: The Uganda tourism website (www.visituganda.com) and www.murchisonfallsnationalpark.com are good resources. Accommodation includes Sambiya River Lodge (www.sambiyariverlodge.com), Chobe Lodge Uganda (www.chobelodgeuganda.com) and Paraa Safari Lodge (www.paraalodge.com). Giraffe Conservation Foundation (www.giraffeconservation.org).

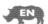

Did You Know? Despite their height giraffes can reach speeds of up to 56 kilometres per hour (35mph). Their long tongues reach an average 45cm (17in).

Wildlife:
- Elephant
- Lion
- Buffalo
- Leopard
- Shoebill stork
- Nile crocodile
- Hippopotamus
- Warthog
- Chimpanzee
- Ugandan kob (antelope)

WOLVERINES IN LIESKA
FINLAND

The wolverine holds almost mythical status, so rare are sightings of this fierce little mammal. It roams the northern boreal forests and alpine tundras of northern Canada, Alaska, western Russia and the Nordic countries in solitary isolation, its fiery reputation for killing animals much larger than itself having awarded it an iconic status. Resembling a small bear the size of a medium dog, it is the largest land-dwelling member of the Mustelidae (the family which includes stoat, badger and pine marten). Indeed, only South America's giant river otter is larger. It travels great distances in a single day in search of food, forever on the move, which adds to its elusiveness.

Because of the wolverine's secretive lifestyle and small numbers, little research has been done on this Arctic nomad. While it is believed there are more individuals roaming the forests of North America and Russia than Scandinavia, getting to see one is like searching for the proverbial needle in a haystack. In Finland's north easternmost stretches however, an estimated 200 wolverines live in the dense forested wilderness and, thanks to a baited hide, sightings have become fairly commonplace.

Hugging the border with Russia and just outside the nondescript town of Lieska is a magnificent and feral forest studded with deep, still lakes. Owls hoot through the silence, red squirrels scamper up the stout pine trees and the 'Big 4', the wolverine, bear, lynx and wolf, pad through the silence.

Photographing the Ghosts of the Forest

Getting to see the formidable and rarely seen predator that is the wolverine is one of the animal kingdom's biggest challenges, but the forests near Lieska hold some of the best chances on the planet. And what better way to capture the once-in-a-lifetime sighting than on a photography adventure.

Making your way through the isolated wilderness you hunker down in a traditional, no-frills Finnish cabin for a stay amongst the rustic beauty of the Taiga forest. By day soak up the peace and tranquillity of this remote region, listening to the birds, fishing in the lakes and getting ready for the sun to set. Whether you visit during the long summer days or when a blanket of powdery snow lays over the ground, you venture to the hide as night falls and wait in silence for the imminent arrival of the glossy, brown-haired creatures. Baits are set to lure not just wolverines but bears and on lucky occasions lynx and wolves too. Yet long gone are the days when the baits were used for hunting and today the only shooting that happens in this secret spot is from a long lens camera.

TAKE ME THERE

How to Visit: The northern Finnish town of Lieska is the jumping off point into the forests near the Russian border where sightings of wolverine are common. Accommodation is in a traditional log cabin with night trips to a nearby hide. Wolverines can be seen year round but photography opportunities are best late April to mid-September and early January to late March.

Further Information: All-inclusive tours can be arranged through Responsible Travel (www.responsibletravel.com), NatureTrek (www.naturetrek.co.uk) and Wildlife Safaris Finland (www.wildfinland.org), or direct through Era Eero (www.eraeero.com).

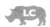

Did You Know? Wolverines have been known to give off a very strong, extremely unpleasant odour, awarding them the nicknames 'skunk bear' and 'nasty cat.'

Wildlife:
- Bear
- Wolf
- Lynx
- Red squirrel
- Parrot crossbill
- Pygmy owl
- Elk
- Reindeer
- White-tailed eagle
- Snowy owl

In the dark depths of the Saguenay Fjord, which plummets from the vertical cliff walls to a dizzying depth of 270 metres (885ft), ghostly figures skim the surface. They glow ethereally, their pure white skin making them unmistakable in this thriving whale wonderland. As one of the southernmost haunts of the beluga whale, Saguenay-Lac-Saint-Jacques and its imposing fjord are the year-round home to hundreds of these highly sociable animals who, along with 13 different species of whale, thrive on the plentiful krill stocks.

The 100 kilometres (62 miles) river fjord, the mostly southerly one in the Northern Hemisphere, stretches from the town of Chicoutimi to the village of Tadoussac at its mouth, its cliff walls rising 500 metres (1,640ft) into the blue skies. In these perfect conditions, massive volumes of krill, salmon, trout, halibut and cod attract one of the greatest gatherings of whales in the world. Blue whales break through the tranquil black waters with a great puff of air, and minke, fin and humpback can be spotted from the water's edge. Porpoises and seals join the feeding frenzy and occasional orcas, bottlenose dolphins and sperm whales take part in the melee.

The village of Tadoussac is the oldest surviving French settlement in the Americas, founded as a trading post in the 17th century, although Aboriginals have lived in this region for centuries. From its rugged, pine tree-clad shores, where the frigid Saint Lawrence and Saguenay rivers tumble into the fjord, belugas congregate in pods up to several hundred big. Indeed, between 500 and 1,000 of the small, chubby white whales are believed to live in this highly protected marine park.

Kayaking with Ghosts

Majestic mountains teeming with black bears and beavers, ancient glaciated valleys and coursing rivers characterise the natural beauty of the landscape from where kayaking excursions venture into the heart of the fjord. While day trips head out of Tadoussac in search of belugas and other whales, for a true back-to-nature experience set off on a multi-day adventure starting amidst the old world charm of Quebec City. From there you immerse yourself in the abounding nature, kayaking under towering cliffs and past giant boulders in search of the behemoths that live just below the surface. By night camp on the shores of the fjord, hike the mountain trails and clamber aboard Zodiac launches for the best wildlife-watching opportunities.

Beluga whales usually inhabit the icy realms of the Arctic, making them more difficult to find. Yet in this sub-Arctic landscape they can often be spied from shore, their rounded heads and small bodies emerging from the surface after diving to depths of 600 metres (2,000ft) in search of fish. Appearing as a flash of white against the waves, belugas or 'sea canaries' are known to communicate with pod-mates with clicks, grunts, squeals, screeches and whistles.

TAKE ME THERE

How to Visit: The region is located 200 kilometres (124 miles) from Quebec City. Towns and villages near the fjord offer a plethora of tourist facilities including Tadoussac where many of the whale kayaking trips begin. While the belugas are year-round residents, the best time to visit is between May and October.

Further Information: The Saguenay-Lac-Saint-Jean (**www. saguenaylacsaintjean.ca**), Tadoussac (**www.tadoussac.com**) and Saguenay-St Lawrence Marine Park (**parcmarin.qc.ca**) websites offer a wealth of trip-planning information. There are several single or multi-day kayaking outfits including ROW Sea Kayak Adventures (**www.seakayakadventures.com**).

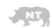

Did You Know? Unlike other whale species, the beluga whale's vertebrae is not fused which means it can turn its head in all directions.

Wildlife:
- Blue whale
- Humpback whale
- Minke whale
- Fin whale
- Grey seal
- Harbour porpoise
- Harbour seal
- Wolf
- Black bear
- Lynx

FLAMINGOS IN EDUARDO AVAROA ANDEAN FAUNA NATIONAL RESERVE
BOLIVIA

High in the Andean Altiplano, in a remote region known as the Eduardo Avaroa Andean Fauna National Reserve, an otherworldly realm exists. Surreal landscapes of bizarre wind-sculpted rock formations play tricks on the eye (and have been awarded the name Salvador Dalí Desert). Lava and clouds of steam puff out of perfectly conical volcanoes, and fumaroles spout boiling water up to 50 metres (164ft) in the air. And, like splashes of paint across the barren, dry land, great lakes and lagoons of psychedelic colours are home to great clouds of flamingos.

Laguna Colorada (red lagoon) shines like a dazzling ruby amidst the dusty brown. White borax islands dot the surface like the spots on a magic toadstool, and in the shallow 60 square kilometres (23 miles²) waters, flamingos dance gracefully in their hundreds. The rare James' flamingo – thought to have been extinct until a remote population was discovered in 1956 – abounds in this wild region. Its pale candyfloss pink feathers and brick red legs stand it apart from the Andean and Chilean flamingos that share this strange land.

While Laguna Colorada National Wildlife Sanctuary forms the centrepiece of flamingo activity – it is home to the greatest population of James' flamingos in the world – they also find respite in the piercingly turquoise Laguna Verde (green lagoon). Icy winds whip across the salt lake, which can turn to dark emerald in the blink of an eye. With the towering 5,868 metre-high (19,252ft) Licancabur Volcano looming over its craggy shores, flamingos tiptoe through the steaming hot springs that pour into the −56°C (−68°F) waters (although the chemical composition of its waters prevent it from freezing over).

Jeep Explorations of a Fantasy Land

To embark on a journey through erupting volcanoes, steaming hot springs, bubbling geysers and iridescent lakes is not for the feint at heart. Perched at a breathtaking altitude between 4,200 metres (13,800ft) and 5,400 metres (17,700ft) it is a fierce and cold terrain, inhabited by only the hardiest of people and wildlife.

Jeep trips head out from the Bolivian towns of Tupiza and Uyuni (on the shores of the famous salt pans), traversing unpaved roads and overnighting in rustic village huts. Yet it's a trip of mind-blowing proportions, where the vastness of the mountains and valleys are only put in perspective by dots of alpacas and llamas grazing at their foot. Residents of the small oasis villages with their adobe homes pan for gold and rear their spitting camelids for wool and meat. Rabbit-looking chinchilla creatures known as viscacha, elusive pumas, and wild vicuñas (ancestors of the llama) exist in this inhospitable land. And, like jewels in an otherwise expanse of brown, great iridescent lakes attract clouds of powder puff pink flamingos to one of the harshest yet most beautiful landscapes on the planet.

TAKE ME THERE

How to Visit: Buses from La Paz, Potosí and other Bolivian towns arrive in Uyuni and Tupiza for the start of 4x4 jeep tours across the region. Tours range from one to five days and accommodation is in rustic village lodgings. The best time to visit is November to January.

Further Information: The Bolivia Tourism website (www.bolivia.travel) provides some travel advice and there are countless operators in both towns offering tours including Red Planet Expedition (www.redplanetexpedition.com).

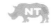

Did You Know? The colour pink comes from beta-carotene in the crustaceans and plankton that flamingos eat. Without it they would turn white.

Wildlife:
- Puma
- Andean fox
- Viscacha
- Vicuña
- Andean condor
- Lesser rhea
- Andean goose
- Giant coot
- Andean puma
- Andean tree iguana

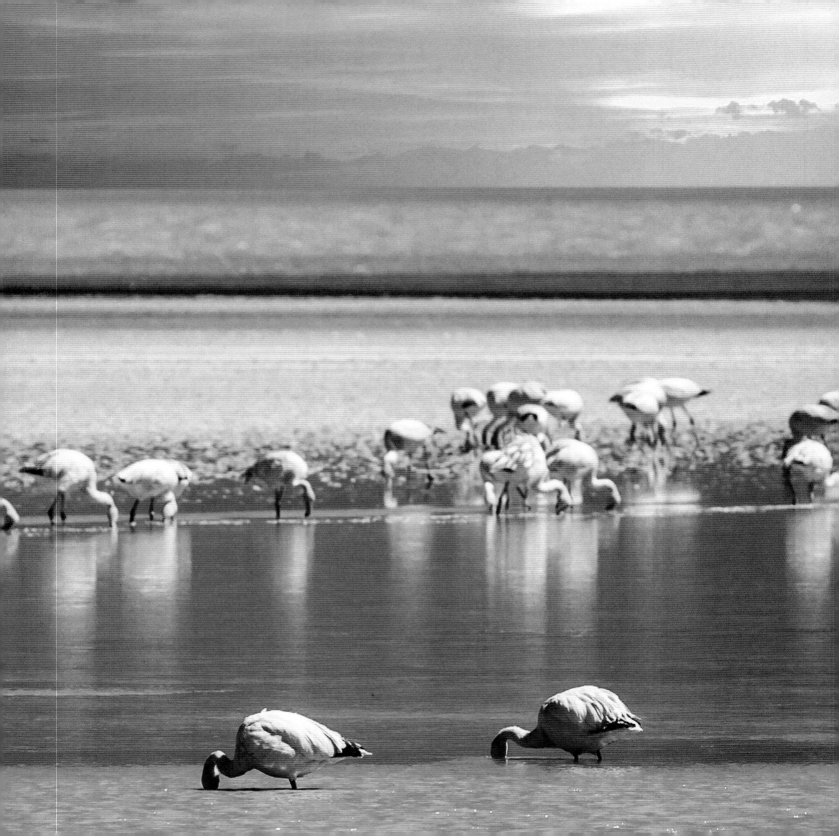

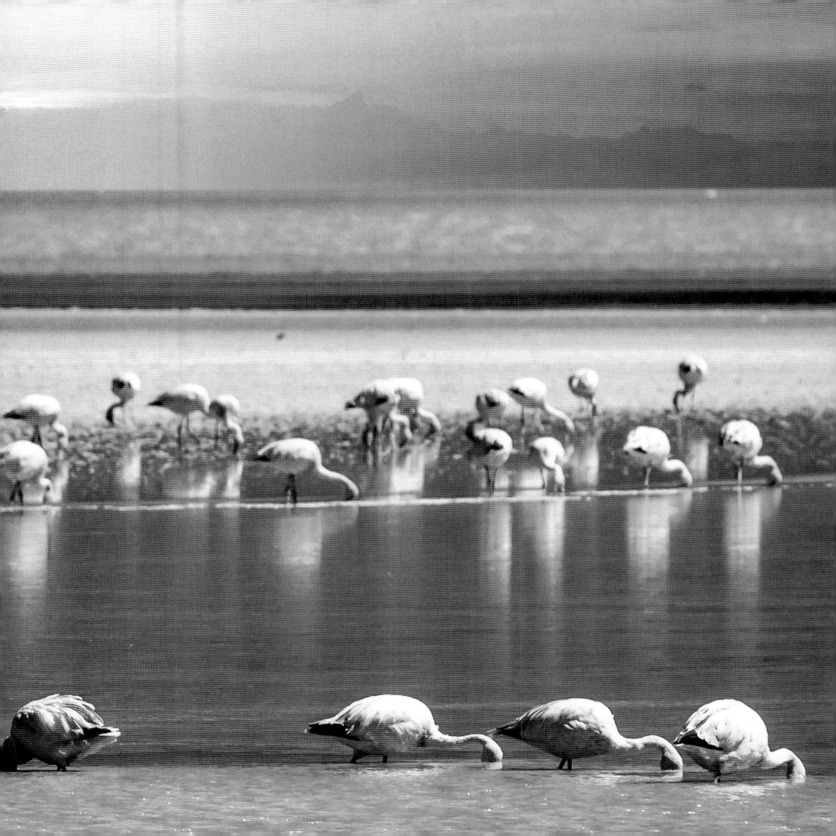

The Chang Tang Nature Reserve is one of the most inhospitable places on the planet. Stretching for 700,000 square kilometres (270,000 miles²) it is the second largest nature reserve on earth (after the Northeast Greenland National Park) – making it bigger than 183 countries. The massive sweeping expanse of rolling alpine steppes and sparse shrub land plains teeters on the top of the world, with an average altitude over 4,800 metres (16,000ft) and towering, terrifying peaks that stand at over 6,000 metres (20,000ft) high.

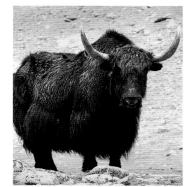

Much of the Chang Tang plateau – which stretches from Ladakh in India, across northern Tibet and into China's Qinghai and Xinjiang provinces – is uninhabited by man, the extreme cold, lack of rainfall and sparse landscape forming one of nature's most formidable barriers. In the southern and western portions of the gargantuan reserve, Tibetan farmers tend their livestock and crops, but the feral and untamed north is left to pockets of hardy nomads and a few well-adapted species of wildlife.

In the shadow of glacier-capped mountains shaggy black wild yak wander the alpine tundra, over half of the world's remaining population living in the Chang Tang. Massive declines in population have led the wild yak – whose domesticated relatives are widespread across Asia – to be listed as vulnerable, and today only 15,000 still exist. Alongside them wander an eclectic collection of wildlife, many species endangered or endemic to the Tibetan plateau.

Stepping Foot in One of the World's Last Great Wildernesses

To visit the Chang Tang Nature Reserve is to step foot in one of the last great expanses of wilderness left on Earth. It is not an easy trip, the harsh climate, whipping winds, blistering sunshine and lack of civilisation making for both an arduous and exhilarating experience.

From Tibet's capital of Lhasa a handful of guided tours venture into the wilds of the reserve where Kiang (Tibetan wild ass) and Tibetan gazelles find nourishment in the frigid soils, wolves and snow leopards hunt argali and Himalayan blue sheep, and the endangered chiru (Tibetan antelope) seeks refuge from hunting (its prized fur is considered the finest in the world).

As you travel by jeep through the pristine landscape, holy mountains rear their snow-capped heads and wetlands sit amidst vast basins. Isolated monasteries appear after hours of driving and the Brahmaputra and Indus rivers begin their long journeys here. You spend nights in tents wrapped against the biting cold, the days spent on a breathtaking journey through an untouched world, where some of the planet's very last herds of wild yak roam.

TAKE ME THERE

How to Visit: The Chang Tang Nature Reserve is one of the most remote places on the planet and should only be visited with a reputable and experienced guide. A few specialist tours head out of Lhasa, Tibet or Ladakh, India where camping and rough conditions should be expected. The best time to visit is June to October.

Further Information: Contact China Highlights (**www.chinahighlights.com**), Plateau Tours (**www.plateautours.com**) or Tibetan Ecology (**www.tibetanecology.org**) to discuss tour options.

Did You Know? In the heart of winter wild yak herds travel in single file, carefully stepping in the footprints of the animal in front.

Wildlife:
- Kiang (Tibetan wild ass)
- Himalayan blue sheep
- Argali
- Snow leopard
- Mongolian gazelle
- Tibetan blue bear
- Wolf
- Lynx
- Tibetan antelope
- Tibetan sand fox

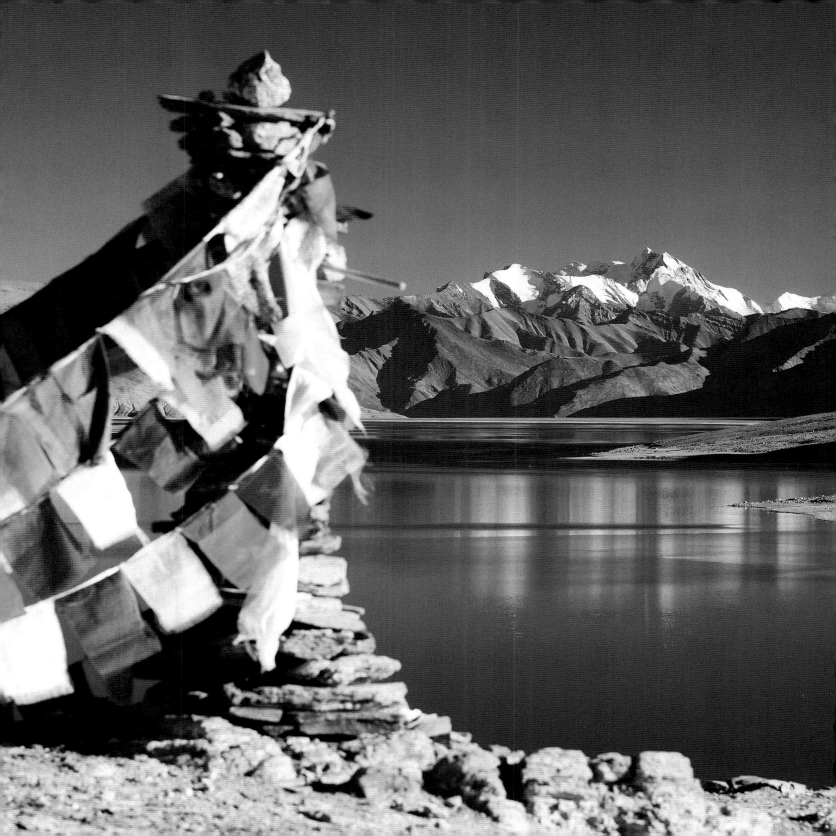

MOUNTAIN GORILLAS IN BWINDI IMPENETRABLE NATIONAL PARK
UGANDA

Impenetrable is the right word for Uganda's tangle of rainforest which rises steeply from the rift valley on which it sits. A thick mist hangs like a grey blanket over the roof-like canopy, underneath which an ancient forest thrives. For 25,000 years Bwindi's montane and lowland forest has nurtured over 1,000 flowering plants and a truly unique biological diversity, a place where it's easy for even forest elephants to hide unnoticed. Giant forest hogs scamper through the undergrowth, African golden cats slink between the lush foliage and in the treetops colobus monkeys, chimpanzees and other primates swing gracefully.

Uganda might be home to the greatest concentration of primates anywhere in the world, but there is only one king of the jungle in Bwindi and it is the 340 mountain gorillas that call the 331 square kilometres (128 miles²), UNESCO-designated national park home. Making up half of all the mountain gorillas left in the world (the other half can be found in the nearby Virunga Mountains), the critically endangered animals have found a safe haven against the threat of poaching and habitat loss.

Several of the groups have been habituated and are, for the most part, fairly apathetic towards visitors. Strict laws govern the forest, where permits and trained trackers take groups of tightly controlled numbers of visitors to see the great apes nurturing their young, displaying dominance, interacting socially and foraging.

Gorilla Tracking in the Jungle
To stare into the eyes of a 220kg (485lb) silverback mountain gorilla and have him gaze back at you is one of the most profound and unnerving wildlife experiences on the planet. Yet finding the gorillas is a test of endurance, patience and fitness in this impenetrable jungle where thorny vines wrap around towering trees and giant fern fronds sprout. It is a beautiful yet feral landscape of volcanoes and jagged valleys, gushing waterfalls and deep lakes.

Setting off into the rainforest with a tracker can, if you're lucky, be a hike of just a couple of hours, a troop of gorillas appearing not far from base camp. Yet they can also be ensconced in the heart of the vegetation, where full-day treks up steep hills and through humid valleys are tough going. You walk through a world filled with 200 species of butterfly and listen to the cacophony of sounds; the orchestra of frog croaks, the call of 350 species of birds and the deep howls of monkeys, all the while looking for tell-tale signs of gorillas nearby. To spend time in the presence of a troop of these endangered creatures is a unique experience, and you watch as they forage for roots, shoots and fruit, play and climb trees or, in the case of the dominant males, put on a show of impressive physical power.

TAKE ME THERE

How to Visit: Gorilla tracking is strictly by guided excursion and day hikes can be booked through accommodation and offices in the towns of Buhoma and Nkuringo where there is a range of luxury lodges, rustic hostels and budget campsites. The gorillas can be seen year round.

Further Information: The official park website (**www. bwindiforestnationalpark.com**) offers plenty of information to help plan a trip and for further background on the park and animals see UNESCO (**whc.unesco.org**). There are dozens of international and local tour operators offering gorilla-tracking trips.

Did You Know? Gorillas are nomadic and each day at dusk they build a new nest out of bent branches in trees or grasses on the ground.

Wildlife:
- Black and white colobus monkey
- Chimpanzee
- L'Hoest's monkey
- Forest elephant
- African golden cat
- Bushbuck
- 350 species of bird
- Giant forest hog
- Duiker
- 200 species of butterfly

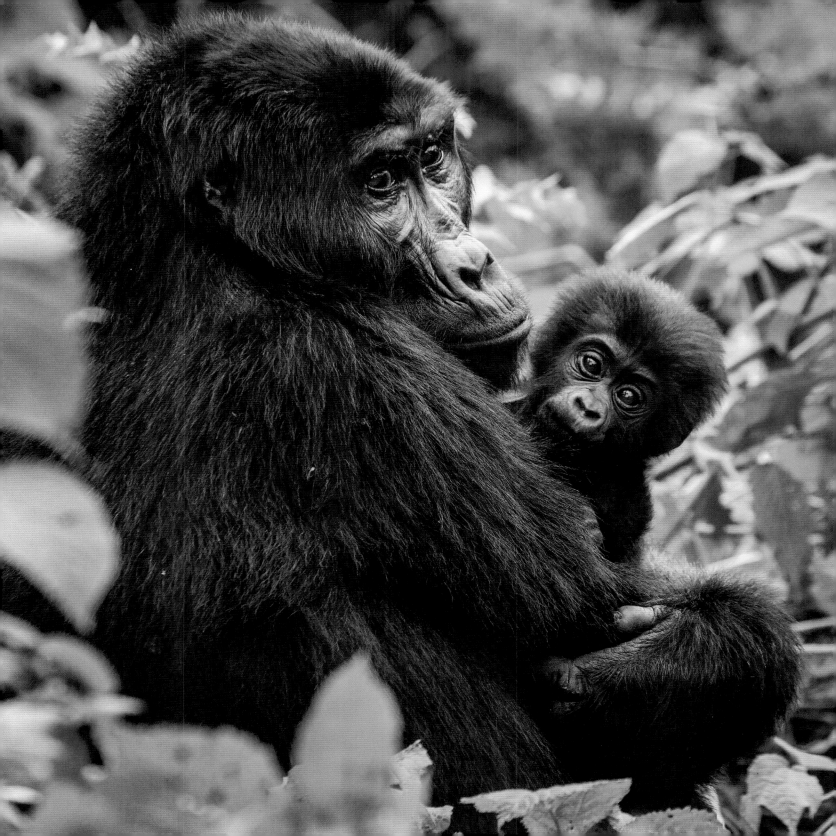

BUTTERFLIES IN THE DOLOMITES
ITALY

Towering into piercingly blue skies, the jagged wind-sculptured peaks of Italy's Dolomite mountains loom over the rolling green valleys below. The steep walls and vertical granite pinnacles are geologically unique, the setting sun bathing them in a daily hue of deep reds, pinks and purples. Nestled into the Italian Alps, the Dolomites are simply stunning. Peaks rise over 3,000 metres (9,800ft) high, mirrored in the calm deep waters of great lakes, and ice-cold rivers course through meadows and long, deep valleys. Picturesque mountain villages and storybook castles have stood for centuries, withstanding the cold snowy winters and enjoying the fresh, crisp air of summers. It is a haven for alpine wildlife, a place where wildflowers signal the advent of spring and with it a swirl of colourful butterflies.

The Dolomites are one of Europe's butterfly hotspots, many rare species flourishing amidst the pristine mountain landscape. Apollo's, Alpine blue's and mountain clouded yellow's flutter on the gentle breeze alongside Titania's and Thor's fritillaries, Alpine ringlets and Amanda's blues in a kaleidoscope of colour. In the lush fragrant meadows wildflowers bloom in numbers few, if any, other places in Europe can match, providing the perfect environment for butterflies. Orchids and bellflowers, orange lilies and gentians burst from the ground or find their place in the deep rock crevices, creating a splash of vibrant colours.

Colonies of Alpine marmots inhabit the high altitude pastures, roe deer stroll through the verdant meadows and in the dark forests woodpeckers and owls make their distinctive hoots and calls. High in the mountain rooftops golden eagles soar on the currents, and Asp vipers and common adders slither through the long grasses on the valleys floor.

Ambling Through Alpine Wildflower Meadows

There are places in the Dolomites so secluded that the inhabitants still speak an ancient form of Latin, and where legends abound. Vall di Fassa is one such remote valley, its centuries of isolation having retained a unique cultural identity and unblemished landscape. It makes for the perfect base from which to set out into the mountains in search of rare butterflies and wildflowers, either under your own steam or with the aid of an experienced guide.

Settle into a traditional guesthouse or plush hotel, where you wake each morning to sun-dappled vistas that stretch interminably. Take gentle strolls through the valley as you explore the different landscapes. Wander along the Avisio River, or through the richly blossoming meadows in search of butterflies. Explore the wooded glades, or venture into the higher alpine pastures for snowmelt flowers and rocky outcrops festooned in the iridescent blue King of the Alps flower.

TAKE ME THERE

How to Visit: Venice is the gateway to the Dolomites, which can be easily visited independently or as part of a butterfly and wildflower tour. Traditional hotels and guesthouses are dotted throughout the mountains. The best time for butterflies is during the spring wildflower blossoms, and Val di Fassa is a popular area for spotting a variety of species.

Further Information: Visit Dolomites (**www.visitdolomites. com**) is a good starting point for planning a trip. There are several specialist wildlife tour agencies offering week-long walking trips including NatureTrek (**www.naturetrek.co.uk**) and Green Wings (**greenwings.co**).

Did You Know? Butterflies can only feed or fly when their bodies are warmed to at least 30°C. They gain this heat from the sunshine using their wings as solar panels.

Wildlife:
- Golden eagle
- Roe deer
- Alpine marmot
- Mouflon
- Grouse
- White partridge
- Woodpeckers (black and spotted)
- Owls (boreal and pygmy)
- Asp viper
- Common adder

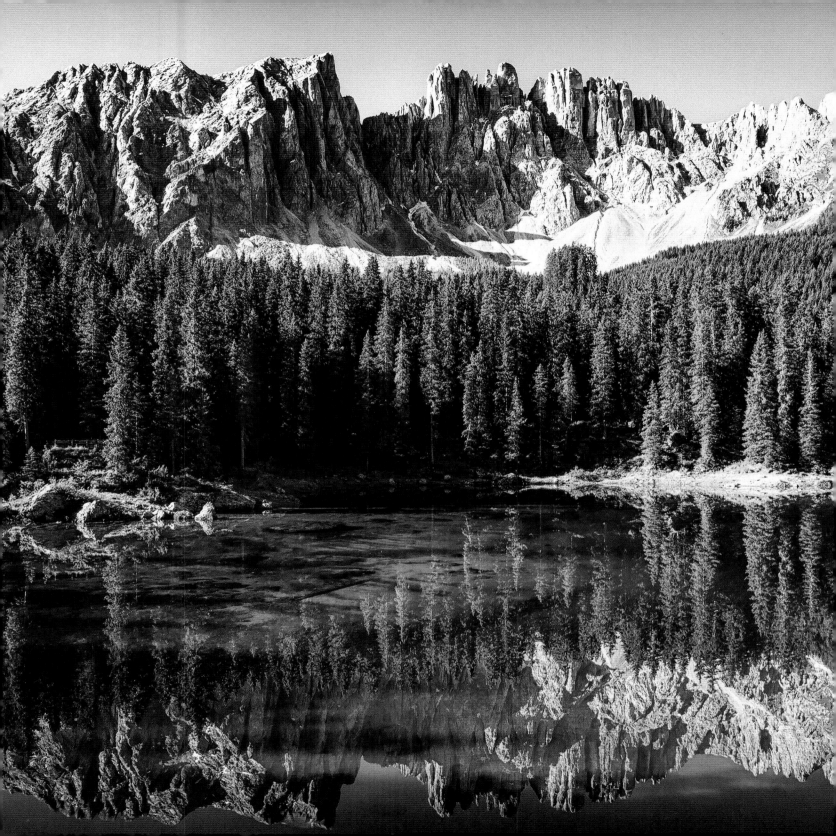

RED-SIDED GARTER SNAKES IN NARCISSE SNAKE DENS
CANADA

It is the biggest gathering of red-sided garter snakes in the world, a writhing mass of bodies entwined in giant knots. For here, just north of the town of Narcisse in rural Manitoba, a series of underground dens are the winter home to thousands of the reptiles who emerge twice a year to perform a startling mating ritual.

As the first few days of warm spring descend on Manitoba's beautiful Interlake region tens of thousands of snakes emerge from the subterranean caverns carved into the soft limestone rock. For two to three weeks they embark on a mating frenzy at the surface of their dens, one female surrounded by up to 100 males in a vast 'mating ball'. When the mating is over they disperse to the nearby marshes where they will spend the summer, returning in time to escape the cold winter months. In late autumn, before the ground freezes over, a second display can be witnessed as the snakes make their way back to their dens to hide amidst the fissures and crevasses of the caverns.

Manitoba's Interlake region is wild and remote, home to some of the world's largest boreal forests and freshwater lakes. Lake Manitoba, Lake Winnipegosis and Lake Winnipeg – the 10th largest freshwater lake on the planet – dominate the state, their pristine white beaches, gently lapping waves and abundant aquatic life making them the beating heart of a flourishing ecosystem and tourism industry.

Walking Amongst Snakes

For a sufferer of ophidiophobia (a phobia of snakes), it is like something from a nightmare. Yet for those not afflicted, it is one of nature's most fascinating spectacles. A 3 kilometre (1.8 mile)-long self-guided interpretive trail weaves around the dens, from where platforms proffer views of the mating snakes swarming and writhing together as one. The trail weaves through grasslands and aspen forest, where picturesque picnic areas offer the chance to rest and contemplate the sheer number of reptiles that inhabit this small region.

Timing your trip to coincide with the emergence of the snakes can be tricky, but there is plenty to do as you while away the last of the winter days waiting for the first burst of spring. Base yourself in a quaint B&B or cottage and seek out elk, moose and black bears in the dense boreal forests. Learn to windsurf on Lake Winnipeg, keep a close eye out for Manipogo – the local version of the Loch Ness Monster – on Lake Manitoba, or venture into the national parks in search of porcupines and skunks, bald eagles and great grey owls.

TAKE ME THERE

How to Visit: The Narcisse Snake Dens are located just north of the town of Narcisse, 130 kilometres (78 miles) from Winnipeg. The dens are located in the Interlake region of Manitoba which offers lots of tourism opportunities and rural accommodation. The snakes are most active during the spring and autumn – late April to early May, and early September.

Further Information: Start planning a trip with www.gov.mb.ca and www.travelmanitoba.com which offer detailed travel information, national parks, activities and accommodation options.

Did You Know? Every year 10,000 snakes were killed by vehicles as they crossed Highway 17 to and from their dens. Fences forced them to use purpose-built tunnels which has hugely reduced fatalities.

Wildlife:
- Elk
- Moose
- Black bear
- Bison
- Great grey owl
- Bald eagle
- Beaver
- Eastern chipmunk
- Porcupine
- Striped skunk

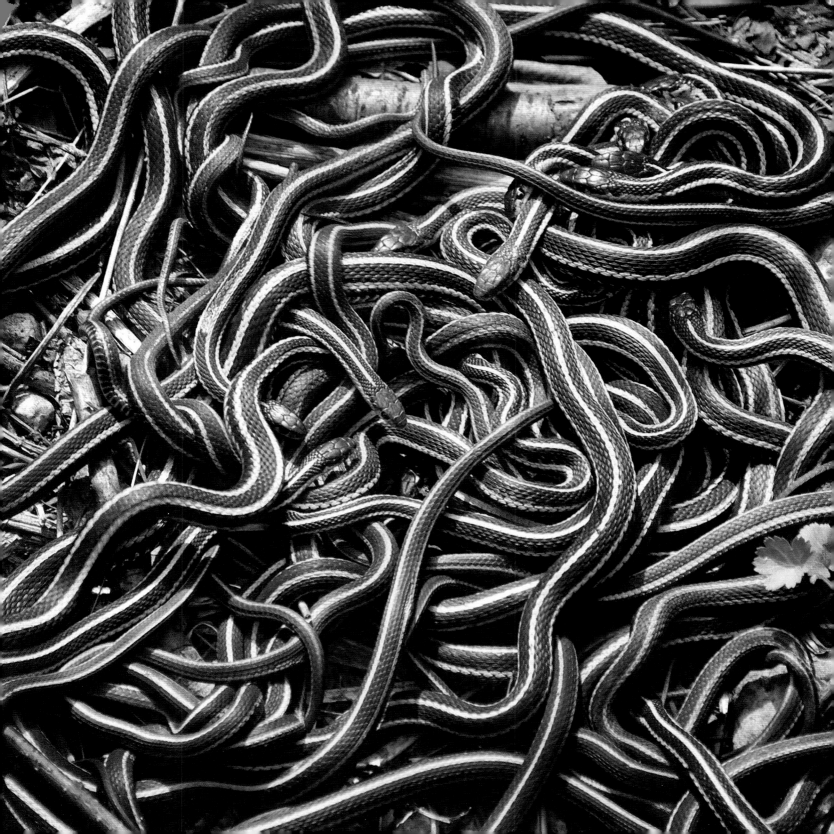

BLACK HOWLER MONKEYS IN TIKAL NATIONAL PARK
GUATEMALA

Tikal means 'place of voices', and to hear the roar of black howler monkeys echoing through the thick jungle, it is perhaps easy to see why. For in the heart of 575 square kilometres (222 miles²) of tangled, pristine rainforest only wildlife survives in what was once one of the Mayan world's most important ancient cities.

The Maya settled here in 900BC, and the city grew into an important ceremonial, cultural and commercial centre over the centuries. Vast temples and plazas were built and it became the greatest city in the Maya world with a likely population of 100,000. Today the park is part of the one-million-hectare Maya Biosphere Reserve, a place where steep-sided crumbling temples 44metres (144ft) tall poke above the dark emerald green canopy and enormous trees shroud the relics.

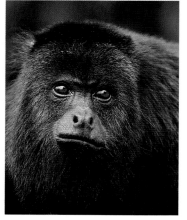

The cause of the fall of the Maya empire is still unknown, but from the end of the ninth century the ancient city was left to the ravages of the jungle and the animals that inhabit it. Of those, the Guatemalan black howler monkey is probably the most prominent, its booming call reaching up to three kilometres (2 miles) away. As the largest primate in the Neotropics they're hard to miss, the black males and brown females living high in the treetops in groups up to 19 strong. The biosphere reserve is an important refuge for the species, protecting the endangered monkeys from both hunting and habitat destruction that threaten their existence over the next 30 years.

In the Footsteps of the Mayans

Exploring the forgotten city of Tikal is to wander through an ancient world untouched for hundreds of years. Amble through a maze of pathways shaded by the thick forest as you discover ornate temples and grassy plazas – indeed, the central part of the city alone contains 3,000 buildings.

Dawn and dusk are the best times to experience the magic of Tikal and the abundant wildlife that thrives within its boundaries. Over 300 species of birds flutter noisily through the canopy, parrots, woodpeckers and warblers amongst them. Bats pour out of the temples at sunset, and elusive jaguars and pumas skulk through the undergrowth. Cheeky coatimundis scamper along the paths, wild turkeys cluck as they forage, and in the treetops nimble spider monkeys exist alongside their robust and vociferous howler cousins.

While it is possible to find black howler monkeys in spots across Guatemala, Belize and Mexico's Yucatan, Tikal's sheer number and the magical surroundings in which they live make this one of the continent's most special wildlife encounters. To walk amongst a city claimed by nature or to climb one of the temples and look across the treetops as the sound of howler monkeys booms through the silence is a truly unique experience.

TAKE ME THERE

How to Visit: The town of Flores is a jumping off point to the park from where tours and buses run daily. There is a selection of backpacker hostels and small hotels. The park is also accessible from Belize City. You can explore under your own steam or hire a guide.

Further Information: There is lots of travel information on the official park website (**www.tikalnationalpark.org**), official tourism website for Guatemala (**www.visitguatemala.com**) and UNESCO (**whc.unesco.org**).

Did You Know? The black howler monkey is known as a baboon in Belize, although it is not closely related to the baboons of Africa.

Wildlife:
- White-nosed coati
- Spider monkey
- Agouti
- Wild turkey
- Keel-billed and emerald toucans
- Red-lored parrot
- Jaguar
- Tarantula
- Hummingbirds
- Crocodile

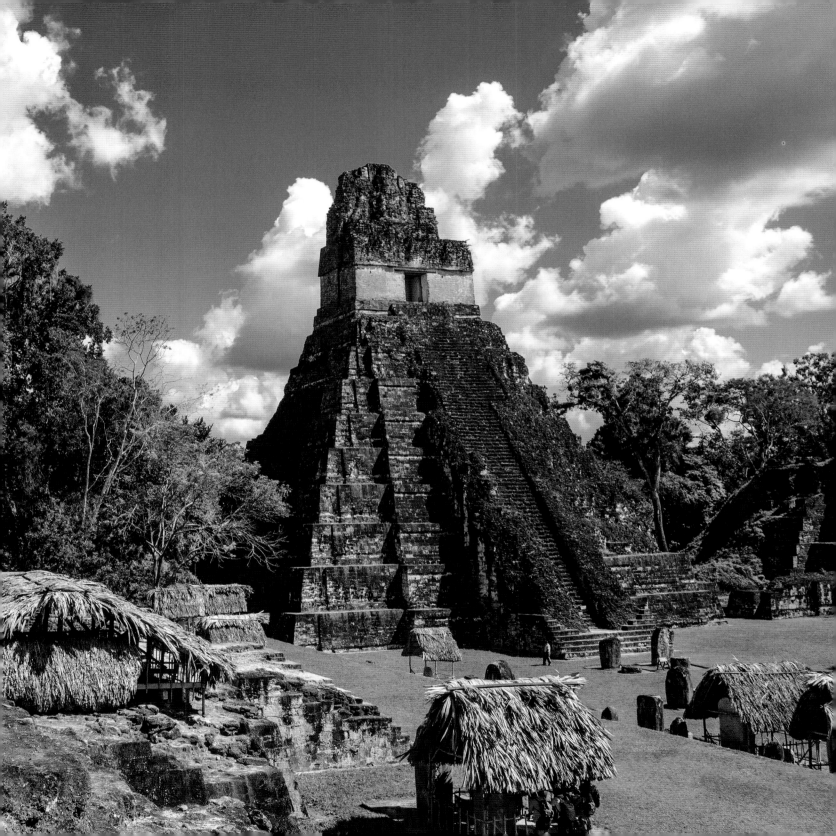

The great age of world exploration may have ended with the leather-booted, intrepid explorers of yesteryear, but there is something raw and untouched about Papua New Guinea, a true last frontier. Indigenous tribes live in the lofty highlands and amidst the dense rainforest which blankets three quarters of the vast island of New Guinea, and weird and wonderful creatures can be found in staggering numbers; 190 species of mammal, 25,000 of beetle, 6,000 butterfly species, 160 types of frog, 170 lizards and 110 species of snake. Yet they pale into insignificance compared to the 708 species of birds that flutter through the thick jungle canopy, the famous and flamboyant birds of prey taking the limelight.

With their eccentric plumage and elaborate mating dances, the bird of paradise has become one of the world's best-loved birds. Yet few have set eyes on it, hidden as they are in the depths of one of the planet's least explored countries. They come in all shapes and patterns, iridescent feathers protruding from their heads, tails, wings or beaks in a full kaleidoscope of colour, and the male's mating rituals as choreographed and intricate as any ballet.

The wildlife of Papua New Guinea is extraordinary and other-worldly, most found nowhere else on earth. In this land of thick rainforests, mist-shrouded mountains and open grasslands, the kangaroos climb trees, the echidna's have long pointed beaks, and the bronze quoll stands as the largest mammal. The world's largest butterfly, the smallest parrot and the longest lizard all thrive amidst this, one of the planet's most diverse regions.

Exploring a Last Frontier

Bird of paradise seems an apt name for a creature found only in the virgin, untouched jungles of Papua New Guinea. Venturing on an expedition to watch them prance and preen in all their kaleidoscopic glamour is a true adventure, a trip that will take you deep into a land made up of 600 islands and 800 indigenous languages.

Travel through rainforests broken only by mighty rivers, and trek past 70 metre- (230ft) tall conifers, vibrant orchids and great bushes of rhododendrons in search of the birds of paradise and their exotic feathered companions; fruit doves, fig parrots, fairywrens, paradise kingfishers, jewel-babblers, honeyeaters and bowerbirds. Visit far-off tribes like the yellow-painted Huli Wigmen whose dances and songs replicate those of the famed birds of paradise, and watch as possums and wallabies, giant flightless cassowaries and all manner of insect and reptile scamper past. When you're all birded out, choose to cruise the mighty Sepik River, dive the coral reefs or go fishing in the Fjord of Tufi.

TAKE ME THERE

How to Visit: PNG's tourism infrastructure is in its infancy so embarking on a birding tour is the best way to visit. International flights land in Port Moresby from where tours begin and accommodation is of good standard. Birding tours run from June to September (dry season) with the best time to see mating displays in August and September.

Further Information: The national tourism website (**www. papuanewguinea.travel**) offers lots of handy travel information. There are lots of international and local birding tours available including Exodus (**www.exodus.co.uk**), Rock Jumper Birding (**www.rockjumperbirding.com**), PNG Tours (**www.pngtours. com**) and Kiunga Nature Tours (**www.kiunganaturetours.com**).

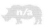

Did You Know? Birds of paradise found fame in the Western world when a 1996 David Attenborough documentary showed footage of the resplendent birds in Papua New Guinea.

Wildlife:
- Tree kangaroo
- Agile wallaby
- Cassowary
- Mountain cuscus
- Long-beaked echidna
- Bronze quoll
- 708 bird species
- 170 species of lizard
- 110 species of snake
- 25,000 species of beetle

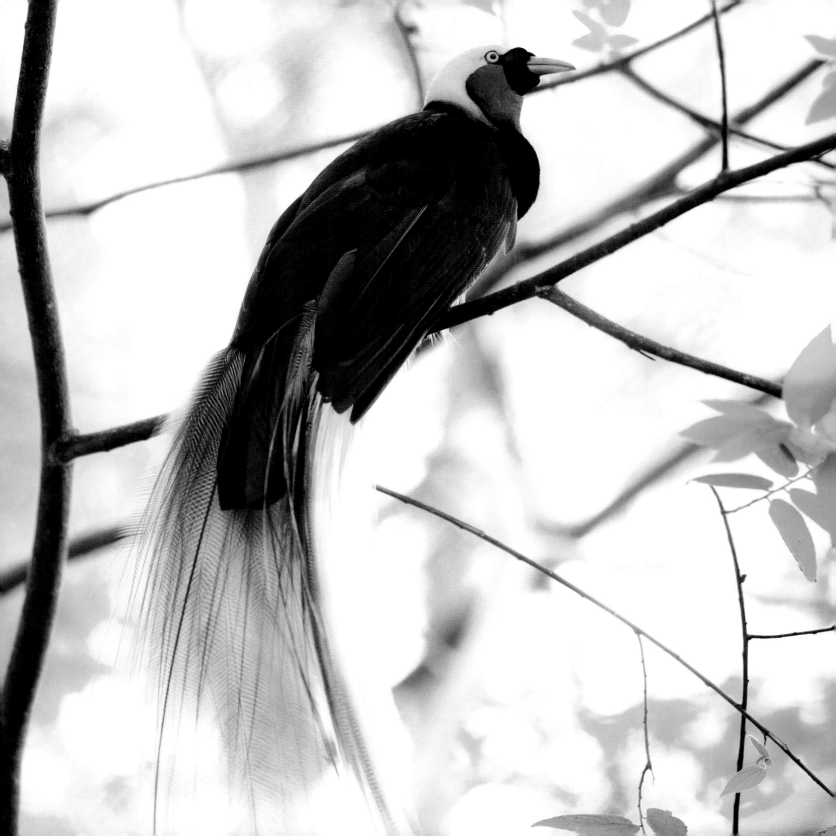

Like their African cousins, Asiatic lions once roamed vast territories, great prides inhabiting the forests from North West India through Persia, Arabia, Greece and north Africa. Today, while the larger African lion remains the king of the plains south of the Sahara, the story of the Asiatic lion is less rosy. Just 523 individuals exist in the wild, and all of them can be found in India's Gir National Park (and surrounding areas). Hunted as a coveted trophy during the British Raj era, the number of lions plummeted to a mere dozen in the early part of the 20th century. But with the creation of the Gir sanctuary in 1965, a 258 square kilometre (100 miles²) core area was declared a national park and, since the late 1960s, lion numbers have increased.

It is the last refuge of the Asiatic lion, a densely forested and hilly region tucked into the heart of Gujarat. Acacia, teak and banyan trees swing their fronds over a maze of rivers and streams, which in turn have gouged great ravines. Swathes of lush grassland peep out from in between the thick jungle, sulphur springs bubble to the surface and majestic Hindu temples hide within the depths. Despite a conflict for lands, around 1,000 Maldahari people still live within the park's boundaries (the rest having being resettled), their cattle providing controversial food for the lions.

Yet there is plenty to feast on for the top of the food chain predators; chital (spotted deer), sambar deer, nilgai antelopes, chousinghas (four-horned antelopes) and chinkaras (gazelles) thrive in plentiful numbers. Alongside them golden jackals, marsh crocodiles, wild boar and over 300 species of bird are widely seen, the leopard being the most elusive of the park's inhabitants.

Safari in Search of the King of the Jungle

Despite there being just over 500 Asiatic lions left in the wild, the chances of spotting one of the proud and majestic creatures is surprisingly high in Gir National Park. Self-drive or guided safaris trundle through the deep emerald green foliage when, often during the early morning or late afternoon, prides of lions saunter out of the forest onto the path in front in arrogant nonchalance. They are unperturbed by their human spectators, and it is a wonderful up-close wildlife experience to watch an animal that came within a whisker of becoming extinct once again rule the jungle.

Other wildlife entertains as you keep a watchful eye out for the lions, bird calls making a cacophony of noise through the canopy and sprightly, timid deer and antelope skipping through the trees. Ancient Hindu temples appear regally in the midst of nowhere and traditional lodges and camps dot the perimeter of the park offering classic Indian hospitality and a romantic sense of the old colonial safari lodges.

TAKE ME THERE

How to Visit: Gir National Park is located in the state of Gujarat in South West India 55 kilometres from Junagadh City which acts as the gateway. The city is accessible by road, train and air and there is a wide variety of accommodation option. The best time to visit is from December to April.

Further Information: The regional tourism website (**www.gujarattourism.com**) is a good starting place for planning a trip and tickets and permits can be arranged through the Gir Online Permit Booking System (**girlion.in**). There are dozens of hotels, lodges and safari camps to choose from including the Asiatic Lion Lodge (**www.asiaticlionlodge.com**) and the Gir Pride Resort (**www.girprideresort.com**).

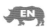

Did You Know? Unlike African lions, male Asiatic lions do not tend to live with the females of their pride unless they're mating or have a large kill.

Wildlife:
- Chital (spotted deer)
- Sambar deer
- Nilgai antelope
- Porcupine
- Marsh crocodile
- Leopard
- Golden jackal
- Wild boar
- Indian cobra
- Over 300 species of bird

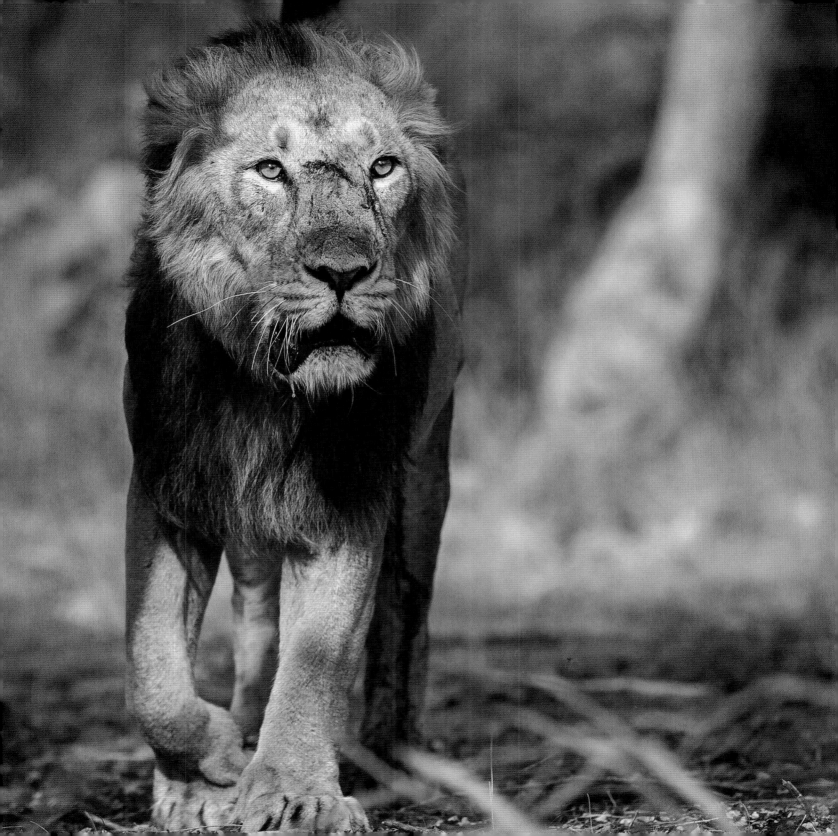

81 HIPPOPOTAMUSES IN THE LOWER ZAMBEZI NATIONAL PARK
ZAMBIA

Mighty rivers flow through a huge rift in the earth's crust creating a watery floodplain studded by oxbow lakes, a lush, vibrant vegetation and, at its heart, the great Zambezi River. This huge fertile valley, ringed by a steep escarpment blanketed in miombo woodland, is the Lower Zambezi and the 4,200 square kilometre (1,620 miles²) national park it envelops. Mirrored on the other side of the river is the Mana Pools National Park in Zimbabwe, together the two parks harbouring a staggering array of wildlife and plants.

The swollen river is the lifeline of the magnificent Lower Zambezi, where grassy floodplains give way to mahogany and ebony forests. Stout jackleberry and winterthorn trees grow along the banks, where huge herds of elephants up to 100 strong come to drink and cool off in the blistering African sun. Buffalo wade between the river's islands, and waterbuck, zebra, kudu and eland are common. Lions, leopards and wild dogs hunt expertly, and by night emerge hyenas, porcupines and honey badgers.

Despite its huge diversity, the Lower Zambezi is renowned for its vast numbers of hippo, their black backs protruding from the shallows like great clumps of rock all along the banks. Spending up to 16 hours a day submerged in water these river horses are graceful swimmers and nocturnal grazers, often travelling 10 kilometres (6 miles) in a single night to consume 35kg (80lbs) of grass. Once broadly distributed across Africa, their status is now deemed vulnerable as their population declines, the Lower Zambezi being one of the greatest gatherings in the world.

Canoeing the Mighty River

Flying over the steep escarpment, your light aircraft dips into a green valley where the sun glints off the threading rivers and lakes. Below you huge herds of elephant and buffalo move as one, and along the banks crocodiles and hippos can be spied in still, silent repose. Landing in the Lower Zambezi National Park you head to one of a handful of luxury lodges which ooze bush chic, from where safaris set off into the wilderness.

4WD excursions trundle across the floodplains, walking safaris offer a close encounter and boat trips glide up and down the river. Yet to fully feel at one with nature set off on a canoeing safari along the mighty artery. Spend hours paddling along a waterway teeming with life, where elephant are often seen swimming to feed on grassy islands where buffalo graze. Listen for the unmistakable cry of the fish eagle overhead, look to the sandy river banks for iridescent carmine bee-eater colonies while kingfishers and African skimmers flit above the waters. And all the while be enchanted by the lazy wallowing of the hippos who line the banks, their eyes protruding above the surface watching you pass in curious nonchalance.

TAKE ME THERE

How to Visit: The main entrance is Chongwe Gate although many visitors choose to fly in from Lusaka or Livingstone. The handful of upmarket lodges can arrange pick-ups or flights and offer a range of safari options including canoeing. The best time to visit is from June to September, but all lodges and canoeing operators are open from April to November.

Further Information: Start your trip planning at the Zambia Tourism website (**www.zambiatourism.com**) and for more information on the conservation efforts of the area visit Conservation Lower Zambezi (**conservationlowerzambezi.org**).

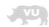

Did You Know? Hippos secrete an oily red substance which once gave rise to the myth that they sweat blood. It is in fact a natural skin moistener and sunblock.

Wildlife:
- Elephant
- Buffalo
- Waterbuck
- Crocodile
- Zebra
- Hyena
- Lion
- Leopard
- Wild dog
- Fish eagle

SEABIRDS IN ST KILDA
SCOTLAND

In the furthest remote corner of the British Isles, 100 kilometres (62 miles) from Scotland's mainland, lies the tiny archipelago of St Kilda. It is the outermost of the Outer Hebrides, a place with a proud past and inhabited for over 4,000 years by generations of hardy locals. Today however it has been left to the millions of seabirds which flock to the wind and wave-battered craggy coastline, making it the most important seabird breeding station in north-west Europe.

The largest island, Hirta, measures just 3 kilometres (2 miles) by 1.6 kilometres (1 miles), yet its towering cliffs are the highest in the United Kingdom. And St Kilda is just one of 29 places in the world awarded World Heritage Status for both its natural and cultural significance – putting it on a pedestal with Peru's Machu Pichu. Each of the four islands – Hirta, Soay, Boreray and Dun – exude their own charm, where white sand beaches, fields of wild flowers, precipitous cliffs and towering sea stacks combine to form a stark beauty. Remains of human life are scattered across the emerald green hills and vales, from medieval villages to the perfect row of little stone houses, left as they were on the day the last residents evacuated this far flung outpost in 1930.

The call and screech of the seabirds soaring in the buffeting winds is one of the most indelible memories of a trip to St Kilda. Of the 44 gannet colonies in the world, the one here is by far the largest accounting for 24 per cent of the world's population – a staggering 60, 500 breeding pairs. There are more northern fulmars here than anywhere else in Britain – 67,000 pairs – and 90 per cent of the European population of Leach's petrels. But by far the most prolific of the seabirds are the Atlantic puffins, numbering some 136,000 pairs, which make their nests in burrows on the grassy cliffs.

Cruising Through a Bygone Landscape

Visiting St Kilda is like taking a step back in history to a time when nature ruled the land, and the trappings of modern life were yet to be invented. Even in the height of a Scottish summer it is easy to imagine the difficult and inhospitable conditions in which generations of islanders survived, ferocious winds and churning grey waves moulding the shore at their whim.

Boat trips set out from neighbouring islands, cruising the fish-laden waters and stopping at bird colonies so great the sky seems to darken as they take flight in a cacophony of noise. In the plentiful seas, dolphins and minke whales, orcas and basking sharks gorge on the feast. It is a trip to a bygone age, where even the wild indigenous sheep hark from a Neolithic heritage.

TAKE ME THERE

How to Visit: St Kilda isn't the easiest place to get to due to its remoteness. Several cruise ships visit every year, including the National Trust for Scotland Cruise (**www.nts.org.uk/Cruises**). Day trip boats leave from the Western Isles, Isle of Skye and Isle of Lewis in the summer months (April to September).

Further Information: Visit Scotland (**www.visitscotland. com**) offers information on getting to the Outer Hebrides as well as accommodation choices. Day boat trips depart from several islands with operators including Kilda Cruises (**www. kildacruises.co.uk**), Sea Harris (**www.seaharris.com**), Integrity Voyages (**www.gotostkilda.co.uk**) and Northern Light Charters (**www.northernlight-uk.com**).

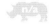

Did You Know? Highly protective of their nests, northern fulmars will spit a fishy smelling oil at anyone or anything that gets too close.

Wildlife:

- Northern gannet
- Atlantic puffin
- Northern fulmar
- Guillemot
- Soay sheep

- Basking shark
- Dolphin
- Minke whale
- Orca
- Golden eagle

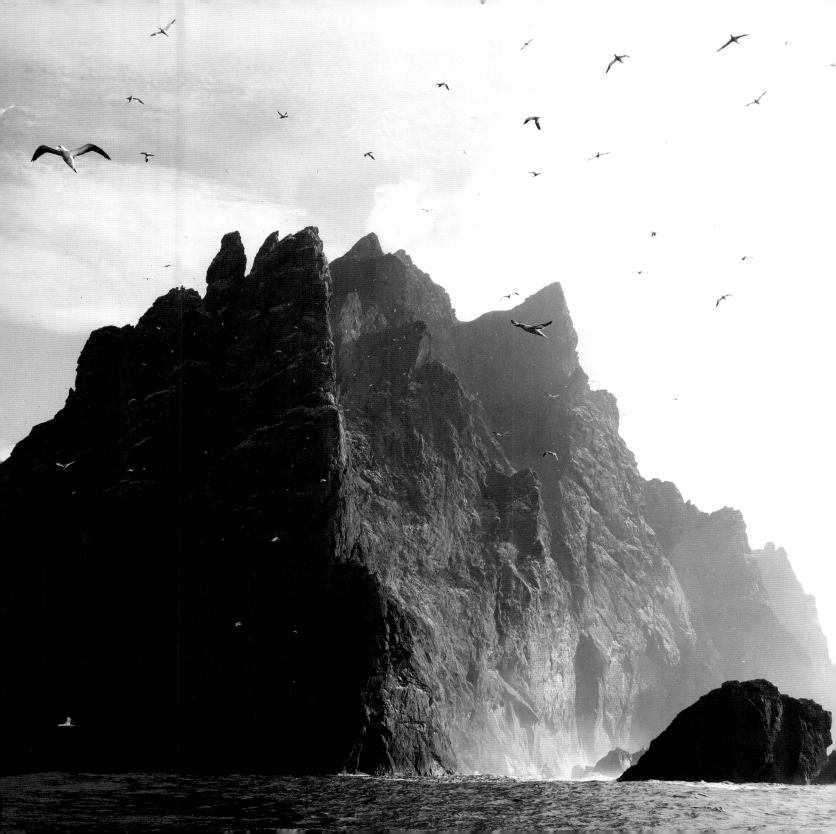

Tortuguero is one of Costa Rica's most remote national parks, a dense jungle threaded by creeks and rivers which tumbles onto sandy beaches lapped by the Caribbean Sea. There are no roads leading here, the watery highways providing the only thoroughfares through a soggy forest whose abundant rains soak the land and feed trees 60 metres (196ft) tall. It is one of the world's most biodiverse wetlands, a place where mangroves and palm swamps, beaches and lagoons create homes for wildlife.

The park might be named 'Turtle Catcher' after a long hunting history, but today it is one of the most important green turtle nesting sites on the planet. Under the white light of the moon, green, hawksbill, loggerhead and leatherback turtles lay their eggs in the warm sand, their tiny hatchlings erupting two months later to scuttle into the waves. They are the stars of Tortuguero, a true story of successful conservation brought back from the brink of extinction. Yet they are a long way from alone, and in the virtually impenetrable, vivid green jungle toucans and parrots flap furiously, Baird's tapirs emerge to drink and bull sharks make occasional forays upriver.

High in the canopy, in complete contrast to the spider, howler and capuchin monkeys which screech excitedly, great numbers of three-toed sloths live out their gentle and lethargic existence. With long claws making it difficult to walk on land, sloths spend the majority of their lives in the trees, clambering painstakingly down only to relieve themselves. Their silent stillness and camouflaged fur can make them challenging to spot, but Tortuguero offers one of the best chances anywhere in the world to do so.

Paddling Jungle Creeks

Where freshwater meets salt in a brackish maze of backwater canals and creeks, crocodiles stand as the largest of the 111 species of reptile. Shy manatees and river otters slip through the waters, and jaguars, ocelots and peccaries inhabit the jungle depths. And sloths hang like great bunches of leaves from the tallest of trees.

There is really only one way to explore Tortuguero, and that's by boat. Paddle under your own steam or with a local, eagle-eyed guide through the labyrinthine channels, where swaying fronds dip into the water and the vegetation closes in like a green tunnel. It's hard to remain focused on sloth-spotting, the dark waters below and the depths of the forest floor offering a bounty of distracting wildlife.

The tiny beachside village of Tortuguero exudes Caribbean culture, where muddy footpaths weave through rustic buildings, and eateries serve traditional cuisine. Accessible only by boat from a banana plantation or small plane from San Jose, it makes for a laid-back base from which to go in search of nesting turtles and gentle sloths.

TAKE ME THERE

How to Visit: Guided trips by boat or plane depart San Jose or Limón, although it is possible to visit independently. Accommodation ranges from guesthouses to luxurious lodges. The best time to visit is July and August when Green and Hawksbill turtles lay their eggs.

Further Information: Lodges can arrange trip packages, and there are many operators to choose from including Explore Outdoors (**www.exploradoresoutdoors.com**) and Iguana Verde Tours (**www.iguanaverdetours.com**). The Costa Rica-based Sloth Sanctuary (**www.slothsanctuary.com**) is a good resource.

Did You Know? The critically endangered pygmy three-toed sloth can only be found on the tiny Escudo Island off the coast of Panama. It is believed that less than 500 exist.

Wildlife:
- Turtles (Hawksbill, Loggerhead, Green, Leatherback)
- Crocodile
- Manatee
- Monkeys (Geoffroy's spider monkey, Mantled howler, White-headed capuchin)
- River otter
- 375 species of bird
- Iguana
- Collared peccary
- Salamanders
- Baird's tapir

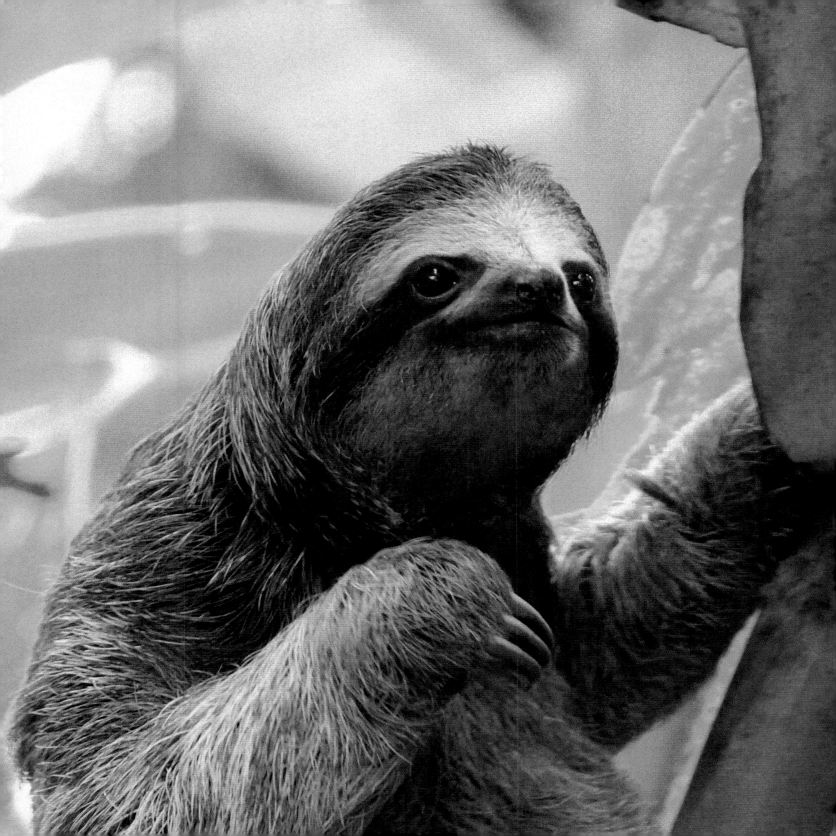

The Galápagos Islands might be isolated, far-flung and sparse, but it is precisely these qualities that gave rise to one of the planet's most diverse and unique ecosystems. When Charles Darwin sailed aboard the HMS *Beagle* to this remote group of volcanic islands some 1,000 kilometres (620mi) off the coast of present-day Ecuador his observations of bizarre endemic species inspired his theory of evolution and changed the world of science as we know it.

The archipelago – formed of 18 main islands – has some of the highest levels of endemism found on the planet. About 80 per cent of the land birds, 97 per cent of the reptiles and land mammals, and more than 20 per cent of the marine species are found nowhere else on earth. The giant Galápagos tortoise is a famous resident and one of the remaining two groups of giant tortoises in the world (the other is in the Aldabra Atoll in the Indian Ocean). The Galápagos penguin waddles along the sandy beaches, and land iguanas of psychedelic colours roam over the rocky landscape.

Yet the concept of a swimming iguana (better known as the marine iguana) probably best represents the weird and wonderful world of the Galápagos. Charles Darwin described them as 'hideous looking' and with their spiky dorsal scales, long tails and sharp claws they are certainly odd in appearance. These gentle herbivores however, survive solely on underwater algae and seaweed, delving into the cold seawater and swimming crocodile-like using their long tails to propel them.

Cruising in Darwin's Wake

The wildlife of the Galápagos isn't shy of the strictly controlled numbers of humans that visit the islands. Sea lions lounge comically on benches in towns, blue-footed boobies amble past spectators and schools of scalloped hammerheads encircle hardy divers. Marine iguanas are no exception, and spotting one of the estimated 200,000 to 300,000 individuals that live on the moon-like coasts is almost guaranteed.

Sail in Darwin's footsteps with a cruise around the micro world of the Galápagos and experience the biodiversity that inhabits the volcanic beaches, bare hills and rocky coasts. By kayak or Zodiac venture ashore in search of sea turtles and great colonies of shore birds, meet giant tortoises at the Charles Darwin Research Station, or head below the waves to experience a melting pot of marine species – huge whalesharks, playful fur seals and schools of sharks.

TAKE ME THERE

How to Visit: Visitors have the option of land-based tours or cruises around the islands lasting from a few days to over a week. All flights leave from Quito and Guayaquil on Ecuador's mainland. Cruise ships range from simple tourist class boats to luxury vessels.

Further Information: There are hundreds of international and local tour operators offering cruises and ships of varying quality. Some luxury vessels include National Geographic Expeditions/Linblad Expeditions (**www.expeditions.com**), Klein Tours (**www.kleintours.com**) and Metropolitan Touring (**www.metropolitan-touring.com**). For more information on the islands see The Galápagos Conservancy (**www.galapagos.org**) or UNESCO (**whc.unesco.org**).

Did You Know? Scientists believe that the ancestors of marine iguanas were land iguanas from the South American continent which drifted to the islands on logs or debris.

Wildlife:
- Galápagos penguin
- Galápagos giant tortoise
- Galápagos sea lion
- Galápagos fur seal
- Waved albatross
- Galápagos land iguana
- Hammerhead shark (great, smooth and scalloped)
- Flightless cormorant
- Blue-footed booby
- Galápagos bullhead shark

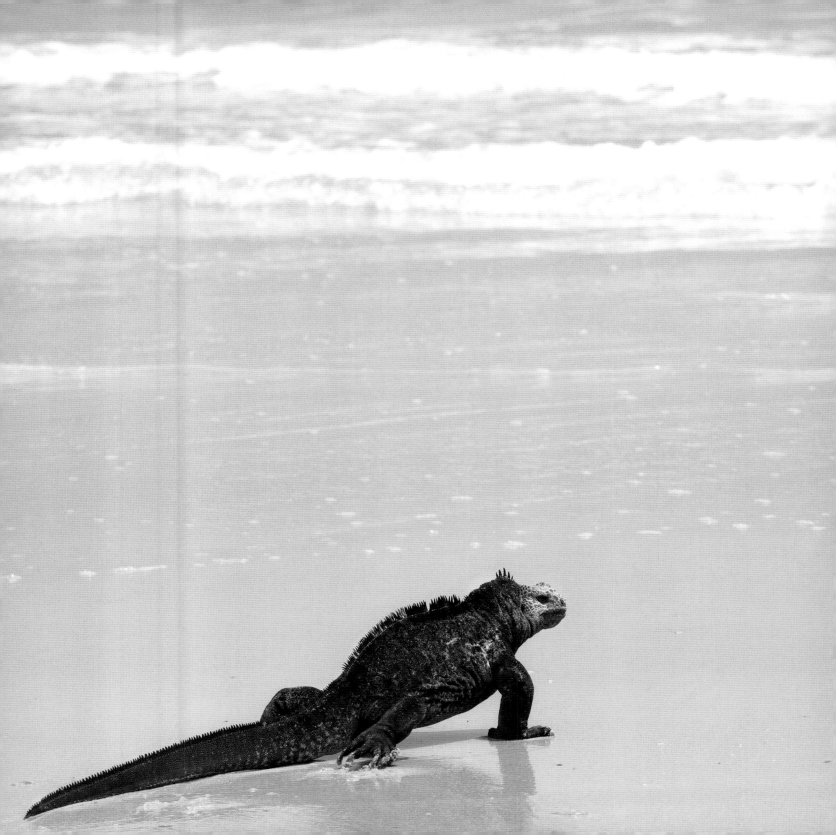

85 BLACK RHINOCEROS IN OL PEJETA CONSERVANCY
KENYA

From 1960 to the 1990's the population of black rhinos declined 97.6 per cent as a direct result of poaching. By 1993 only an estimated 2,300 remained in existence in the wild, a sad fate that put them on the IUCN's critically endangered list. While they remain under huge threat – their horns sought after for Asian medicine at US$60,000 to 100,000 each – their numbers have risen to some 5,000 individuals thanks to conservation efforts throughout Africa. In Kenya, the Ol Pejeta Conservancy is leading the way in the protection of this solitary, majestic and often aggressive animal and 105 rhinos live within the protected borders of the estate.

It is the largest black rhino sanctuary in East Africa, a sprawling 360 square kilometre (139mi²) estate in the heart of the pristine Lakipia County. The equator line runs through the wildlife-laden lands, which stand in the shadow of snowy Mount Kenya and the Aberdares, and the Big 5 (African lion, African elephant, Cape buffalo, African leopard, and White/Black rhinoceros) enjoy the unfenced protection alongside a diverse and rare selection of African animals including wild dogs and Grevy's zebras, cheetah and oryx. More common wildlife can be found here too, giraffes, hippos, impala and hyena.

Ol Pejeta is today a model for conservation, huge game corridors allowing all but the endangered rhinos to pass through the region freely. The Sweetwaters Game Reserve is home to a chimpanzee sanctuary where orphaned and rescued primates live amidst the beautiful surroundings, and three of the four last remaining northern white rhino in the world live in close protection.

Conserving for the Future

To visit Ol Pejeta is no ordinary safari. Understated and free from the huge numbers of jeeps that ply many other national parks and conservancies, it is a quiet and serene place where nature has been allowed to evolve in a safe and sustainable way. Self-drive safaris are possible, where you explore the open plains and acacia forests, hills and swamps in search of the myriad of wildlife that exists here.

Yet opportunities to get hands on with the preservation efforts are one of its biggest draws, where tracking lions, visiting the chimpanzees and learning about the complex methods of safeguarding the rhinos from poaching can be undertaken – even drones are now in use to monitor illegal activities. Seven luxury bush camps dot the conservancy, each exuding safari chic. To sit with a sundowner in hand and watch as the last rays of red sun dip below the horizon and elephants and rhinos wander lazily in front of you is to feel an Africa of yesteryear, long before the majestic wildlife of this vast continent had such a huge price on their heads.

TAKE ME THERE

How to Visit: Ol Pejeta is three hours' drive from Nairobi which is served by an international airport. It can be visited as a self-drive safari or as part of guided walks, safaris and conservation activities. There are seven upmarket accommodation options inside the conservancy. It can visited year-round although the rainy seasons are rains April, May, early June and November.

Further Information: The conservancy website (www.olpejetaconservancy.org) offers a comprehensive guide to planning a trip, booking accommodation, arranging activities and further background information on the conservation methods in place.

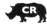

Did You Know? There is actually no difference in colour of black and white rhinos. The main differences are that black rhinos are smaller and have a hooked lip.

Wildlife:
- Elephant
- Lion
- Leopard
- Buffalo
- Grevy's zebra
- Giraffe
- Cheetah
- Gazelle (Thomson's and Grant's)
- Baboon
- African wild dog

BEAVERS IN BERGSLAGEN
SWEDEN

Seen from above, Sweden's central heartland is a patchwork of lakes and forests. Tightly packed pine trees roll over hills to the shores of the deep dark lakes and narrow snaking rivers, where beavers, wolves, elk and brown bears easily outnumber humans. It is a true wilderness, a place where winter lays an icy hand over the landscape and summer brings with it the balmy midnight sun.

The fate of the Eurasian beaver once hung precariously in the balance, hunted to the brink of extinction throughout Europe for its fur and castoreum – a secretion from its scent gland believed to have medicinal properties. By 1900 only 1,200 beavers existed in isolated pockets, and Sweden's forests were completely empty of the continent's largest rodent. A successful reintroduction programme in the 1920's saw numbers soar, and today the region is once again spattered with the tell-tale signs of beaver life.

Dusk is a busy time in the Malingsbo-Kloten Nature Reserve and the surrounding landscape. Beavers emerge cautiously from their dome-like homes (called lodges) and the king of the forest, the 650kg (1,430lb) elk (or moose), splashes through the lakeshores. With a population of over 400,000, Sweden has more elk per square kilometre than any other country on the planet. Red foxes, lynx, bears and owls pad silently under the cover of darkness, and the haunting howl of the wolf fills the quiet.

Canoeing Under the Midnight Sun

In the soft evening light, the silence of the forest is broken only by the gentle ripple of a Canadian canoe gliding through the still, dark lake. The crack of a branch echoes through the wilderness and, as a single splash signals a beaver's tail slapping on the surface you gesture in mute hand signals.

To spy one of the busy little creatures is a challenge, but one which is most easily completed in this remote and untouched part of Sweden. Throw yourself wholeheartedly into the abounding nature, staying in a lakeside, family-run lodge, spending days ambling the forests, and evenings canoeing in search of some of Europe's largest mammals.

Or embark on a multi-day, self-guided adventure. Canoe past tiny islets dotted like pebbles across open lakes and through narrow, steep-sided river valleys. Learn to read the landscape, where gnawed trees and camouflaged lodges signal beavers nearby, and pitch your tent on the shores of the gently-lapping lakes. By the light of the midnight sun you listen to the unmistakable call of nature that surrounds you; the crackle of a log fire, the hoot of an owl or the howl of a nearby wolf.

TAKE ME THERE

How to Visit: Stockholm's Västerås airport is the most convenient entry point to the region. Canoe trip/rental companies can arrange pick-ups from the airport or city of Örebro. Lakes and rivers are frozen in winter so late spring to late summer is the only time to visit.

Further Information: The national tourism website (www.visitsweden.com) offers valuable trip-planning information. For guided tours, wilderness packages or canoe rentals try Nordic Discovery (**www.nordicdiscovery.se**) or Wild Sweden (**www.wildsweden.com**).

Did You Know? Beavers can swim at speeds of up to 8km (5mi) an hour and can remain underwater for 15 minutes. They have transparent eyelids which act like goggles.

Wildlife:

Elk	Red fox
Wolf	Roe deer
Mountain Hare	Lynx
Bear	Black woodpecker
Red squirrel	Great grey owl

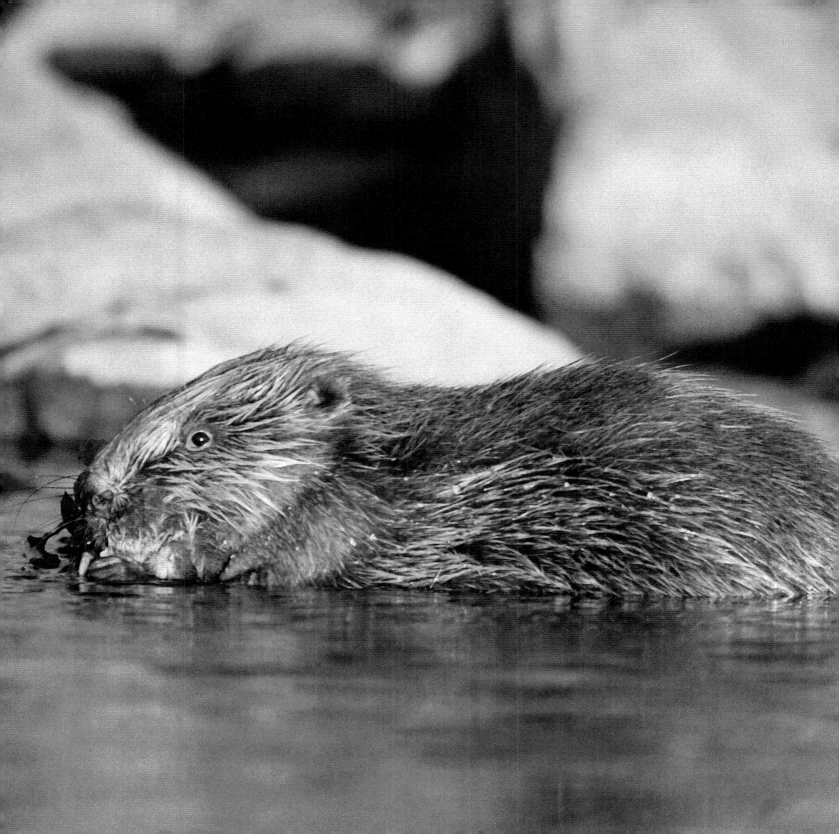

87 PINK DOLPHINS IN LOS LLANOS DE MOXOS
BOLIVIA

Pink dolphins might sound like creatures of fairy stories, but in Bolivia's vast Moxos Plains (Los Llanos de Moxos) cetaceans the colour of pale pink candy floss nimbly skip through the waters of the Ibare River. Cut off from the Orinoco river dolphins by rapids and waterfalls, they have evolved into a completely separate species, known in Bolivia as *bufeos,* and in 2012 were given special government protection.

The plains, stretching for an area the size of North Dakota (69,000 square kilometres/26,600square miles), are part of an ancient lake bed reaching eastward from the foothills of the Andean mountains. In this wild and mostly uninhabited tropical wetland on the edge of the rainforest, tributaries of the Amazon snake their way through pampas and primary forest, tipping into great lakes. Black and Yacaré caimans laze on the riverbanks under the tropical sunshine, capybaras grunt through the reeds, Pampas deer wade through the watery terrain and anacondas, giant river otters and river turtles navigate the tributaries and channels.

Little research has been done on the dolphins and it is not understood fully why they are the pastel pink shade that makes them so special; thinner skin allowing blood vessels to show through like a rosy blush perhaps, or maybe because of the Coca Cola-coloured water in which they swim and the food they eat. The dolphins, weighing up to 200kg (440lb), have a bulbous head, a ridge instead of a fin and a long nose, perfect for ferreting out fish and crabs in hollows on the riverbed.

Cruising the Amazon Basin

To go in search of Bolivia's pink river dolphins is a true adventure through a region inhabited by just one person per square kilometre. Nature dominates in this stretch of the Amazon Basin where a traditional way of life abounds.

Embark on a multi-day boat trip along the Ibare or Mamoré rivers on the Ruta del Bufeo (the river dolphin route), camping or lodging in local villages, or aboard a larger boat with comfortable cabins. Trips depart from the charming colonial city of Trinidad, the hot and humid capital of the Department of Beni, and pass traditional homes made with bamboo or mud and roofs of palm fronds, and riverbanks dotted with cacao, bana and yucca trees. Try not to get distracted by the wading birds and abundant wildlife as you keep your eyes on the surface of the river for a flick of a rosy pink tail or the spouting from a blow-hole.

It is a trip filled with adventure, and sightings of the dolphins are almost guaranteed (the hardy are even able to swim alongside them). Trek the riverbanks, fish in the lagoons, camp with the local communities and bird-watch in the evening sun.

TAKE ME THERE

How to Visit: The city of Trinidad in the Department of Beni is the gateway to Los Llanos de Moxos region and accessible by flight from cities including La Paz, Santa Cruz and Cochabamba. Multi-day tours up the river run from there staying with local communities or camping.

Further Information: There are numerous tour operators in Trinidad which offer trips and High Lives (**www.highlives.co.uk**) can arrange full travel to Bolivia. There are several operators through which you can book cruises on the large, plush Reina de Enin riverboat.

Did You Know? Pink river dolphins can temporarily become a very vivid pink at times of excitement, like a human blush.

Wildlife:
- Black caiman
- Piranha
- Capybara
- Pampas deer
- Giant river otter
- Blue-throated macaw
- Magdalena river turtle
- Anaconda
- Yacare caiman
- Greater rhea

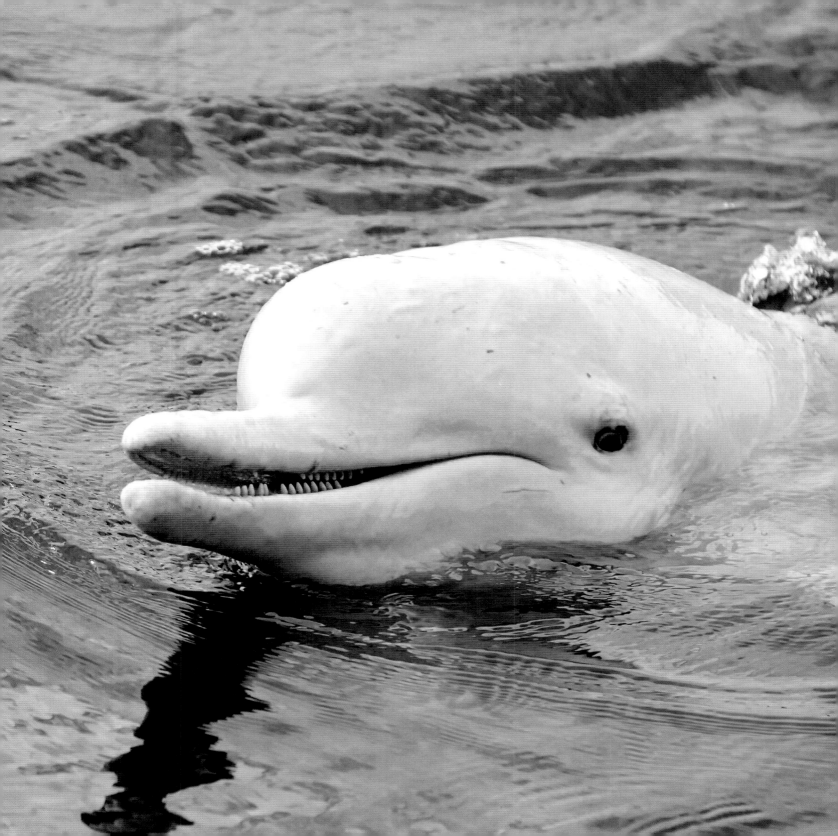

AMERICAN ALLIGATORS IN THE EVERGLADES NATIONAL PARK
USA

Called 'The River of Grass' by native Americans, the Everglades are more than simply a vast wetland. The largest subtropical wilderness in the United States is a flat patchwork of wet sawgrass prairies, cypress swamps and mangroves that stretches for over 8,000 square kilometres (3,100mi²). Reaching from central Florida all the way to Florida Bay is a maze of watery features, rivers and lakes, prairies and grasslands merging into one and giving way to the brackish waters of the mangroves and the sea beyond.

It is one of the country's most famous regions, a wild and untamed world amidst the hustle and bustle of Florida's vibrant cities. Not only does it contain the largest mangrove ecosystem in the Western Hemisphere, the largest continuous stand of sawgrass prairie and the most significant breeding ground for wading birds in North America, it also harbours staggering numbers of wildlife, including rare and endangered species such as the Florida panther (of which only about 80 exist) and West Indian manatee – even the rabbits have adapted to be able to swim. Yet the most famous inhabitants are the thousands of American alligators which are a vital part of the ecosystem.

The nests built by female alligators are crucial to the formation of peat and several turtle species incubate their

eggs inside active and abandoned alligator nests. As the dry season descends across the region, alligator nests retain water and become a vital refuge for a variety of wildlife including wading birds.

Backcountry Canoeing and Camping

There is a certain raw appeal about the Everglades National Park, and visitors throng here to experience a natural idyll. The opportunities to appreciate it are many; follow the hiking and biking trails, take a boat ride through the shallows or join a ranger led programme. Yet in this watery landscape, the best way is set off on a guided backcountry canoeing and camping trip (venturing independently is recommended only for advanced canoeists).

Begin on the shores of the Gulf of Mexico, where bottlenose dolphins and pelicans can be spotted, and explore the brackish waters of the gnarled mangroves, home to manatees and gargantuan crocodiles. Paddle through the maze of 10,000 islands, sleep under the stars, look out for spoonbills, egrets, and wood storks and, in the depths of the wetlands revel in the sense of being watched by the beady eyes of observant alligators. It is a trip that can last from three days to a week, submerged in the wilds where nature is truly in charge.

TAKE ME THERE

How to Visit: There are three main entrances to the national park; Homestead which connects to the Flamingo Area, Miami for the Shark Valley entrance and Everglades City for Gulf Coast Entrance. There are a plethora of tourist facilities and accommodation in all. The best time to visit is the dry season from December to March.

Further Information: The National Parks Service (**www.nps.gov/ever/index.htm**) has a hugely comprehensive website for planning a trip. There are dozens of canoeing/kayaking companies, boating outfits and hiking guides in all the major park gateways.

Did You Know? American alligators are smaller than their crocodile counterparts and adult males grow up to about 3.4 metres (11ft) in length, and weigh up to 227kg (500lb).

Wildlife:
- West-Indian manatee
- Florida panther
- Bottlenose dolphin
- American crocodile
- River otter
- Raccoon
- White-tailed deer
- 16 species of turtles and tortoises
- 27 species of snake
- 350 species of bird

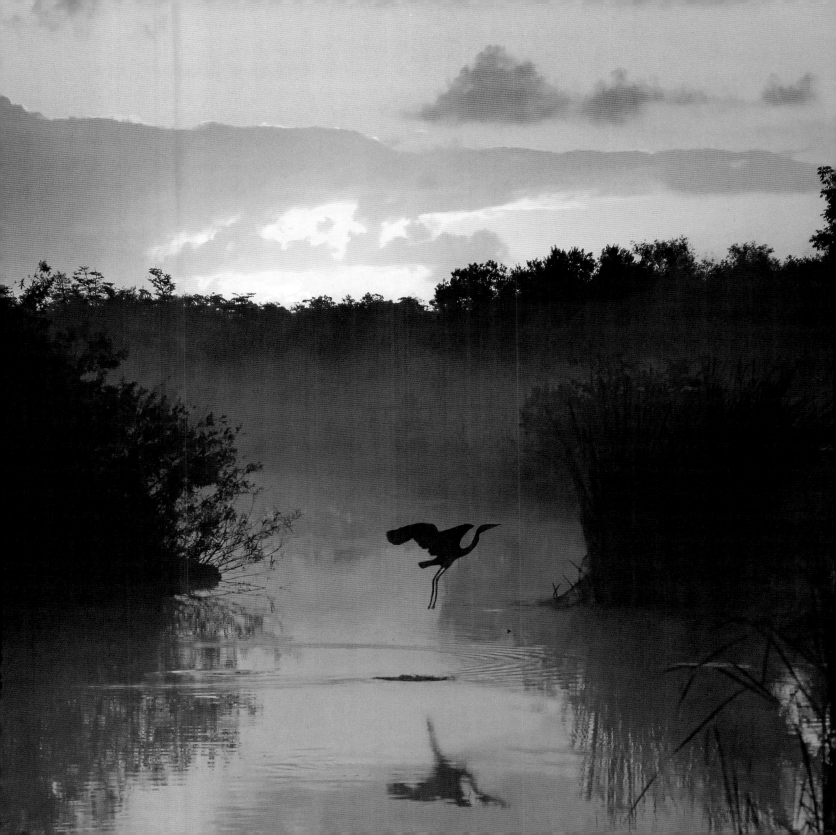

The island of Hokkaido couldn't be further from the stereotypical picture of Japan's flashing neon lights, cities bursting with people and modern trappings. The second largest and northernmost of the country's four main islands might make up 20 per cent of Japan's landmass, but it holds just 5 per cent of the population. Separated from the mainland by a deep ocean trench it forms the transitional zone between the cool temperate forests of the south and the Siberian climate and thick woodlands of the north. Long, cold winters lay their icy hand over a landscape which, until the 19th century, was inhabited only by the indigenous Ainu people and a weird and wonderful selection of wildlife.

Hokkaido's forests are home to Japan's only population of brown bears, who arrived from the Siberian mainland during the last Ice Age. Dainty, endemic Sika deer totter through the patchwork of crop fields that bloom with wheat and potatoes, maize and lavender in the warm spring months, and come winter whooper swans, Stellar's sea eagles, Blakiston's fish eagles and the most famous of all, the red crowned crane, put on spectacular displays.

By the beginning of the 1900's it was believed the huge, elegant red crowned crane had become extinct. But the discovery of a small flock in Hokkaido's eastern Kushiro marshes launched conservation efforts and today over 1,000 of these impressive birds live year round in what has become a national park. In Japan they are iconic and legendary, a symbol of luck, longevity and fidelity.

An Evening at the Ballet

At almost man-height and with a 2.5metre (8ft) wingspan, the red crowned crane is a spectacular sight to behold, its white and black feathers almost camouflaged in the snowy landscape. Winter is the perfect time to watch them as they gather around feeding stations in the Kushiro National Park to enact one of nature's most beautiful spectacles. Arching their long slender necks back in unison, pairs of cranes dance together in a perfectly choreographed ballet, tiptoeing daintily as they dip and skip.

Travel amidst the mountains and volcanoes of Hokkaido by rental car to behold the mating dance of the red crowned cranes in their only remaining habitat. From the road, viewpoints offer the chance to stop and scour the marshes (where a myriad of other rare and endangered birds can be spotted), while evening riverside roosting spots proffer idyllic crane-spotting opportunities. Make a stop at the Akan International Crane Centre, a museum and sanctuary, or for some of the best chances to see the dance of the rarest cranes in the world visit winter feeding stations such as the Marsh Observatory.

TAKE ME THERE

How to Visit: Flights to Sapporo's airport arrive from mainland Japan and international destinations, and there is good public transport and road networks to the national parks (although a rental car is recommended for getting around the parks). The cranes can be seen year round but the best time is in winter (November to March) when they congregate around feeding stations.

Further Information: Both the national (**www.jnto.go.jp**) and regional (**en.visit-hokkaido.jp**) tourism organisations offer trip-planning information and further details on the national parks and cranes.

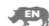

Did You Know? The red crowned crane might be big, but the tallest crane (and tallest flying bird) is the Sarus crane which can be 1.75 metres (5ft 7in) tall.

Wildlife:
- Stellar's sea eagle
- Blakiston's fish owl
- White-tailed eagle
- Ural owl
- Whooper swan
- Brown bear
- Red fox
- Ezo momonga (flying squirrel)
- Sika deer
- Chipmunk

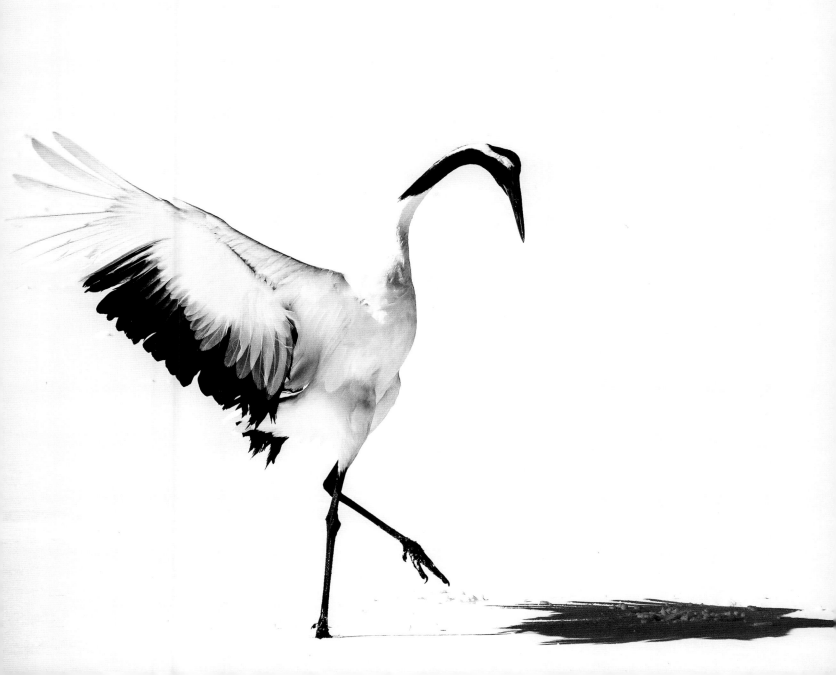

It is one of the most spectacular wildlife events on the planet, the greatest show on earth playing out across the vast plains and rolling hills of the Serengeti National Park. Every year, led by the life-giving rains that feed the lush savannahs, 1.5 million wildebeest make a circular journey, rivers of black pouring across from Tanzania's southern Serengeti to Kenya's Masaai Mara and back again. Some 400,000 zebra and 200,000 gazelles (Grant's, Thomson's, eland and impala) accompany them along the way, making a total of over two million migrating animals thundering as one. It is an 800 kilometre (500mi) journey filled with peril, and 250,000 animals will lose their lives from thirst, hunger, exhaustion or predation before its end.

The migration is only as predictable as the rains, but the life-cycle of the great stampede usually begins between January and March when, in the southern reaches of the Serengeti in the Ngorongoro Conservation Area, half a million calves are born in a two to three week period. As the rains dry out in May and the plains become parched, streams of wildebeest begin their journey towards the Masaai Mara, pouring across the granite kopjes of the Seronera Valley or Western Corridor. Both routes are fraught with dangers, the famous Serenegti lion prides – totalling around 3,000 individuals – waiting to feast on the young and weak, and the great Grumeti River lined with powerful, patient crocodiles. Hyenas, cheetahs and leopards join the feeding frenzy as the herds make their way to their dry season refuge in the Masaai Mara where they will stay until the October rains send them back towards the Serengeti.

Tracking the Great Migration

In 1972 the United Nations met to elect the very first World Heritage Sites, and the great Serengeti found itself at the top of the list. It is one of the most famous national parks on the planet, a cauldron for African wildlife who roam in unfathomably vast numbers. It is a complex ecosystem, at the heart of which is the great wildebeest migration, undoubtedly one of the most impressive wildlife spectacles you can experience.

While lodges and camps dot the Serengeti, nature doesn't always adhere to fixed dates and the unpredictability of the rains can mean the risk of missing out on the migration. To ensure a guaranteed heart-of-the-action experience, choose to stay in one of the mobile tented camps which follow the herds. Abounding in safari chic luxury they move with the rains, pitching in the midst of the herds and providing the perfect base from which to venture out on jeep safaris and photography excursions to watch as millions of animals thunder past on a journey that has played out on these soils for thousands of years.

TAKE ME THERE

How to Visit: Experiencing the migration is all about timing. Mobile tented safari camps follow the herds and offer luxury accommodation. The best times to visit are January to March in the Ngorongoro Conservation Area of the southern Serengeti, northwest around the Grumeti River from May to late June and north of the park in October as they return from the Masaai Mara.

Further Information: Start planning a trip with the official Serengeti (**www.serengeti.org**) and Tanzania Parks (**www.tanzaniaparks.com**) websites. There are many lodges and camps including mobile migration camps such as Nomad Serengeti Safari Camp (**www.nomad-tanzania.com**) and Sanctuary Serengeti Migration Camp (**www.sanctuaryretreats.com**).

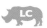

Did You Know? The name 'wildebeest' comes from the Afrikaans for wild beast due to the animal's fierce appearance. It is also known as a gnu.

Wildlife:
- Lion
- Giraffe
- Buffalo
- Leopard
- Elephant
- African wild dog
- Hyena
- Crocodile
- Hippopotamus
- Cheetah

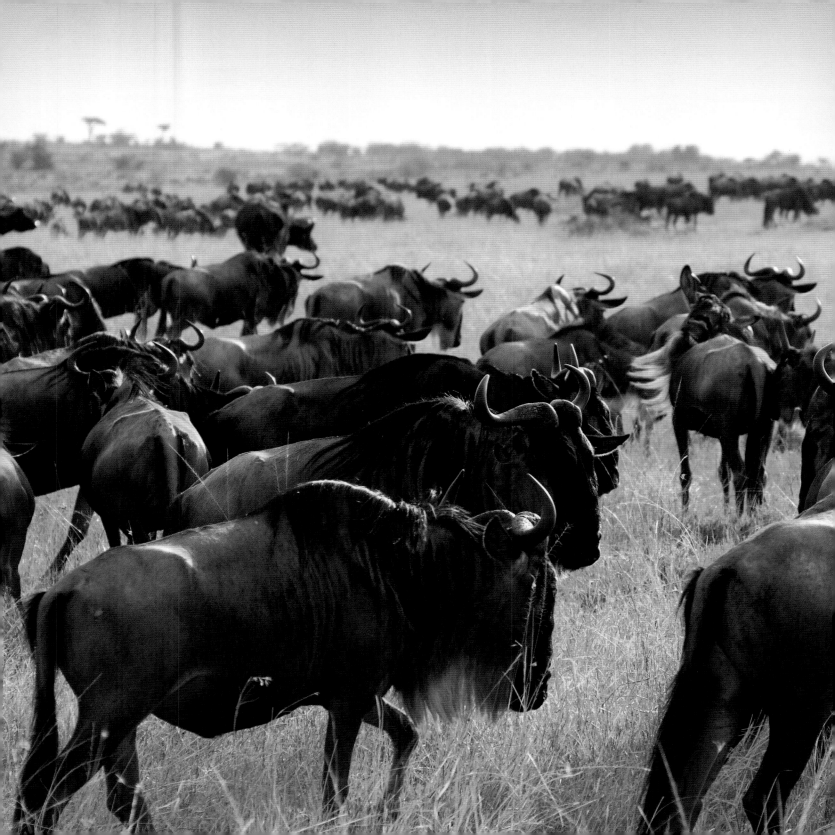

SEA OTTERS IN MONTEREY BAY
USA

There are few animals on the planet that invoke more a sense of 'aawww' than the sea otter. Lounging on their backs, bobbing gently on the waves, they clasp paws in huge floating 'rafts' dozens strong, wrapping themselves in kelps fronds to stop them drifting away from each other. Yet they are industrious little creatures too, spending much of their lives fishing for abalone and octopus, crabs and urchins amongst the huge kelp forests. Today in California's protected Monterey Bay National Marine Sanctuary they are a common sight, with over 2,000 otters thriving in the plentiful waters. It is a conservation success story, a species that was pulled from the brink of extinction at the turn of last century (although they are still classified by the IUCN as endangered).

Sweeping beaches, twinkling tide pools and the nation's largest undersea canyon—bigger and deeper than the Grand Canyon – make up the sanctuary which stretches along 444km (276mi) of shoreline and 12,000 square kilometres (4,600mi²) of ocean. The coast might be dotted with vibrant cities, where the golf courses, restaurants and colonial architecture of Santa Cruz and Monterey lure holidaymakers, but the ocean is where the action truly happens.

Dubbed the 'Serengeti of the Sea', the nutrient-rich waters are teeming with life, from the smallest shrimps to great blue whales. Bottlenose dolphins and orcas, grey and humpback whales, harbour seals and elephant seals mass here to dine on the thick plankton soup, and seabirds flock to the steep cliffs. Loud, playful California sea lions bark from rocks and jetties where they gather in great numbers, and in the skies brown pelicans swoop over the surface like great bombers.

Exploring the 'Serengeti of the Sea'
Set off to explore the hidden secrets of this sweeping coastline, where redwood-studded hillsides and high bluffs reach down to the lapping ocean. To be in with a chance of spotting otters frolicking in the waves walk the Monterey Bay Coastal Recreation Trail to Cannery Row in Monterey, or dine at one of the seafood restaurants in Fisherman's Wharf where you may just spot them twirling in the water below. Hike the trails in Point Lobos State Reserve in Carmel or embark on a boat trip through the mangroves of the Elkhorn Slough National Estuarine Research Reserve and Moss Landing Harbour for almost guaranteed sightings of otters as they bob around in the protected rocky coves.

Monterey Bay's wildlife is raw yet accessible. Whale watching tours head out of the cities, harbour seals follow you timidly yet inquisitively as you wander the paths or scuba dive amongst the kelp forests, and elephant seals can be sighted battling for turf and birthing their pups as you kayak the shore.

TAKE ME THERE

How to Visit: Flights to Monterey Regional Airport connect to international airports and there is a good train service connecting to Los Angeles and Seattle. The region has accommodation of all levels and types and developed tourist facilities. There are dozens of reputable sea otter and whale watching tours, kayak rental outfits and boat trips.

Further Information: For trip planning information the Monterey Bay tourism website (**www.seemonterey.com**) is a good starting point. Other good resources include the Monterey Bay National Marine Sanctuary (**montereybay.noaa.gov**) and **www.monterey.com**.

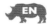

Did You Know? A sea otter has an incredibly fast metabolism and has to eat 7kg (15lbs) of food per day – that's 25 per cent of its body weight.

Wildlife:
- Orca
- Minke whale
- Grey whale
- Humpback whale
- Blue whale
- Bottlenose dolphin
- Harbour seal
- Elephant seal
- California sea lion
- California brown pelican

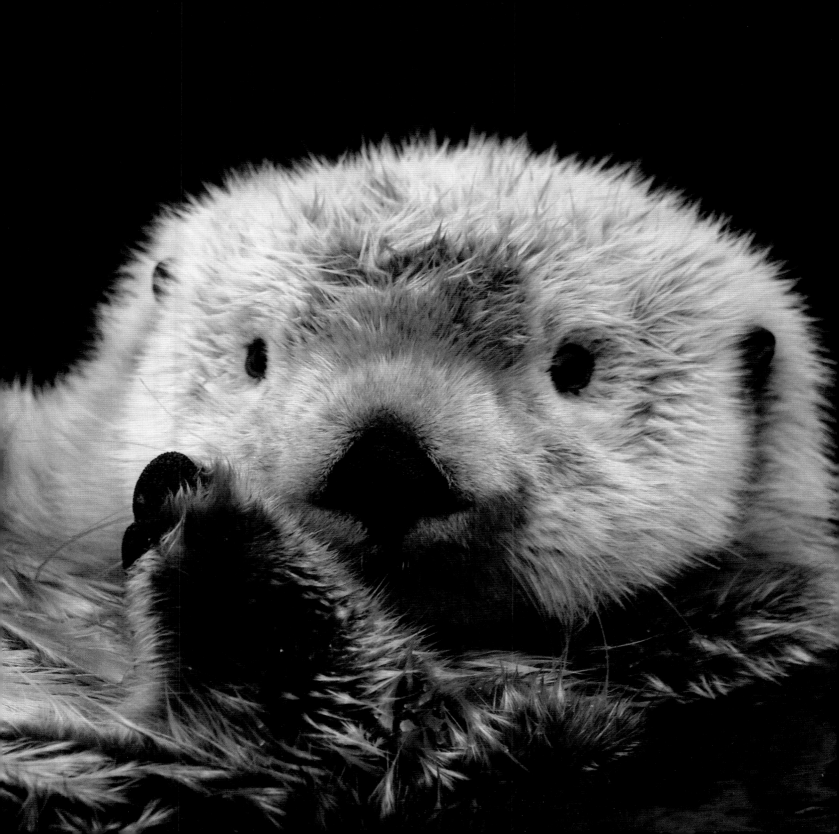

92 PUFFINS IN ICELAND
ICELAND

The puffin spends the majority of its life at sea, bobbing alone on the waves in a solitary existence. Propelling its way through tumultuous oceans with powerful little legs or taking to the air like a cumbersome jetliner with a great flapping of its black and white wings, the charming little bird only reaches landfall but once a year. But when it does it is in one of the greatest gatherings on the planet, millions of the orange-beaked seabirds coming together to nest on the shores of Iceland's vast sea cliffs.

Over half of the world´s population of Atlantic puffins breeds in Iceland – around 3 – 4 million pairs – and the total puffin population in the country is believed to be 8 to 10 million birds. The great colonies are dotted around the craggy coast of the vast island on the edge of the Arctic Circle, a place where puffing volcanoes and steaming geysers loom over plateaus and fertile lowlands. For Iceland is wild and untamed, a country of fire and ice, swirling northern lights and the golden glow of the midnight sun. Nature reigns supreme in Europe's least populated country, and 80 per cent of the country is uninhabited.

The laid-back Icelanders might not number many, but the seas and cliffs are home to not only great puffin colonies but minke and humpback whales, harbour porpoises and white-beaked dolphins. Orcas make occasional visits and seals lounge on the rugged rocky outcrops of the numerous islands that sit just off the black sand beaches and towering cliffs.

Puffin-Spotting in a Volcanic Land

Choose to embark on a day's boat trip from the cosmopolitan capital of Reykjavík to see the colonies that inhabit the rocky islands of Akurey or Lundey, or venture into the remote wilderness to experience a different side of the country where tiny towns and traditional fishing villages dot the shores and enormous jagged fjords have been gouged out of the steep cliffs. The largest single puffin colony in the world is in the Westmann Isles, a remote windswept archipelago that lays claim to being the windiest place in Europe. Like something from Mars, the Eyjafjallajökull Volcano peers over the region as you set sail on the grey choppy seas in search of marine life and seabirds.

In the Westfjords, a coastal road winds along the precipitous edge of the fjord from where gyrfalcons and sea eagles, snowy owls and seals can be spotted. The Hornstrandir Natural Reserve Park allows for some of the closest encounters with puffins in the country, the little birds unafraid of visitors thanks to a lack of harvesting (puffins are sustainably harvested for food).

TAKE ME THERE

How to Visit: There are many national and budget airlines connecting Europe with Iceland's Reykjavík Airport. Puffin-watching destinations are found all around the country and vary in difficulty and length of travel. Most tours are by boat. Puffins start arriving in Iceland in May but the main nesting season is June.

Further Information: Visit Iceland (**www.visiticeland. com**) and Promote Iceland (**www.iceland.is**) both offer excellent trip-planning information including tour companies and accommodation options.

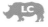

Did You Know? Puffins can fly at speeds of 88km (54mi) per hour by flapping their wings 400 times a minute and swim to depths of 60 metres (196ft).

Wildlife:
- Minke whale
- Harbour porpoise
- Humpback whale
- Orca
- White-beaked dolphin
- Kittiwakes
- Harbour seal
- Arctic fox
- Snowy owl
- Sea eagle

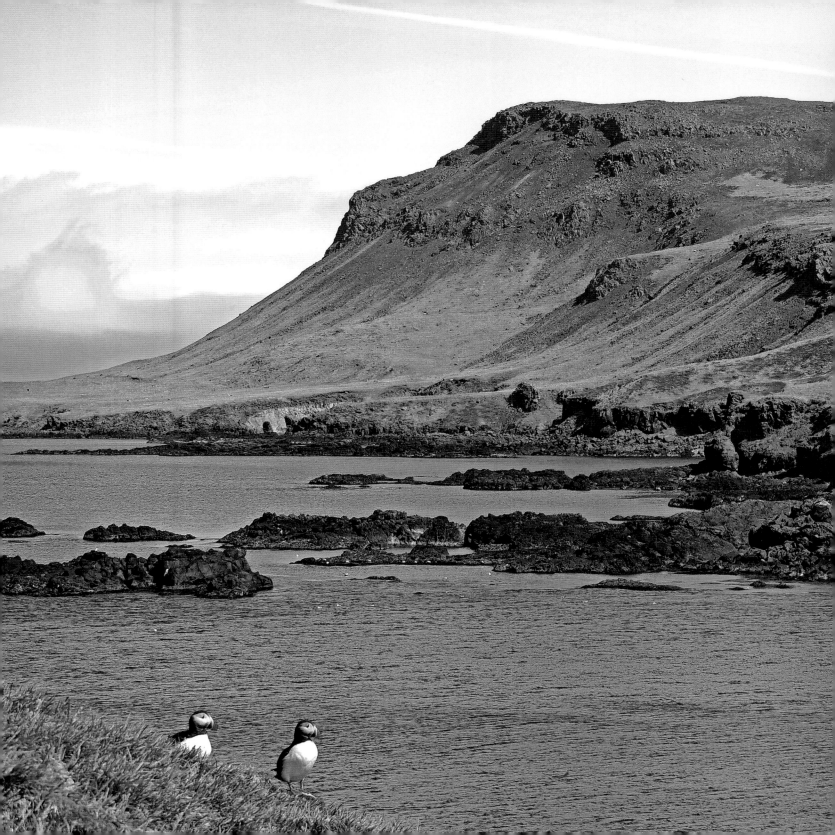

In the heart of Guyana is a vast rainforest. Rivers thread their way through, tumbling over precipices as dramatic waterfalls, and a dense canopy 30 metres (100ft) high provides shade to the wildlife that teems within it. Guyana is half the size of California with a population of just 750,000, its heartland mostly uninhabited save for a scattering of indigenous Amerindian villages. Ranking alongside Congo, New Guinea and Amazonia, it is one of the world's last four pristine tropical forests, a place where the giants of South America carve out their existence.

Black caiman alligators – the Amazon basin's biggest predator at 5 metres (16ft) long – saunter along the Essequibo River under the black of night, and the 200kg (440lb) air-breathing Arapaima fish – one of the largest freshwater fish on the planet – pokes its huge head above the fast-flowing waters. The world's biggest rodent, the capybara, ambles through the wetlands, anacondas coil around the tangle of trees and giant anteaters, giant river otters and giant freshwater turtles thrive. Amongst the 500 bird species that flutter through the canopy, the Harpy eagle stands as the largest in the Americas, and the false vampire bat takes the crown as South America's largest. Yet it is the continent's largest cat, one which usually slinks through the shadows as a clandestine master, which takes centre stage in Iwokrama. Seemingly unthreatened by the presence of people, jaguar sightings are relatively common, the beautiful and powerful animals padding through the jungle or swimming expertly across rivers.

Exploring the Deep Amazon

Here in the Amazon basin Iwokrama's 3,710 square kilometres (1,430mi²) of virgin rainforest is a model for eco-friendly sustainability. The Iwokrama Centre for Rainforest Conservation and Development is not government funded, the local community of Amerindian people finding a delicate balance between self-sufficiency and overexploiting the resources. Like a huge laboratory for forest management, tree felling, cottage industries and ecotourism are practised, the profits funding further research.

At the heart of the project, perched on the banks of the Essequibo River, is the Iwokrama River Lodge, a scientific centre where a handful of cabins and some back-to-nature hammocks offer a delightful place from which to venture into the forest. Trek the trails in search of the unmistakable black spots of the jaguar (known as rosettes for their delicate rose shape), or walk the 30 metre (100ft) high canopy walkway for face to face encounters with toucans, macaws, and black spider monkeys. As dusk falls and the giant water lilies slowly open, embark on a river trip guided only by the pale light of the moon as you strain to catch a glimpse of alligators or hear the distinctive cough of the Arapaima.

TAKE ME THERE

How to Visit: Guyana's capital Georgetown is the main entry point from where Iwokrama's main office can arrange transportation and accommodation. Options include eco-cabins in lodges or the hammock camp at the field station.

Further Information: Book activity and accommodation packages directly through the Iwokrama River Lodge (**www.iwokramariverlodge.com**), which is part of the Iwokrama International Centre (**www.iwokrama.org**) or Atta Lodge and Canopy Walkway (**www.iwokramacanopywalkway.com**).

Did You Know? The name jaguar is derived from the Native American word *yaguar*, meaning 'he who kills with one leap.'

Wildlife:
- Giant river otter
- Black caiman alligator
- Arapaima
- Capybara
- Giant anteater
- Anaconda
- Harpy eagle
- Black spider monkey
- Crimson Fruitcrow
- Blue and scarlet macaw
- Bats

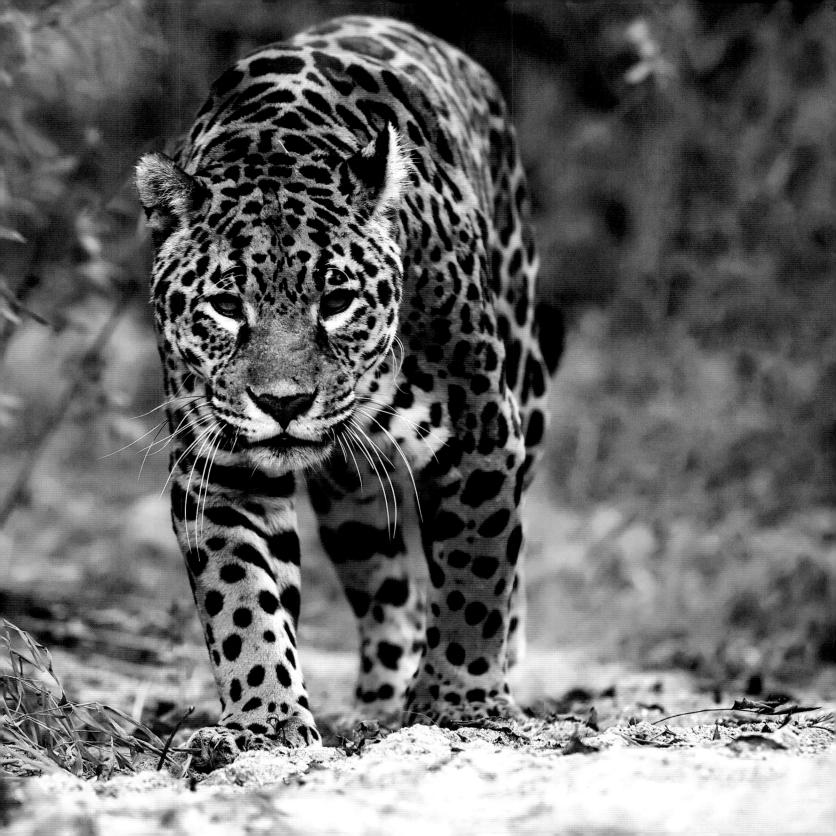

94 BATS IN GUNUNG MULU NATIONAL PARK
MALAYSIA

In the depths of Malaysian Borneo is a vast national park 528 square kilometre (204mi²) hectares in size whose astounding secrets have been drawing scientists and explorers for decades. Great jagged karst formations and caves of massive proportions dominate the landscape, where some 3,500 plants grow in the 17 vegetation zones. Gunung Mulu, a 2,377 metre-(7,800ft) high sandstone pinnacle towers above the park, below which weathered tropical limestone has been carved into razor-sharp spires and deep canyons coursed by crystal-clear rivers. The biodiversity is staggering, 262 species of birds (including the impressive rhinoceros hornbill) and 75 species of mammal living alongside an ever-increasing number of discovered frogs and fish, butterflies and insects

The most abundant of the wildlife however, are the millions of bats that have found an ideal home in the gargantuan caves that weave beneath the landscape. Twenty seven species of bat have been recorded in Mulu, inhabiting some of the largest caves on the planet that span hundreds of mostly unexplored miles of gargantuan passages. The world's largest under-ground chamber, the Sarawak Chamber, is so large it is said to be capable of accommodating forty Boeing 747 airplanes, and the Deer Cave is home to the world's second biggest cave passage, big enough to fit five cathedrals the size of London's Saint Paul's. An enormous colony of Wrinkle-lipped bats live within the dark recesses of Deer Cave, numbering in the millions, their guano blanketing the cave floor and giving life to a scurrying mound of insects and their predators.

Witnessing a Bat Exodus

As the sun drops towards the horizon in Gunung Mulu, a frenzy of activity begins in the mouth of the vast caves. Creating ring formations, millions of bats circle up the cliff face, higher and higher until they explode into the twilight in endless black ribbons. Spiralling and swirling above the rainforest, the dark cloud of bats go in search of food, eating five to ten grams of flying insects per night before returning in the early dawn light to the safety of the caves.

In a park of challenging treks and pursuits crafted for the adventure-lover, Deer Cave is the least taxing way to see the nightly mass exodus of bats, and one of the largest colonies of wrinkled-lipped bats in the world. A guided walk takes you past gushing streams and old-growth rainforest, where gibbons and birds whoop in the canopy, to the mouth of a cave so vast its main chamber is 174 metres (570ft) wide and 122 metres (400ft) high.

Explore the cathedral-like caves, trek to the limestone Pinnacles, walk along the 480 metre (1,574ft) -long canopy trail – the world's longest tree-based canopy walkway – or take a boat trip down the river as you explore the mosaic of habitats and their unique wildlife.

TAKE ME THERE

How to Visit: To reach the park there are daily flights from Miri or a longer boat ride from Kuala Baram. Accommodation in the park ranges from a luxury resort to guesthouses, lodges and homestays. The park HQ can arrange guides which are obligatory for cave visits and many treks.

Further Information: The official national park (**www.mulunationalpark.com**) and Malaysia tourism (**www.tourism.gov.my**) websites are good starting points for planning a trip. For further information on the ecology, biodiversity and geology of the park see UNESCO World Heritage website (**whc.unesco.org**).

Did You Know? Clearwater Cave in Gunung Mulu National Park is the longest in Asia measuring 108km (67mi) and its subterranean river is navigable by boat.

Wildlife:
- Rhinoceros hornbill
- Bearded pig
- Barking deer
- Mouse deer
- Gibbon
- Long-tailed macaque
- Sun bear
- Squirrel
- Swiflets
- Bornean tarsier

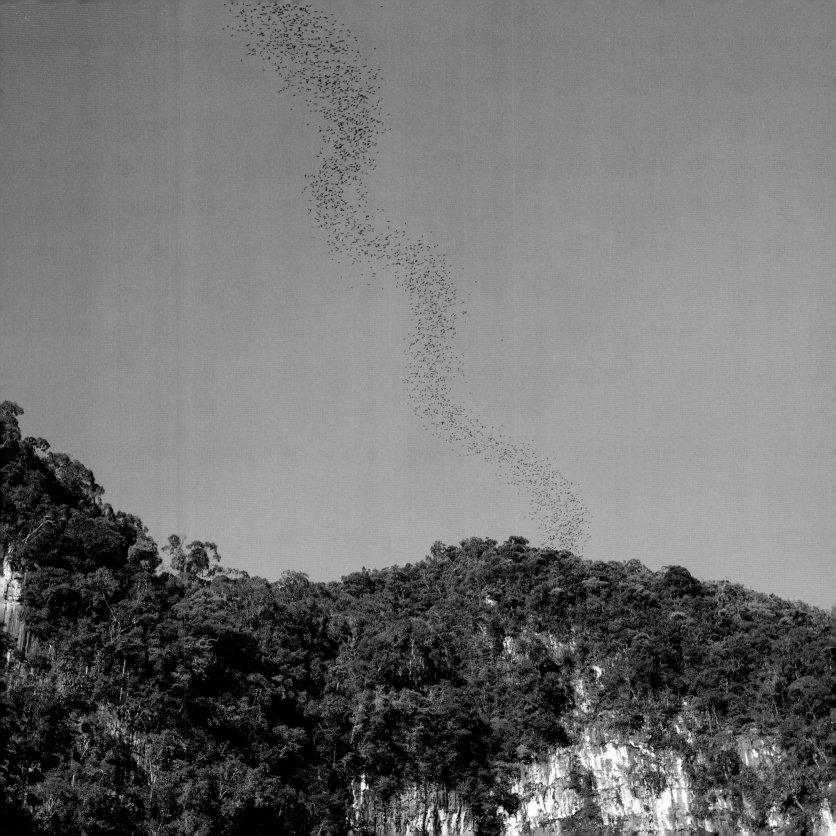

BARREN-GROUND CARIBOU IN NUNAVIK
CANADA

Nunavik forms the northern third of Quebec, a wild Arctic territory spanning 507,000 square kilometres (195,000mi²) – bigger than California and twice the size of Britain. It is the ancestral homeland of the Canadian Inuit, whose strong cultural traditions, myths and way of life are entwined with the landscape. Great roaring rivers pour through tundra and taiga forest, past jagged mountains and gargantuan lakes into the frigid, iceberg-laden waters of the Arctic which swirl around three sides of the land. It is a feral and untouched snowy realm, a place of raw, powerful beauty left to the ravages of nature.

Delicate but sprawling ecosystems support a thriving wildlife, their existence an integral part of Inuit traditions and life. Seals (ringed and bearded) are plentiful, and minke whales, belugas and orcas puff through the dark seas. Long-toothed walruses sit idly on floating sea ice and shingle beaches, and the king of the arctic, the polar bear, pads majestically along the shores. Inland are grey wolves and Arctic foxes, prehistoric musk oxen and soaring birds of prey.

Yet by far the most numerous of Nunavik's faunal inhabitants are the barren-ground caribou. Vast herds hundreds of thousands strong roam the desolate tundra, making arduous migrations hundreds of kilometres to their calving grounds and back again every year. They are fast runners and strong swimmers, using their well-adapted hooves to power across fast-flowing rivers with nothing but their heads and regal antlers protruding above the surface. It is a rare and humbling sight to behold, the mass movement of so many animals through one of the world's last great frontiers.

Tracking the Arctic Migration

To experience the thundering roar of the caribou migration as it stampedes across the permafrost is no easy feat. No roads traverse Nunuavik, the only way to get around being by light aircraft, on foot or by canoe. Accommodation is scant and basic, camping in the numerous national parks or hunkering down in rustic lodges the only options. Yet the trials and tribulations of visiting the region are somehow its biggest asset. Tourism has yet to take a hold here, specialist tour operators offering a handful of intrepid travellers the opportunity to embark on a journey into the remote north.

There are ways aplenty to experience Nunavik – trekking, river rafting, snow-shoeing, canoeing, cruises and helicopter rides. Yet to watch and photograph the migration an epic journey by plane and canoe – guided by Inuit guides – takes you to the heart of the river crossing to set up camp and, with the help of aerial reconnaissance, GPS and intuition, track the great movement. Trips can be combined with the chance to go in search of the shaggy musk oxen and fearsome polar bear.

TAKE ME THERE

How to Visit: Nunavik is not an easy place to travel to and is best arranged through a guided trip. The jumping off point is Kuujjuaq which can be accessed by flight from Montreal. There are no roads and most travel is by light aircraft, helicopter or along rivers by canoe. The best times to see the migration are spring and autumn.

Further Information: The regional parks (**www. nunavikparks.ca/en**) and tourism (**www.nunavik-tourism.com**) websites are an excellent source of information. There are several specialist outfitters offering guided trips to see the migration including Audley Travel (**www.audleytravel.com**), Great Canadian Wildlife Adventures (**www.thelon.com/carboo.htm**) and Inuit Adventures (**inuitadventures.ca**).

Did You Know? Food in the Arctic is scarce and caribou live on a diet of lichen, grasses, twigs and mushrooms.

Wildlife:
- Grey wolf
- Polar bear
- Musk ox
- Minke whale
- Walrus
- Seals (ringed and bearded)
- Beluga whale
- Snowy owl
- Peregrine falcon
- Arctic fox

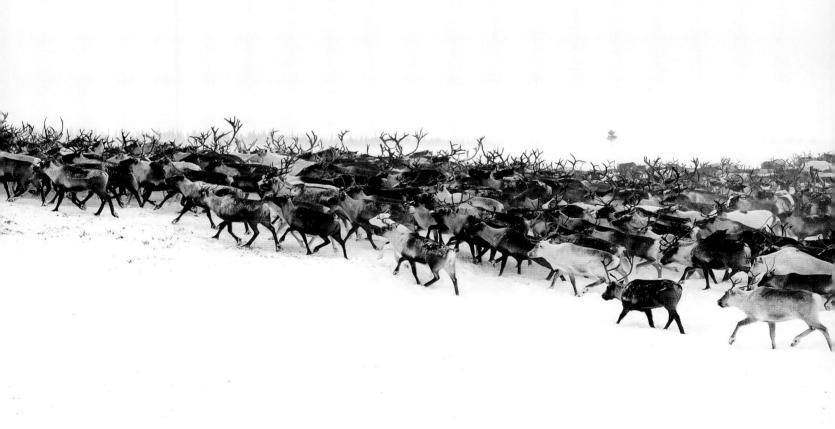

SHOREBIRDS IN BANC D'ARGUIN NATIONAL PARK
MAURITANIA

Mauritania is a country steeped in tradition. Ancient sand-blown villages dot the sprawling Saharan desert where vivid green oases give respite to the nomads who tend their flocks in the ways of their forefathers. It is a wild and untamed place that stretches from the shifting dunes of the great African desert to the tumultuous shores of the Atlantic. And it is in this unique transition zone that the country's largest and most important national park lies.

Stretching for hundreds of kilometres along the undeveloped coast, Banc D'Arguin is a patchwork of vast mudflats, rolling sand dunes, offshore islands and brackish mangroves. Here, a third of all the wintering shorebirds which soar along the Atlantic flyway between Europe and Africa stop – over 100 species numbering more than three million birds. It is one of the largest gatherings in the world, where flamingos, broad-billed sandpipers, pelicans, black terns, ringed and grey plover and bar-tailed godwit number in their thousands. The area is one of the most important wintering grounds for the Eurasian spoonbill, and breeding birds include the white pelican, reed cormorant and several species of tern.

While the marshes and shifting sand banks might form the most important habitat in the Western Atlantic for shorebirds, the park doesn't stop when it reaches the ocean, with over half of the UNESCO designated territory stretching into the crashing seas. Here, endangered monk seals thrive on the plentiful fish stocks, joined by dolphins, orcas and pilot whales, and four of the world's five turtle species clamber ashore to nest.

Back to Basics in Mauritania

Few roads traverse the Banc D'Arguin National Park, and the ones that do are rudimentary. There are no fancy lodges and hotels, but rustic community-run camps offering a traditional Mauritanian experience. It is not an easy place to travel to, but that's precisely what makes a trip here a true adventure.

Guided 4x4 jeeps will bounce you across the sand dunes, where fennec, jackals, Dorcas gazelle and hyena roam, to the remote village of Iwik from where traditional non-motorised fishing boats set out into the battering surf for the offshore islands. The Imragen people who live within the park's boundaries survive off fishing for mullet roe using only traditional techniques which includes the symbiotic help of dolphins, an impressive sight to behold.

It is an ornithologist's dream, the skies filled with great flocks of swirling birds, swooping over the mudflats and marshes covered with seagrass beds. It is hard to comprehend the sheer numbers that arrive here every winter from Europe, Siberia and Greenland.

TAKE ME THERE

How to Visit: Facilities in and around the national park are rudimentary and there are few roads. 4x4 jeeps with a guide are required and can be hired from the towns of Nouakchott or in Nouâdhibou. Traditional fishing boats take you offshore to see the birds and can be hired in Iwik. Accommodation is limited to tents inside the park. The best time to visit is winter (November to February).

Further Information: As an UNESCO World Heritage Site a wealth of information can be found at **whc.unesco.org**.

Did You Know? The Mediterranean monk seal is one of the world's most endangered marine mammals, with fewer than 600 individuals currently surviving. One of the most important and thriving colonies exists in the Banc D'Arguin National Park.

Wildlife:
- Mediterranean monk seal
- Atlantic humpback dolphin
- Bottlenose dolphin
- Risso's dolphin
- Orca
- Pilot whale
- Turtles (green, leatherback, hawksbill and loggerhead)
- Dorcas gazelle
- Striped hyena
- Jackal

97 KOMODO DRAGONS IN KOMODO NATIONAL PARK
INDONESIA

At the beginning of the 20th century, Dutch sailors went in search of a mysterious, seven metre (23ft)-long fire-breathing dragon which legend had it lived on a tiny island in Indonesia's Lesser Sunda Islands. While it turned out the tales had been aggrandised in folklore, what they did find was a huge fierce lizard, three-metres (10ft) long and weighing over 70kg (154lbs). The Komodo Dragon – so named after the island on which it lives – became a living legend, the world's largest lizard able to knock a buffalo to the ground with one swipe of its powerful tail.

There is a certain juxtaposition to Komodo National Park (which encompasses the islands of Komodo, Rinca and Padar) and its most famous inhabitant. Amidst the pristine landscape, where turquoise seas and vivid coral reefs lap against white and pink sand beaches, walks a lizard no-one could describe as beautiful. Leathery folds of skin envelope a dinosaur-esque body and a mouth of sharp teeth delivers a fatal blow of poisonous bacteria. As dominant predators of their small realm, they silently stalk their prey with fearsome menace, eating almost everything they encounter from deer to pigs, and even water buffalo.

Komodo, Rinca and Padar are just three of Indonesia's 17,508 islands, the national park encompassing rugged hillsides of dry savannah, pockets of upland cloud forest and mangrove forests nestled into protected bays. Snakes and Timor deer, cockatoos and macaques share the land with the great dragons, but it's the teeming oceans where a rich marine biodiversity exists. Dugong, whale sharks, manta rays and ocean sunfish exist alongside whales, dolphins and turtles, and a myriad of colourful reef fish dart through the sponges and corals.

Walking in the Dragon's Lair
The islands are part of the Coral Triangle, one of the richest marine biodiversities on earth. So it seems somehow apt that a trip to the Komodo National Park should be aboard a dive liveaboard, where delving under the surface of the clear blue seas reveals the throbbing life that exists within it. While the dragons may be the focus of your visit (the three islands walked by no less than 5,700 of the fearsome lizards), embarking on a week-long scuba diving cruise harnesses the power of the abounding nature of the park.

Channel your inner pirate and set sail aboard a wooden schooner into the heart of Komodo National Park. Clamber ashore and stare into the eyes of a seemingly docile dragon as they bathe serenely under the hot sun. Walk the savannahs in the footsteps of the giants whose very existence is still making valuable contributions to the theory of evolution.

TAKE ME THERE

How to Visit: From Denpasar, Bali travel by ferry or air to the gateway cities of Labuan Bajo on the island of Flores or Bima on Sumbawa island. From there multi-day dive liveaboards and boat cruises head out to Komodo and Rincon islands. The national park can be visited year round with May to October being the driest and July and August the busiest.

Further Information: Start planning your trip with the information on the national tourism (**www.indonesia.travel**) or official national park (**www.komodonationalpark.org**) websites. Further information about the flora and fauna can be found at **whc.unesco.org**. There are dozens of dive liveaboards including Komodo Liveaboard (**komodoliveaboard.com**) and Siren Fleet (**sirenfleet.com**).

Did You Know? If the initial bite of Komodo Dragon doesn't kill its prey, it will die within 24 hours from blood poisoning from the bacteria-filled saliva.

Wildlife:
- Whale sharks
- Manta rays
- Ocean sunfish
- Dugong
- Sea turtles
- Timor deer
- Snakes (including Javan spitting cobra, Timor python, Russel's viper)
- Cockatoo
- Macaque
- Orange-footed scrub fowl

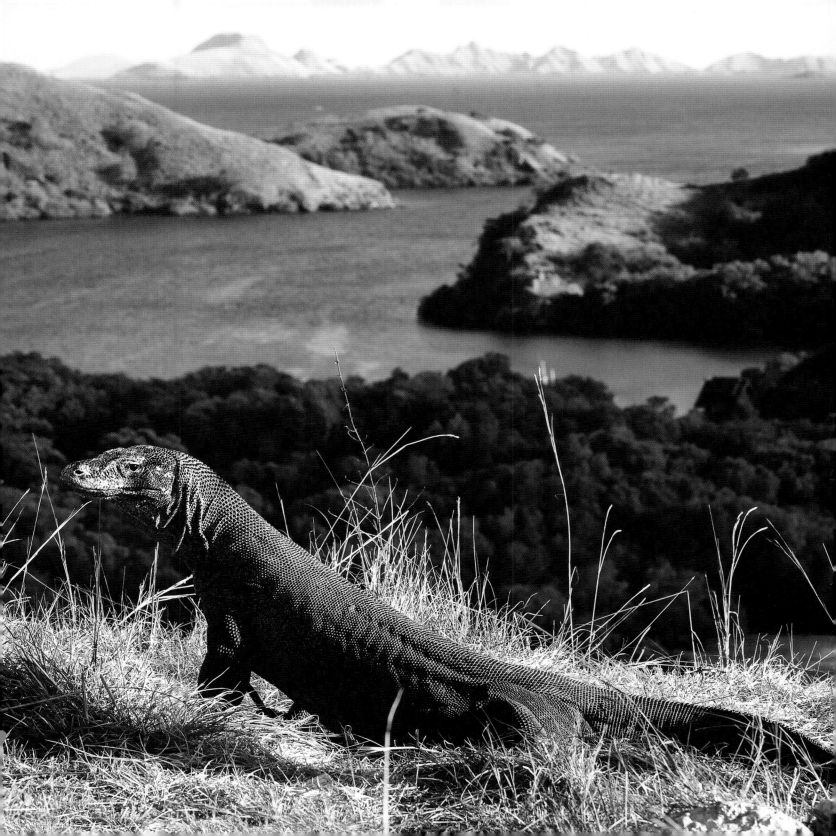

Established in 1907, Jasper is the largest national park in the Canadian Rockies, a pristine mountain wilderness stretching for 10,878 square kilometres (4,200mi²). The scenery is mesmerizing, rugged snow-capped mountains which meet in alpine valleys strewn with summer wildflowers, and wild icy rivers coursing through dense emerald forests. Vast iridescent blue lakes nestle between the towering peaks, their glacial waters as clear as glass. And the great Columbia Icefield carves its way through the heart of the park (and into neighbouring Banff National Park), a hundred ancient glaciers straddling the continental divide amidst a landscape of snowy mountains, roaring waterfalls and razor sharp ice.

Jasper is a true unadulterated wilderness, an UNESCO World Heritage Site that is home to some of North America's rarest wildlife. Grizzly and black bears amble through the open meadows, moose and caribou tiptoe through the winter snow and masterfully camouflaged wolves and wolverines pad through the great forests. It is a thriving ecosystem where elk, bighorn sheep, mule deer, white-tailed deer, beavers, Rocky Mountain pikas and hoary marmots exist alongside their predators.

Despite being widely distributed – they can be found from Alaska to the U.S. Rocky Mountains – mountain goats inhabit mostly precipitous and inaccessible terrains. Yet even in the highest echelons of the park, these pure white goat-antelopes are often sighted, their distinctive beards and long dazzlingly

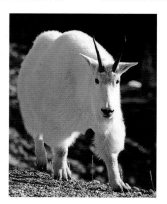

white fur perfect for blending into snowy landscapes and protecting them against the biting wind and icy cold of winter. They are amazingly surefooted, skipping along precipitous rocky ledges with nimble agility.

Exploring the Rockies

The surest way to spot a mountain goat teetering stomach-churningly on the narrowest of ledges is to get out into the heart of the park. Famed for its backcountry hiking, Jasper has a never-ending swirl of trails that weave between great lakes and through sweeping valleys, past jagged glaciers and under precipitous mountains.

While winter hosts its own catalogue of adventures – from skiing to snowshoeing, and ice climbing to skating, the spring to autumn months offer the best chances of spotting wildlife. By night hunker down in one of the many campsites, or try your hand at backcountry camping, where roaring log fires and clear skies filled with splashes of stars while away the evenings. By day, take your pick of activities and venture into the wildlife-laden lands in search of mountain goats, bears and moose. Hike, mountain bike or horse-ride the alpine trails, kayak through lakes scattered with islets, fish in the fierce rivers or take a dip in the hot springs. Drive the scenic Icefields Parkway – the only road in the world to snake alongside an icefield – or delve into underground caves and canyons.

TAKE ME THERE

How to Visit: Jasper National Park is located in the Rocky Mountains in western Alberta and offers a huge range of tourist facilities and activities. There are lots of excellent campsites as well as lodges, hotels and guesthouses. The park can be visited year round but the best wildlife viewing is from March to June or September to November.

Further Information: Find a wealth of travel and trip-planning information through Parks Canada (**www.pc.gc.ca**), Travel Alberta tourism (**travelalberta.com**), Jasper National Park (**www.jaspernationalpark.com**) and Tourism Jasper (**www.jasper.travel**).

Did You Know? Mountain goats can jump almost 3.5 meters (12ft) in a single leap.

Wildlife:
- Brown bear
- Black bear
- Moose
- Caribou
- Grey wolf
- Elk
- Mule deer
- Mountain lion
- Bighorn sheep
- Coyote

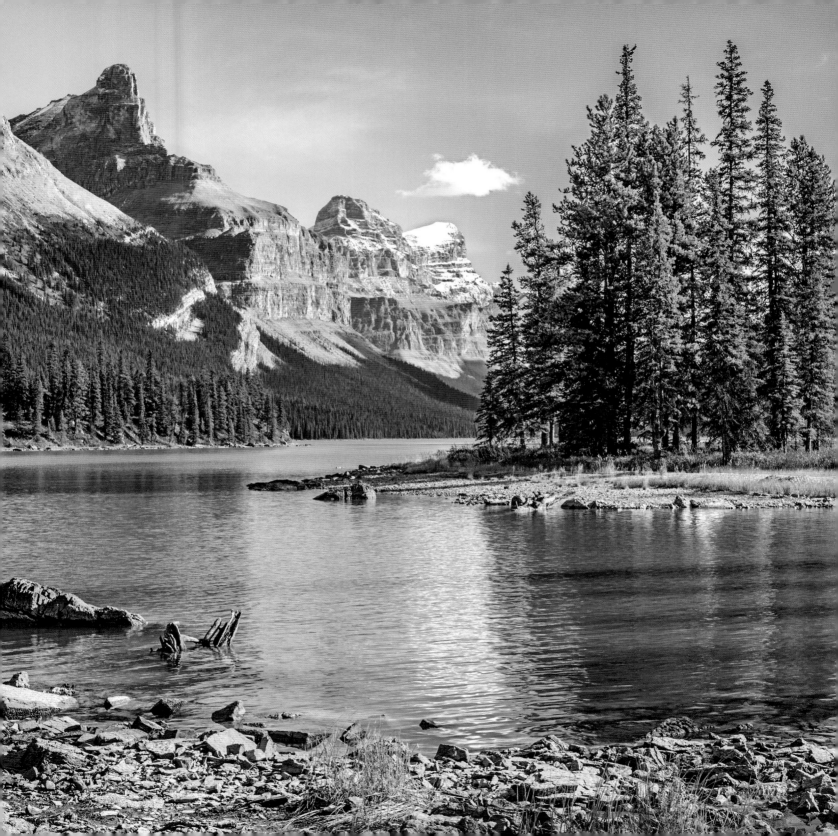

LEMURS IN MADAGASCAR
MADAGASCAR

When the island country of Madagascar separated from the African continent some 88 million years ago, it created the perfect conditions in which a kaleidoscope of one-of-a-kind plants and animals would evolve. Today, 90 per cent of all the flora and fauna found on the world's fourth largest island is unique, growing or living nowhere else on the planet. Indeed, 150,000 of the 200,000 fauna species are endemic. The landscapes change in the blink of an eye, from lush rainforest to arid deserts, coral fringed beaches to high humid plateaus. And in it weird and wonderful animals exist, the cute and cuddly, the hard-to-believe, and the downright strange carving out an existence amidst the patchwork of terrains and bizarre plants.

As the icons of this strangely beautiful land, where baobab trees grow like eerie hands out of the ground, lemurs rule the evolutionary roost. From the very smallest primate in the world, the Madame Berthe's mouse lemur, which weighs 30 grams (1.1 oz), up to the largest of the lemurs, the indri (which can weigh as much as 9.5kg/21lbs) there are over 100 different recognised species spread across the country. In the absence of monkeys and other predators lemurs thrived in Madagascar until the arrival of man. Today many have become extinct and others are in danger of following suit. However, to see and experience them for yourself, head to one of the many national parks for an up-close encounter with one of the wide-eyed nocturnal primates.

Lemur Adventures in a Bizarre Land

At 580,000 square kilometres (224,000mi²) – almost the size of Texas – Madagascar is a big country, one of such variety, drama and intrigue that it is impossible to see it all. Whether you choose to venture independently into the national parks in search of lemurs or go as part of an organised tour taking in the best of the Indian Ocean island, experiencing it in bite-sized chunks is the only manageable way.

Lemurs have evolved and adapted to the many environments, from the stone forests of the northwest, to the highland rainforests and the offshore islands. Go in search of the big noisy Indri lemurs in Parc National d'Andasibe, whose distinctive song echoes up to 3km (1.8mi) through the rainforest, or find the famous ring-tailed lemurs, with their fluffy coats and bushy tails, amidst the canyons and cliffs of Parc National de l'Isalo. In the steamy rainforests of Ranomafana National Park, the golden bamboo lemur (and 11 other species) can be tracked with the aid of an experienced guide, and for a true challenge head to the island of Nosy Mangabe in search of the elusive and bizarre-looking aye-aye.

TAKE ME THERE

How to Visit: Begin a trip in the capital of Antananarivo from where you can venture out to the national parks and islands. There are many international and local tour operators offering a wide range of tours throughout Madagascar, and there is a good network of high end and budget accommodation. The best time to visit depends on which part of the country you wish to visit but avoid the cyclone season (January to March).

Further Information: Start planning a trip at the official tourism website (**www.madagascar-tourisme.com/en**). Several top operators offer tours to Madagascar including Responsible Travel (**www.responsibletravel.com**), Audley Travel (**www.audleytravel.com**) and Natural Habitat Adventures (**www.nathab.com**).

Did You Know? The word Lemur derives from the Latin meaning 'spirit of the night'.

Wildlife:
- Fossa
- Narrow-striped mongoose
- 30 species of tenrec
- 75 species of chameleon
- 36 endemic genera of birds
- 100 species of endemic freshwater fish
- 115 species of endemic bird
- 300 species of endemic frog
- 270 species of endemic reptile
- Sharks (whale, reef)

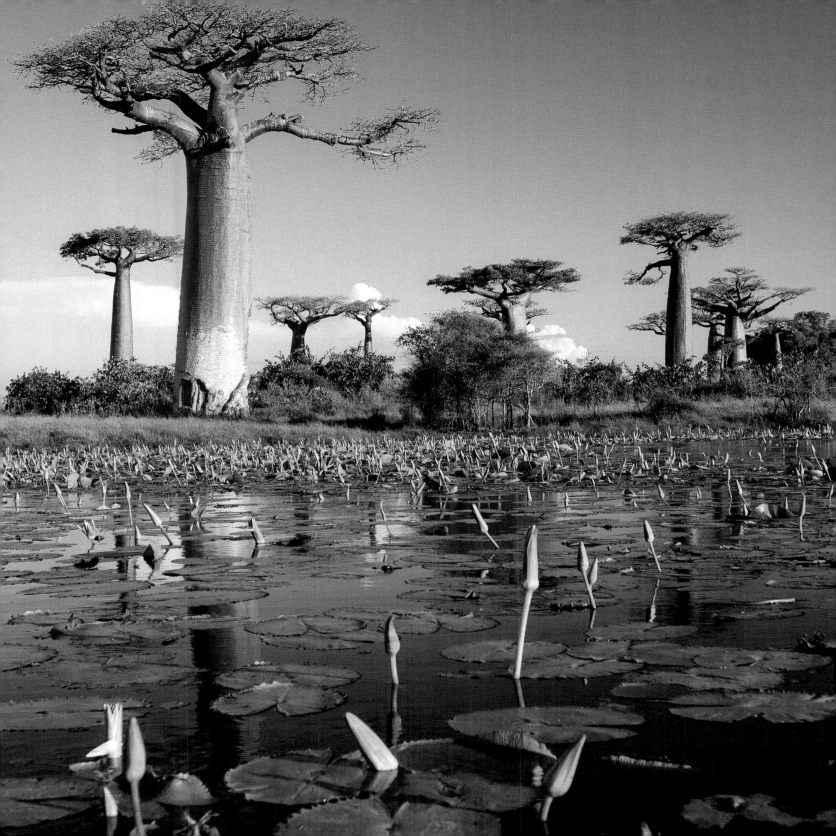

When polar bears outnumber human inhabitants in one of the world's harshest environments, you know you are truly in the heart of the Arctic. The Norwegian archipelago of Svalbard is about half way between the mainland and the North Pole, a starkly beautiful place where winter brings glaciers and snow-covered valleys, wide wintry plains and frosty caverns decorated with turquoise icicles. In turn summer bathes the land in a golden glow of the midnight sun. There is an eerie beauty to this remote and inhospitable stretch of land, a seemingly perfect place to find some of the world's most incredible wildlife.

Wildlife in this unforgiving place, where roads are few and far between and snowmobiles outnumber the main town's 2,000 residents two to one, might be small in diversity but it makes up for that in sheer numbers. In the frigid waters unicorn-beaked narwhals and bowhead and white whales thrive year round; five species of seal inhabit the ice blue coves, poking whiskered noses above the surface; and walruses drag their lumbering bodies onto huge chunks of floating sea ice. On land, reindeer and Arctic foxes tiptoe through the snow and across the summer tundra, and millions of seabirds nest in the cliffs. Yet it's the king of the arctic, the magnificent polar bear, which draws most visitors to this frosty and untouched wilderness. With males weighing 350–680 kg (770–1,500lbs) they are the largest carnivore on the planet. The polar bear is classified as a vulnerable species, with eight of the nineteen subpopulations

in decline. Yet a joint effort between the Norwegian and Russian governments has protected the animals by law since 1973 and today polar bears in this icy realm (which encompasses Franz Josef Land) are thriving.

Cruising the Arctic

It is just 1,333 kilometres (828mi) to the North Pole and for four months a year darkness shrouds the icy landscape. Docile reindeer amble along the streets of Longyearbyen and the northern lights dance in a swirl of green and red across the black, starry skies. Yet it's the summer months when the polar bears can be spotted as they pad across the retreating sea ice in search of their favourite food, the ringed seal.

Embark on a week-long small ship cruise of the islands, during a time when the snow melts and green grasses and bright, hardy flowers rear their heads, and watch as waterfalls pour down icy walls and birds squawk through the skies. In small dinghies you navigate the mountains of ice calved from glaciers as you keep eyes peeled for the lumbering yet graceful polar bear. While they can appear anywhere in Svalbard – they are proficient swimmers – and the lucky few might even glimpse a bear on day trips from Longyearbyen, the best chances of spying them in their truly remote and natural habitat is in the north-western and northern parts of Spitsbergen island, on the east coast and on Nordaustlandet and the surrounding islands.

TAKE ME THERE

How to Visit: There are flights from Oslo and Tromsø to Longyearbyen Airport and the town offers a handful of lodges, guesthouses and hotels. A number of activity providers offer multi-day cruises in search of polar bears. The best time to see the bears is in July and August.

Further Information: Both the Northern Norway Tourism (**www.nordnorge.com**) and Svalbard Tourism (**www.svalbard. net**) websites offer a wealth of information on visiting the region. Spitsbergen Travel (**www.spitsbergentravel.com**) and Natural World Safaris (**www.naturalworldsafaris.com**) can arrange tours, accommodation and travel packages.

Did You Know? Despite being born on land polar bears spend most of their lives at sea. Indeed, their scientific name *Ursus maritimus* translates as 'maritime bear'.

Wildlife:
- Svalbard reindeer
- Seabirds
- Arctic fox
- Walrus
- Narwhal
- Bowhead whale
- White whale
- Ringed seal
- Harbour seal
- Atlantic puffin

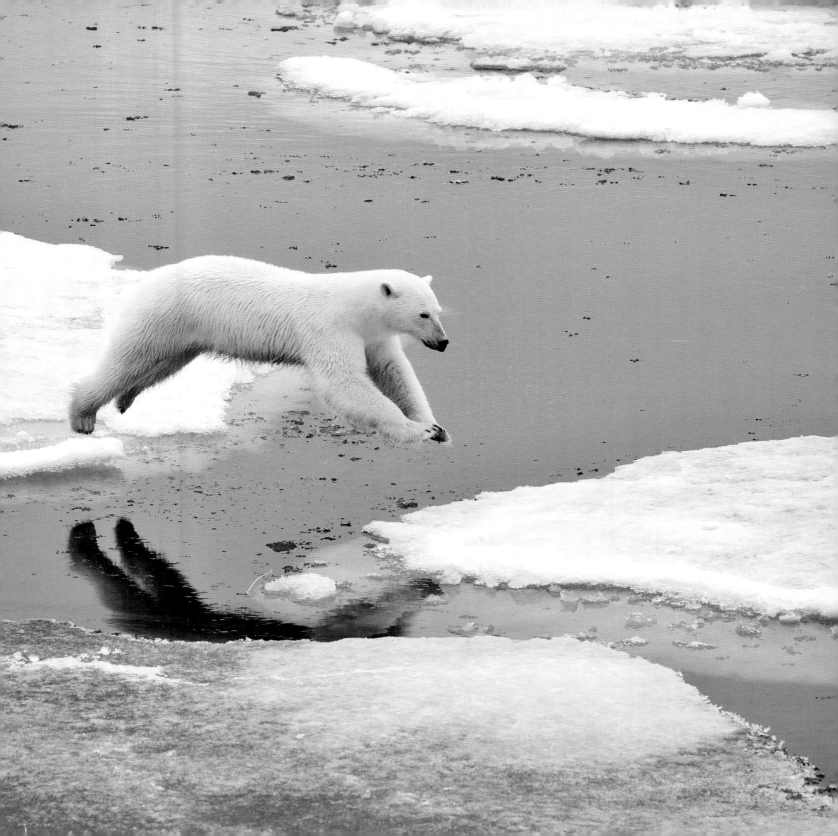

PHOTO CREDITS